RODIN IN HIS TIME

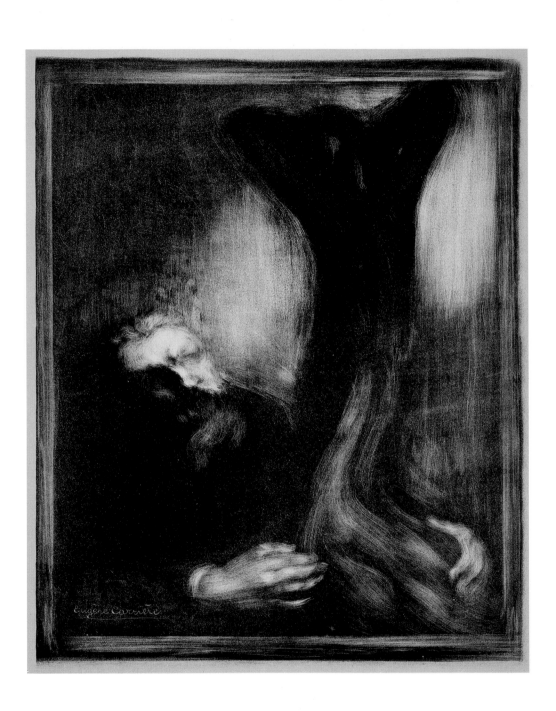

Rodin
IN HIS TIME

*The Cantor Gifts
to the
Los Angeles County Museum of Art*

Mary L. Levkoff

LOS ANGELES COUNTY MUSEUM OF ART

Copublished by

Los Angeles County Museum of Art
5905 Wilshire Boulevard
Los Angeles, California 90036

and

Thames and Hudson Inc.
500 Fifth Avenue
New York, New York 10110
(in the United States of America)

Thames and Hudson Ltd.
30 Bloomsbury Street
London WC1B 3QP
(in all other countries)

Library of Congress number: 93-61544
British cataloging-in-publication data:
a catalogue record for this book is
available from the British Library.
ISBN: 0-500-23678-X

98 97 96 95 94 5 4 3 2 1

The publication of *Rodin in His Time*
was made possible in part by the Andrew
W. Mellon Foundation Publication Fund.

Editor: Mitch Tuchman
Designer: Jim Drobka
Photographer: Steve Oliver

Printed and bound in Japan by
Toppan Printing Company, Ltd., Tokyo

JACKET/COVER (FRONT)
Auguste Rodin
France, 1840–1917
The Crouching Woman, c. 1880–82
Painted plaster
12¹/₂ x 10 x 7 in. (31.8 x 25.4 x 17.8 cm)
Gift of Iris and B. Gerald Cantor
Foundation in honor of Vera Green
M.91.153
(CATALOGUE NO. 15)

JACKET/COVER (BACK)
Albert-Ernest Carrier-Belleuse
France, 1824–87
Fantasy Bust, c. 1865–70
Terra-cotta on wood socle
29⁷/₈ x 11³/₄ x 11 in.
(75.9 x 29.8 x 27.9 cm) (without socle)
Gift of Iris and B. Gerald Cantor
Foundation through the
1992 Collectors Committee
AC.1992.19.1
(CATALOGUE NO. 7)

FRONTISPIECE
Eugène Carrière
France, 1849–1906
Rodin Modeling a Sculpture, 1900
Lithograph
21⁵/₈ x 17¹/₂ in. (54.9 x 44.5 cm)
Gift of Cantor Fitzgerald and Co. Inc.
M.90.118

CONTENTS

14

The Nineteenth Century before Rodin

46

The Sculptures of Auguste Rodin

152

Rodin's Contemporaries and Successors

A substantial portion of the publication program of the Los Angeles County Museum of Art is devoted to the documentation of its permanent collection. Since the growth of the museum's collection depends in large part on the commitment of individual collectors, scholarly publications such as the present volume constitute a record of the extraordinary generosity of the museum's most devoted constituency, the donors of art. Among that select group the relationship of B. Gerald and Iris Cantor with the Los Angeles County Museum of Art is particularly outstanding. It is a pleasure, therefore, to celebrate their long-term benefaction with this catalogue of their gifts.

In addition to establishing the Iris and B. Gerald Cantor Sculpture Garden and Plaza, with fourteen bronzes by Auguste Rodin and several of his principal followers, the museum also features a gallery dedicated to the Cantors' gifts of Rodin's art, installed under the direction of Associate Curator Mary L. Levkoff. Ms. Levkoff's years of research, analysis, and original interpretation have resulted in the publication of this important volume, which is enhanced by the photography of Steve Oliver. Ms. Levkoff's efforts are to be commended.

The Los Angeles County Museum of Art is above all grateful to Iris and B. Gerald Cantor, who, in enriching the museum's collection in such a significant way, have also enriched our community and the world of scholarship.

Stephanie Barron
Coordinator of curatorial affairs

B. Gerald Cantor has been entranced by the work of Auguste Rodin since 1945, when he returned from the war and saw Rodin's marble *The Hand of God* at the Metropolitan Museum of Art. Acquiring a version of it a short time later, he subsequently built what has become the foremost private collection of sculptures by Rodin.

Recognizing his good fortune, Mr. Cantor has long felt a profound responsibility to share the collection with others. Together with his wife, Iris, he has donated more than 430 works by Rodin and 250 paintings and sculptures by other nineteenth- and twentieth-century artists to over seventy museums and universities. Three of the most substantial of these public collections are in the Stanford University Museum of Art (where Iris and B. Gerald Cantor have also funded a fellowship program for studies focused on Rodin), the Brooklyn Museum, and the Metropolitan Museum of Art. The Cantor gifts to the last two are well known thanks to the publications devoted to them, and now this catalogue celebrates the twentieth anniversary of

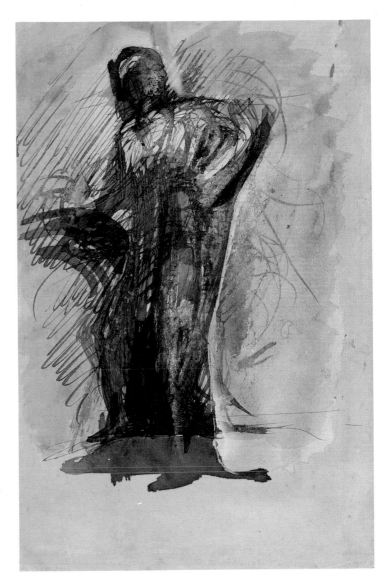

Mr. Cantor's donation in 1973 of dozens of Rodin bronzes to the Los Angeles County Museum of Art, forming the core of the fourth major public collection of Cantor sculptures.

The publication of this book gives us a welcome opportunity to acknowledge the Cantors' lengthy relationship with Los Angeles. In 1949 Mr. Cantor opened a branch office of Cantor Fitzgerald in Beverly Hills and established his residence here. His involvement with the Los Angeles County Museum of Art began in the 1960s with his gift of the magnificent German expressionist painting by Ernst Ludwig Kirchner *Two Women* as well as paintings by Max Beckmann and André Derain. Since that time the philanthropy of Iris and B. Gerald Cantor has enriched our holdings not only with sculptures but also with prints, drawings, photographs, paintings, and costumes, all of which are chronicled in this catalogue.

In addition to the broad financial support the Cantors have provided to the museum, Mr. Cantor is an honorary life trustee, and Mrs. Cantor serves on the board of trustees. They have enhanced the quality of life in southern California in a variety of other ways, through their support of the Iris Cantor Center for Breast Imaging at the UCLA Medical Center, the Music Center of Los Angeles County, and the Otis College of Art and Design.

In their commitment to the visual arts, music, health care, and education, Iris and B. Gerald Cantor have shown the same passion for life that they find in their preferred works of art: a pure emotional response and a dedication to the fulfillment of promise in individual lives. It is appropriate that this love of art and this focus on narrative and feeling are reflected in this book about the romance of artistic creation.

J. Patrice Marandel
Curator
European Painting and Sculpture

Auguste Rodin
France, 1840–1917
Study for the Gates of Hell, c. 1880–82
Brown ink, brown wash, and watercolor
7 x 4⁹/₁₆ in. (17.8 x 11.6 cm)
Gift of B. Gerald Cantor Art Foundation
M.87.76.4

PREFACE

The sculpture of Auguste Rodin has become such an important part of our visual culture that it seems to have been with us always. Much of the growth of interest in Rodin since 1960 has been nourished by B. Gerald Cantor's substantial gifts of Rodin's sculpture to museums throughout the world. In contrast to these, the Cantor gifts made to the Los Angeles County Museum of Art include works by several of Rodin's immediate predecessors, his contemporaries, and his successors. In order to do justice to the richness of context for nineteenth-century European sculpture that has been developed here over the past twenty years, the entries in this catalogue have been composed not only as studies on individual objects but also as parts of a narrative, so that the collection will be understood as a general introduction, through the works of art themselves, to the study of the art of this period. By virtue of the interests of Iris and B. Gerald Cantor, the primary focus is on Rodin and other French artists, but sculptures by the Belgian Constantin-Émile Meunier and the Russian-Italian Prince Paul Troubetzkoy, both of whom knew Rodin personally, and by the Italian medalist Domenico Trentacoste, who was influenced by Rodin, give a sense of the international fame of Rodin's work and of related movements in the art of sculpture.

There have been considerable contributions to and interest in the study of French nineteenth-century sculpture since 1979–80, when simultaneously the Metropolitan Museum of Art installed permanent galleries devoted to its collection and the Los Angeles County Museum of Art presented the encyclopedic exhibition *The Romantics to Rodin*, organized by Peter Fusco and H. W. Janson. The debt the present book owes to that exhibition's catalogue is easy to recognize. To general studies like Janson's posthumous *19th-Century Sculpture* (1985) we can now add the catalogues of the extensive exhibitions *Rodin Rediscovered*, organized by the National Gallery of Art in 1981, *De Carpeaux à Matisse*, held at the Musée Rodin in 1982, and *La Sculpture française du XIXe siècle*, shown at the Grand Palais in 1986. Other books produced by a new generation of curators at the Musée Rodin have made substantial contributions to the documentation of Rodin's art. The sculptor gave all his studies to France, thereby preserving a largely uncatalogued collection of rich complexity. The present book cannot attempt to take into account the vast amount of research and theory already devoted to Rodin's work. It attempts rather to present the attentive reader with an introduction to further investigation, encouraging personal interpretation, as Rodin himself wished.

ACKNOWLEDGMENTS

Many people contributed to this book in many ways. It is a pleasure to acknowledge them here.

Colleagues at various museums in Paris provided information and access to their collections and documentation: at the Musée d'Orsay, Anne Pingeot and Catherine Chevillot; at the Louvre, Jean-René Gaborit and Isabelle Leroy-Jay Lemaistre; at the Musée Rodin, Nicole Barbier and Alain Beausire; at the Musée Bourdelle, Rhodia Dufet-Bourdelle; and at the Maison de Balzac, Judith Meyer-Petit. So too did colleagues in Italy: Guido Cornini and Mario Ferrazza of the Musei Vaticani and Ettore Spalletti of the Galleria d'Arte Moderna di Palazzo Pitti; and in the United States, Ian Wardropper of the Art Institute of Chicago and Clare Vincent of the Metropolitan Museum of Art.

Others who made personal contributions to this catalogue are M. and Mme Paul Audouy, Ronny H. Cohen, Enzo Costantini, Jean-René Delaye, Annie and Marcel Grunspan, James Holderbaum, Joëlle Mortier-Vallat, Margaret and Olivier Panico, and Klaus-Otto Preis.

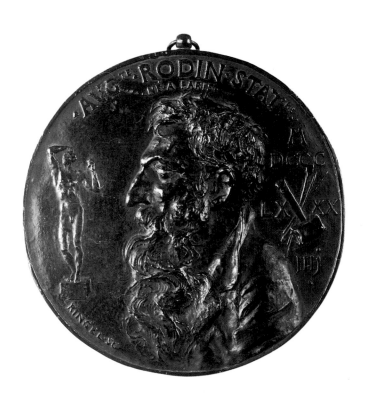

At the Los Angeles County Museum of Art Peter Brenner, Philip Conisbee, Jim Drobka, Roger Jones, Sandra Kline, Ralph Loynachan, Barbara Lyter, Steve Oliver, John Passi, Linda Rapagna, Mitch Tuchman, Marcia Tucker, and Susan Wiggins collaborated in a variety of ways to produce this book. They were aided by the staff of the Alan C. Balch Research Library. A further contribution was graciously provided by the staff of the library of the J. Paul Getty Center for the Humanities.

It is a particular pleasure to acknowledge an introduction to nineteenth-century French sculpture that was offered twelve years ago at the Metropolitan Museum of Art by Olga Raggio and Clare Vincent.

In New York Philippa Polskin, president of Arts and Communications Counselors, and Joan Inciardi, coordinator of the B. Gerald Cantor collections, supplied needed information, while in Los Angeles Susan Sawyers, curator of the B. Gerald Cantor collections, was unwavering in her interest and encouragement.

This collection would not have the form it does today without the efforts of Peter Fusco, former curator of European sculpture and decorative art at the Los Angeles County Museum of Art, now curator of European sculpture at the J. Paul Getty Museum, who provided constant support at every level. Vera Green, who until her death in 1991 was curator of the Cantor collections and worked tirelessly behind the scenes to coordinate the efforts of the Iris and B. Gerald Cantor Foundation in building this collection, tragically passed away before this book was completed.

Finally it is to Iris and B. Gerald Cantor that the author expresses the fundamental acknowledgment for having provided the primary documents of this catalogue, the works of art themselves. In spite of any defects, which are the author's responsibility, she hopes that this book makes a satisfactory expression of heartfelt and respectful gratitude to Mr. and Mrs. Cantor on behalf of the Los Angeles County Museum of Art.

Mary L. Levkoff
Associate curator
European Painting and Sculpture

Jean-Désiré Ringel d'Illzach
France, 1847–1916
Portrait of Auguste Rodin, 1884 or 1894
Bronze
Diameter: 6⅞ in. (175 mm)
Gift of Michael Le Marchant in honor
of B. Gerald Cantor
M.79.59

Jean-Désiré Ringel d'Illzach, a native of Alsace, continued the format of the large, fluidly modeled portrait medallion most closely associated with Pierre-Jean David d'Angers (1788–1856). This portrait shows Rodin's sculpture *The Age of Bronze* (1875) at the left and the sculptor's modeling and carving tools at the right.

NOTE TO THE READER

Catalogue entries are arranged chronologically according to the date of
the artist's birth within sections that have been determined subjectively.
A question mark following the date of a work of art means that the proposed
date is still open to revision.

Because much of the chronology of Rodin's individual sculptures is
not clear, his sculptures have been arranged first according to his three most
important commissions represented in this collection—*The Gates of Hell,
The Burghers of Calais*, and the *Monument to Balzac*—with *Saint John the
Baptist Preaching*, his earliest securely dated sculpture catalogued here,
serving as an introductory entry. Independent sculptures follow these.
Sculptures that are directly related to each other, such as enlargements of
earlier compositions, are grouped together.

The works of art that Rodin bequeathed to France are housed in
two collections: one in the Musée Rodin in Paris and the other, consisting
primarily of Rodin's plaster studies, in the Musée Rodin at Meudon.
References in this catalogue are to the museum in Paris unless otherwise
indicated.

The titles given by Georges Grappe to Rodin's sculptures have been
followed here. They are indicated in French. Rodin cast many sculptures
without having determined a title for them in advance. If these were not
catalogued by Grappe, they have been given conventional titles as
appropriate.

Rodin's bequest authorized casting his sculptures under the jurisdiction
of the Musée Rodin's administration to generate funds for the museum.
Not until 1981 was the number of these casts limited to an edition of twelve.
The cast number given in this catalogue refers to this edition. Furthermore,
a number in Roman numerals indicates a cast destined exclusively for public
institutions.

T

HE STORY OF NINETEENTH-CENTURY EUROPEAN
sculpture opens with Antonio Canova (1757–1822), the greatest sculptor of that century before
Rodin. The magic unearthliness of the ideal beauty he invented, enhanced by its secret pearly
finish, could not be duplicated. He went where few, if any, could follow, but his example was
so compelling that the academies of art could not resist imposing his example on their students,
especially in an atmosphere where taste for the antique was preponderant. Neoclassicism was
itself redolent with nostalgia for the past and thus carried with it its own romanticism, but the
academies, by allowing only the most formulistic treatment of style, bound themselves to
produce formulistic works of art, in which the uniqueness of the artist's personality was largely
suppressed in favor of an elusive ideal. The result after decades was a mummified classicism.

It was against this search for an imposed, absolute perfection, admirable though it was
in theory, that the romantic sculptors reacted. Eighteenth-century art offered them a vital
tradition in the rococo's lively modeling, and the subject of famous men lent itself easily to new
interpretations. Sculpture was reinvigorated through compositions fired with emotion, and new
subjects were invented to convey this drama. Rather than continuing to work primarily in
stone, sculptors saw greater expressive possibilities offered by bronze. Technical advances in
casting allowed further license in the development of increasingly complex models.

*The
Nineteenth Century
before Rodin*

Pietro Marchetti

ITALY, 1770–1846

Bust of a Veiled Child

CATALOGUE NO. I

c. 1840
Marble
15 x 11 x 9 in. (38.1 x 27.9 x 22.9 cm)
Incribed on base, back: Marchetti
Gift of B. Gerald Cantor
M.78.117

FIGURE I

Antonio Corradini
Italy, 1668–1752
Chastity (La Pudicizia), after 1745–52
Marble
Dimensions unavailable
Naples, Sansevero Chapel
Photo: Anderson /Art Resource

The signal feature of this small marble is its veil. Although Stefano Maderno's *Saint Cecilia* (1599, Rome, Santa Cecilia), was the distant ancestor of this motif, in the present bust it was directly descended from sculptures carved during the preceding one hundred years, beginning with Antonio Corradini's *The Vestal, Tucia* (1744, Rome, Palazzo Barberini)[1] and his *Chastity* (FIGURE I) in the Sansevero Chapel in Naples, for which his *Shrouded Body of Christ* was carried out after his death by Giuseppe Sanmartino in 1753.[2] Other shrouded figures in the same vein were Gaetano Callani's more naturalistically styled caryatids (1774–77) in Milan[3] and Innocenzo Spinazzi's *Faith* (1781) in Florence,[4] both of which probably owe a debt to Corradini's *Tucia*.

Pietro Marchetti, a native of Carrara, the Italian city famed for its deposits of brilliant white marble, must have known the *Faith* as well as the *Tucia* from his stay in 1782 in Rome, where he studied and won a prize from the Accademia di San Luca.[5] He returned to Carrara and in 1806 was appointed a professor at its newly established Academy of Fine Arts, where Lorenzo Bartolini would also be given a position two years later. Marchetti served as the academy's director from 1835 until his death.[6] Almost an exact contemporary of Berthel Thorvaldsen (1770–1844), Marchetti taught his own nephew, Pietro Tenerani (1789–1869), who became Thorvaldsen's practitioner before going on to achieve international fame in his own right, primarily as a sculptor of funerary monuments.[7] It is a near certainty that Marchetti became familiar with the work of Antonio Canova, the greatest neoclassical sculptor, during his stay in Rome[8] or, it has been suggested, also during a trip to Paris at the beginning of the nineteenth century.[9]

The virtuosity and fantasy of the Italian sculptors of the eighteenth century, qualities exemplified by the veiled figures cited here, were inherited by Canova, who transformed them in his singular vision of classical beauty. Unfortunately those who simply copied him, possessing neither his magical power of inventiveness nor his individuality, used technical finesse for its own sake and sapped the mystery out of art. Other veiled figures from the 1850s and 1860s, like Raffaele Monti's *The Sleep of Sorrow and the Dream of Joy* (1861, London, Victoria and Albert Museum), were admired as *tours-de-force* of technique but criticized for being nothing more than that.[10]

The present marble has a hint of modern naturalism, while its veil and flowers show a strong reliance on the iconographic heritage of sculptures like Corradini's *Chastity*.[11] Its subtle reference to the shroud of death and the blossoms of rebirth make the *Bust of a Veiled Child* an appropriate metaphor for the renewal of the sculptor's art in the nineteenth century.

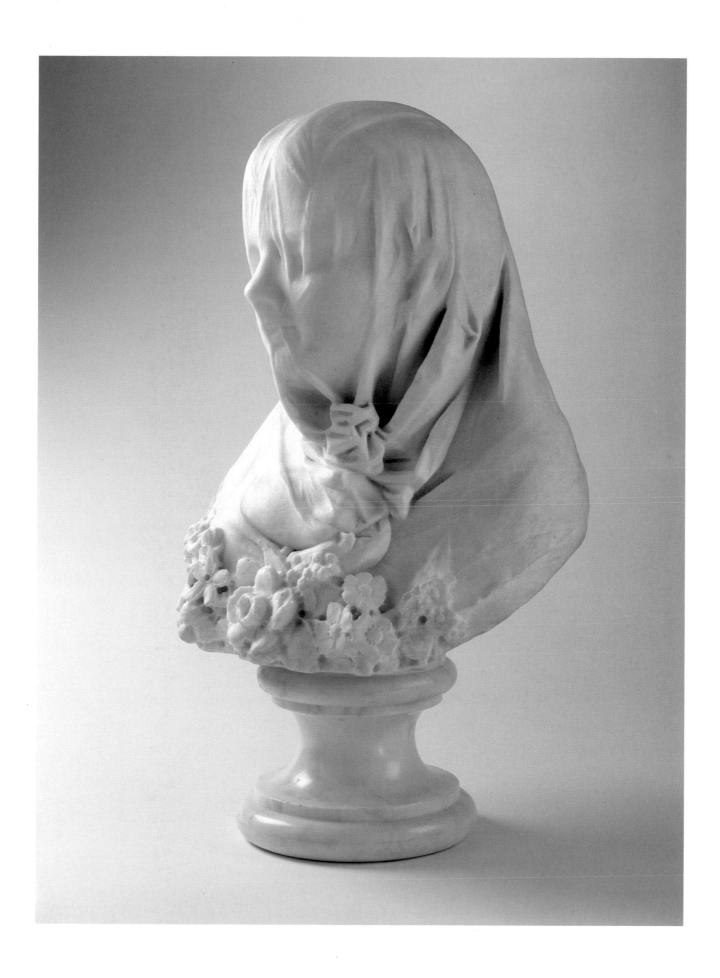

François Rude

FRANCE, 1784–1855

Head of
the Old Warrior

CATALOGUE NO. 2

c. 1833–36
Bronze
12 x 9 x 8 in. (30.5 x 22.9 x 20.3 cm)
Inscribed on back: F. RUDE (rein-
forced over smaller signature)
Gift of B. Gerald Cantor
Foundation
M.86.275

François Rude formed, with Antoine-Louis Barye and Pierre-Jean David d'Angers, the triumvirate of great French romantic sculptors. Rude is best known as the creator of one of the most famous sculptures in the history of Western art, *The Departure of the Volunteers in 1792* (*Le Départ des volontaires en 1792*), on the Arc de Triomphe at the Place de l'Étoile in Paris (FIGURE 2). This titanic relief[1] so completely embodied the patriotic zeal of the French that it came to be known as the *Marseillaise*, after the Revolutionary song adopted by France as its national anthem. The two dominant figures of this sculpture, the winged Genius of Liberty (also known individually as the Marseillaise) and the armored Old Warrior (alternatively called the Old Gaul), were the sources of bronzes in various sizes cast independently after them: the *Head of the Genius of Liberty*[2] and the present sculpture.[3]

There is a possibility that the figure of the Old Warrior had autobiographical symbolism for Rude; indeed, to a great extent much of his oeuvre can be interpreted in the context of his personal experiences and beliefs. His father, a locksmith and stovemaker in Dijon, was a determined opponent of the monarchy and ardently supported the adoption of a republican government in France. When the tide of revolution rose in Burgundy, Rude's father joined the national guard and presented his eight-year-old son for enrollment in a children's brigade of volunteers.[4] It is possibly this experience that determined the definitive form forty years later of *The Departure of the Volunteers*; in the final stage of design Rude transformed the figure of the soldiers' leader into an older, bearded man instead of a hero in the prime of life. The inspiration offered by the generational contrast between the Old Warrior and the boy he encourages was thus more clearly drawn.

Having succeeded in convincing his father to allow him to take a limited number of formal art classes in his spare time, Rude was noticed by the director of the local academy of design, François Devosge, whose son later supported the commission from the city of Dijon that resulted in Rude's *Hebe and the Eagle of Jupiter* (CATALOGUE NO. 3). Devosge provided Rude with an introduction in Paris to another native of Dijon, Napoleon's powerful superintendent of arts, Vivant Denon. Through him in 1807 Rude was recommended to Edme Gaulle, in whose studio he probably worked on reliefs for the Vendôme column, glorifying Napoleon's victories. Soon, however, he left Gaulle's shop for that of Pierre Cartellier, who proved more sympathetic to the younger artist.[5] Rude entered the École des Beaux-Arts in 1809 and won the Prix de Rome in 1812, but a deficit in government funds precluded the trip. It was during this time in Paris that he was exposed to the glittering refinement of imperial neoclassicism.

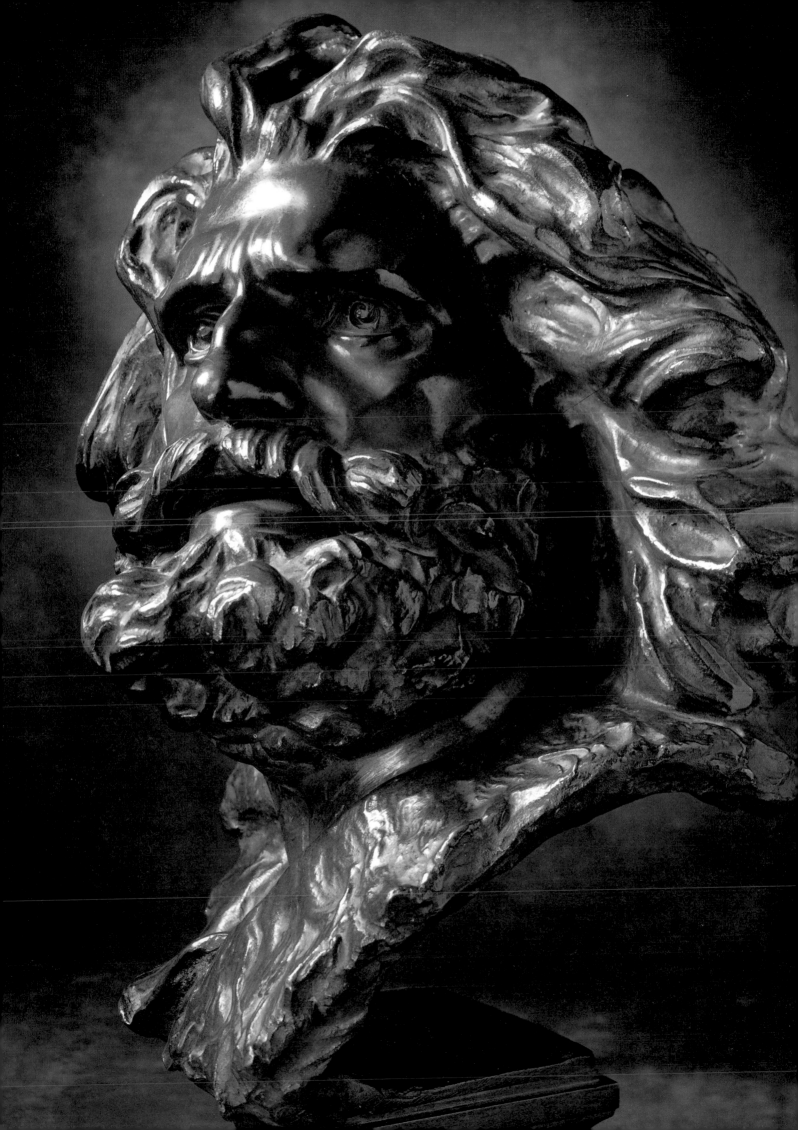

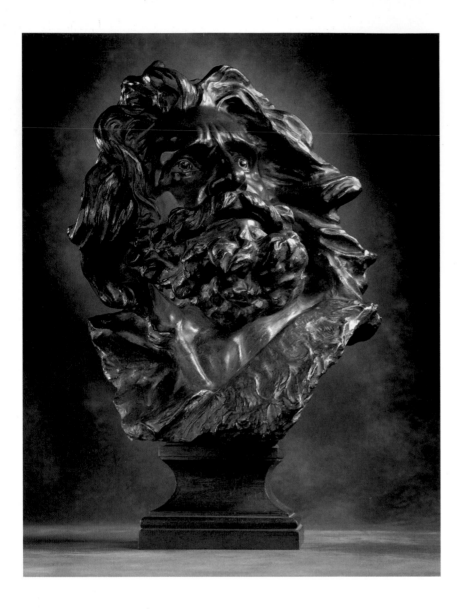

Rude remained deeply patriotic throughout his life and devoted to Napoleon Bonaparte. Despite Napoleon's absolutist rule and the wars he waged across Europe, he was nevertheless idealized as the savior of France from the anarchy of the Terror that had followed the deterioration of the Revolution. For Rude there was no contradiction in seeing Napoleon not only as the emperor who restored France's grandeur but also as the republic's true prophet who supplanted a discredited monarchy. With the emperor's ultimate fall from power Rude fled in 1815 to Belgium, where he lived in exile until 1827.

Rude's return to Paris was marked by the success of his *Mercury Attaching His Wings* (*Mercure rattachant ses talonnières*), presented in its plaster version at the Salon of 1827.[6] This sculpture is justly celebrated as a key monument in the history of romanticism. It mated a classicizing vocabulary to a prime example of high mannerist sculpture, Giambologna's *Flying Mercury* (1564–65, Florence, Museo Nazionale del Bargello), and it was full of the élan for which Rude became famous. The illusion of movement in his *Marshal Ney* (*Le Maréchal Ney*, c. 1848–53, Paris, Carrefour de l'Observatoire), for example, was later greatly admired by Rodin.[7] Rude attracted the attention of Adolphe Thiers, minister of the interior, who commissioned *The Departure of the Volunteers* for the Arc de Triomphe in 1833.

The construction of a triumphal arch at the Place de l'Étoile was initiated by Napoleon in 1806 to honor his Grand Army, but its progress was interrupted by the emperor's fall in 1815. Work resumed, albeit sporadically, in 1823 under the reinstated monarchy, but the definitive iconographical program of its relief sculptures was not set until 1833. Apparently in order to transpose nostalgic memories of France's imperial greatness onto the new monarchy, Thiers selected four crucial dates that evoked the challenges faced by the republic, the triumphs of the empire, and the consummation of peace.[8] The first of these dates, 1792, referred to the defense of the young republic against the combined armies of Prussia and Austria, and it was awarded to Rude. (This was also the subject of a later sculpture by Jean-Baptiste Carpeaux; see CATALOGUE NO. 9.) The three other major reliefs on the arch represented *The Triumph of 1810* (*Le Triomphe*), by Jean-Pierre Cortot (1787–1843), and *The Resistance of 1814* (*La Résistance*) and *The Peace of 1815* (*La Paix*), both by Antoine Etex (1808–88).[9]

The difference between these three reliefs, with their static, relatively frontal compositions, and Rude's is visible even from great distance. *The Departure of the Volunteers* has a strong, leftward surge in its lower register of soldiers. The Genius of Liberty flies above them, stretching out her hands, sword, legs, and wings before a background of javelins and banners, forming a bursting star or pentagon on the face of the arch's pylon. This dynamic shape is echoed in the figure of the Old Warrior. The determined power of his movement can be discerned in the turn of his head alone, which can be recognized also in the independent bronze adapted from the full figure. His shaggy beard, unkempt hair, and furry cloak make a decisive reference to the indigenous Gaul of ancient France, and it was through him that Rude invented a hero with both specific and universal meaning for his people.

FIGURE 2

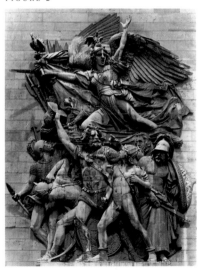

François Rude
France, 1784–1855
The Departure of the Volunteers in 1792
(*Le Départ des volontaires en 1792*),
1833–36
Stone
Height: approx 40 ft. (12 m)
Paris, Place de l'Etoile
Photo: Girardon/Art Resource

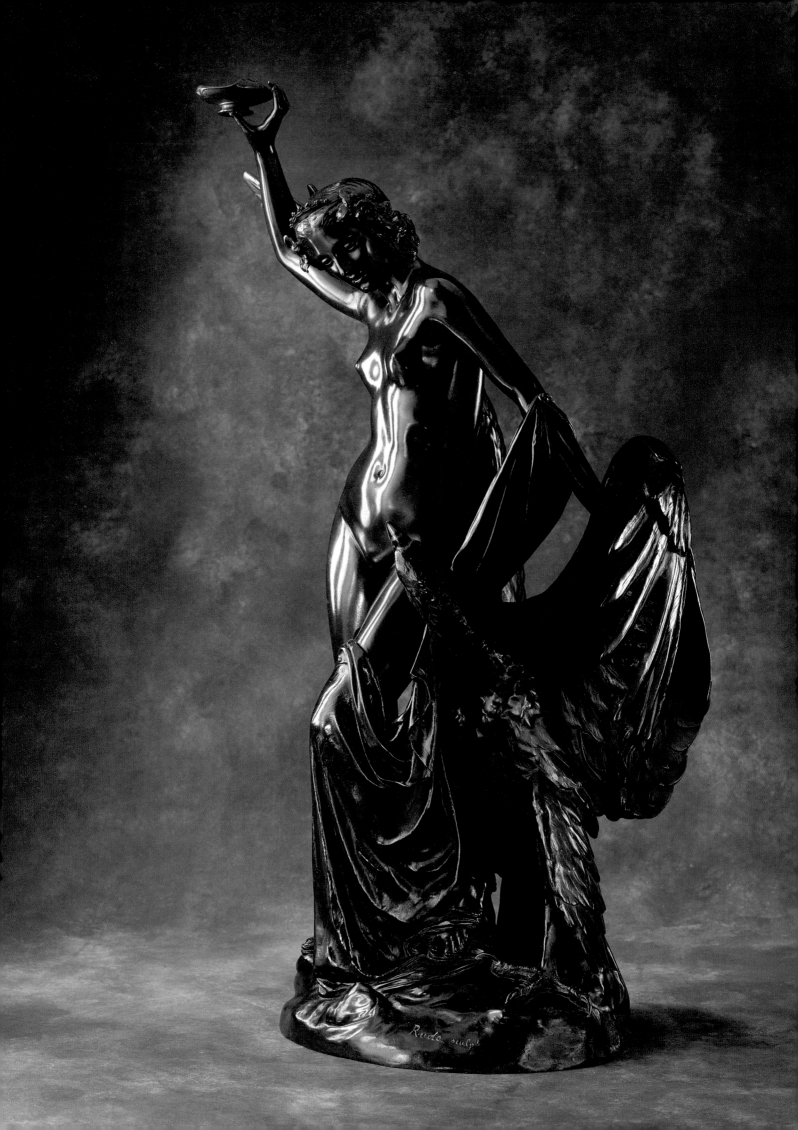

Few sculptures could seem further apart in conception than Rude's *Marseillaise* (CATALOGUE NO. 2) and *Hebe and the Eagle of Jupiter* (*Hébé et l'aigle de Jupiter*), one of his last works. The dramatic variations in his oeuvre have been attributed to his method of treating different subjects in specifically appropriate styles, particularly when he had a special philosophical commitment to a subject.[1] A commonality between the *Marseillaise* and *Hebe* might be found in their evocation of a mythic past without reliance on physical types derived from classical or academic models. However, this still cannot entirely explain the enigmatic purpose of *Hebe* in Rude's oeuvre; the subject was, after all, Rude's own choice for a commission from his native Dijon. (The present bronze is a reduction of that marble.) In addition to this, Rude paired *Hebe* with another creation, *Love, Ruler of the World* (*Amour, dominateur du monde*, 1848–57, Dijon, Musée des Beaux-Arts); he is said to have called them his artistic testament.[2]

On November 11, 1846, the city of Dijon, having realized that it possessed no major work by one of its most distinguished descendants, requested an example of Rude's famous *Young Neapolitan Fisherboy* (*Un Petit Pêcheur napolitain*, 1831). The artist declined, saying that he wanted to create a new sculpture. The city agreed. Furthermore, no condition was imposed on the artist; he was free to choose not only the subject but also the size and medium of the sculpture. Cost and date of completion were unspecified. Rude was simply to produce a model within a reasonable time and to inform the municipal officials of the material to be used.[3] Nothing else seems to have been officially discussed about the sculpture until May 1851, when it was referred to as a marble and its subject mentioned by Rude.[4] The lapse in time may have been due to Rude's preoccupation with several other commissions in the intervening years. The most important of these were *Napoleon Awakening to Immortality* (*Le Réveil de Bonaparte*, 1845–47, Fixin-lès-Dijon), the tomb of Godefroy Cavaignac (1845–47, Paris, Montmartre Cemetery), and the monument to Marshal Ney.

In January 1852 Rude wrote that the plaster model was ready for the practitioner to begin to translate into marble,[5] but a letter (March 1852) from Mme Rude mentions difficulty in finding a block of Carrara marble suitable for the composition (nearly nine feet tall when completed) and attributes additional delay to objections raised by the city council of Dijon to the considerable price demanded by Rude for the sculpture and its pedestal.[6] By January 1853 the body of *Hebe* seems to have been fully blocked out in the marble.[7] The sculpture was complete when Rude died in 1855 except for

François Rude

FRANCE, 1784–1855

Hebe and the Eagle of Jupiter

CATALOGUE NO. 3

c. 1853–55
Bronze
30 5/16 x 18 5/8 x 10 1/4 in.
(77.0 x 47.3 x 26.0 cm)
Inscribed on base, front, right: Rude
sculp[t]
Foundry mark on base, back, right:
FUMIERE/ET C[OMPAGN]IE
SUC[CESSEU]RS/THIEBAUT
FRE[RE]S/PARIS (in circular cachet)
Gift of B. Gerald Cantor
M.77.79

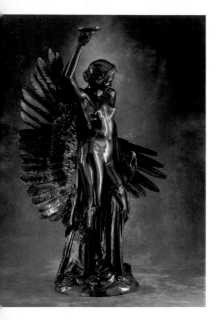

the face, which was entrusted to Rude's nephew Paul Cabet (1815–76).[8] The semicylindrical socle was carved with classicizing figures in relief and inscribed with the names of Homer, Hesiod, Euripides, Ovid, Virgil, and Catullus.[9]

The bronze master model that without doubt served for the reductions of *Hebe*, having come from the studio of Cabet, is preserved in the Louvre.[10] The several known examples of the bronze are all the same size but have slight variations in the flowered tiara of Hebe: those in Chicago and Minneapolis have small daisies above the ears and a hairband with numerous lobes, while those of the master model in the Louvre and the present bronze have larger, single flowers over the ears and hairbands with fewer lobes. The signatures are apparently in different scripts, and the color of the bronzes also varies. The cups, which were cast separately, also differ; they can be modeled with more tightly detailed ornament, or they can resemble that of the Los Angeles bronze, with a more streamlined profile. The fact that the master model has no cup may account for these variations.[11]

These examples of *Hebe* attest to its popularity. Hebe was a favorite subject for nineteenth-century sculptors:[12] as cupbearer to the gods she served ambrosia, the nectar of youth, on Olympus. After Ganymede superseded her in Jupiter's attention, she was wed to Hercules. The playful erotic shiver that runs through the present bronze is generated by the juxtaposition of Hebe's long, sleek, teasing body against the metal feathers of the upraised wing of the eagle, brandished like a weapon.

Rude said that he chose a subject "from mythology so that I could carefully avoid having any kind of political allusion applied to it."[13] The figure of Hebe could scarcely have had any connection to the political issues with which Rude was so closely identified. Yet, paradoxically, this sculptor who so admired the example set by classical art invented images that were more strongly imprinted with the emotions of his day than those of virtually any of his contemporaries. Although the compelling imagery of such monuments as the Cavaignac, Ney, and Napoleon has defined Rude's position in the history of art, *Hebe* was not an anomaly in his oeuvre. Her languid forms were presaged by the figures on the socle of Rude's *Young Louis XVIII* (*Louis XVIII adolescent*, 1840–42, Château de Dampierre), and her pose is an extension of that of *Joan of Arc Listening to the Voices* (*Jeanne d'Arc écoutant ses voix*, 1845–52, Louvre). That Rude saw her in tandem with his *Love, Ruler of the World* only adds to the sense of elusiveness of these two late sculptures and holds out the promise of further interpretation of their meaning.

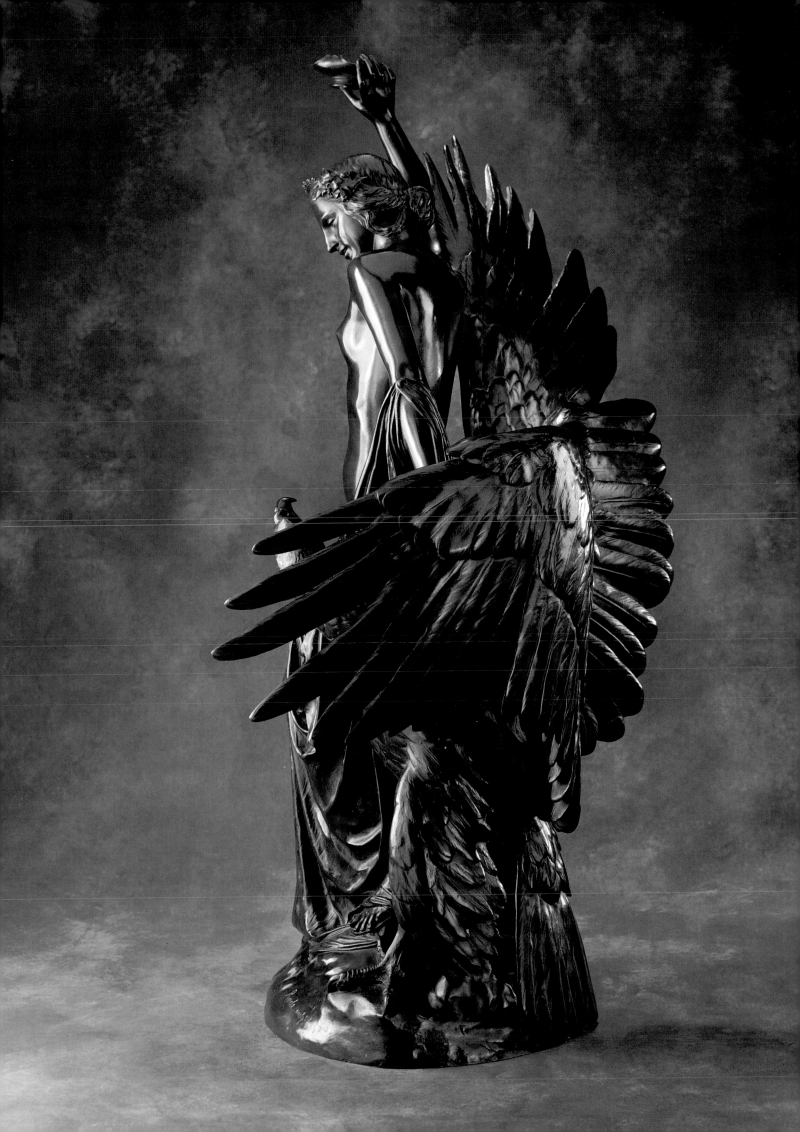

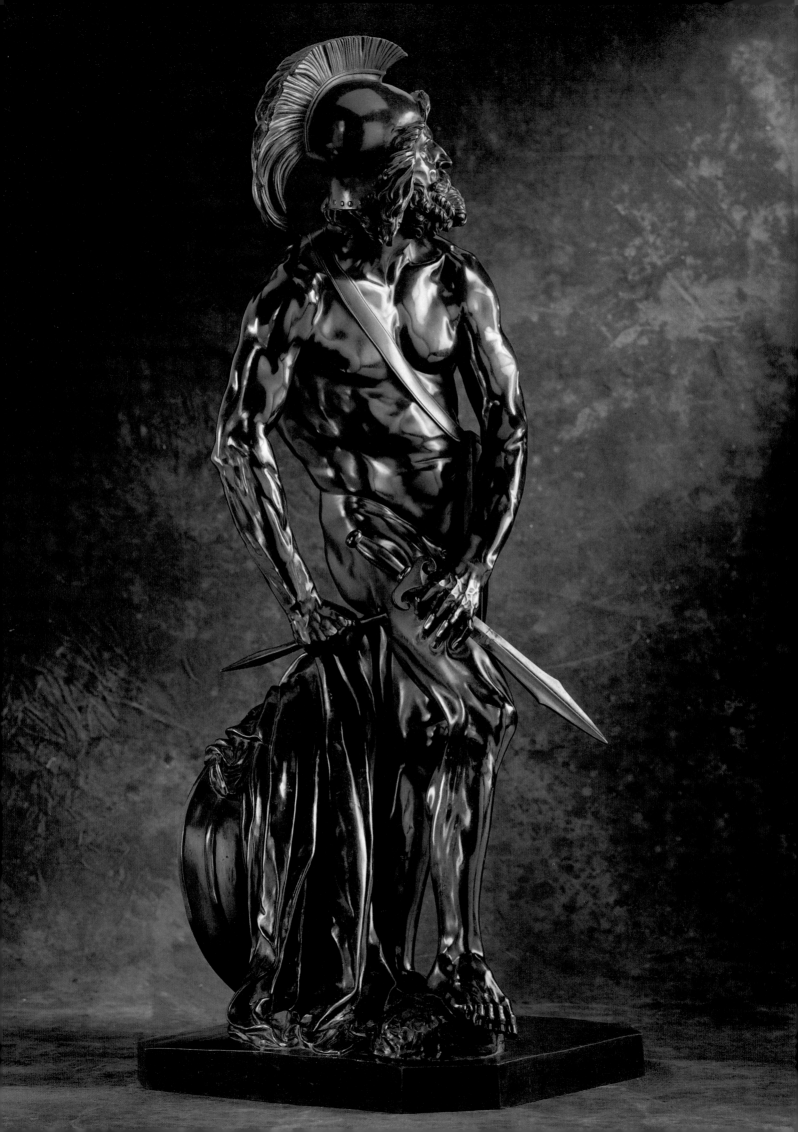

Pierre-Jean David d'Angers[1] stands alone among nineteenth-century sculptors for his single-minded devotion to a uniquely pedagogic concept of sculpture, dedicated to the higher moral evolution of society. He saw sculpture, in its hierarchy of formats, as the true vehicle that conveyed exemplars of valor and lessons of heroic greatness not only to his contemporaries but also to posterity. To this end David left a pantheon of more than five hundred portrait medallions of past and present heroes, a multitude of portrait busts, and a sequence of full-size statues as well as voluminous journals that recorded his encounters with his subjects and his reflections on the purposes of art.

It is likely that this highly cerebral approach to his own work and his devotion to republican values developed directly from his personal experiences. As a child during the French Revolution he accompanied his father, a wood-carver, in the republican armies. Throughout decades of alternating regal, imperial, and republican governments in France his commitment to democracy never wavered.[2] Later, having won the Prix de Rome,[3] he came to know Canova, whose vision of the Ideal was also highly theoretical. Their relationship remains intriguingly problematic.[4] David's portrait of the poet Alphonse de Lamartine (1830, Louvre)[5] is but a step away from Canova's own self-portrait (1812, Possagno, Tempio Canova); smoothly executed, the broadened planes of their ecstatic faces catch the light. David's treatment of the hair, however, is more vigorous, and the modeling of the muscles is softer. Both of these are subjective interpretations of human appearance; the subtle distortions in their physiognomies enhance the sense of vital illumination of greatness. Phrenology fascinated David.

Slight modifications of the features in what are otherwise objectively observed appearances are essential to the effectiveness of David's portraits.[6] Rather than making life-casts, which are, he wrote, only "casts of truth" (therefore not the truth), the artist looks into his own heart to find the spark that lights up the man of genius:

The artist models with his brain, calling for the expression of truth. It is the soul that he evokes; he is creating the appearance of a hidden power....

The eye [of the sculptor] plunges into the sublime depths where his hero resides. He sees him with the eyes of his soul.... The artist...fixes in bronze... that noble apparition reflected [by the sitter] within [the artist's] soul.[7]

Thus the artist produces an image of what he feels is the essence of his subject, not a reproduction of its physical reality.

Pierre-Jean David d'Angers

FRANCE, 1788–1856

Philopoemen

CATALOGUE NO. 4

1837
Bronze
35 1/2 x 13 1/2 x 14 1/4 in.
(90.2 x 34.3 x 36.2 cm)
Inscribed on back:
DAVID/D'ANGERS/1837
Foundry mark on base, right:
EUG[ÈNE].CORNU.PARIS
Gift of B. Gerald Cantor Art
Collections
M.82.126.3

In the case of *Philopoemen* the artist even altered the age of his ancient subject, known to him only through history. According to Plutarch's *Lives of Illustrious Men*, the great Greek general Philopoemen of Megalopolis, surnamed the "last of the Greeks," was only thirty years old when he fought courageously in the Battle of Sellasia in 222 B.C.[8] David decided instead to represent Philopoemen as an old man because, he said, "nature placed an immutable, universal feeling in the heart of man: the further one advances in life, the more tightly does he cling to it."[9] It was age that communicated the true poignancy of this image. David believed that the limited days remaining to the aged are all the more precious because they are few, while the days of the young are without number. David continued, "Old age is the time of the self; by aging my hero, I made him greater; I needed a purpose for him that was truly compelling, something for which a man who was already old would sacrifice himself."[10] Furthermore, David made no use of a historical "Greek" style that might otherwise have been deemed appropriate[11] or preferred by academic classicists.[12]

This bronze is a reduction of a grand marble commissioned in 1852 from David by the French government under the new king, Louis-Philippe (r. 1830–48), as one of a series of statues destined for the Tuileries Gardens (and since transferred to the Louvre).[13] David was not entirely satisfied with his composition: he wrote later that he should have ennobled the figure by making it more erect. Its awkward stance revealed a double meaning, however, depending on the approach taken to the Tuileries by the viewer. From one side it shows the courage of the wounded hero as he turns, undaunted, to take up the battle again. From the other side his human vulnerability and suffering are made plain.[14] This kind of distortion heightened the expressiveness of the figure and opened it up to subjective interpretation on several levels. It is a fundamental example of the romantic movement in sculpture.

Small-scale plaster variants of the model are preserved in the Musée d'Angers, the primary repository of David's work.[15] A bronze example, signed on the base at the proper left foot, is in the David Daniels collection and corresponds in size (13 11/16 in.) to the plasters.[16] Another example of the present bronze, slightly smaller and without a foundry mark, is on loan to the David and Alfred Smart Gallery of the University of Chicago.[17]

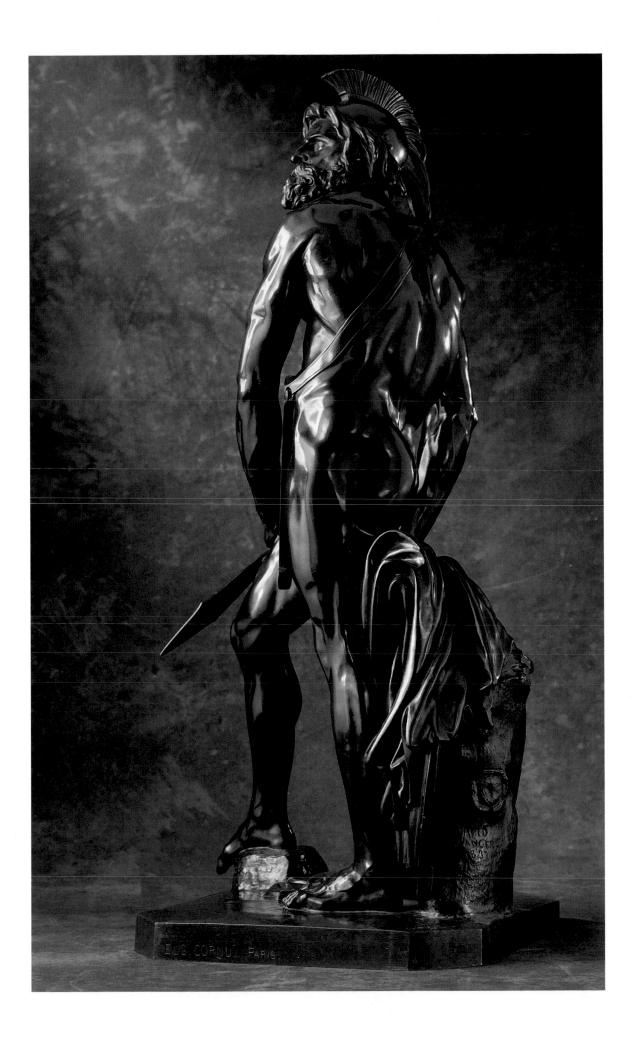

Pierre-Jean David d'Angers

FRANCE, 1788–1856

Johannes Gutenberg

CATALOGUE NO. 5

1839
Bronze
16 x 6¼ x 6¼ in.
(40.6 x 15.9 x 15.9 cm)
Inscribed on front: GUTEMBERG;
on scroll: Et la lumière fut; on base,
right: P J DAVID/1839;
Gift of B. Gerald Cantor Art
Collections
M.82.126.2

David's bronze statue of Johannes Gutenberg (c. 1390–1468), a monument in Strasbourg to the printer who invented movable type there, was finished in September 1838.[1] The present statuette may be either a reduction of that statue or a cast of a study for it. David's widow, Émilie, wrote that "David's statuettes ... are for the most part only the first essay on the statues. He never had either the patience or the desire to recopy, so to speak, a work that was already finished. He gave in to the demands of the foundries that wanted to reproduce some of his statues, using the method [developed] by [Achille] Collas."[2]

Of the hundreds of portraits David produced, the Gutenberg has gained a particular historical significance as a symbol of David's philosophy. David the sculptor was a prolific writer, filling thick journals with his memoirs, observations, and theories of art. (Despite his remarkable eloquence, David believed that as a writer he was inadequate).[3] He felt that the written word could, in fact, determine the relative importance of sculptures, which he placed in a hierarchy. Thus "the inscription of a name on a monument is the equivalent of a statue.... There are men for whom a statue can be only a full-length portrait, and others whose merit demands the colossal."[4] The variety of styles of inscription on his medallions and portrait busts, like that of the writer Pierre-Jean de Béranger (1834, Metropolitan Museum of Art), is evidence of what has aptly been called his obsession with writing.[5] David's image of Christ, for example, showed Him, not on the cross nor being resurrected, but rather nearly transformed as an antique god seated on the world and *writing* on it in His blood the words *liberté, égalité, fraternité*.[6] In addition to this, David scribbled an extensive description of a monument to the abolition of slavery, his life's dream. Unwittingly or not, he placed the inscription below a drawing for this monument, as though the written words were the pedestal for his never-realized sculpture.[7]

Similarly he provided one of his first ideas for the monument to Gutenberg with an elaborate description, including a reference to the abolition of slavery:

Gutenberg, on a pedestal, a [printing] press next to him; his arms are outstretched, and he holds in his hands sheets of paper with printing, which he distributes to the peoples [of the world] who surround the pedestal. On the face of the pedestal Europeans break the irons of Negro slaves and offer them books. America, leaning on its flag, is surrounded by happy children. Poland brandishes its sabre, as do Hungary and Italy. On each side, two crouching figures represent Asia and Oceania.[8]

The pedestal as completed bears four reliefs illustrating the good works achieved by printing in Europe, Asia, Africa, and America.[9] The Gutenberg monument honors the emancipating power of knowledge, gained through the democratization of learning made possible by the invention of movable type. (A terra-cotta sketch for the monument [Musée d'Angers] shows a slab set with type positioned in front of the printing press; in a bronze statuette of the same subject in the Louvre this is behind the press.)[10]

The statue of Gutenberg also reveals David's inventiveness in developing heroic monuments that were devoid of references to classical style or imagery. Although the split sleeve of the printer's fur-lined coat and the hat are not exact reproductions of fifteenth-century costume, they are accurate enough to evoke the northern Renaissance in general; the style of the short boots can be dated to about 1450.[11] The repetition of the tapering, pointed forms of such details as the sleeves, the boots, and the mustache and beard enhances the elongation of the figure as a whole, and together with the use of Fraktur type on the page, they give a late-Gothic tone to the figure.[12] These sensitively modeled elements are juxtaposed abruptly with a nearly industrial rendering of the press's screw, while the fluid handling of the bronze itself distinguishes the technique of this sculpture from the tight precision of other neo-Gothic statuettes by David's contemporaries Antoine-Louis Barye, Marie d'Orléans (1813–39), and Christian Rauch (1777–1857).

Antoine-Louis Barye

FRANCE, 1796–1875

Roger and Angelica Borne by the Hippogriff

CATALOGUE NO. 6

First modeled c. 1840–46
Probably cast later
Bronze
20 x 27 x 9⁷/8 in.
(50.8 x 68.6 x 25.1 cm)
Inscribed on base, top, right: BARYE
No foundry mark
Gift of Iris and B. Gerald Cantor
Foundation
M.92.269.2

Roger and Angelica is romantic sculpture *par excellence*. The subject of this bronze is an episode from Ariosto's epic poem *Orlando Furioso* (1532), a fictional story set in the early Middle Ages. In it the knight Roger saves the captive princess Angelica from being killed by a sea monster (shown here in the form of a dolphin) as a sacrifice to appease Proteus, who tends the flocks of the sea god Neptune. Roger carries her away on the fantastic winged hippogriff, the imaginary offspring of a mare and a griffin. He hopes to seduce Angelica, but he is foiled by his heavy armor. By the time he removes it, Angelica has been spirited away to safety by her magic ring, which renders her invisible. True to the spirit of the epic, Antoine-Louis Barye did not shrink from suggesting the erotic tension between the human figures.

The first model of this composition was commissioned by one of Louis-Philippe's sons, Antoine, duc de Montpensier, either in 1840 or 1846, the year of his marriage to the sister of the queen of Spain, and the idea behind it may have been the bold bronze ensembles of hunting scenes (*surtouts*) done for Montpensier's brother, the duc d'Orléans.[1] It was originally intended as a grand mantelpiece decoration, complete with a clock and flanked by elaborate, figurated candelabra also designed by Barye. The reason for the choice of subject is still debated. It is known, however, that between 1822 and 1850, twenty-seven editions of *Orlando Furioso* were published in France, a popularity in those years comparable with that enjoyed today by *Gone with the Wind*.[2] Although *Roger and Angelica* originated as a private commission, Barye probably decided at the outset to issue other casts of it, because he listed it in the 1847 sales catalogue of his enterprise.[3]

This is the most "literary" bronze by Barye, who was the greatest *animalier* sculptor of the nineteenth century.[4] He was trained first as an engraver, but his desire was to learn the art of sculpture. After the end of the Napoleonic wars he entered the studio of François-Joseph Bosio (1768–1845). Then he studied with the romantic painter Antoine-Jean Gros (1771–1835). In the 1819 competition in medallic art at the École des Beaux-Arts, for which the required subject was Milo of Crotona attacked by a lion, he won an honorable mention. As an allegory of man's powerlessness over nature, this classical subject was already colored with romanticism, but the medallion, Barye's earliest dated work, gave little indication of the revolutionary character of his mature art. Barye perfected his technical training in the shop of the goldsmith Jacques-Henri Fauconnier (c. 1776–1839), where the first examples of his animal sculptures were produced as ornamental elements for decorative objects.[5]

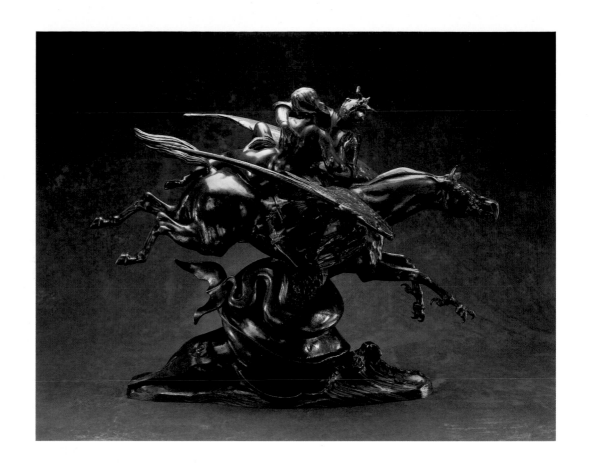

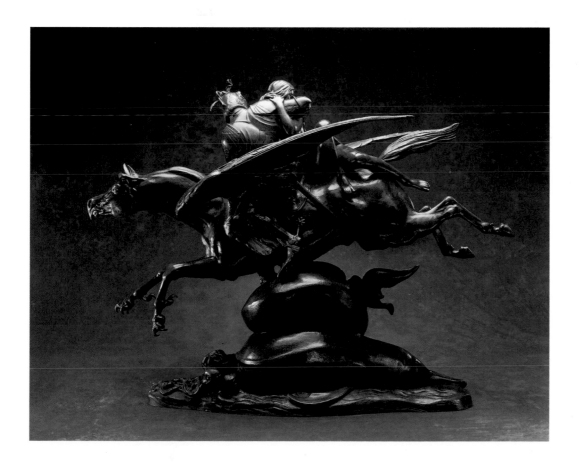

FIGURE 3

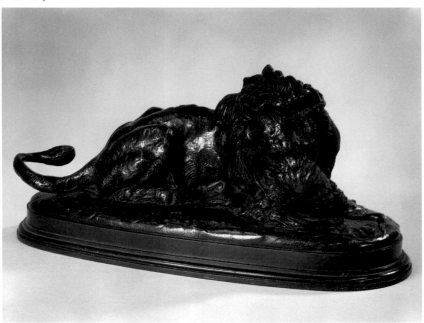

Antoine-Louis Barye
France, 1796–1875
Lion Devouring a Doe (*Lion dévorant une biche*), 1837
Bronze
5¹/₂ x 12¹/₄ x 5¹/₂ in. (14 x 31.1 x 14 cm)
Los Angeles County Museum of Art, gift of Rowena Thom Rathbone
62.2.1

Barye's great contribution to the history of sculpture was his ratification of the animal world as a legitimate subject for major sculptures. His efforts to produce decorative bronzes of quality for a wide public are part of the romance of the creative force that fueled the enormous progress of industrialization in the nineteenth century. The sales catalogues of bronzes produced by his various enterprises[6] give an idea of the kinds of decorative sculpture destined in the second half of the nineteenth century for the household, whether bourgeois or noble, as their subjects are also classified according to their appropriateness for particular rooms of the house.

The excellence of Barye's models was based on his meticulous study of anatomy, but he invested his models with an elemental strength and rendered his compositions with a unique equilibrium of objective meticulousness and subjective sketchiness. He seemed to penetrate every aspect of the life of the animal world and saw its humor, naiveté, viciousness, and mortality (FIGURE 3). With his friend Eugène Delacroix (1798–1863), he closely observed and drew the animals in the Jardin des Plantes, the Paris zoo. Indeed, the critic Théophile Gautier even measured Delacroix against Barye.[7] Although his sculptures of human figures are not as well known, they also hold an important place in his oeuvre.

Barye won prizes in the fine arts, but he also encountered resistance to his choice of subjects.[8] Between 1837 and 1850 he did not exhibit at the Salons,[9] but royal and other government commissions came to him. In the industrial sections of the international expositions from 1855 onward his work was honored. A contemporary account of the 1855 exposition gives an idea of his status until then:

He is an artist beyond compare, called to give a new impetus to dying sculpture. But he saw all those tired, official talents rise up against him, those which had no real strength other than to fight against everything that did not share their useless, boring ideas.

Barye was systematically excluded from exhibitions; he was thought to be too violent, too savage; none of those [people] wanted to recognize the exquisite truth of his form, the greatness of his spirit, and he remained alone.[10]

In 1854 Barye was named professor of zoological drawing at the Musée d'Histoire Naturelle (Museum of natural history) in Paris, a position he held until his death, and it was there that Rodin studied, however briefly, with him.[11] According to Rodin's assistant Antoine Bourdelle, it was only much later in Rodin's life that he acknowledged Barye's greatness and realized the error he had committed in leaving his instruction:

The disdain, the solitude with which Barye was surrounded, the wounded pride of this great misunderstood [man], the sarcastic remarks of the powerful at the feet of the isolated colossus, all of that dampened [the spirit] of Barye's young students, who left him, one by one. Finally Rodin left him too.... He understood later what Barye was.... "Oh!" he said sometimes, "except for that child's mistake I made, except for that giant error of my youth, I did well to avoid [formal] instruction."[12]

It is tempting to speculate on whether or not Barye's working method did influence Rodin, if only subliminally, because Barye was a genius not only in the study of anatomy but in the reconstruction of a complete figure from its fragments as well. The sculptor Alfred Jacquemart (1824–96) is said to have recounted this anecdote: "Looking about his studio for a moment, [Barye] drew out a couple of legs and stood them erect. After a few seconds of puzzled thought he remembered the whereabouts of other members, and finally drew out the head from a heap in a corner. And the statue once in place was conspicuous for its fine sense of unity."[13]

In his technical skill, anatomical knowledge, and interpretation of the drama and pathos of the animal world Barye was unmatched. In his choice of subject matter of raw passion, torment, and struggles of life and death he could have been considered in his own day as "symbolist" as Rodin was in his.

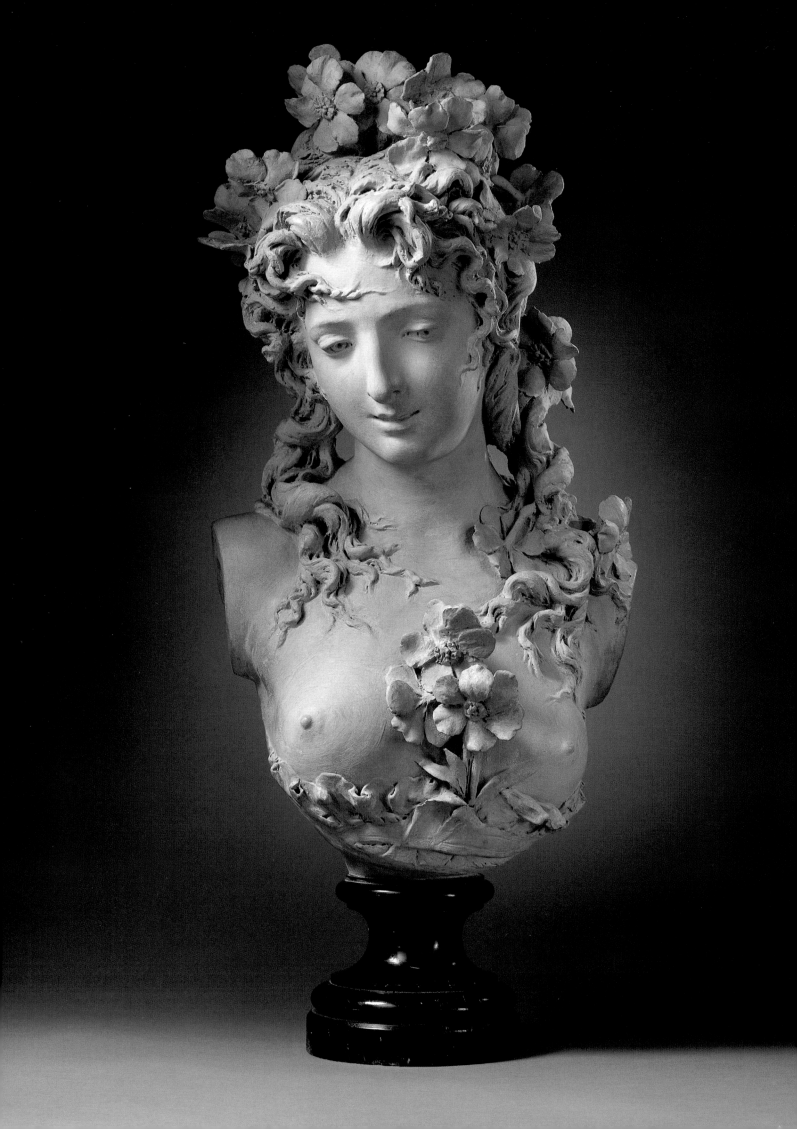

The brilliantly decorative qualities of this bust are shown in its idealized face and the smooth matte finish of the terra-cotta, accentuated by their contrast with the fresh, almost rough handling of the hair, crowned by a magnificent aureole of delicate flowers. Seductive, mysterious, this is a fantasy brought virtually to life by rich chiaroscuro, a fugitive glance, the turn of the head, and the curve of blossoms and curls that leads the eye of the viewer on a sinuous route through the composition. It is a consummate exercise in decorative sculpture by Albert-Ernest Carrier-Belleuse, the consummate decorative sculptor of the nineteenth century.[1]

His career began and ended in the decorative arts. In his youth he was employed in a shop that finished metalwork, and with the support of Pierre-Jean David d'Angers, whom he had met through his cousin François Arago, a close friend of the older sculptor, he went to work in the studio of the goldsmith Jacques-Henri Fauconnier, where Barye had also been employed.[2] Under the auspices of David d'Angers he gained admittance to the École des Beaux-Arts. Although he did not obtain a diploma, it was there, according to the engraver Jules Salmson, that he developed a taste for sculpture.[3] Continuing to support himself by finishing metalwork, he enrolled in the Petite École (the government-supported school of design), increasing his proficiency in the decorative arts. In 1850 he was called to England to design and teach at the Minton China Works.[4] He returned to France five years later and remained there except for a sojourn in Brussels (1870–71), where he employed Auguste Rodin on the commission to create ornamental sculpture for the new stock exchange.

Honors and commissions rained down on him; he was called on for great public monuments and large-scale architectural sculpture as Baron Haussmann remade Paris. He worked in stone, ceramic, bronze, and other precious and base metals. In 1876 Carrier-Belleuse was named director of works of art at the Sèvres Porcelain Manufactory, where he again employed Rodin. His commitment to excellence in the decorative arts and the production of objects of quality that he made available to the general public through the direct sale of his sculptures was further demonstrated in the publication in 1884 of *Application de la figure humaine à la décoration et à l'ornementation industrielle* (The application of the human figure to industrial ornament and decoration), an album of approximately two hundred of his drawings.[5] The impulse behind this album was much like that which lay behind Barye's production of bronzes and can even be interpreted as a predecessor of the Bauhaus's concept of supplying excellence in design for objects that would be manufactured industrially at an economical price.

Albert-Ernest Carrier-Belleuse

FRANCE, 1824–87

Fantasy Bust

CATALOGUE NO. 7

c. 1865–70
Terra-cotta on wood socle
29⁷/₈ x 11³/₄ x 11 in.
(75.9 x 29.8 x 27.9 cm)
(without socle)
Inscribed on back: A. CARRIER
Gift of Iris and B. Gerald Cantor
Foundation through the 1992
Collectors Committee
AC.1992.19.1

FIGURE 4

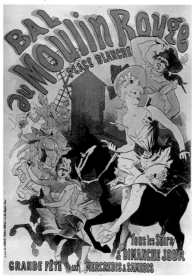

Jules Chéret
France, 1836–1932
Bal du Moulin Rouge, 1889; reprinted
1892
Color lithograph
48 7/8 x 34 5/8 in. (124 x 88 cm)
Los Angeles County Museum of Art,
Kurt J. Wagner, M.D., and C. Kathleen
Wagner Collection
M.87.294.7

Inspired by such eighteenth-century masters of terra-cotta as Clodion and Jean-Antoine Houdon, Carrier-Belleuse exercised his extraordinary facility in modeling to produce a multitude of statuettes, decorative busts, and portraits whose color and beguiling verve contributed to a new form of rococo. In comparison, the older, neoclassical, academic styles began to seem outmoded in the Second Empire's world of hothouse luxury and unashamed glamour, the qualities that, together with Carrier-Belleuse's fecundity, can best be appreciated in a series of terra-cottas like the present fantasy. Carrier-Belleuse's achievements in rendering a multitude of chiaroscuro effects opened the way for the impressionistic techniques of Rodin.

This sculpture was purchased from Carrier-Belleuse by Jules Chéret (1836–1932), the brilliant lithographer who was the father of the modern poster (FIGURE 4).[6] Chéret idolized the eighteenth-century Venetian masters of fresco decoration, so he must have been attracted to the rococo flavor of Carrier-Belleuse's work, with its astonishing technique and smoky plays of light and dark. The provenance of this terra-cotta provides an important document for the understanding of Belle-Époque taste. Along with two other sculptures by Carrier-Belleuse, this fantasy bust was given by Chéret to a great-niece who, through the intermarriage of their families, was Carrier-Belleuse's great-granddaughter.

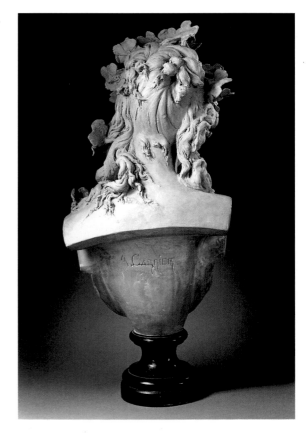

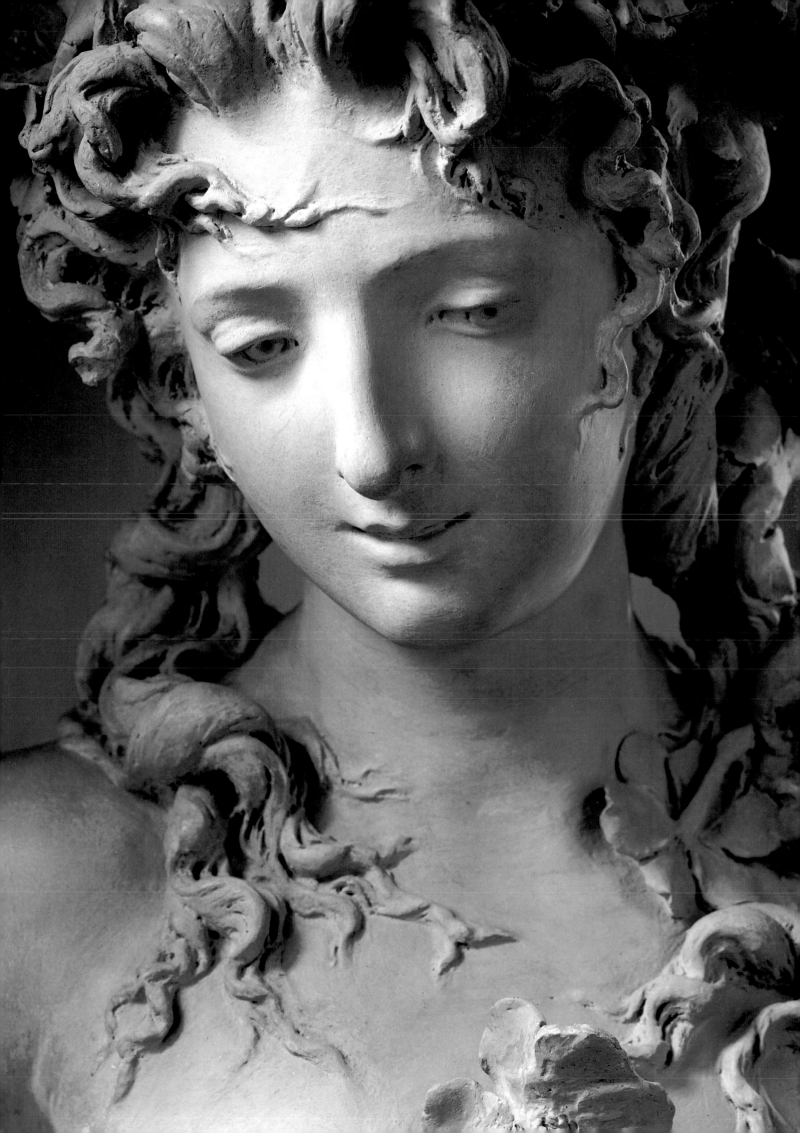

Albert-Ernest Carrier-Belleuse

FRANCE, 1824–87

Portrait of the Actress Aimée-Olympe Desclée

CATALOGUE NO. 8

c. 1874
Terra-cotta
27 1/4 x 14 3/4 x 5 1/8 in.
(69.2 x 37.5 x 13.0 cm)
Inscribed on back: A. CARRIER
Gift of B. Gerald Cantor Art
Foundation
M.81.262.2

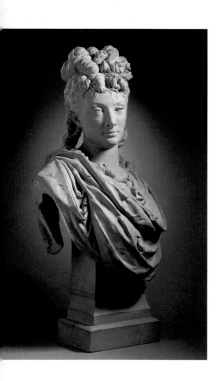

An undistinguished start in the Vaudeville and Variétés theaters in Paris gave little indication of the fame Aimée Desclée (1836–74) would eventually garner in her own country after a tour in Italy and a performance in Brussels acclaimed by Alexandre Dumas the younger. Her greatest triumph came in the title role in *Froufrou* (1869), a crystallization of nineteenth-century charm and ambiguity. Apparently not even Sarah Bernhardt could challenge the popular impression Desclée made in this part, which she played 185 times up to the year before her early death in 1874.[1] A bronze portrait bust of her was commissioned from Carrier-Belleuse for her tomb in the cemetery of Père-Lachaise (Paris), which was paid for by subscription.[2]

The present terra-cotta was doubtlessly derived from that commission. The freshness of Carrier-Belleuse's modeling technique, which brought a new level of vitality to portraiture, was used to advantage in meeting the challenge posed by the commission for a posthumous image. Apparently not classically beautiful, Desclée is said to have been elegant, dignified, and controlled,[3] in antithesis to the role with which she was so closely identified. It is this true character that this portrait by Carrier-Belleuse evokes, showing the introspection and self-awareness of a performer who laid bare the deceit and weaknesses of her characters and their society to her audience.

The sculptor portrayed the actress draped in a heavy mantle appropriate for tragic roles. Here it was also appropriately applied to a funerary figure. The mantle gives the bust a heroic breadth and reinforces the portrait's reticent mood of fatigue and world-weariness. Carrier-Belleuse's mastery of anatomy, expressiveness, and graceful movement are shown in the sensitively modeled face, its slight inclination, and the subtle arrangement of the ropes of hair that are coiled to suggest parts of a loosened figure-eight. In a cunning interplay of realism and artifice reminiscent of Joseph Chinard's (1756–1813) portrait busts, the mantle is hung about an inanimate support that has nothing to do with a sitter's natural shoulders.

It is reasonable to assume that the other terra-cotta (Musée Carnavalet)[4] and plaster versions of this portrait (Compiègne, Musée du Second Empire)[5] were to provide Desclée's admirers with mementos of her. The present bust is nearly identical with the one in the Carnavalet, except for its color[6] and slight differences in the hair and central folds of the drapery. These portraits are perfectly representative of Carrier-Belleuse's production. While his large, well-organized ateliers[7] were set up to respond to the broad demand for his art by producing several examples of his original models, his method of reworking the clay or plaster of a cast sculpture as it came from the mold and was still malleable assured a measure of variety and freshness in his astonishing production, unsurpassed in his lifetime.

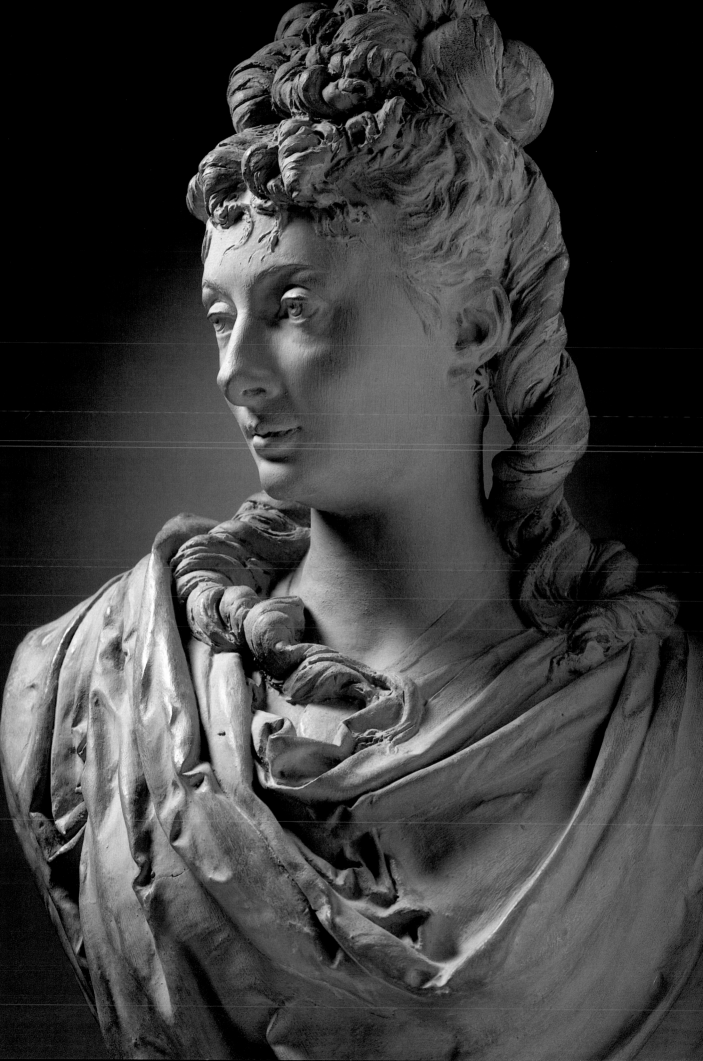

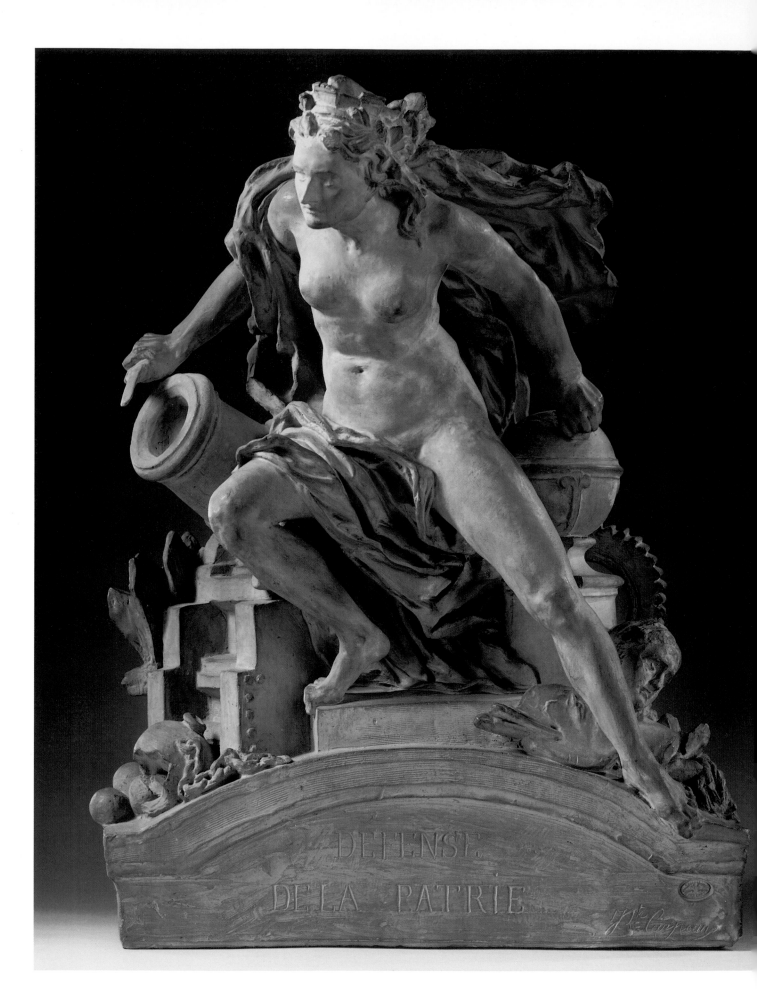

DEFENSE
DE LA PATRIE

This sculpture is a terra-cotta reduction of the frontispiece designed by Jean-Baptiste Carpeaux for the town hall of his birthplace, Valenciennes, in northern France (FIGURE 5). The subject is a personification of Valenciennes defending the young, still-revolutionary French republic in 1793 against the combined armies of Prussia and Austria. This was Carpeaux's last great commission and least-known work.

Carpeaux, the son of a stonemason, became the preeminent sculptor of the Second Empire. He took his first art classes at a local school in Valenciennes, and then, supported by a scholarship provided by that city, he went on to study in Paris at the Petite École and the École des Beaux-Arts with François Rude and Francisque Duret (1804–65). Rude's dramatically heroic style energized his own, but experience with the less controversial Duret afforded greater assurance of winning the five-year fellowship awarded with the Prix de Rome, which Carpeaux did in 1854. Finishing other commissions, he left late for Rome at the end 1856.

Carpeaux's stay in Italy was broken by intermittent returns to France. He was plagued by ill health and disagreements with the director of the Académie de France over the content and unpredictable pace of his work. Acutely self-aware, Carpeaux resisted many of the requirements and deadlines set by the academy. Instead of devoting himself entirely to copying constantly from the antique, Carpeaux found much inspiration in the vibrant activity of the city, and his appreciation of the powerful ideal embodied in Michelangelo's works was reinforced.[1] Drawing rapidly from these and living models in the streets, Carpeaux attained an exceptional proficiency in draftsmanship and composition that can be recognized immediately in his sculptures' vivid interplay of boldly calibrated diagonals.

The masterpiece of Carpeaux's Roman period became a *cause célèbre* in Paris. This was his *Ugolino and His Sons* (*Ugolin et ses fils*), which had evolved over several years from a bas-relief into a monumentally conceived freestanding group. Although criticized when unveiled in Paris in 1862, the sculpture had been admired while still unfinished in Carpeaux's studio in Rome by the comte de Nieuwerkerke, Napoleon III's director of fine arts. The count's support secured official recognition for Carpeaux and the introduction to the aristocracy that he coveted.[2]

Carpeaux became the sculptor of choice of the imperial family and the preferred portraitist of its courtiers. His style was more naturalistic and emotionally charged than that of his near-contemporary Carrier-Belleuse and therefore was hardly without controversy. Although he won commissions for major sculptures in Paris, his work was greeted by the outcries of those who were accustomed to a more subdued academic vision. Such was the reaction to his two most famous sculptures: the explosive *Dance* (*Danse*, 1865–69) for the Opera and the exotic *Four Regions of the World* (*Les Quatre Parties du*

Jean-Baptiste Carpeaux

FRANCE, 1827–75

The City of Valenciennes Defending the Fatherland in 1793

CATALOGUE NO. 9

1869–73 (possibly 1871)
Terra-cotta
20 ½ x 16 x 11 in.
(52.1 x 40.6 x 27.9 cm)
Inscribed on base, front:
DÉFENSE/DE LA PATRIE;
lower right: JB ᵗᵉ Carpeaux
Stamped on base, above Carpeaux's
signature: PROPRIETE CARPEAUX
Gift of Iris and B. Gerald Cantor
Foundation
M.91.138

FIGURE 5

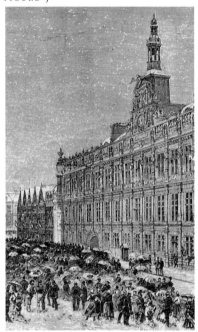

Fichot and Kauffman

*The Funeral Procession of Carpeaux in
the "Grand' Place" of Valenciennes*
(detail)

Probably 1875

Reproduced from *L'Illustration*, in
André Mabille de Poncheville, *Carpeaux
Inconnu* (Brussels: G. van Oest, 1921),
opp. p. 240

Carpeaux's sculpture, shown in its
original state, fronts the belfry of the
town hall.

monde, 1868–74) for the fountain of the National Observatory near the
Luxembourg Gardens. The first of these is a high relief on a new building,
while the second is a freestanding monument. The structural demands they
presented could not have prepared Carpeaux for the challenge he faced when
he was awarded the commission for Valenciennes, around 1865.[3]

In 1860, after the collapse of the forward block of the city's seventeenth-
century town hall, an estimate was made for the cost of its reconstruction.
Carpeaux, one of the most famous artists born in Valenciennes (another was
Watteau, to whom Carpeaux had already begun a freestanding memorial
fountain [1860–84] destined for their birthplace), was asked to design the
frontispiece. Work on the reconstruction was protracted; demolition of the
damaged parts of the building began only in 1867. Carpeaux's first sketch, a
relief, was accepted the following year. This resembled a hybrid of his own
Flora (c. 1863–66) and Rude's *Marseillaise* (see CATALOGUE NO. 2).[4] From this
point through all of 1869, Carpeaux was at odds with the supervising
architect of the renovation, Jules Batigny, who would approve and then
refuse Carpeaux's projects. Batigny suggested a freestanding statue, while
Carpeaux felt that a relief was more appropriate to the narrative context of
the subject. His relief was to be carved in a heavy block of stone, however,
and the architect, estimating that this would weigh 50,000 kilograms, rejected
it as being impossibly heavy for the building. Carpeaux retorted that
Batigny's estimate was exaggerated and accused him of having himself
requested the decorative allegorical accessories that made the sculpture's mass
impracticable. Carpeaux eventually agreed to omit subsidiary narrative
figures to reduce the weight of the sculpture by half. The symbols of war,
industry, and the arts were retained for the final design, as shown in the
present terra-cotta.

Even with those alterations the sketch was still criticized for the nudity
of the central figure and for compositional asymmetry, both considered
highly inappropriate for the crowning element of the town hall. The
asymmetry, however, is an illusion produced by Carpeaux's manipulation of
diagonals; in fact, the composition is a nearly equilateral triangle. The real
oddity is the billowing cloak behind the figure, where physical laws
governing the weight of stone seem to have been rescinded. The cloak,
however, may have had the practical purpose of balancing the forward thrust
of the figure. The rich vocabulary Carpeaux used to create a variety of
painterly effects in the composition contributes to the pictorial character of
the sculpture. Indeed its relationship to paintings of similar subjects, ranging

from Eugène Delacroix's *Liberty on the Barricades* (1831, Louvre) to Ange-Louis Janet's *The Republic (France Enlightening the World)* (1848, Musée Carnavalet)[5] remains to be fully explored.

Carpeaux's sculpture was destroyed in World War II when the town hall of Valenciennes was set on fire (1940). (It has been replaced by a replica.) Several reductions in bronze survive, however, along with the original plaster model (Valenciennes, Musée des Beaux-Arts). Perhaps six terra-cottas were recorded in sales documents during Carpeaux's lifetime.[6] Of the terra-cottas that have been located, one is in the Musée Roybet-Fould in Courbevoie, where Carpeaux died, another is in the Tanenbaum collection,[7] and a third has recently been acquired by the Musée d'Orsay.

The Sculptures of
Auguste Rodin

UGUSTE RODIN (1840–1917) WAS BORN IN PARIS
to a family of modest circumstances. His father, a functionary in a police bureau, tried to
dissuade him from studying art, but Rodin prevailed and entered the École Impériale de
Dessin (the "Petite École"), which emphasized the practical application of design in the crafts.
There, in addition to copying the old masters, students were encouraged to draw directly from
nature. Rodin took additional life-drawing classes at the school of the Gobelins tapestry
manufactory. Although he won two first prizes in drawing and modeling (1857), when he tried
to gain admission to the École des Beaux-Arts, he was refused three times. In 1863 or 1864
he studied anatomy with Antoine-Louis Barye at the Musée d'Histoire Naturelle. Rodin,
therefore, was primarily trained in the fundamental crafts of the visual arts, not in the
classicizing academic formulas that were dominant at the prestigious École des Beaux-Arts,
although he did draw from the antique on his own.

By the mid-1860s Rodin was making his living by working on decorative sculpture.
The building programs of urban renewal in Paris, mandated at that time by Napoleon III and
Baron Haussmann, created a demand for a variety of architectural sculptures. Rodin went to
work for Albert-Ernest Carrier-Belleuse, whose studio produced much of the ornamental

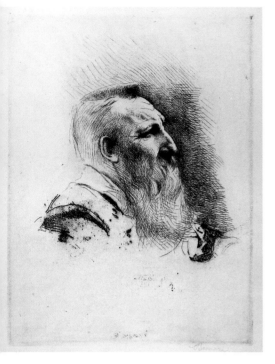

Albert Besnard
France, 1849–1934
Auguste Rodin, 1900
Etching and drypoint
10¾ x 7¾ in. (27.3 x 19.7 cm)
Los Angeles County Museum of Art,
gift of B. Gerald Cantor Art Foundation
M.87.76.1

PREVIOUS PAGE
Émile Druet
France, active c. 1900
Rodin in the Pose of Balzac, 1914
Platinum print
10¾ x 6½ in. (27.3 x 16.5 cm)
Los Angeles County Museum of Art,
gift of B. Gerald Cantor Art Foundation
M.87.74.1

sculpture for Paris's new buildings. When France was defeated by Prussia in 1870, Paris went into a steep economic decline, so in 1871 Rodin went to Brussels to find work. There he was again employed by Carrier-Belleuse among others. At the end of 1875, the fourth centenary of Michelangelo's birth, Rodin traveled to Italy on a pilgrimage of study. In Florence and Rome he was able at last to experience for himself a substantial number of Michelangelo's sculptures, which he had admired since his youth.

Except for the trip to Italy and a brief excursion to Paris, Rodin remained in Brussels until late 1877. He exhibited a sculpture of a male nude, now known primarily as *The Age of Bronze* (1875–76), which brought him nearly instant notoriety when he was accused of having made it from a life-cast. This was considered a deceitful practice beneath the contempt of fine artists. He showed it again when he returned to Paris in 1877, and there he proved that he had created the figure himself. The episode helped to bring him to the attention of Edmond Turquet, undersecretary of state for fine arts, who suggested that Rodin be awarded the commission for a "decorative portal" to a new museum of decorative arts that was to be built by the French government. Thus in 1880 Rodin secured the first of his three most famous public commissions, *The Gates of Hell*, the subject of which was based on Dante's epic poem. Rodin's primary work on the *Gates* seems to have been done in the 1880s, although he continued to revise the sculpture through 1900, and he used the project as a laboratory for the invention of a vast population in an untold number of poses and attitudes. The French government never built the museum for which the *Gates* had been commissioned, and they were not cast in bronze in Rodin's lifetime. It is likely that he continued to work on its figures until he died.

In 1884, while occupied on the commission of the *Gates*, Rodin was asked by the city of Calais to create a monument to six of its burghers who in the fourteenth century had offered their lives to their English conquerors in exchange for the salvation of their city. The life-size maquette for this sculpture was shown in 1889 at the Georges Petit gallery in Paris in an exhibition devoted to the work of Rodin and Monet. Titled simply *Claude Monet / Auguste Rodin*, it signaled the beginning of Rodin's enormous fame as an artist, unsurpassed in his time.

Rodin's mature work, represented by the *Burghers* and the fully resolved figures of the *Gates*, presents a highly individualized interpretation of the treatment of anatomy, with expressive distortions and a variety of inventive attitudes, while his handling of surface departed from the finished skins and perfected anatomies of academic sculptures. The vitality of his work comes from this powerfully subjective, emotional sense in combination with a free, impressionistic handling of material, modeled in dynamic compositions.

The monument to Victor Hugo was commissioned in the same year as the *Burghers*, 1884, and the monument to Balzac, the third of Rodin's most famous public commissions, in 1891. As with *The Gates of Hell*, work on them was protracted. One version of the Hugo monument was executed (see CATALOGUE NOS. 42–43), but the *Balzac*, like the *Gates*, was not cast in bronze until after Rodin's death. Rodin also created numerous portrait busts, experimented in developing new compositions out of elements invented for earlier ones, and was asked to produce other public monuments, like the *Claude Lorrain*, *Bastien-Lepage*, and *Domingo Sarmiento*.

A pavilion at the International Exposition in Paris was devoted to a retrospective of Rodin's sculpture in 1900, and in 1902 he was honored in Prague with an exhibition of his work. Through this his art transmitted its influence to central and eastern Europe. It was at about this time that Rodin's studio turned out an increasing number of sculptures in marble, many of them derived from figures from the *Gates*. Around 1908–10 Rodin increased his experiments in the radical enlargements of much smaller models.

In 1908 Rodin moved to the Hôtel Biron, an eighteenth-century mansion at what was still the outskirts of one of the most luxurious neighborhoods in Paris. He filled it with his eclectic art collection, which consisted of such diverse objects as paintings by his friend Eugène Carrière, Greek and Egyptian antiquities, and Asian sculptures. He had also acquired a country house, the Villa des Brillants in Meudon, outside Paris, in 1895 and worked there as well, hosting international celebrities who came to meet him.

The 1910s were difficult: despite trips to Italy in 1912, 1914, and 1915, the outbreak of World War I sent Rodin and his lifelong mistress, Rose Beuret (1844–1917), to seek temporary haven in England. In 1916 Rodin reached an agreement with the French government bequeathing all of his possessions to France. This bequest established the Musée Rodin in Paris and the study collection in Meudon, with a government guarantee of their administration and maintenance to be supported in part by the casting of bronzes under the jurisdiction of the museum's direction. This was mandated by Rodin. In 1981 France established a code that regularized the definition of series editions for the work of all artists, and this policy is applied to the bronzes of the Musée Rodin. The museum is allowed to cast an edition of twelve bronzes, eight of them numbered with Arabic numerals and four with Roman numerals designating casts destined exclusively for public collections.

SUGGESTIONS FOR FURTHER READING

John Tancock, *The Sculpture of Auguste Rodin: The Collection of the Rodin Museum, Philadelphia* (Boston: Godine, 1976). In addition to full biographical information, the introduction (pp. 17–59) provides a thoughtful analysis of many aspects of Rodin's working method. A detailed, schematized chronology can be found on pp. 60–88.

Hélène Pinet, *Rodin: The Hands of Genius* (New York: Abrams; London: Thames and Hudson, 1992). Recently translated from the French edition, *Rodin: Les Mains du génie* (Paris: Gallimard, 1988), this paperback is an excellent introduction to Rodin's life and times, with many illustrations from vintage sources.

Robert Descharnes and Jean-François Chabrun, *Auguste Rodin* (Lausanne: EDITA, 1967). Although some of the information is out-of-date, this profusely illustrated monograph offers a thematic and historical introduction to Rodin's work.

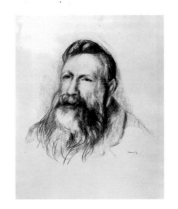

Pierre-Auguste Renoir
France, 1841–1919
Auguste Rodin, c. 1910
Lithograph
15 ¾ x 15 ³⁄₁₆ in (40.0 x 38.6 cm)
Los Angeles County Museum of Art, gift of B. Gerald Cantor Art Foundation
M.87.76.2

Auguste Rodin

FRANCE, 1840–1917

Saint John the Baptist Preaching

CATALOGUE NO. 10

1878

Musée Rodin cast 6/12, 1966

Bronze

31 ½ x 19 x 9 ½ in.

(80 x 48.3 x 24.1 cm)

Inscribed on base, top: A. RODIN;

front: © by musée Rodin.1966

Foundry mark on back: .Georges

RUDIER./.Fondeur.PARIS.

Gift of B. Gerald Cantor Art

Foundation

M.73.108.12

In order to find work in the disastrous aftermath of the Franco-Prussian War, Rodin moved to Belgium. While in Brussels he modeled his first major surviving sculpture, a standing male nude, which was exhibited there in 1877 as *The Vanquished*. Shown soon after in Paris as *The Age of Bronze*, it became a *cause célèbre*: life-size and modeled with such convincing artistry, it appeared to critics as a life-cast, and they accused Rodin of fraud. Rodin successfully defended himself against these charges. His complete vindication came in 1880, when the government purchased the plaster and ordered it to be cast in bronze.[1]

A few of Rodin's letters written in Paris to his mistress, who remained behind temporarily in Brussels, indicate that he had been working on a clay sculpture, *Joshua*, before his departure from Belgium,[2] but it seems not to have survived. The next major figure that Rodin modeled was *Saint John the Baptist Preaching*.

Rodin is said to have decided to model an over-life-size figure in order to confound his accusers further and to have chosen the subject before he began the sculpture,[3] although he later commented that he was inspired by an Italian peasant who came to his studio looking for work as a model: "This man, rough and hairy…expressed in his physical power all the violence, but also the mystical character of his race. I thought immediately of a John the Baptist, that is, of a natural man, enlightened, a believer, a forerunner," and the position this man took as he stepped before Rodin and turned to look at him inspired the artist to seize the idea of his movement.[4] Like a self-fulfilling prophecy, this sculpture embodied three of the salient principles of Rodin's subsequent oeuvre: deliberate omission of traditional attributes, willful anatomical distortion, and an emphasis on compositional movement to give vitality to the sculpture.

John the Baptist, the "voice crying in the wilderness," who predicted the coming of Christ, is described in the New Testament as wearing camel's hair,[5] symbolic of his rustic state in the rugged wilderness of Judea. Rodin's interpretation, by contrast, was one of the rare instances in which the Baptist was shown absolutely naked. To the modern eye this enhances the elemental nature of the prophet. Furthermore, although Rodin is said to have initially included the attribute of a cross borne on the figure's left shoulder,[6] the finished sculpture was devoid of any attribute except for the gesture of its right hand. Not to be mistaken for a trivial signal of beckoning to the masses, this gesture is a time-honored element of the iconography of the Baptist as a prophet who indicates the coming of the one greater than he.

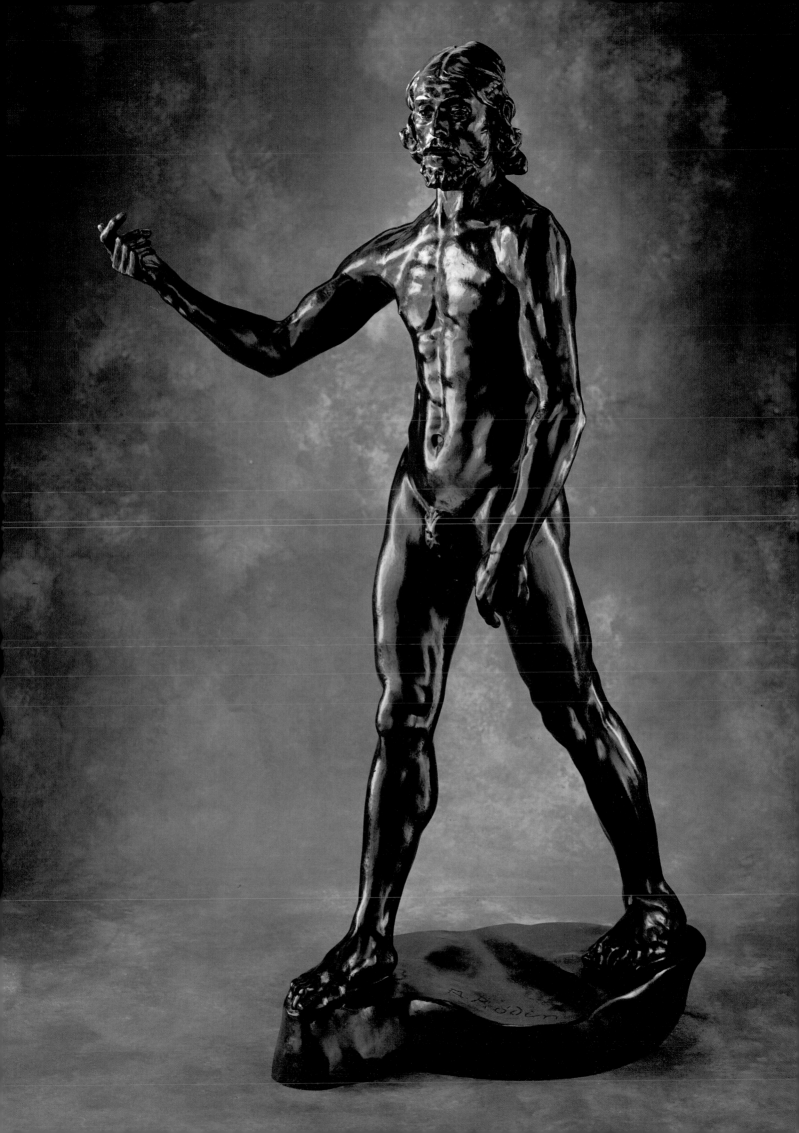

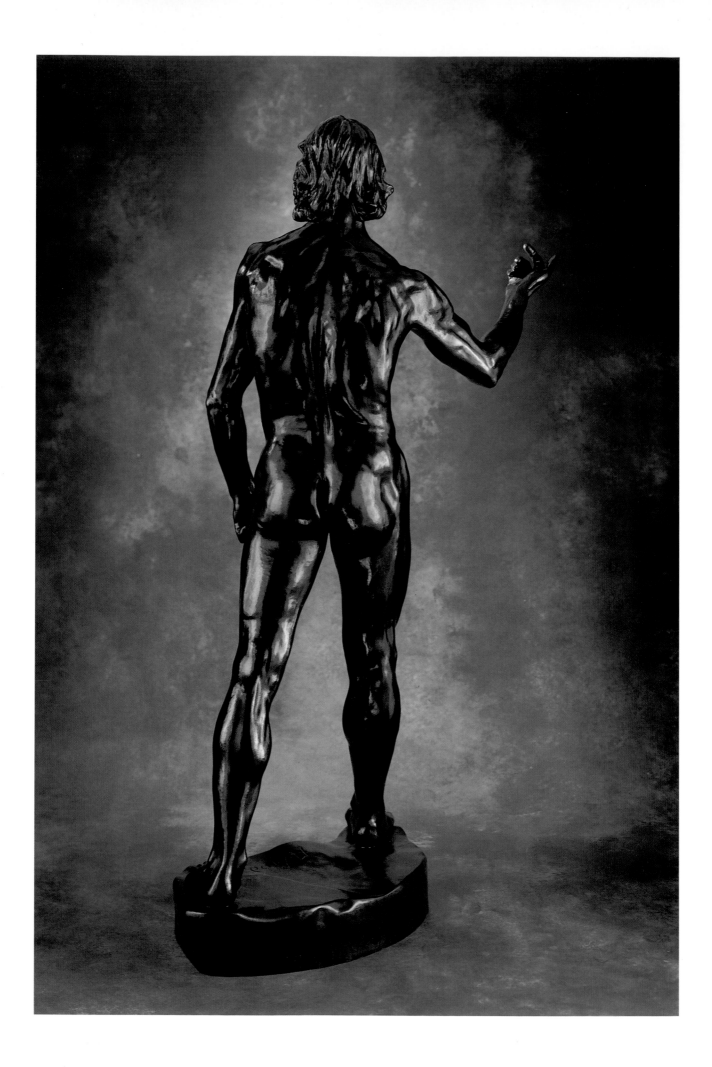

The sculptor was faithful to traditional representations of the physical type of the Baptist. The long hair and beard, the open mouth of prophecy, and the fiery eyes identify the saint. The vibrant spirit of the face is enhanced by delicate modeling of irregular surfaces in the eyes and beard. The interplay of deep shadows and twinkling highlights may show the lingering influence of Carrier-Belleuse's technique on Rodin. This treatment is more noticeable in Rodin's large-scale bust of the Baptist, which was cast independently.[7] In addition to this the taut, sinewy musculature of the shoulders and arms gives a sense of the ascetic body from which all excess fat has been burned off in the desert, while the torso is robustly formed.

The most original feature of the sculpture, however, is its pose. Each leg is set individually in a position of different segments of a stride, so that the figure is not shown arrested in a single movement nor in an academic pose. This demands the movement of the viewer's eye to perceive the legs sequentially. It is a treatment that Rodin discerned in François Rude's *Marshal Ney*,[8] and when applied by Rodin, its persuasiveness was reinforced by the distorted size of the legs, one of which is slightly longer than the other.[9] This angular set of the legs simultaneously gives a sense of tense momentum and an awkwardness that suggests the natural, unsophisticated essence of the prophet, who showed the path of the future. A compelling interpretation of this figure was offered by Antoine Bourdelle:

The old fanatic—erect, rigid on his clenched feet that he arches—walks, explains, and traces a sign in the air with his big, bony finger.

In this figure, the bones turn in their sockets, the muscles slide and lock into each other, the tendons are tangled up with the veins, and the whole body, like the open mouth, seems to hurl forward a roaring saint.[10]

The Gates of Hell

I N 1 8 8 0 R O D I N W A S A W A R D E D A G O V E R N M E N T C O M M I S S I O N to produce a "decorative portal" for a museum of decorative arts that was planned for the site of the Cour des Comptes (the auditing office of the national government), destroyed in the Franco-Prussian War. The undersecretary of state for fine arts, Edmond Turquet, had noticed the sculptor through the scandal that arose over *The Age of Bronze*. It was Turquet who had the controversial sculpture cast in bronze and purchased by the state. Turquet had a genuine interest in the arts and apparently was open to the inventiveness of the artists of his day. His brother-in-law, the painter Maurice Haquette, may have introduced him to Rodin, or Rodin may have asked Haquette to intercede with Turquet for the commission for the portal.

The subject of the portal, the Gates of Hell, was drawn from *The Divine Comedy* by Dante Alighieri (1265–1321), and it was without doubt chosen by Rodin himself. In this epic poem, probably written late in his life, Dante recounted the tale of his imaginary journey through Hell and Purgatory to Paradise, guided by the ancient Roman poet Virgil. The three sections of the epic described hierarchies of condemnation and salvation. In the nineteenth century the *Comedy* (the qualifier *divine* was not originally part of the title) was read with renewed

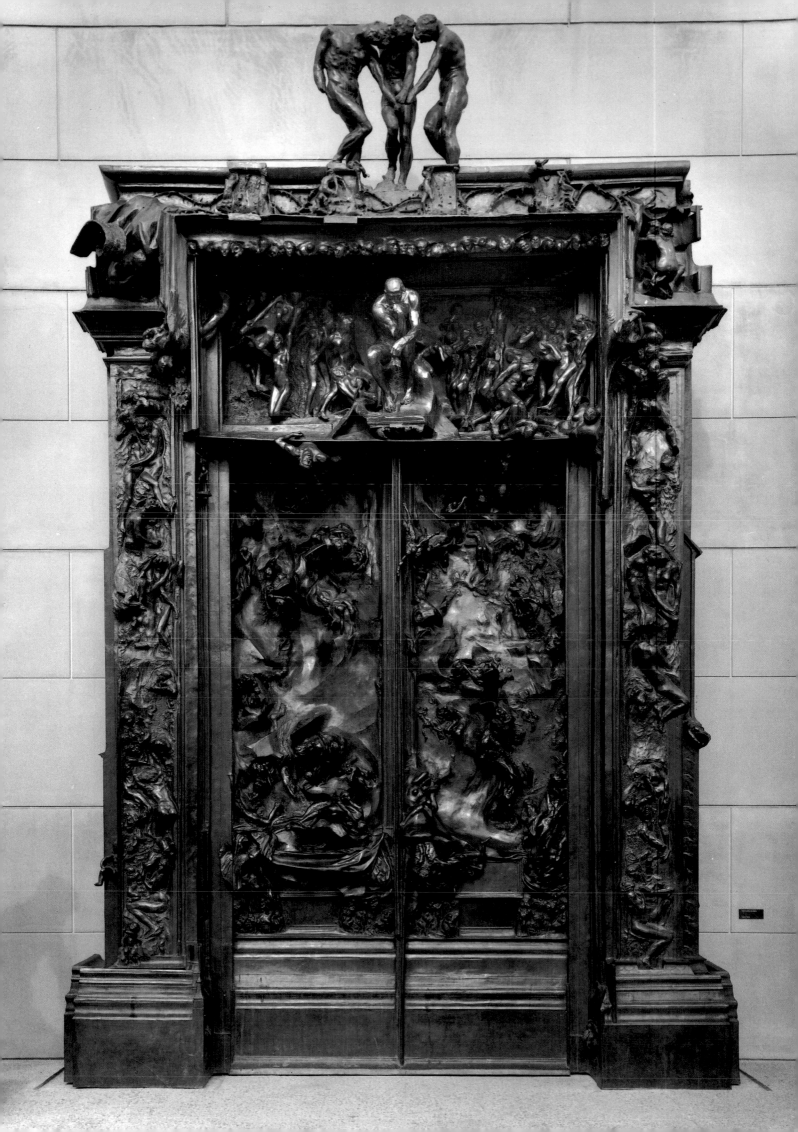

*The diagram (above) is numbered
to indicate the location of individual
sculptures that are the subject of
catalogue entries.*

interest, and Rodin was not alone in treating it. He seems to have made a
deliberate choice, however, in concentrating his attention on the vision of the
underworld, but as his ideas developed, he moved away from correlating his
sculpture with specific episodes in the narrative. The subject of Rodin's *Gates*
became the alienated, ambiguous nature of the human condition and human-
ity's hopeless regret over mistakes or sins that could not be made right
through acknowledgment and repentance.

Just as Rodin relinquished the idea of narrative structure, so too did he
relinquish a formal structure based on precedents of historiated images in
other bronze doors. His early drawings and terra-cotta studies for the com-
position illustrate sets of compartments in which he had probably intended to
model pictorial reliefs. Rodin's prime inspiration was, in all likelihood,
Ghiberti's east doors (1425–52) for the baptistery of the cathedral of
Florence. Made of gilt-bronze panels, they were known as *The Gates of
Paradise*, a name anecdotally attributed to Michelangelo, and it was probably
no coincidence that Rodin saw his *Gates of Hell* in connection with them.
The compartmentalized organization of these doors was part of a venerable
history of similar compositions for such honored portals to churches, and it
is likely that Rodin saw several examples of them during his trip to Italy,
including the set on the cathedral of Pisa (left doors, late sixteenth century,
executed by sculptors trained in Giambologna's studio), in which the richness
of sculptured decoration in relief, much higher than that in Ghiberti's, makes
an overwhelming impression of sculptural density.

Having abandoned the gridlike structure of compartments, Rodin rapidly developed his *Gates of Hell* as a free matrix in which a population of figures, most of them almost completely in-the-round, floated and churned in a weaving and surging design defined primarily by the figures alone. The *Gates* as developed by Rodin have almost no spatial or pictorial referent except for the "tombs" at the bottom, which give a massive visual foundation to the whole. (They are probably related symbolically to the tombs mentioned by Dante in *The Inferno*.) The spatial relationships in the *Gates* are ambiguous. At once a real space before the viewer, the sculpture crests over and draws him in while simultaneously presenting a realistic architectural frame, which is interrupted and at times negated by nearly three-dimensional human figures. The *Gates* also present a nonspace as a heavy curtain of bronze, sinking and swelling in much the way that the ambiguous space in another vision of damnation, Michelangelo's fresco of the Last Judgment, does. The composition of this sculptor's painting is defined throughout by rising and falling bodies and has only a suggestion of rationally recognizable space and depth in the abbreviated, barren landscape at its lower margin. It is difficult to believe that Michelangelo's composition, with a focal point in the figure of Christ near the top at the center, flanked by the Virgin and St. Peter, was not somehow conflated in Rodin's experiments with the example provided by medieval church portals. Rodin's invention, however, was completely his own, and it would be wrong to force a kind of predetermination of visual sources on his, or indeed on any artist's, creative will.

Rodin began to exhibit some of the figures from the *Gates* as independent, freestanding sculptures in the early 1880s, but the plaster monument was not largely complete until 1900, and even then Rodin seems to have continued to work on it—and in it, as though it were a private universe in which to develop a new vocabulary to express the psychological turmoil of modern existence.

The museum for which *The Gates of Hell* were commissioned was never built. It is unlikely that they would ever have been used as a door, given their extremes of concavity and protrusion. Indeed, the commission had called for a decorative portal; perhaps no one was ever intended to pass through it.

The principal sources for this essay are Albert Elsen, *Rodin's Gates of Hell* (Minneapolis: University of Minnesota Press, 1960); idem, "The Gates of Hell: What They Are About and Something of Their History," in Elsen, ed., *Rodin Rediscovered*, exh. cat. (Washington, D.C.: National Gallery of Art, 1981); idem, *"The Gates of Hell" by Auguste Rodin* (Stanford: Stanford University Press, 1985).

See also Jacques De Caso, "Rodin at the Gates of Hell," *Burlington Magazine* 106, no. 731 (February 1964): 79-82.

A fine synthetic study on the *Gates* with magnificent illustrations is Yann Le Pichon and Carol-Marc Lavrillier, *Rodin: La Porte de l'Enfer* (Paris: Pont Royal, 1988).

Good pictorial documentation of other bronze doors can be found in Gerald K. Geerlings, *Metal Crafts in Architecture* (New York: Scribner's, 1929).

For the historiography of Ghiberti's bronze doors on the baptistery of the cathedral of Florence, see Richard Krautheimer, *Lorenzo Ghiberti* (Princeton: Princeton University Press, 1956), pp. 18–26. The reference to the anecdotal source of the name "the Gates of Paradise" appears on p. 18.

Auguste Rodin

FRANCE, 1840–1917

The Shade

CATALOGUE NO. 11

c. 1880, enlarged c. 1901

Musée Rodin cast 6/12, 1969

Bronze

75¾ x 20 x 44 in.

(192.4 x 50.8 x 111.8 cm)

Inscribed on base, front: RODIN;

left: COPYRIGHT BY MUSEE RODIN

1969

Foundry mark on base, back:

SUSSE FONDEUR.PARIS

Gift of B. Gerald Cantor Art

Foundation

M.73.108.1

The crowning element of *The Gates of Hell* is called *The Three Shades* (*Les Trois Ombres*); it is composed of three smaller examples of the present model, arranged in a semicircle facing each other. Rodin's contemporaries interpreted *The Three Shades* as the warning "Abandon all hope, you who enter here," inscribed over the entrance to the Inferno described by Dante (canto 3:9),[1] but the precise symbolism (if any) of this trinity is still open to interpretation. The enlargement of the single *Shade* (*L'Ombre*) was likely carried out in 1901.[2]

The original model of *The Shade* so closely resembles another sculpture by Rodin, *Adam*, as to be considered a variant of it. In *The Three Shades* the right hand withered into nothing so that the arm directly follows the contour of the right hip, and the left hand became a vestigial member. The pose of *The Shade* is more open, with a less rigid position for the left arm and a looser turn of the head to the shoulder. It is as though *Adam* had been posed at the initial moment of a gesture that would open into a spiral, and this is followed through the pose of *The Shade*. Because *The Shade* depends so obviously on *Adam*, the history of the figure is best told through that of the earlier sculpture.

Soon after he began to work on *The Gates of Hell*, Rodin decided to make an addition to the project in the form of two flanking figures, set in front of the panels. Rodin preserved this arrangement in ink sketches. Two of the prime examples of these studies show that the flanking figures were initially conceived as being greater in proportion to the *Gates* than they were when they were eventually carried out.[3] Thus from the outset the flanking figures were hardly subsidiary accessories. Given the additional expense they would entail, Rodin had to ask the government's approval before adding them. This permission was granted.[4] It has been logically assumed that the two figures were the *Adam* and *Eve* that were ultimately developed as completely independent figures (see CATALOGUE NO. 12).

While he was still in Belgium, it is said, Rodin created a sculpture of Adam and either destroyed or modified it.[5] Whether or not this early *Adam* was the source of or the same as the one associated with *The Gates of Hell* is unknown. In any case the unmistakable reliance in *Adam* on specific examples from Michelangelo's oeuvre suggests that Rodin modeled it after his trip to Italy. It is widely believed that the extended left arm and pose of the body, although oriented vertically, allude to Michelangelo's fresco of *The Creation of Adam* on the Sistine Chapel ceiling and that the pose of the figure reflects such sculptures as Michelangelo's *St. Matthew* (1505–6, Florence, Accademia) and the Slaves (c. 1530–34, Florence, Accademia). In both *Adam* and *The Shade* the facial type depends on Michelangelo's ideal, with its broad, square forehead closer to that of *David* (1501–4, Florence,

Accademia) than are those of many of Rodin's other male figures. The influence of Michelangelo is most strongly recognizable in the bulging musculature. It has a grandeur of scale that makes for a superhuman physique. This is what Rodin referred to when he spoke of Michelangelo's "modeling";[6] it has nothing to do with the act of modeling in soft materials. Michelangelo was a carver. He denigrated work in bronze.

For a sculptor who, unlike many of his contemporaries, was keenly interested in Michelangelo's art (not just in the romantic legends about him), 1875 was an especially timely year to travel to Italy because it was the fourth centenary of Michelangelo's birth.[7] With the principal exception of Jean-Baptiste Carpeaux, many of Rodin's immediate predecessors and contemporaries, like Albert-Ernest Carrier-Belleuse, instead put a premium on the mannerist refinement of French sixteenth-century sculptures, whether by Jean Goujon or Germain Pilon or in the style represented by the *Diana of Anet* (probably c. 1546–55, Louvre) (which they did not know had been revisited by restorers' hands), while academic painters looked to Raphael for inspiration. Rodin's interest in Michelangelo should not be taken for granted, because it was part of a specific, renewed recognition of his style.

The model for the present sculpture, multiplied by three, was originally exhibited as three separate statues, with more space between them than in the final composition of *The Three Shades*,[8] where they are joined at the base. Repeated, whether joined or not, *The Shade* becomes one of the foremost examples of Rodin's repetition of identical figures, a compositional device he would develop in the *Gates* and use throughout his life. This procedure not only afforded the possibility of simultaneity of experience of one figure but also simply and creatively intensified the presence of that figure by imposing it repeatedly in the eye of the viewer.

A few of Rodin's drawings from around 1880 record his early concepts for the disposition of *The Gates of Hell* that clearly indicate the presence of two full-size, flanking statues,[1] which must be Adam and Eve.[2] It is not difficult to imagine that such an arrangement would have been inspired by the configuration of statue-columns on the jambs of medieval church portals like those of Chartres, Amiens, and Rheims,[3] which Rodin noted had made a special impression on him.[4] The flanking figures of the *Gates* are like statue-columns that, detached, have stepped down from their elevated perches, contradictory though the expression may seem. *Adam* and *Eve* were not, however, expressly commissioned as part of the *Gates*, and they were always treated as independent figures.[5]

In addition to the arrangement of a pair of independent statues, Rodin also made a drawing of an idea for the *Gates* that shows a sculpture in the traditional location of trumeau figures, between the two main vertical panels and slightly elevated. This sculpture is drawn with braided lines that might suggest the composition of *Eve*, and its position is in keeping with the idea of the *Gates*: as the victim of the temptation that caused mankind's downfall, Eve is the pivotal character in the first part of the Christian story of salvation, even though she does not appear in Dante's *Inferno*. A plaster model for a fireplace in the Musée Rodin is flanked by versions of *Adam* and *Eve*; there their reference to the underworld is clear.[6]

Although the date of the plaster *Adam* is known from its exhibition in the Salon of 1881, the date of the life-size *Eve* is far from certain. In 1881 Rodin announced his intention to produce a companion for his *Adam*,[7] and indeed 1881 has often been cited as the date for *Eve*. A small-scale version of it was exhibited in 1883.[8] A sketch was documented by Edmond Goncourt in Rodin's studio in 1886, and the life-size version was cast in 1887.[9] This larger version was not exhibited, however, until much later, in 1899.[10] The title *Eve on the Rock* is also used to distinguish the marble versions and the bronzes related to the marbles that show the rocklike support behind the legs.[11] The present bronze retains the strut on the right ankle that braced the plaster model.[12]

Rodin's memory of having posed an Italian model, a Mme Abruzzezzi (also spelled Abruzzesi), for the sculpture recurs in the literature about his *Eve*. The story was certainly riveting, as it involved the pregnancy of the woman who modeled for him. Rodin recalled his struggle to achieve a satisfactory form for the sculpture without understanding the source of his difficulties until he learned that the shape of his model's body was changing

Auguste Rodin

FRANCE, 1840–1917

Eve

CATALOGUE NO. 12

c. 1881
Musée Rodin cast 9/12, 1968
Bronze
68 x 19 x 25 in.
(172.7 x 48.3 x 63.5 cm)
Inscribed on base, right: RODIN;
left: COPYRIGHT BY MUSEE RODIN
1968
Foundry mark on back:
SUSSE FONDEUR.PARIS
Gift of B. Gerald Cantor Art
Foundation
M.73.108.2

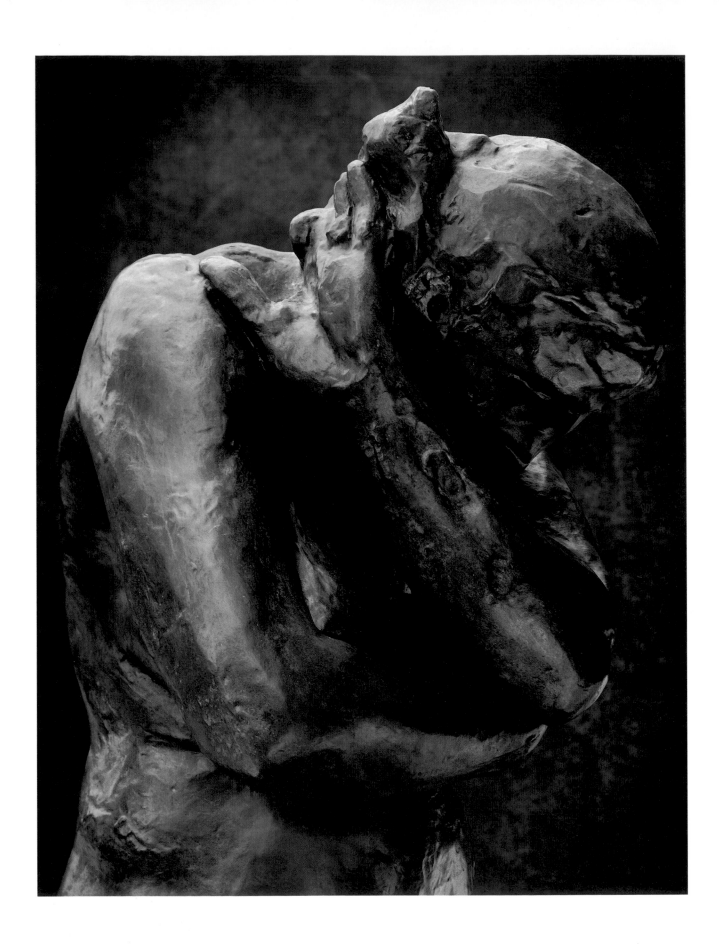

daily in the course of her pregnancy. It was a physiological narrative that duplicated Eve's. In a careful analysis of primary documents Lynne Ambrosini recently suggested that Rodin's recollection might have been mistaken because Anna Abruzzezzi was born only in 1874, so that she would have been too young in the early 1880s to have modeled for *Eve*, and that the model for *Eve* was another Italian, Carmen Visconti.[13] However, if the life-size *Eve* was modeled in the 1890s, then Anna Abruzzezzi could well have been the model Rodin recalled, because she was pregnant in 1895.

References to Michelangelo's art have also been cited consistently in formal analyses of *Eve*: the gesture of her left arm seems to have been inspired by that of Adam in the fresco of *The Expulsion from Paradise* on the Sistine Chapel ceiling, and her body is related to that of Eve from the same vignette.[14] Her form has nothing in common with the shapes of contemporary female nudes in the salon sculptures that enjoyed such popularity in the last quarter of the nineteenth century; to the contrary, the roughened surfaces in some of the passages in the bronze give a toughness to the image. With somewhat shorter proportions than the types preferred by Albert-Ernest Carrier-Belleuse, for example, which revived the finish and the tapering, elongated, graceful forms of mannerist sculptures, Rodin's *Eve* made an exceptional departure from the taste for perfected anatomies. With large feet, low-set thighs, and more heavily muscled upper arms, this bronze is brilliantly styled to be more naturalistic than reality.

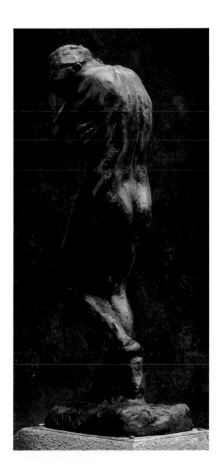

Auguste Rodin

FRANCE, 1840–1917

The Falling Man

CATALOGUE NO. 13

1882
Musée Rodin cast 2/12, 1972
Bronze
22 7/8 x 14 1/2 x 10 in.
(58.1 x 36.8 x 25.4 cm)
Inscribed on base, left: A. Rodin/
n o 2; below and to the left of that:
© BY MUSEE RODIN 1972
Foundry mark on right, at lower
edge: Susse Fondeur Paris
Gift of B. Gerald Cantor Art
Foundation
M.73.108.22

In the overall composition of *The Gates of Hell* the figure generally known as *The Falling Man*[1] occupies a place of critical importance. Positioned at the very top of the left vertical panel, it is a key element in the design of the *Gates*.

Initially Rodin arranged the composition of the *Gates* in a highly rationalized system that divided each of the two large upright panels horizontally into four compartments of reliefs. The composition evolved rapidly, with Rodin dissolving the gridlike pattern. The only absolutely straight elements remaining in the *Gates* were their frames and the moldings of the lintel. The frame at the top of the left panel was broken by *The Falling Man*.

Attached to the frame by the base of his rib cage, *The Falling Man* arches backward away from the relief field. His left arm is raised up and around the base molding of the lintel, completely interrupting its line. In addition to this, the left half of the upper frame of the panel was deformed so that it was no longer a straight line either. Thus interrupting one of the most important perpendiculars of the *Gates*, *The Falling Man* becomes the agent of chaos, transmitting the fluctuating nature of the Inferno into the objective reality of the monument.

Beyond this, *The Falling Man*, looping backward away from the relief field, also brings the chaos of the relief into the viewer's real space. Whoever stands at the foot of the *Gates* feels drawn up into their wavering compositional forces. The reliefs pull back and away and surge over the viewer; *The Falling Man* is the forward agent of this cresting wave of bronze.

Suspended and reeling backward, *The Falling Man* also tests the fundamental law of gravity that governs the composition and action of traditional sculptured figures. Neither a part of the relief field nor completely belonging to the objective world of reality outside the relief, *The Falling Man* is an inverted being cast down from the *Gates*. He is either expelled from or is in the process of falling back into the Inferno. Such unusual positioning of a sculptured human form accounts for the great variety of satisfying viewpoints and orientations given to the figure as it is adjusted upright to become a free-standing sculpture.

Rodin developed several other compositions associated with *The Falling Man*. They are discussed in the next three entries.

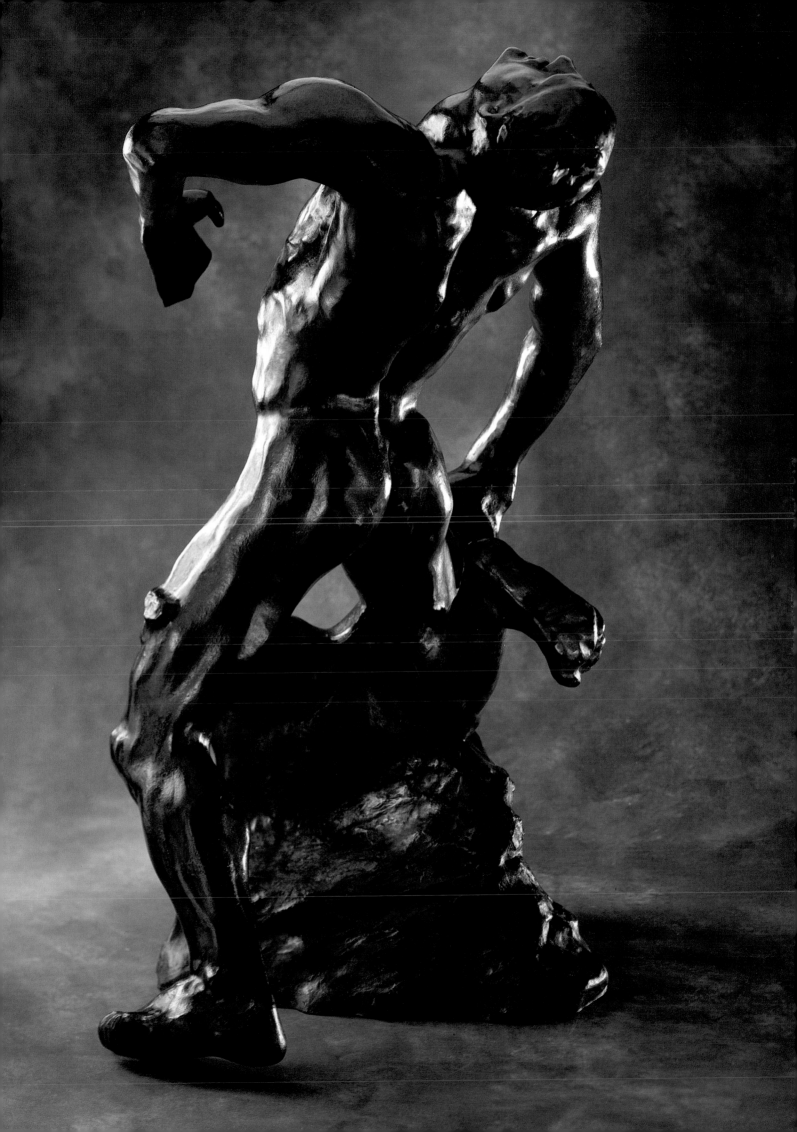

Auguste Rodin

FRANCE, 1840–1917

*Marsyas
(Torso of
"The Falling Man")*

CATALOGUE NO. 14

c. 1882–89

Musée Rodin cast 2/12, 1970

Bronze

40¼ x 29 x 18 in.

(102.2 x 73.7 x 45.7 cm)

Inscribed on proper left leg,

side: A. Rodin/Nº 2;

back: © by Musée Rodin 1970

Foundry mark on support, back,

at lower edge: .Georges Rudier./

.Fondeur.Paris.

Gift of B. Gerald Cantor Art

Foundation

M.73.108.5

Three other independent compositions are related to the figure called *The Falling Man*. Combined with Rodin's *The Crouching Woman* (CATALOGUE NOS. 15–16), *The Falling Man* became a relief when pressed into the top of the right border of *The Gates of Hell*; as a freestanding sculpture this couple became known as *I Am Beautiful* (*Je suis belle*, 1882), after the opening line of a poem by Charles Baudelaire. At the request of the collector Antony Roux in 1885, Rodin made another sculpture of *The Falling Man* struggling with a python, called *The Man with a Serpent* (*L'Homme au serpent*), now in the Sterling and Francine Clark Art Institute.[1]

It is to the latter two compositions, therefore at one remove from *The Falling Man*, that *Marsyas* is more closely related. Indeed, the pointed cusp of bronze at the center of the chest and the light horizontal ripple that lies across the collarbones are perhaps remnants of material left after the disengagement of the torso from the body of *The Crouching Woman*.[2] The muscles of the back of *Marsyas* are more tightly contracted than those of *The Falling Man*. They convey the great stress on the body that would be caused by the strain of carrying *The Crouching Woman*.

In Rodin's world such tension has psychological as well as physiological meaning. Although Rodin may have arbitrarily applied Baudelaire's poem "Beauty" (*Beauté*) to the sculpture now known by its opening words, the association was Rodin's choice nevertheless. While the primary meaning of this symbolist poem is obscure, it can be loosely translated as follows: "I am beautiful, o mortals! like a dream of stone, / And my breast, where each man is crushed in his turn, / Is made to inspire in the poet a love / as eternal and silent as matter itself."[3] These verses give an impression of cold fatality, dense and inexorable and absolute as rock, like the crushing burden that weighs on the male figure in the sculpture. Whether or not they can be related to one of Rodin's drawings of a man struggling with another figure positioned above him, inscribed "the genius of sculpture,"[4] is left to the viewer's imagination.

The bold contraction of the torso's flesh is emphasized by the irregular treatment of the surface of the bronze, which suggests the ragged appearance of flayed muscles and would account for the title of the torso as *Marsyas*.[5] The raised triangle of metal left between the pectoral muscles is an aggressively inorganic form stuck like the blade of a knife into this vital physique. Together they may symbolize the life force that contracts the muscles and the torment, whether literal or spiritual, which either challenges life to struggle or destroys it.

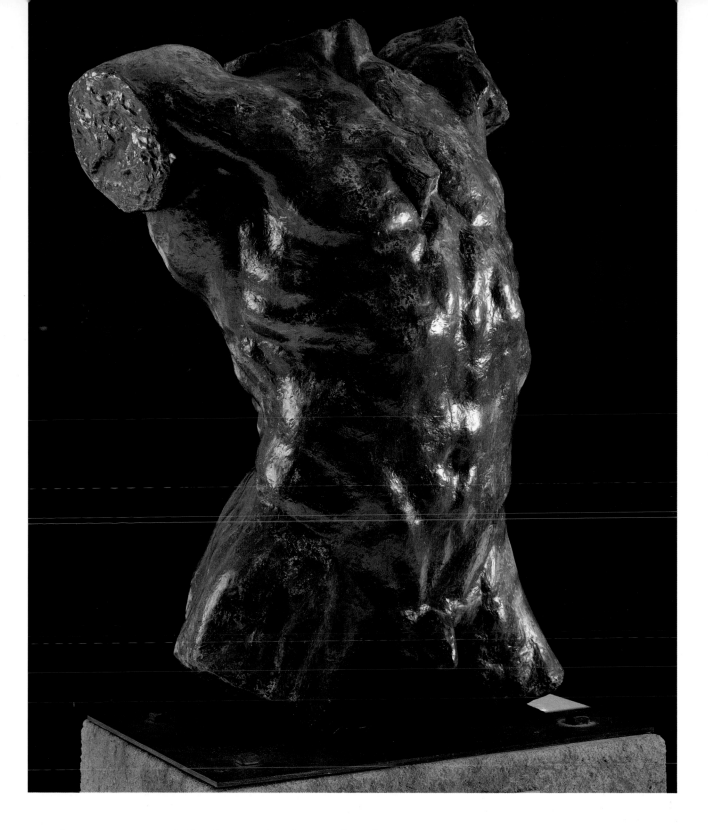

The torso is customarily dated to 1882, but the exact date of its derivation as an independent work is unclear. If it was the *Torso* shown in the Monet-Rodin exhibition at the Galerie Georges Petit, it would have existed by 1889.[6] In Rodin's oeuvre this would be an early date for an enlargement of a partial figure (see CATALOGUE NO. 16). Because of its fragmentary nature, without head and limbs, it might be related to Rodin's earliest experiments with enlargements of small-scale models, which involved piecemeal work on the original models. The enlargements were carried out in separate parts, which were then joined to make a finished sculpture.[7]

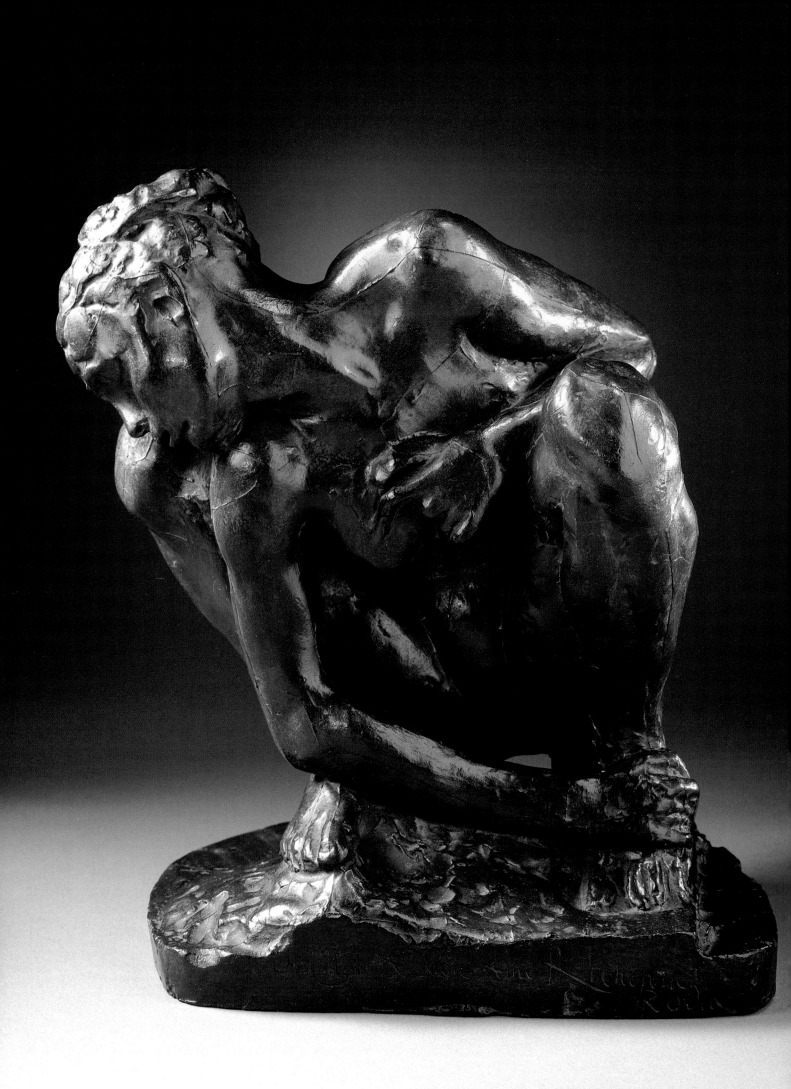

The Crouching Woman is one of Rodin's most provocative sculptures, with a physical tension derived from a highly compressed but simultaneously revealing pose. Probably conceived early in the development of *The Gates of Hell*, around 1880–82,[1] it can be found in the tympanum of the *Gates* next to *The Thinker* and is repeated in combination with a male figure at the upper right side. This latter composition was produced as a freestanding sculpture known primarily by the title *Je suis belle*.[2] The head was also turned into an independent sculpture known as *The Head of Lust* (*La Luxure*).[3]

Although *The Crouching Woman* is probably better known today in the large-format casts (33 and 37 1/2 in., see CATALOGUE NO. 16), the small-format version, closer to the scale suitable for application in *The Gates of Hell*, must predate the enlargements. A terra-cotta example (11 3/4 in.) and a plaster (12 in.) in the Musée Rodin[4] might be studies for it, because their bases and the treatments of the musculature differ from the definitive bronze version,[5] to which the present plaster corresponds exactly.

Rodin's creative process required several plaster casts, through which he worked out a final composition by carving the plaster directly, marking it, or adding to it. Plaster also could be colored to give an idea of the appearance of a model when executed in bronze.

Rodin may have preferred to offer plasters rather than expensive bronzes as gifts. He thought of them as finished works of art in their own right, signing and dedicating them to their recipients.[6] The high quality of the present cast is shown by the delicacy of the sharp raised lines left on the surface when the sculpture was pulled from the mold.[7] The modulated color of the painted skin, with its subtle greens and rich chocolate brown, imitates the tones of carefully patinated bronzes.[8]

Rodin dedicated this plaster to Auguste-Jean Richepin (1849–1926), a prolific French playwright, poet, and critic. Claiming to have been born of gypsies, Richepin had an exuberant, eccentric personality. The inscription "*La Glu*" (English: "glue"; figuratively, "snare" or "trap") must refer to Richepin's five-act drama of the same name, staged in Paris in 1883 and in Nice in 1910.[9] Rodin met Richepin at the salon of Mme Henri Liouville, wife of the representative from the Meuse region and a patron of Rodin, following his rapprochement with Albert-Ernest Carrier-Belleuse, whose nomination to the directorship of the Sèvres manufactory put Rodin in touch with society.[10] It is certain that Rodin knew Richepin at least by 1897, judging from a letter from Richepin acknowledging receipt of "your wonderful *Faunesse*." Whether or not this might really refer to *The Crouching Woman* instead is open to speculation.[11]

Auguste Rodin

FRANCE, 1840–1917

The Crouching Woman

CATALOGUE NO. 15

c. 1880–82
Painted plaster
12 1/2 x 10 x 7 in.
(31.8 x 25.4 x 17.8 cm)
Inscribed on base, front:
LA Glu. A mon Ami Richepin/
Rodin
Gift of Iris and B. Gerald Cantor
Foundation in honor of Vera Green
M.91.153

Auguste Rodin

FRANCE, 1840–1917

The Crouching Woman

CATALOGUE NO. 16

c. 1880–82, enlarged 1906–7?
Musée Rodin cast 4/12, 1963
Bronze
37 1/2 x 25 x 21 1/8 in.
(95.3 x 63.5 x 53.7 cm)
Inscribed on base, top, right:
A. Rodin; at lower edge:
© by musée Rodin 1963
Foundry mark on back:
.Georges Rudier./.Fondeur.Paris.
Gift of B. Gerald Cantor Art
Foundation
M.73.108.4

Although Stanislas Lami reported that from about 1890 Rodin worked up his full-scale figures by means of the mechanical enlargement of smaller maquettes,[1] his most important experiments in altering the scale of pre-existing models to monumental size fall primarily in the first decade of the twentieth century. This process continued until his death. In 1902 the enlargement of *The Thinker* was begun,[2] and by 1909 the colossal version of the *Head of Pierre de Wissant* was exhibited in various salons.[3] The *Large Head of Iris* was shown in 1909 and 1910.[4] An enlargement of *The Crouching Woman* must have existed by 1907, the date of an anecdotal drawing of Rodin's studio in which the sculpture is illustrated;[5] the accounts of Henri Lebossé, the collaborator to whom Rodin entrusted the process of reducing and enlarging many of his models, record that Lebossé worked on an enlargement of *The Crouching Woman* in 1906, 1907, and 1911.[6]

Magnified to life size, *The Crouching Woman* presents itself as immobile but simultaneously aggressive in its massive physical presence. Even though still in bronze, the figure takes on the character of a boulder, thus recalling Rodin's early commitment to the idea of defining a composition by a cubic shape. This he took ultimately from Michelangelo's precept that held that a figure's contours should be determined by the form of the block of stone from which it was carved. However, in this context it should be noted that although a smaller *Caryatid* (1886, Boston, Museum of Fine Arts) is a marble derived from this composition, it is less materially coherent.[7] Furthermore, there is no known surviving carved example of *The Crouching Woman*.[8]

The present bronze can correctly be called an enlargement of the small model, but it is not an enlarged replica. While the skin of the small plaster is smooth and refined, the surfaces of the bronze have been textured with a multitude of irregularities that, catching the light, turn into vibrantly shimmering patterns distributed across the broad expanses of the muscles.[9]

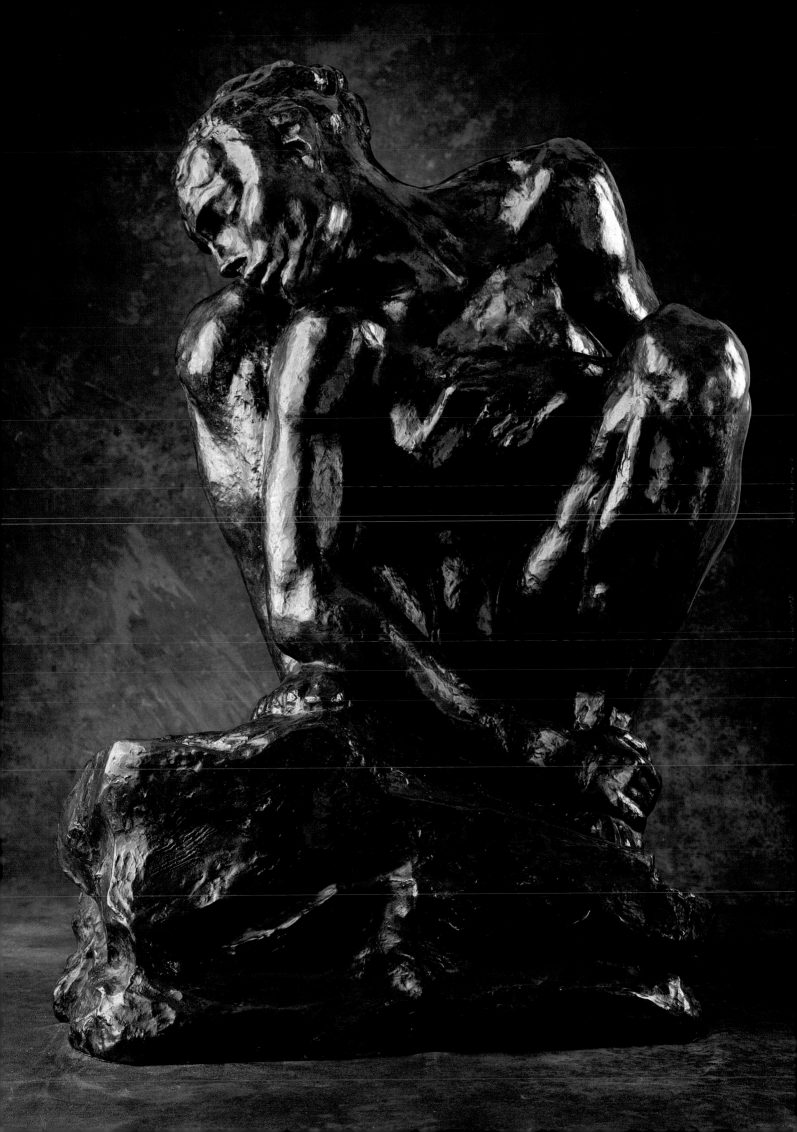

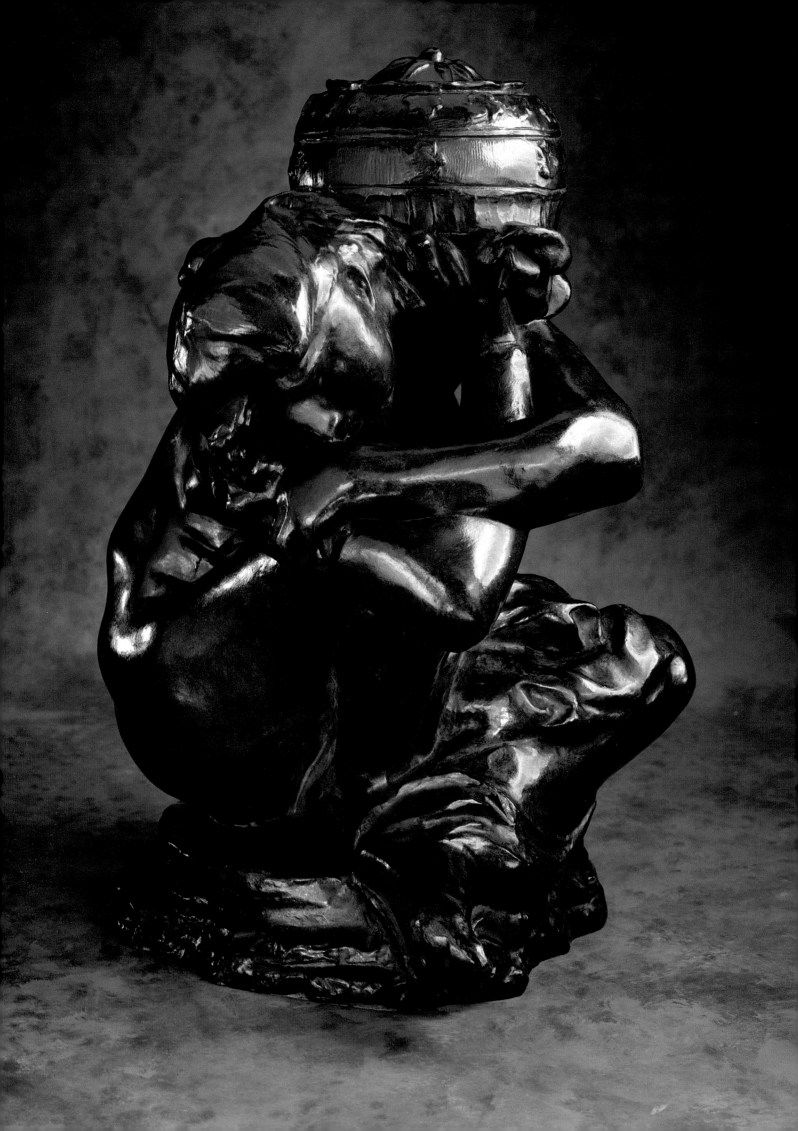

Although technically caryatids are most often standing figures of women used as decorative supports in architecture,[1] the present composition has been known constantly in Rodin's oeuvre by the title *The Fallen Caryatid with Urn* (*La Cariatide tombée portant une urne*).[2] There are two main versions of it: one bearing a rock (*The Fallen Caryatid with Her Stone* [*La Cariatide tombée portant sa pierre*]) and the other an urn, as in this instance.[3] Because the figure with the rock is the version that occurs in *The Gates of Hell* (nearly hidden within the frame at the upper left corner), it is probably the earlier of the two.[4] It may also reflect one of the few identifiable passages from Dante's *Inferno* that Rodin chose to represent in the *Gates*. Canto 10 relates how Dante strains to discern the nature of certain hobbled forms in the Inferno but fails to identify them. Virgil explains that they are the prideful, so bent under the stones they bear that they seem "shapeless":

So courb'd to earth, beneath their heavy terms
Of torment stoop they, that mine eye at first
Struggled as thine. But look intently . . .
And disentangle with thy labouring view,
What, underneath those stones, approacheth . . .
As to support incumbent floor or roof,
For corbel, is a figure sometimes seen,
That crumples up its knees unto its breast;
With the feign'd posture, stirring with unfeign'd . . .
Each, as his back was laden, came indeed
Or more or less contracted.

The attitudes of the punished seem to Virgil to say, "I can endure no more."[5]

Rodin's secretary, Rainer Maria Rilke (1857–1926), contemplating the *Caryatid*, wrote, "Even its collapse and failure [have] remained a way of bearing."[6] This commentary follows directly on his analysis of the *Danaïd* (CATALOGUE NO. 35), and it is not difficult to understand how Rilke linked them. Besides their slim physiques, their closed, manipulated poses connect them in Rodin's oeuvre, although perhaps not as closely as the caryatid can be related to *The Crouching Woman* (CATALOGUE NOS. 15–16). The association of *The Crouching Woman* with the *Caryatid* is even more clearly demonstrated through a marble in the Boston Museum of Fine Arts,[7] which is a hybrid of the two.

Auguste Rodin

FRANCE, 1840–1917

The Fallen Caryatid with Urn

CATALOGUE NO. 17

c. 1883
Musée Rodin cast 5/12, 1967
Bronze
15⁵/₈ x 10¹/₄ x 10¹/₄ in.
(39.7 x 26.0 x 26.0 cm)
Inscribed on base, back, right:
A. Rodin/Nº 5; at lower edge:
© by musée Rodin 1967
Foundry mark on left, at lower
edge: .Georges.Rudier./.Fondeur
Paris.
Gift of B. Gerald Cantor Art
Foundation
M.73.108.13

Unlike *The Crouching Woman*, the *Caryatid* is not painfully contorted, and the arrangement of its body conveys little sense of stress or anguish. Even its long, curving, nearly inarticulated fingers, so reminiscent of the type used by mannerist sculptors, show little exertion. The *Caryatid* is not crushed by its burden. Rather it conveys a sense of weariness and heartache through its isolation, much like *La Douleur* (CATALOGUE NO. 23). Its immobility contrasts greatly with the movement sweeping through the rest of the *Gates*.

Georges Grappe wrote that *The Fallen Caryatid with Her Stone* was modeled before 1881, and he noted that it was exhibited in Paris in 1883.[8] He suggested placing the version with the urn in 1883 also. Its date cannot yet be precisely determined,[9] although a lost version is said to have been exhibited in the winter of 1882–83.[10] The compactness of the figure might suggest an early date such as this. A similarly early date has been proposed for the drawing *The Genius of Sculpture*, in which a sculpture very much like the *Caryatid* appears.[11] Furthermore, Rodin treated the *Caryatid* as a complete figure. Even though caryatids are, more often than not, partial figures (traditionally they were either truncated terms or armless), there were ample precedents of them as complete figures. Rodin was perhaps not yet exploring the expressive potential of partial figures, and he perhaps deliberately chose to ignore convention to produce an independent type.

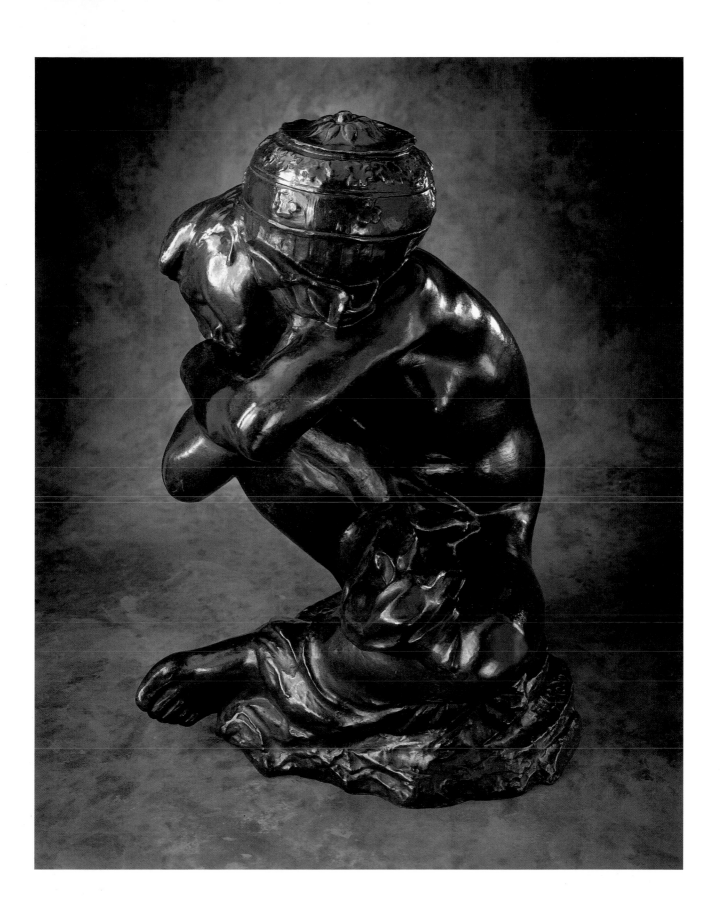

Auguste Rodin

FRANCE, 1840–1917

She Who Was
the Helmet-Maker's
Beautiful Wife

CATALOGUE NO. 18

c. 1880–85
Bronze
19 1/2 x 12 x 7 3/4 in.
(49.5 x 30.5 x 19.7 cm)
Inscribed on base, front: A. Rodin
No foundry mark
Gift of Iris and B. Gerald Cantor
M.84.164

The title by which this sculpture is primarily known, *She Who Was the Helmet-Maker's Beautiful Wife* (*Celle qui fut la belle heaulmière*), was taken from a poem by François Villon (1431–after 1463). Quoted extensively in Paul Gsell's book conventionally called *Conversations with Rodin*, this meditation on the theme of *vanitas* is one of the few known specific literary sources that Rodin applied to his sculpture. Gsell describes this sculpture as a work that Rodin "wrought upon the text of Villon's poem,"[1] and Rodin referred to it himself as "my *Vieille Heaulmière*" (old helmet-maker's wife)."[2] In the poem the helmet-maker's wife laments her lost beauty:

Ah, wicked old age
Why have you struck me down so soon?
[You] have stiffened me so that I cannot strike
And with that kill myself!
When I think, alas! of the good times,
What [I] was, what [I] have become,
When [I] look at myself completely naked
And I see myself so changed.
Poor, desiccated, thin, shriveled,
I nearly go mad!
What has happened to my smooth brow,
My blond hair....
My slender shoulders,
Small breasts, firm thighs
High, clean, perfectly made
For love's pleasures;
This is the fate of human beauty!
Shrunken arms and clenched hands
[And] completely hunchbacked.
What breasts! All wizened
Like my hips....[3]

It is quite possible that Rodin applied Villon's title after the fact, because the figure was exhibited in 1890 with the simple names *The Old Woman* and *The Old Courtesan*.[4] Paired with its mirror image as a high relief in plaster, it is believed to have been shown in 1889 as *Two Old Women* (*Deux Vieilles Femmes*); this double composition also bears the title *Springs Gone Dry* (*Sources taries*).[5]

In the same chapter of Gsell's book (entitled "To the Artist All in Nature Is Beautiful") Rodin also offers a commentary on Baudelaire's poem *"Une Charogne"* (Carrion): "Nothing can equal in splendor his picture of this

terrible juxtaposition of beauty which we could wish eternal and the atrocious disintegration which awaits it."[6] Rodin believed that ugliness is what harms or shows the result of harm, either physical or psychological, like disease, poverty, and cruelty. Ugliness, however, could be transfigured by art: "What is commonly called *ugliness* in nature can in art become full of great beauty."[7] He added, "In art, only that which has *character* is beautiful. *Character* is the essential truth of any natural object."[8]

The figure of an aged woman appeared several times in Rodin's oeuvre. Consequently the *Helmet-Maker's Wife* has been difficult to date with precision. A variant of it occurs in his design for a ceramic vase produced by Sèvres, completed by 1887,[9] on which his assistant Jules Desbois (1851–1935) collaborated. Anecdotal evidence suggested that an old Italian woman who modeled for Desbois may have inspired Rodin also; two of Desbois's sculptures represent a haggard figure, one in terra-cotta (*Poverty*) and another in wood (*Misery*). These are, however, possibly later than Rodin's *Helmet-Maker's Wife*.[10] They would also be later than the relief on the left side of the frame of *The Gates of Hell*, where an image similar to the design from the Sèvres vase was reprised (or where it originated). A date in the early 1880s for Rodin's sculpture had also been proposed because of its resemblance to works such as *Advanced Age* (*L'Âge mûr*) and related studies by Camille Claudel (1864–1943), who was heavily influenced by Rodin at that time; however, *Advanced Age* is later (1894–98), while Claudel's early *Old Helen* (*Vieille Hélène*, 1882) portrays a different model.[11]

The *Helmet-Maker's Wife* does use the compositional device of cunningly juxtaposed triangles, which may be related to those in Rodin's *The Call to Arms* from 1879 (Musée Rodin).[12] Rodin's attention to the frightening deformation of the face of the Genius of War in that sculpture, its harsh modeling, and its wiry limbs can be found again in the *Helmet-Maker's Wife*. The expressionistic stiffness suggestive of rigor mortis or the surprise of discovering that one has aged is suggested by the right hand stretched rigidly open behind the back of the helmet-maker's wife.

Rodin's figure has often been discussed in comparison with Donatello's wood *Magdalene* (1457, Florence, Museo Nazionale del Bargello).[13] It is likely that Rodin knew this masterpiece either from photographs or from his trips to Italy, but it is imprudent to assert that Rodin's sculpture was directly inspired by Donatello's. The relationship between the two was undoubtedly enhanced by the lengthy commentary of Gsell, who illustrated Donatello's sculpture and compared it with Rodin's work.[14] Another comparison to the *Helmet-Maker's Wife* is the bronze statuette of a seated old woman, attributed to Andrea Riccio (1470–1532), in the Bibliothèque Nationale.[15]

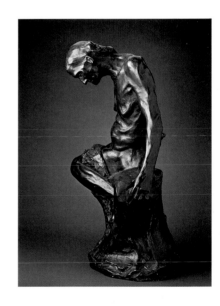

This early genre figure has an obvious similarity to Rodin's *Helmet-Maker's Wife* in its seated position, but Rodin's sculpture is modeled with a sweeping strength and bent with a pathos that mark it as a quite independent creation. It is one of Rodin's sculptures in which the harsh brutality of direct lighting most successfully takes on its own meaning: only when lit from below can the shock of the face be fully revealed, and only when lit directly from above does the figure seem to be crushed by the unforgiving brilliance of direct light. The *Helmet-Maker's Wife* is posed with a relative openness, while Desbois's huddled creatures, shivering in cold, fear, or despair, seem more individualized. Rodin's treatment lends a universality to the figure. Without the spiritualized verticality of Donatello's *Magdalene*, the *Helmet-Maker's Wife* is nonetheless more directly displayed to the viewer's objective analysis.

Auguste Rodin

FRANCE, 1840–1917

*Fugitive Love
(Fugit Amor)*

CATALOGUE NO. 19

1881–87?

Musée Rodin cast 10/12, 1969

Bronze

17 x 14½ x 8½ in.

(43.2 x 36.8 x 21.6 cm)

Inscribed on base, back, at upper edge: A. Rodin; lower edge:

© by musée Rodin 1969

Foundry mark on front:

.Georges Rudier./.Fondeur.Paris.

Gift of B. Gerald Cantor

M.73.139

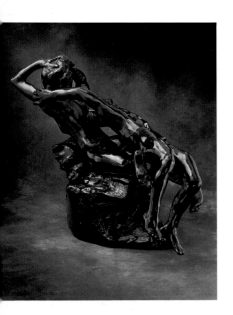

This composition is known by many names—*The Sphinx*, *Dream*, *Chimera*, *Night*, *Dawn*, and *The Arrival*—but it is usually called *Fugit Amor* for the fleeting love that slips from one's grasp like quicksilver,[1] thus representing the tormenting lack of fulfillment and the isolation that dominate *The Gates of Hell*. Possibly created early in the genesis of the *Gates*, *Fugit Amor* is usually said to have been modeled around 1881,[2] even though the streamlined, stylized physiques might suggest a slightly later date. A bronze version of *Fugit Amor*, now in the Musée d'Orsay, is cast integrally with a square base, the traditional profiles of which might argue, to the contrary, for an early date for the model.[3] In *The Gates of Hell*, *Fugit Amor* appears in the lower corner of the right panel; it is also placed prominently at the center of the right panel, positioned as though careering out from the plane of the relief into the space of the viewer, who sees it from below, inverted, so that the torso of the male figure dominates, presenting itself like *The Prodigal Son* (CATALOGUE NO. 20). The female figure is seen from the back, her hands clutching her head in anguish. Looking up, her nearly expressionless face is barely visible to the viewer of the *Gates*. The forklike silhouette of the couple adds to the explosiveness of their flight.

As an independent sculpture *Fugit Amor* is, by contrast, composed in a primarily lateral sense. The streamlined figures sweep, floating and ascending, through space. Now the form seems to be an undulating sequence of interlocking wishbones of arms and legs stretched apart by the elongated torso of the male figure. The fluid shapes of art nouveau are not far from this.

There are variants of *Fugit Amor* in plaster, bronze, and marble, of which four examples are said to exist.[4] Two of these are in the Musée Rodin: the earlier shows the figures almost fully carved away from the base, while in the later version the couple is barely disengaged from the rock.[5] A plaster also in the Musée Rodin conforms closely to the earlier marble.[6] Bronzes were no doubt cast from it.[7] The base of the present model is closer to the cloud of bronze that supports the example in the Musée d'Orsay, although the squared socle of that early bronze has been replaced by a more abstract form shaped like an inverted anvil.[8]

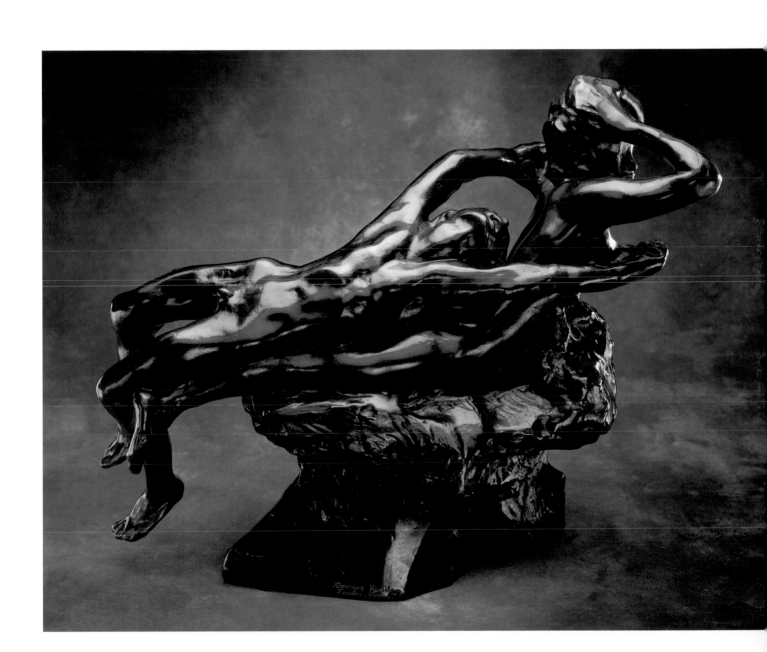

Auguste Rodin

FRANCE, 1840–1917

The Prodigal Son

CATALOGUE NO. 20

c. 1884, as an independent sculpture, 1894–99

Musée Rodin cast 8/12, 1967

Bronze

55 x 28 x 42½ in.

(139.7 x 71.1 x 108 cm)

Inscribed on base, front:

A. Rodin; right, at lower edge:

© musée Rodin 1966

Foundry mark on back:

.Georges RUDIER./.Fondeur.PARIS.

Gift of B. Gerald Cantor Art Foundation

M.73.108.7

The broad variance in the dating of this sculpture reflects Rodin's habitual reinterpretation of individual models and their use in different contexts. This bronze ephebe originated as a study for *The Gates of Hell*, occurring there twice in combination with a female figure in the composition that came to be better known as a freestanding sculpture, *Fugit Amor* (CATALOGUE NO. 19).[1] Because *Fugit Amor* is said to date from as early as 1881, the possibility that the model for the present bronze may have been developed as early as that year (or, indeed, earlier if Rodin had worked on the individual members of the pair before combining them) cannot be excluded.

Isolated, in a small scale, and posed vertically, the same figure was shown in 1894 as *Child of the Century* (or *Child of the Times* [*L'Enfant du siècle*]) at the salon sponsored by the magazine *La Plume*.[2] Exhibited again in *La Plume*'s salon the next year, it bore the title *L'Enfant prodigue* (The Prodigal Son).[3] It came to be known primarily by that name, although it took on still others, among them *La Prière* (The prayer). Rilke wrote that it outgrew that title too,[4] testifying to its expressiveness. It is a quintessential example of Rodin's invention of completely convincing, yet thoroughly unnatural anatomies that had unlimited emotive power, allowing a number of titles to be applied to them successfully.

The parable of the Prodigal Son (Luke 15:11–32) relates how the younger of two sons was given half his father's wealth, squandered it, found himself impoverished and degraded, and returning to his father's house, was welcomed back. Although the moment at which the Prodigal Son realized his debasement is laconically related in the parable, it is the turning point of the narrative. Rodin characteristically applied this darkest moment of the story to his sculpture.

The large-scale version of *The Prodigal Son* came into existence carved in limestone by 1899, when it was discussed by Léon Maillard.[5] Maillard's comments suggest that until then it had not been seen publicly and that Rodin was still thinking of modifying it. This may have resulted in an alteration in the form of the rocky base of the sculpture. As illustrated in Maillard's book, the base had yet not been sheared off at the lower left side, as it is today. The limestone sculpture was purchased by Carl Jacobsen in 1907,[6] and before sending it to Denmark, Rodin took a mold from it, which could be used for casting bronzes.

Thus *The Prodigal Son* shows not only Rodin's manipulation of subject and context but also the give-and-take in his choice of different materials for the same composition. The figure was destined at the outset for the bronze *Gates of Hell*, where it has all the fluidity and élan of a modeled sculpture

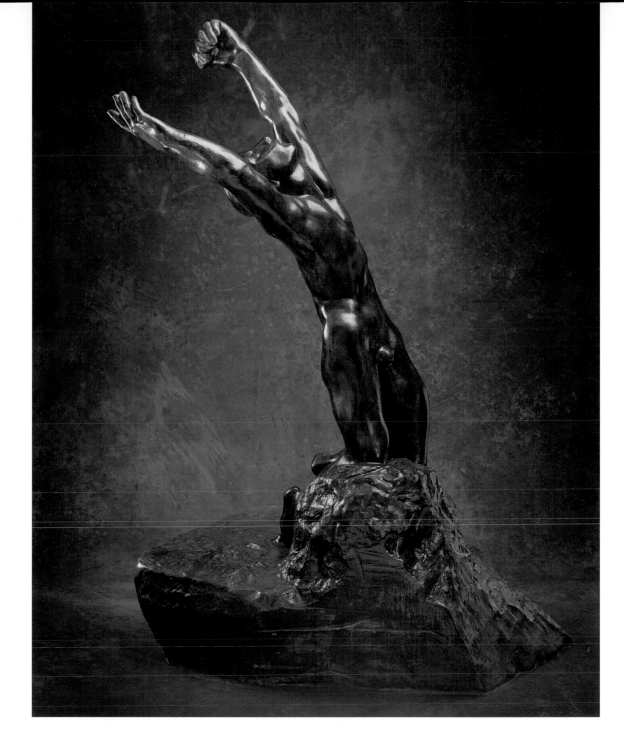

floating out from the relief. In limestone it was given a rocky base and struts of stone to support it from the back. These were not needed in the final stage, but their traces can still be seen on the present bronze.[7] The cycle was completed when the carving was cast back into bronze, returning the necessary tensile strength of metal to the figure, which stretches into the void.

Although the modern eye may be troubled by this kind of indifference to the appropriate physical properties of the media of sculpture, such practice was customary in the nineteenth century. Rodin modeled in pliant materials, cast bronzes from marbles, and carved plasters to make them look as though they were made of marble. There is reason to believe that Rodin late in his life contemplated this issue. In Florence in 1916 he saw a monument made up of bronze casts of Michelangelo's *David* and *Times of Day*. He deplored their reproduction in bronze because they were, he said, "'made for marble, [so] their technique was not that required by metal.'"[8]

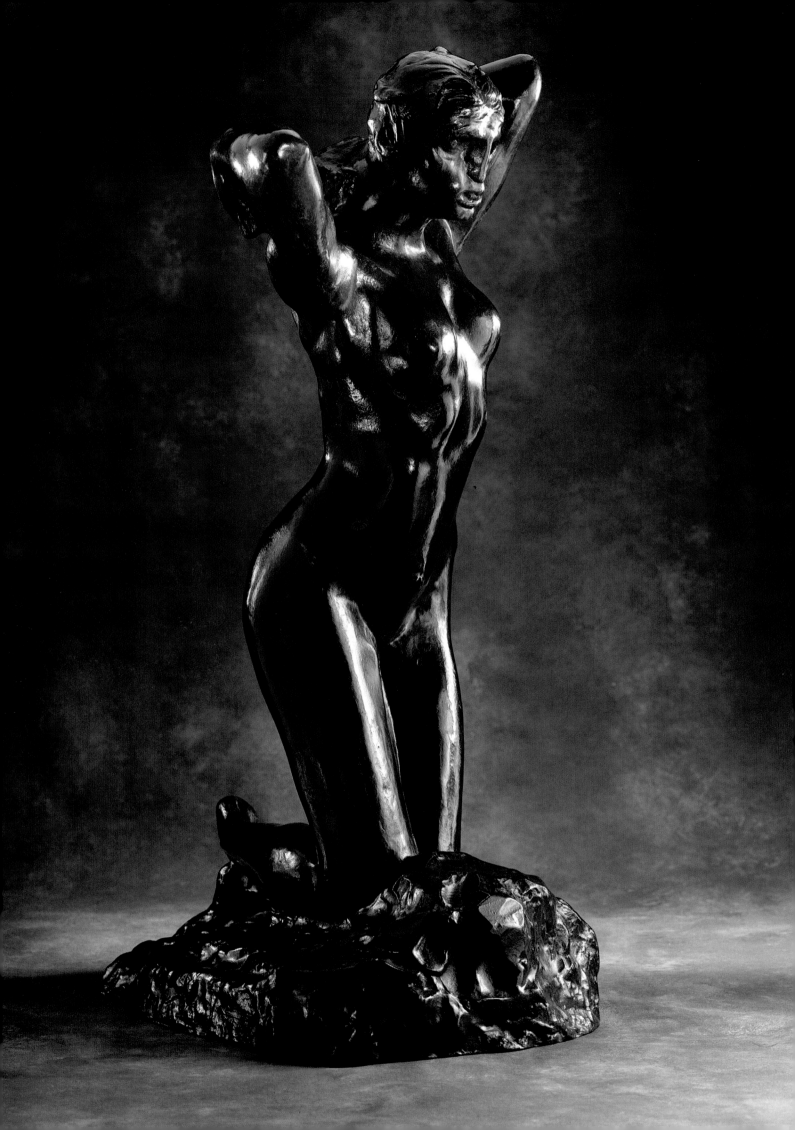

There are two female fauns in *The Gates of Hell*: *The Kneeling Female Faun* (*La Faunesse à genoux*) on the left side of the lintel, and *The Standing Female Faun* (*La Faunesse debout*) on the right. Although the only traits that identify them as satyresses are their pointed ears, they seem to have always been called female fauns.[1] In classical mythology these half-human demons of the forest, which strictly speaking were supposed to be male, had goat's legs and tails and voracious sexual appetites and thus represented the animal side of unmeditated lust, as they do in *The Gates of Hell*. Rodin seems not to have included sculptures of male fauns in the *Gates*, although he did produce independent marble sculptures of satyrs and satyresses (Musée Rodin);[2] perhaps this omission from the *Gates* can be interpreted as his reflection on the primary source of carnal pleasure as female.

A related plaster called *The Toilet of Venus* (*La Toilette de Vénus*), or *Siren I* (*Sirène I*),[3] is a more curvilinear composition than that of *The Kneeling Female Faun*. Although the reference to a classical goddess evokes a somewhat loftier concept of the erotic, the siren's bifurcated tail nevertheless suggests that this sculpture was imbued with as much symbolism of animalistic passion as *The Kneeling Female Faun*. Rodin modeled in addition to these a third example of a half-human female creature, the *Female Centaur* (*Centauresse*), whose imploring gesture strikes a deeper chord of pathos than is communicated by the others discussed here.

In 1888, at the request of Paul Gallimard, Rodin illustrated one copy of Baudelaire's *Les Fleurs du mal*.[4] For this a variant of the present bronze,[5] sketched as though in a small grotto, accompanied the poem *"Le Guignon"* (Bad luck). Its verses express the overwhelming sadness of isolation. Perhaps this could be brought to bear on Rodin's idea of the meaning of his sculpture, which was, however, modeled before Rodin did the Gallimard illustrations. The straightness of the poses of the female fauns tends to isolate them both from the throng that populates the lintel of the *Gates*.

The flattened facial features of *The Kneeling Female Faun* may allude to a blunting of the intellectual force customarily represented by the head, but this treatment also gives the figure a kind of noble impassivity. The face is boldly structured with high cheekbones and slanting eyes,[6] almost foreshadowing the exotic profile Rodin modeled of Nijinsky. With her hands clenched in a gesture of contained despair and her body energetic and erect, *The Kneeling Female Faun* seems to confront her state in *The Gates of Hell* without fully comprehending it.

Auguste Rodin

FRANCE, 1840–1917

The Kneeling Female Faun

CATALOGUE NO. 21

c. 1884–86
Musée Rodin cast 11/12, 1966
Bronze
21¹/₄ x 8¹/₄ x 11¹/₄ in.
(54 x 21 x 28.6 cm)
Inscribed on base, top, right:
A. Rodin; at lower edge:
© by musée Rodin 1966
Foundry mark on back:
.Georges Rudier./.Fondeur Paris.
Gift of B. Gerald Cantor Art
Foundation
M.73.108.9

Auguste Rodin

FRANCE, 1840–1917

Paolo and Francesca

CATALOGUE NO. 22

c. 1887–89
Musée Rodin cast 1/12, 1972
Bronze
11¾ x 25 x 12 in.
(29.8 x 63.5 x 30.5 cm)
Inscribed on base, back: A. Rodin;
right, at lower edge: © by musée
Rodin 1972
Foundry mark below Francesca's
feet: .Georges Rudier./
.Fondeur. Paris.
Gift of B. Gerald Cantor Art
Foundation
M.73.108.19

In contrast to the detailed histories of the various titles of *Fugit Amor* and *The Prodigal Son* (CATALOGUE NOS. 19–20), the name of the couple in the present bronze is barely documented. Since 1922, when Léonce Bénédite surely referred to it,[1] and since 1927, when Grappe catalogued two related plasters in the Musée Rodin, this sculpture has been known consistently as *Paolo and Francesca*.[2] If this is the primary title intended by Rodin for this sculpture, it would be one of two specific references to characters in Dante's *Inferno* incorporated by Rodin in the last model of *The Gates of Hell*. The other was *Ugolino and His Sons*, which, Grappe noted, was first exhibited at the same time as *Paolo and Francesca*;[3] the face of one of Ugolino's sons was a variant of Paolo's. In the *Gates*, *Ugolino* is also proximate to *Paolo and Francesca*, positioned directly beneath it near the bottom of the left panel.

Paolo Malatesta was the tutor of Francesca da Rimini, the fiancée of Paolo's brother, whom they betrayed in love. In Dante's narrative they were bound together to try forever without succeeding to repeat the single kiss of their downfall: those who could not stay apart were never to part again. In Hell they knew no rest. They were condemned to the second level of the underworld, where they were swept about eternally in a windy miasma. Rodin had already treated their story in one of his most famous compositions, *The Kiss* (*Le Baiser*); although he had intended it to represent the lovers in an early stage of the *Gates*,[4] he developed it instead as an independent sculpture.

The present bronze shows how adroitly Rodin united two pre-existing figures to create a new composition. It is difficult to believe that they were, in fact, ever separate, but there is an obvious seam between their bodies. Rodin himself attested to the fact that he had modeled them separately.[5] Now they are not only a couple but also a single shape, an arc in space; in the *Gates* this form doubles the reciprocal arc of *Ugolino and His Sons*. The uneven silhouette is a response to the irregular forms of the relief field of the *Gates*, with its protruding and receding levels, where figures are stirred in a seething flux in endless cycles of anguish and despair. The curving shape of *Paolo and Francesca* leads the eye on a path of continuous movement.

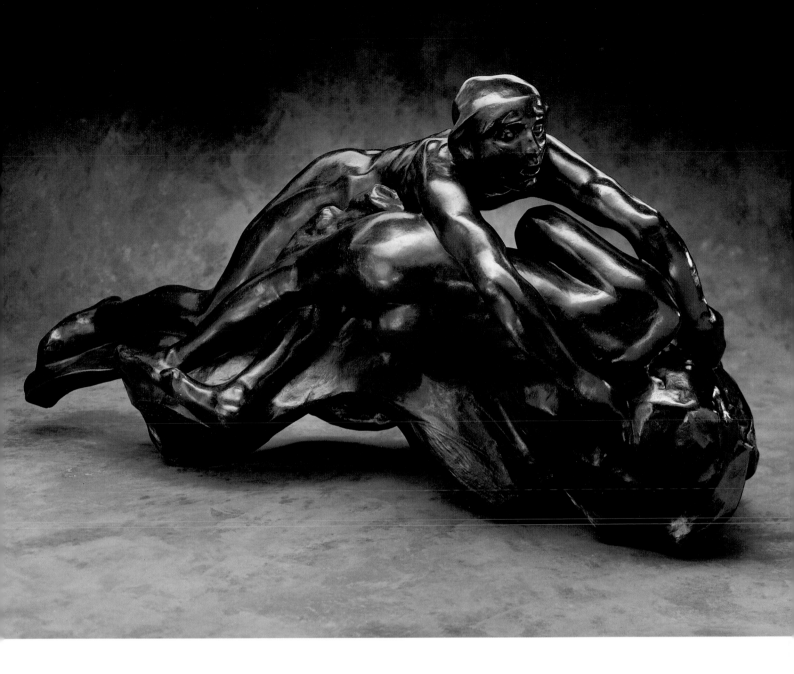

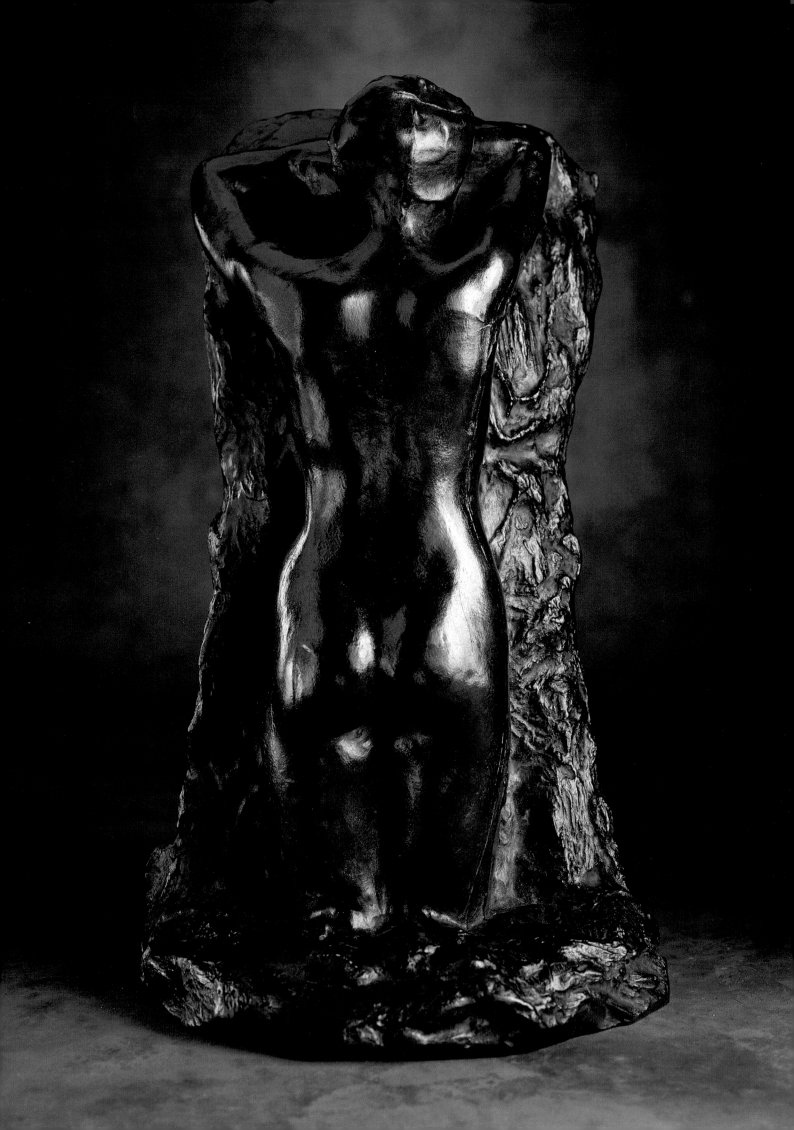

Although the torso of this figure in the *Gates* seems to stand free of the relief field, the torso of the present bronze is modeled in-one with its background support. *La Douleur* is in essence a very high relief, so it is therefore somewhat unusual in Rodin's oeuvre, which was dominated by freestanding figures. Despite the fact that *The Gates of Hell* is a relief sculpture, nearly all of it seems to have been worked up through a composition of what otherwise could have been (and often are) freestanding figures. Rodin's working process on the *Gates* is not completely understood, but it would seem that independently modeled figures were incorporated into the relief field as well as having been removed from it. Thus the *Gates* are not traditional pictorial relief sculptures modeled to present one unified mass; on the whole, only their frames were primarily treated this way.

The background of the present sculpture provides a complete context for the figure, isolating it from surrounding space. Because of this its mood is not unlike that communicated by Rodin's later sketch for Baudelaire's poem *"Le Guignon"* (see CATALOGUE NO. 21), illustrating a kneeling figure in a grotto. The reference to grief in the title of the present bronze probably alludes to quiet, lonely sorrow, not the physical pain that is also meant by the French *la douleur*.

Grappe suggested a date of 1892 for this composition,[1] but it may have been developed slightly earlier than that.

Auguste Rodin

FRANCE, 1840–1917

La Douleur

CATALOGUE NO. 23

c. 1889–92?
Musée Rodin cast IV/IV, 1983
Bronze
12 x 6 ½ x 5 ½ in.
(30.5 x 16.5 x 14 cm)
Inscribed on base, top, right:
A. RODIN; below this: N⁰ IV/IV;
back: LA PORTE DE L'ENFER
1977–1981/DON DE B. GERALD
CANTOR; at lower edge: © By Musée
Rodin 1983
Stamped on back, at lower edge:
Coubertin foundry mark: FC with
rising sun (in relief)
Promised gift of Iris and B. Gerald
Cantor in honor of the museum's
twenty-fifth anniversary
L.90.28.1

Auguste Rodin

FRANCE, 1840–1917

The Earth

CATALOGUE NO. 24

c. 1884–99?

Musée Rodin cast 2/12, 1967?

Bronze

18 1/8 x 43 x 15 in.

(46.0 x 109.2 x 38.1 cm)

Inscribed on base, below proper right shoulder: A. Rodin/Nº 2; below this, at lower edge: © by musée Rodin 1967[?]; inside base, below proper right leg: A. Rodin (in relief)

Foundry mark beneath proper left leg: .Georges Rudier.Fondeur.Paris.

Gift of B. Gerald Cantor Art Foundation

M.73.108.6

This composition is, according to Grappe, related to a plaster study for a single recumbent figure positioned on the edge of the inner molding of the top right-hand corner of the lintel of *The Gates of Hell*. Grappe discussed it in relation to a small plaster, *The Damned Woman Struck Down by Lightning* (*La Damnée foudroyée*), which was oriented with the face up.[1]

If *The Earth* (*La Terre*) was indeed derived from this small plaster, it could only have been by means of a mighty exaggeration that created the heaving arc of the upper back, a radical change of position in the arms, which were then broken off, and the near-suppression of the head. It would be expected that by those amputations the artist could allude to the absent limbs, because a loss cannot take place without a preexisting presence, but this composition is self-contained and bluntly complete. An inventive twisting of the body reminiscent of that used to fill *The Thinker* with energy gives *The Earth* a subtle torsion.

The date of origin of the sculpture is not certain. It was reported that the original composition was seen by one of Rodin's assistants in his studio in 1884. The enlargement (i.e., the size corresponding to the present example) was exhibited in 1900,[2] although it may well be identical to the sculpture exhibited in Geneva in 1896 as *La Terre*.[3]

What of a human figure is shown here seems to be in the process of rising from a mass of unformed material below it, which tends to echo in a very abstract way the nascent human shape that has been coarsely modeled above it. The rising ridge of the shoulders takes on the curve of a landscape and calls to mind the human identities given in reveries to the hills and mountains whose rolling forms along the horizon evoke the contours of recumbent bodies. Who can say whether this sculpture represents the form of the earth herself, the genesis of life from her matter,[4] or the acts of creation and procreation?[5] Even Rodin, late in life, once did not recognize this figure as his own.[6]

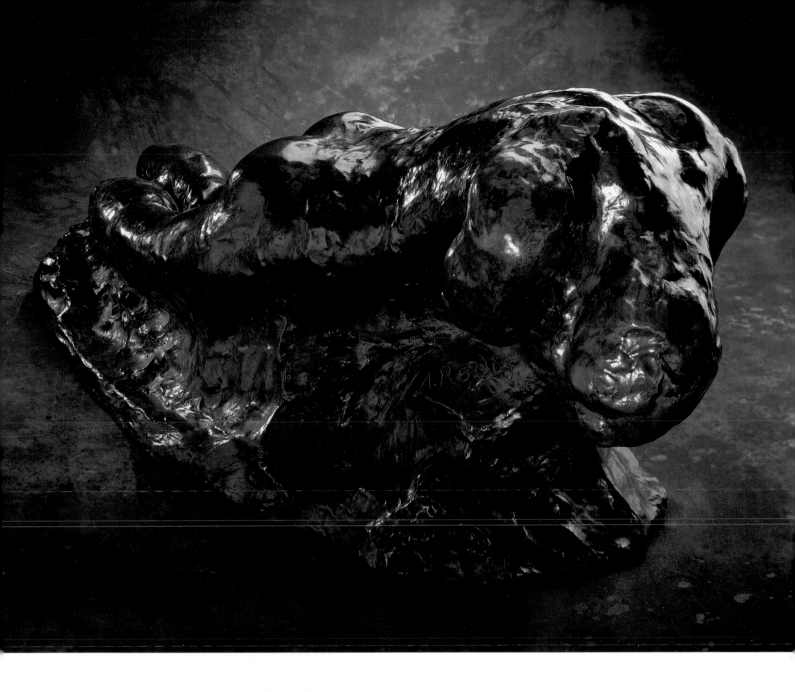

The Burghers of Calais

HE SIX HEROES KNOWN COLLECTIVELY AS THE
Burghers of Calais were leading citizens of that city, strategically located on the coast of
northern France, where the English king Edward III (1312–77) hoped to establish a beachhead
in his claim on French soil, which he justified through the pretext of the dynastic right of his
Flemish queen, Philippa (c. 1314–69). In 1347 the English army laid siege to Calais. The
chronicle of Jehan Froissart (c. 1333–c. 1410), Philippa's secretary from 1361 to 1366,
constituted the primary source for the history of this episode of the Hundred Years' War.
Relying on an earlier account, Froissart related that Edward agreed to lift the siege if six of the
most prominent citizens of Calais surrendered themselves to him. The six burghers were to
emerge from the starving city dressed only in sackcloth, barefooted, and with ropes about their
necks. They were to deliver the keys of the city to the king of England. By giving themselves
up, possibly to meet their deaths, they saved the people of Calais from starvation. They were
not, however, executed. Through the intervention of the devout and magnanimous Queen
Philippa, they were saved from martyrdom. The English held Calais for more than two
hundred years.

Although the story of the Burghers of Calais retained a certain importance in eighteenth-
century France, there seems to have been a lapse of interest in it for several decades until it

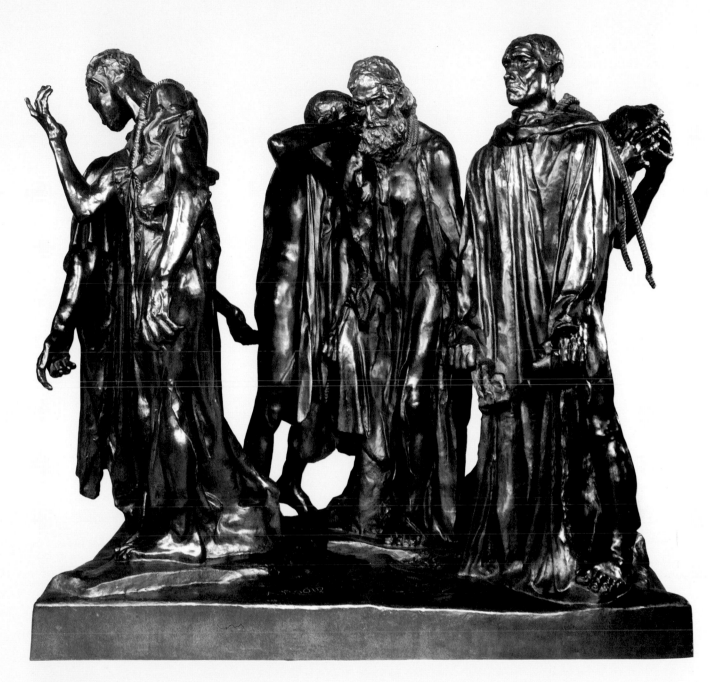

Auguste Rodin
France, 1840–1917
The Burghers of Calais, 1884–88
Musée Rodin cast (Coubertin), 1985
Bronze
82½ x 94 x 75 in. (209.6 x 238.8 x 191 cm)
The Metropolitan Museum of Art, gift of
Iris and B. Gerald Cantor, 1989
1989.407

reemerged in 1840 as the object of a historiographical study that argued convincingly (against a revisionist theory) for the validity of Froissart's account and the legendary heroism of the burghers. In 1845 a committee from Calais proposed commissioning Pierre-Jean David d'Angers to design a monument to Eustache de Saint-Pierre, the first burgher to volunteer to surrender to the English. The project, interrupted by political instability in 1848, 1850–51, and 1870, was never carried out.

In 1884 the idea of a monument was revived, apparently because of the support of the mayor of Calais, Omer Dewavrin. Current consensus attributes the renewed motivation for the commission to the impending merger of the venerable city of Calais with the new industrial district of Saint-Pierre, which had grown up outside the older city's historic walls. These were to be destroyed. The monument would thus preserve and honor the municipal and political identity of Calais.

Dewavrin met Rodin late that year, and Rodin proceeded rapidly to model his first maquette for the commission. The burghers were shown closely grouped in a mass, rushing forward heroically, elevated on a high pedestal. In the second maquette (1885) the burghers were treated separately. The precise arrangement of the individual figures is not known, but criticism leveled against this maquette when Rodin exhibited it in Calais suggests that the figures were set on a uniform level, rather than grouped in the pyramidal form that was preferred in academic monuments. He had apparently also experimented with a linear arrangement, so that the figures formed a *tableau vivant* that directly represented the burghers filing out of the city.

In 1887 at the Galerie Georges Petit in Paris Rodin exhibited the full-scale figures of Jean d'Aire (CATALOGUE NO. 26), Eustache de Saint-Pierre, and Pierre de Wissant as well as the head of Pierre de Wissant. It is thought that *Jean de Fiennes* (CATALOGUE NO. 30) was ready in 1887 also; Rodin wrote then that the three remaining figures of the group were well advanced. The definitive model, on a pedestal reduced to a flat platform, was shown at the Monet-Rodin exhibition in 1889. The bronze was erected in 1895 in Calais on a conventionally raised pedestal that was the opposite of what Rodin wanted. Years after his death the monument was finally installed on the low platform he had intended.

From the outset Rodin foresaw either a very high pedestal or none at all so that the viewers of the sculpture would feel at one physically and atmospherically with his burghers. Although his idea of omitting a pedestal altogether has been hailed as one of the great steps toward the "modern" presentation of sculpture, Rodin had referred to medieval entombment groups as his inspiration. These life-size figures were set directly on the ground, unifying the experience of the viewer with the placement of the figures.

The proportions used by Rodin for the burghers emphasize a sense of venerable age in this monument dedicated to fourteenth-century heroes, but their proportions are not those of figures in fourteenth-century sculpture. They are instead closer to the abrupt realism of ancient Roman sculpture and have been compared with Donatello's unidealized prophets for the campanile of the cathedral of Florence. The burghers have huge feet and large hands, and their heads are boldly scaled in relation to their bodies. Rodin's commitment to naturalism was affirmed at the most fundamental level, as he developed his figures from nude models (1885), which were then draped in canvas saturated with wet plaster.

Rodin worked with the neutral clothing best suited to the universal themes he explored. The deep channeling in the drapery produces deep shadows in the troughs of bronze, creating a stark contrast with the long, vertical folds that seize the light. These verticals in turn contribute to a medievalizing flavor in the composition. Indeed, Rodin greatly admired the expressive play of light and dark in medieval churches produced by the projections of ribs and mullions against the walls and vast windows.

Rodin experimented repeatedly with different models of hands and heads, developed separately from the bodies, until he arrived at the certain archetypes that expressed the varying psychological states of men as they confronted what they believed would be a fatal end. The emotional conflicts that arose in each of them, after they made their initial, idealistic decisions of self-sacrifice, were communicated by facial expression, attitude of body, and form of hands. Rodin repeated some of the hands, and he reworked one of the heads, that of Jean d'Aire, for use in two or three other burghers. (This may reflect the medieval narrative, which identifies three of the burghers as relatives. The names conventionally assigned to the six burghers, following Grappe's designations, do not conform with the medieval account.) Nevertheless, in spite of such repetition, the individuals' reckoning before acknowledgment of heroic ideals and their shame, despair, or regret is effectively conveyed. Even on a small scale, in the reductions of the separate figures that were cast following the inauguration of the monument in Calais, the emotional impact of the individual figures is undiminished.

The relative speed with which Rodin carried out this commission, despite other commitments, disagreement with the sponsors, and a financial problem that delayed casting in bronze, attests not only to the power the subject held for him but also to the determination with which he must have envisioned the monument virtually from its inception, in contrast to his constant experimentation on *The Gates of Hell. The Burghers of Calais* is a consummate exercise in the invention of a heroic monument by a mature artist fully in command of his powers.

Principal sources for this essay are Claudie Judrin, Monique Laurent, and Dominique Viéville, *Auguste Rodin: Le Monument des Bourgeois de Calais (1884–1895)*, exh. cat. (Paris: Musée Rodin; Calais: Musée des Beaux-Arts, 1977); Mary Jo McNamara, "Rodin's 'Burghers of Calais,'" Ph.D. diss., Stanford University, 1983; Mary Jo McNamara and Albert Elsen, *Rodin's Burghers of Calais* (New York: Cantor Fitzgerald Group, 1977). Supplementary summaries can be found in Maison et al., cat. no. 162; and Beausire, pp. 168–72.

The identification of the burghers used here follows Georges Grappe's identifications, but as noted, Grappe's nomenclature seems not to conform completely with the content of the narrative. In addition to the monument in Calais, other casts are in the Kunst-haus, Basel; the park of Mariemont near Brussels; the Ny Carlsberg Glyptotek, Copenhagen; in front of the Houses of Parliament in London; the Musée Rodin in Paris; the Norton Simon Museum, Pasadena; the Rodin Museum, Philadelphia; the National Museum of Western Art, Tokyo; and the Hirshhorn Museum and Sculpture Garden, Washington, D.C. The only example cast by the lost-wax process was commissioned and given by B. Gerald Cantor to the Metropolitan Museum of Art, New York.

Auguste Rodin

FRANCE, 1840–1917

Nude Study for Jean d'Aire

CATALOGUE NO. 25

c. 1884–86

Musée Rodin cast 2/12, 1972

Bronze

40¹/₂ x 13³/₄ x 13¹/₄ in.

(102.9 x 34.9 x 33.7 cm)

Inscribed on base, top:

A. Rodin/Nᵒ 2; right: © by musée

Rodin 1972

Foundry mark on back:

.Georges Rudier./.Fondeur.Paris.

Gift of B. Gerald Cantor Art

Foundation

M.73.110.3

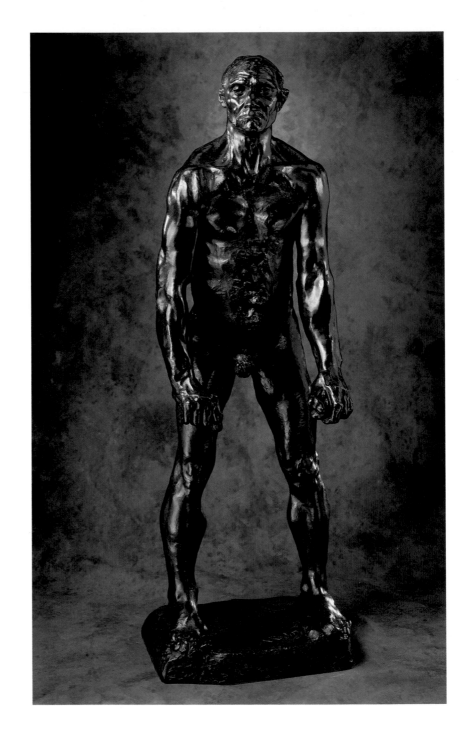

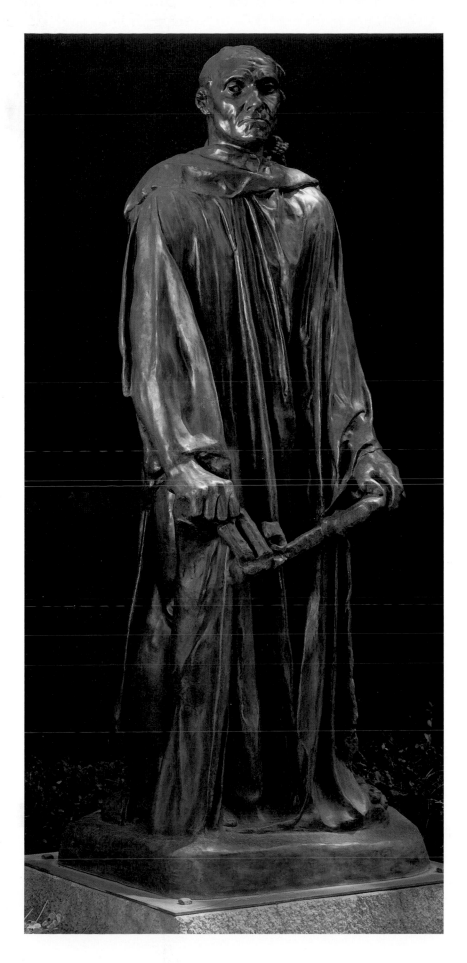

Auguste Rodin

FRANCE, 1840–1917

Jean d'Aire

CATALOGUE NO. 26

c. 1886
Musée Rodin cast 6/12, 1972
Bronze
85 x 33¹/₂ x 28¹/₂ in.
(215.9 x 85.1 x 72.4 cm)
Inscribed on base, right:
A. Rodin/Nº 6; left: COPYRIGHT BY
MUSEE RODIN 1972
Foundry mark on back:
SUSSE FONDEUR.PARIS
Gift of B. Gerald Cantor
M.82.209.2

Auguste Rodin

FRANCE, 1840–1917

Jean d'Aire

CATALOGUE NO. 27

First modeled c. 1886,
reduced c. 1895
Musée Rodin cast, 1959
Bronze
18 ½ x 6 ½ x 5 ¾ in.
(47.0 x 16.5 x 14.6 cm)
Inscribed on base, back, top:
A. Rodin; inside base, back:
A. Rodin (in relief); on base, back,
right: © by musée Rodin 1959
Foundry mark on back,
at lower edge: .Georges Rudier./
.Fondeur.Paris.
Gift of B. Gerald Cantor Art
Foundation
M.73.110.4

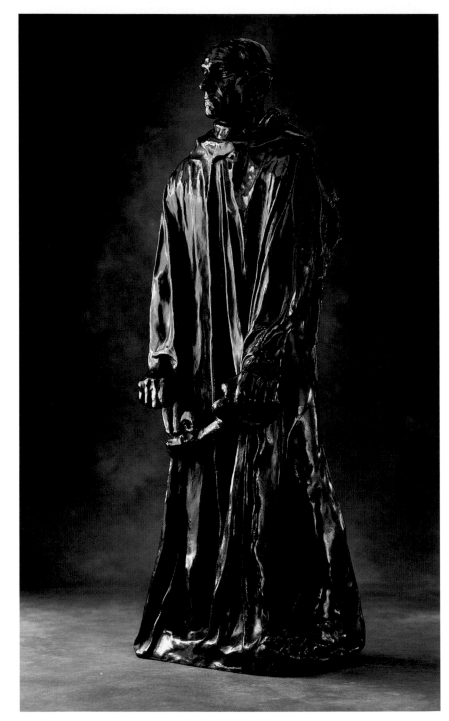

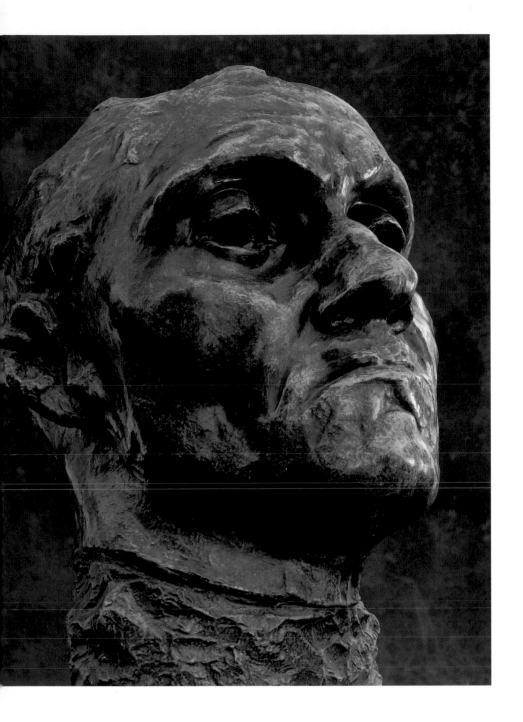

Auguste Rodin

FRANCE, 1840–1917

Monumental Head of Jean d'Aire

CATALOGUE NO. 28

c. 1884–86, enlarged 1909–10

Musée Rodin cast 2/12, 1971

Bronze

$26^{3}/_{4}$ x $19^{7}/8$ x $22^{1}/_{2}$ in.

(67.9 x 50.5 x 57.2 cm)

Inscribed on base, right: A. Rodin;

left, at lower edge: © by musée

Rodin 1971

Foundry mark on back, at lower

edge: .Georges Rudier./

.Fondeur.Paris.

Gift of B. Gerald Cantor Art

Foundation

M.73.110.2

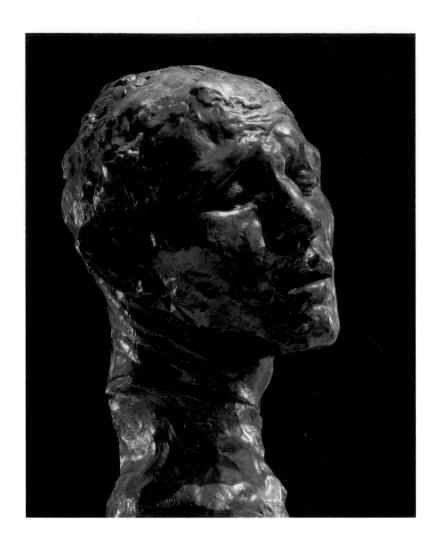

Auguste Rodin

FRANCE, 1840–1917

*Monumental Head of
Pierre de Wissant*

CATALOGUE NO. 29

First modeled c. 1884–85,
enlarged 1909
Musée Rodin cast 3/12, 1971
Bronze
32 x 19 x 20½ in.
(81.3 x 48.3 x 52.1 cm)
Inscribed on base, left: A. Rodin;
right: © BY MUSEE RODIN 1971
Foundry mark on back: Susse
Fondeur Paris
Gift of B. Gerald Cantor Art
Foundation
M.73.110.1

Auguste Rodin

FRANCE, 1840–1917

*Jean de Fiennes,
Draped*

CATALOGUE NO. 30

1885–86
Musée Rodin cast III/IV, 1987
Bronze
Inscribed on base, top: A.Rodin/
Nº III/IV; back: © By Musée Rodin
1987
Stamped on base, beside ©:
Coubertin foundry mark: FC with
rising sun (in relief)
82 x 48 x 38 in.
(208.3 x 121.9 x 96.5 cm)
Gift of Iris and B. Gerald Cantor in
honor of the museum's twenty-fifth
anniversary
M.90.205

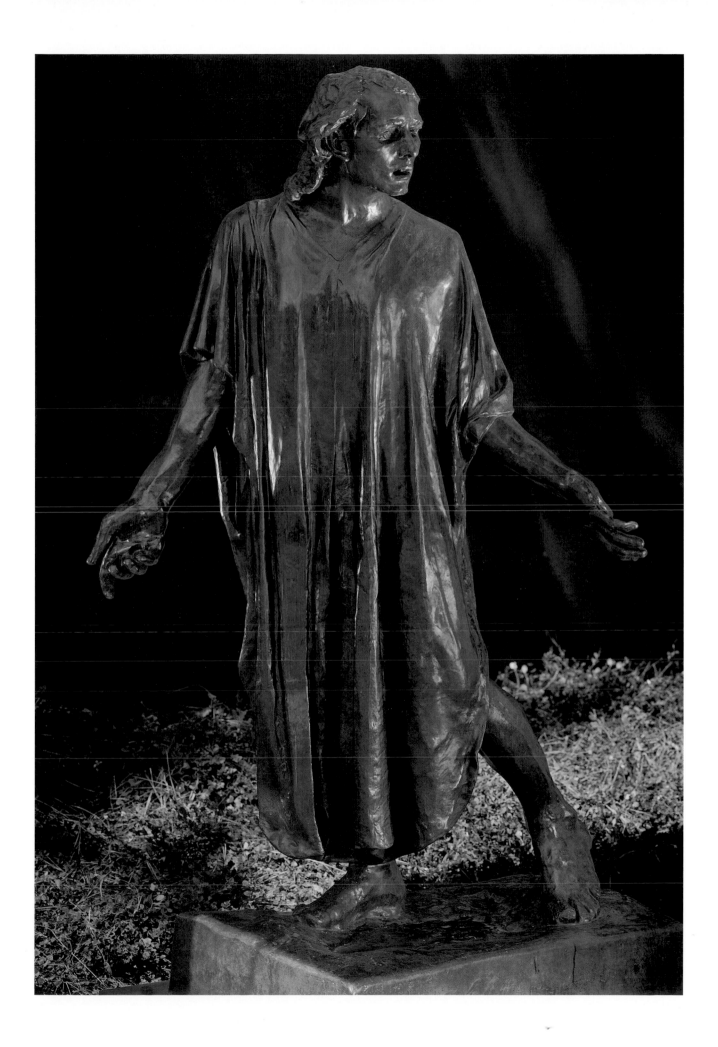

The Monument to Balzac

*I*N 1883 THE SOCIÉTÉ DES GENS DE LETTRES, A PARISIAN
literary union, decided to commission a monument to commemorate the titanic writer Honoré
de Balzac (1799–1850), who had been the society's second president, but not until 1888 did the
society launch its project in earnest. Although a virtual cult had grown up around Balzac
following his death,[1] various attempts to erect a monument to him came to nothing until his
native city, Tours, opened a subscription in 1885 to finance its own Balzac monument, which
was unveiled there in 1889. The project in Tours was apparently the impetus that even before its
fulfillment[2] moved the Société des Gens de Lettres at last to select a sculptor and proceed with
the realization of its monument in Paris. The commission was awarded to Henri Chapu
(1833–91), who died before completing his sculpture. (His terra-cotta sketch is preserved in the
Musée d'Orsay.) By then Émile Zola had become president of the society. Exerting his
influence, he had the commission assigned in 1891 to Rodin, the sculptor he preferred.

Unlike Rodin's monument to Victor Hugo, which portrayed a man Rodin had known
personally (see CATALOGUE NO. 42), the image Rodin would create of Balzac was posthumous.

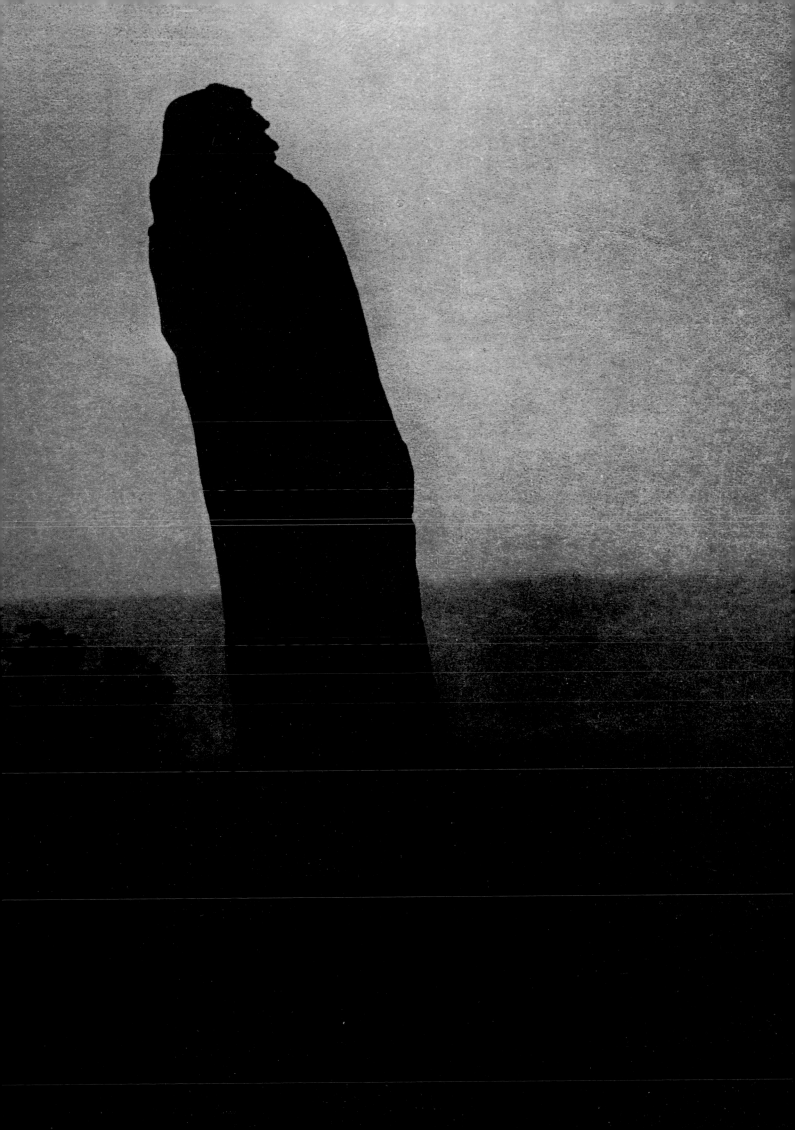

campaign of research for the portrait. He gathered photographs of Balzac, traveled the region around Tours to study the physiognomies of its inhabitants, and obtained measurements from Balzac's tailor in order to have a suit of clothes made up to help him visualize the shape of his subject.[3]

This research resulted in about fifty known sketches.[4] While their exact chronology is by no means clear, the evolution of Rodin's work on the monument seems to have fallen into two periods. During the earlier (from 1891 to about 1894–95) Rodin apparently worked on realistic studies of Balzac that were related to his research on Balzac's actual appearance. In the later period (from around 1894–95 to 1898) he seems to have reconceived his idea of the portrait as a profoundly subjective interpretation, so that the sculpture became more like an abstraction of Balzac. During the course of 1894 Rodin was working on two very different types of studies: one of a figure clothed in an identifiable costume of the 1830s and another, very abstract, of a "shapeless mass."[5] This suggests that Rodin experimented with divergent ideas at the same time.

The model for the first of the bronzes in the Los Angeles collection, *Balzac in a Frockcoat* (CATALOGUE NO. 31), was probably carried out in an early stage of development, although it could perhaps be one of the studies in progress in 1894. It presents a realistic image in a costume appropriate for a public monument. The warm expression of the face and the backward sway of the figure correspond with a characterization of Balzac given by Alphonse de Lamartine: "His legs on which he occasionally rocked a little, easily carried his body. . . . But [the] predominant characteristic [of his face] . . . was the goodness it communicated. . . . It was a loving kindness, aware of itself and others."[6]

The second bronze in the collection, *Balzac in a Dominican Robe* (*Balzac en robe de dominicain*, CATALOGUE NO. 32), is the result of Rodin's having reconsidered the choice of a public image of the writer in conventional day dress. Rodin now portrayed Balzac wrapped in a monk's habit, which he is known to have worn at home for writing at night.[7] (Newspaper accounts from early 1892 mention a maquette in a Dominican robe, but with the arms crossed.)[8] At the figure's proper right what appears to be a sheaf of papers is held at his side, and in place of a tree trunk customarily used as a motif in classic sculpture to support the figure, there is a block that is traced to resemble a stack of books or manuscripts. Great concentration has been focused on the bulky torso in contrast to the reduced substance and modeling around the legs, which are almost inconsequential. The face has been boldly

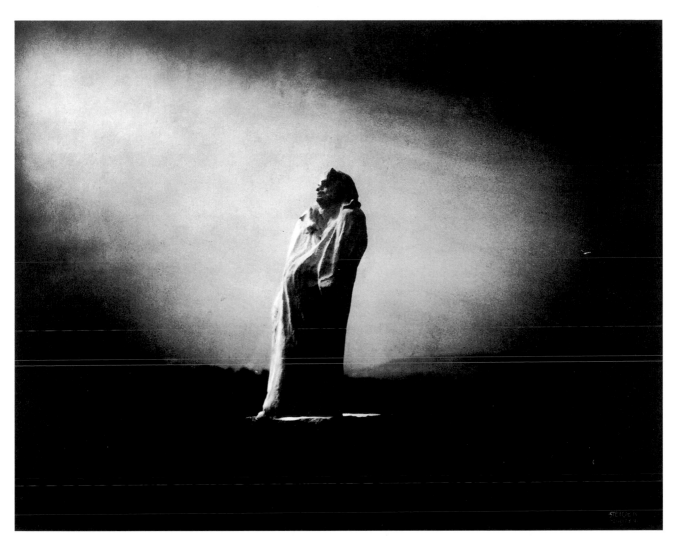

Edward Steichen
United States, 1879–1973
Balzac, Midnight, 1908; printed later
Gelatin silver print
11 x 14 in. (27.9 x 35.6 cm)
Gift of B. Gerald Cantor Foundation
M.87.74.4

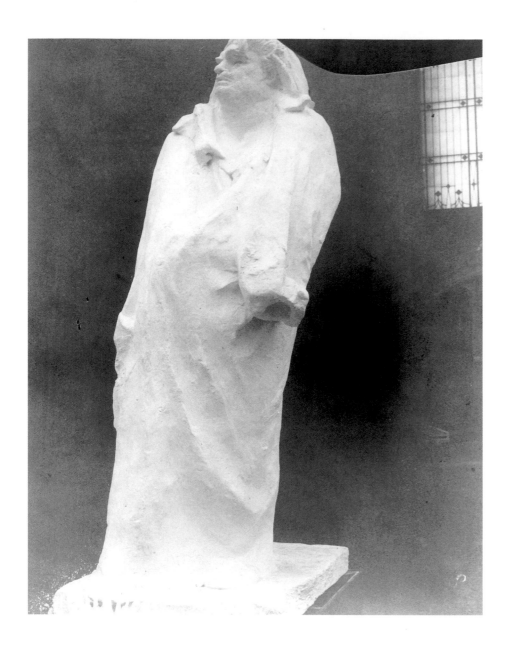

modeled with exaggerated shapes. While still faithful to a realistic representation of Balzac, this sculpture marks a shift to a more subjective interpretation of the portrait, because it alludes to the private intensity of Balzac's creative drive, and the handling of the features is more expressionistic. This bronze is a turning point in Rodin's development of the monument. From the relatively precise representation of contemporary clothing, which he would eventually eschew, Rodin turned toward a revolutionary form that was but a step away from a purely abstract, timeless symbol.[9]

In 1892 Rodin is known to have modeled a powerful nude of Balzac, "'in the attitude of a wrestler, seeming to defy the world,'"[10] and the third bronze in the collection, *Nude Study of Balzac (Étude pour le Balzac,* CATALOGUE NO. 33), likely is related to that description. In the nude study the arms are crossed as they are in the small *Balzac in a Frockcoat*. There is no reference in either to the activity of writing, just a direct confrontation with

the image of the man himself.[11] In the *Nude Study of Balzac* the legendary size of the subject makes an impact of inexorable massiveness. The spread of the legs that normally would contribute to the dynamism and action of a figure, as it does in *Saint John the Baptist Preaching* (CATALOGUE NO. 10) and *Jules Bastien-Lepage* (CATALOGUE NO. 37), is interrupted by the conical mass between the legs, weakening them. It is almost as if the concentration of the figure's torso returns to a state similar to that in the *Balzac in a Dominican Robe*, where the man's natural physical support is diminished. The importance given to the conical mass has not yet been entirely explained. Rodin may have included it to block out the light in the void between the legs that would have otherwise existed so that he could imagine the composition as it would be when draped;[12] there is a plaster sketch that shows the draped figure without the cone.[13] It is known that Rodin experimented with plaster casts of a maquette by draping them in various ways with lengths of canvas.[14]

Reports from 1896 and 1897 suggest that by then Rodin had created a model that satisfied him, although he needed additional time to retouch it; a contemporary description of it still mentions its "crossed arms," however.[15] Perhaps this is simply an imprecise description of the final plaster, in which it is the hands or wrists that are crossed and lower on the body than the term "crossed arms" implies. In either case it is interesting to remark that Rodin, who was a master in the sculpture of expressive hands, concealed them in the final study for his *Balzac*. In this way attention is concentrated on the head and its support. The plaster of the final version, corresponding to the fourth bronze in the collection, *Monument to Balzac* (*Balzac*, CATALOGUE NO. 34), was exhibited in 1898 in Paris at the salon held in the Galerie des Machines, where it provoked a storm of controversy that pitted absolute vilification against thunderstruck praise.

Instead of a portrait, here is a head like a distorted landscape, and instead of the personable character described by Lamartine, here is a symbol of the creator as monolith: superb in its height, drawn up and back, not in a familiar swaying liveliness but in a kind of ecstatic surge.

It was exhibited in Rodin's retrospectives at the Pavillon de l'Alma in Paris in 1900 and in Prague in 1902, but only in 1939 was Rodin's *Balzac* first cast in bronze.[16]

Auguste Rodin

FRANCE, 1840–1917

Balzac in a Frockcoat

CATALOGUE NO. 31

c. 1891–92
Musée Rodin cast 11/12, 1980
Bronze
23 1/2 x 8 x 10 1/4 in.
(59.7 x 20.3 x 26.0 cm)
Inscribed on base, left, front: A.
Rodin Nº 11; rear: © MUSÉE [sic]
Rodin 1980
Foundry mark on base, back:
E. GODARD/Fond.
Gift of B. Gerald Cantor Art
Foundation
M.86.171

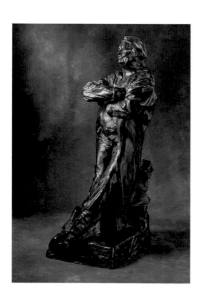

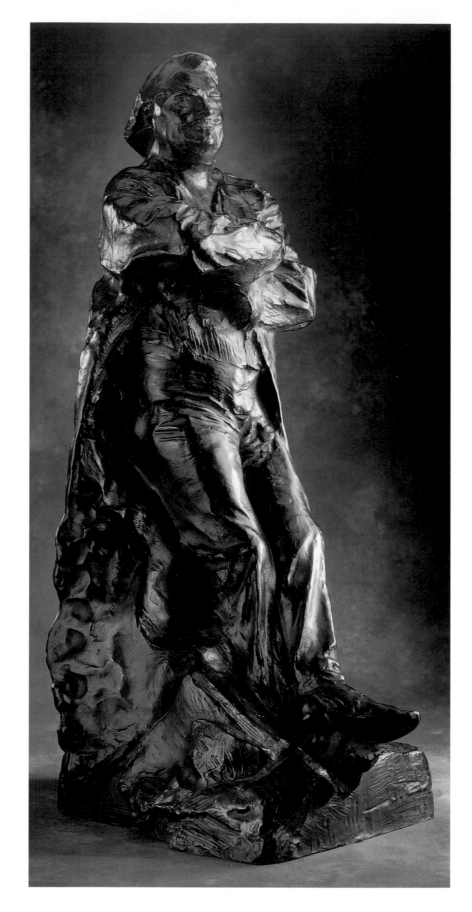

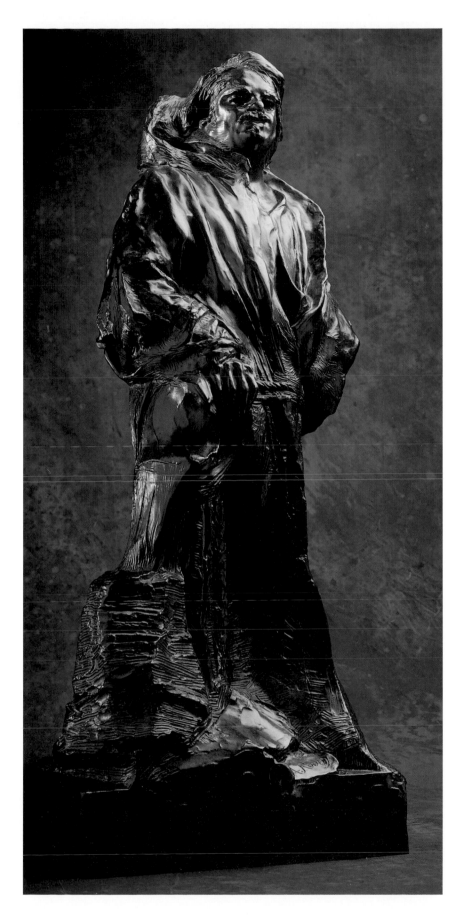

Auguste Rodin

FRANCE, 1840–1917

Balzac in a Dominican Robe

CATALOGUE NO. 32

Probably 1892
Musée Rodin cast 1/11, 1982
Bronze
41¾ x 17¾ x 14⅝ in.
(106.0 x 45.1 x 37.1 cm)
Inscribed on base, front: A. Rodin
1/11; right, at lower edge:
© by musée Rodin 1982
Foundry mark on back,
at lower edge: .Georges Rudier./
.Fondeur.Paris.
Gift of Iris and B. Gerald Cantor
Foundation in honor of
Earl A. Powell III
AC.1992.248.1

Auguste Rodin

FRANCE, 1840–1917

*Nude Study
of Balzac*

CATALOGUE NO. 33

Probably 1892
Musée Rodin cast 4/12, 1967
Bronze
50¹⁄₄ x 21¹⁄₂ x 23 in.
(127.6 x 54.6 x 58.4 cm)
Inscribed on base, top, right:
A. Rodin; at lower edge: © BY
Musée Rodin 1967
Foundry mark on back,
at lower edge: .Georges Rudier./
.Fondeur.Paris.
Gift of B. Gerald Cantor Art
Foundation
M.67.59

Auguste Rodin

FRANCE, 1840–1917

*Monument
to Balzac*

CATALOGUE NO. 34

c. 1897
Musée Rodin cast 9/12, 1967
Bronze
117 x 47¹/₄ x 47¹/₄ in.
(297.2 x 120.0 x 120.0 cm)
Inscribed on base, front: RODIN;
right: COPYRIGHT BY MUSÉE
RODIN 1967
Foundry mark on back: SUSSE
FONDEUR.PARIS
Gift of B. Gerald Cantor Art
Foundation
M.85.267

*Other Sculptures
by Rodin*

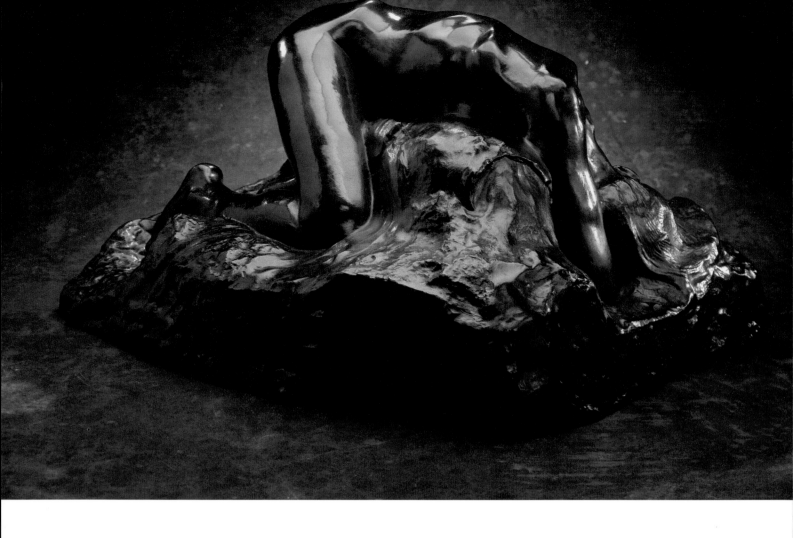

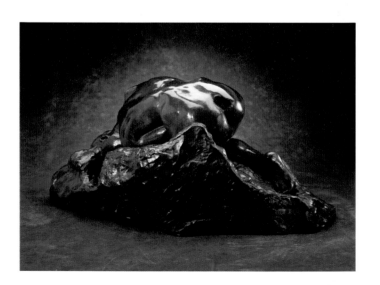

In Greek mythology the Danaïds were the fifty daughters of Danaos, king of Argos, who was in conflict with his brother Aegyptos, father of fifty sons. There are different versions of this legend, but the outcome of the story is the same in each. It seems that the sons went to Argos with an offer to marry their cousins as a conciliatory gesture toward the suspicious Danaos, who continued to resent his brother. Danaos ordered his daughters to murder their bridegrooms on their wedding night; all but one complied. The Danaïds were condemned to the underworld, where their unending penance was to fill pierced jugs with water or to draw it with sieves. This form of punishment may refer not only to the murders but also to the Danaïds' disregard for the sacramental pouring of water at marriage. Furthermore Argos was arid; water was brought there either by Danaos, who showed the inhabitants how to dig wells, or by one of his daughters, who with Poseidon's help had revealed a spring. Perhaps the memory of the water's preciousness made the Danaïds' punishment even more painful.[1]

It is not hard to imagine the tears wept in frustration by Rodin's Danaïd (*La Danaïde*) streaming away with the flood that leaks from her broken vessel, washing her hair, with its watery lines, down over the margin of the sculpture. She is so heavily weighted by her task and engulfed by despair that she is clearly incapable of escaping her fate. Her body, one of the sculptor's most beautifully styled anatomies, is bound painfully to the shape of the rock. The composition is among Rodin's finest achievements in the resolution of physiological distortion and material coherence.

It must have been recognized as such by his contemporaries. This would account for the several marble examples of it carved in his lifetime, in varying sizes.[2] (Of the bronzes in the collection of the Los Angeles County Museum of Art, this one reflects most closely the technique used to carve marble in Rodin's studio, so that the figure seems to emerge from a bank of fog.) Although in most examples of the *Danaïd* the figures closely resemble each other, there are more variations in the bases. Except for minor differences, the dimensions and form of the base of the present bronze are most closely related to those of the marbles in the Musée Rodin and in the Ateneumin Taidemuseo, Helsinki,[3] which Rodin discussed in a letter of 4 February 1889. He wrote that he would have his model enlarged in a marble version and use that for bronzes.[4] The smaller version may perhaps be reflected in a bronze that was cast by Gruet (B. Gerald Cantor collection).[5] Its base is distinctly different from that of the present sculpture, and the head and urn are much sketchier. Another bronze variant is in the Musée Rodin.[6] The original model used to cast the present bronze has not yet been securely identified.[7]

Rodin had once apparently intended to include his *Danaïd* in *The Gates of Hell*, but it exists only as an independent sculpture.

Auguste Rodin

FRANCE, 1840–1917

Danaïd

CATALOGUE NO. 35

1885–89
Musée Rodin cast 4/12, 1967
Bronze
12 3/4 x 28 1/4 x 22 1/2 in.
(32.4 x 71.8 x 57.2 cm)
Inscribed on base, right: A. Rodin;
at lower edge: © by musée Rodin
1967
Foundry mark on base, right,
at lower edge: .Georges Rudier./
.Fondeur.Paris.
Gift of B. Gerald Cantor Art
Foundation
M.73.108.15

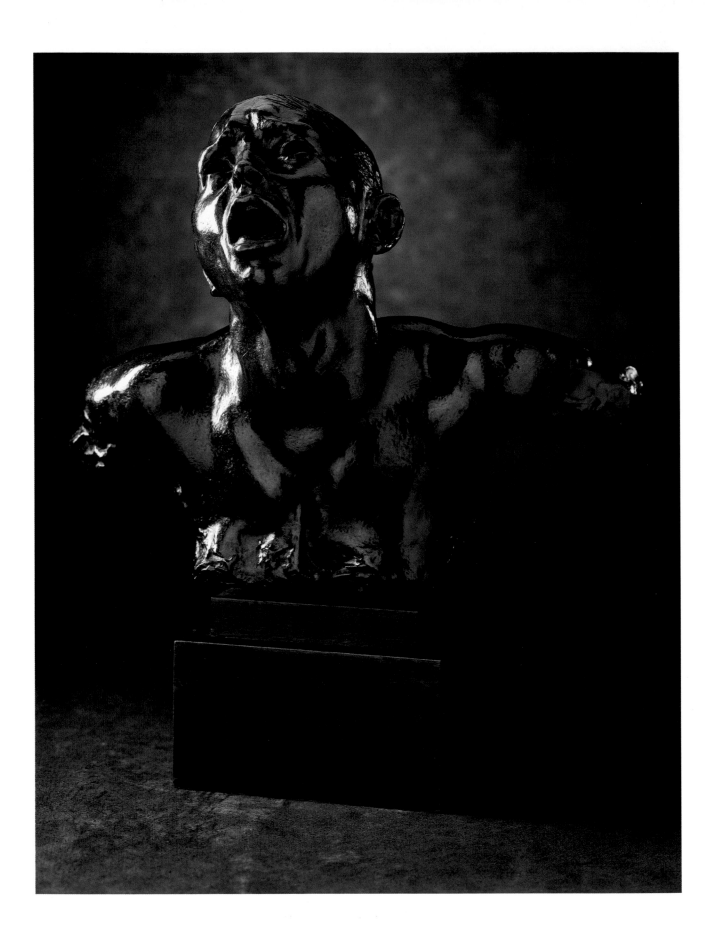

There is a close correspondence between this small bronze and another of Rodin's compositions, executed in marble, known primarily by the title *The Tempest* (*La Tempête*, FIGURE 6) and alternatively as *The Marathon Runner* (*Le Coureur de marathon*) or *The Terror* (*L'Épouvante*).[1] *The Cry* (*Le Cri*) can hardly be analyzed without the marbles. Although the block of marble in the Musée Rodin example is steeper and broader than the Metropolitan's,[2] both reveal the head and shoulders of the same woman, who bursts as though screaming from the stone. The contours of her emerging shoulders and chest correspond directly with the silhouette of *The Cry*, and the trace of a hairline on the forehead of *The Cry* compares with those of the marbles. There is a striking difference, however, in the eyes, which are hollow pits in the bronze but fully sculptured in the marble. Also the bronze is smaller.

It is difficult to determine with certainty which composition was worked out first. *The Tempest* may be a variation on *The Cry*,[3] or *The Cry* may have been treated as an extraction from the matrix of stone from which *The Tempest* was carved. *The Cry* differs from Rodin's other fragmentary sculptures because its silhouette recalls the conventional truncation of portrait busts. This lends it a sense of traditional completeness. Oriented as though in supplication and less horizontally than the same figures in marble, *The Cry* has a deeper pathos than *The Tempest*.

Although *The Cry* is usually said to have been modeled around 1898,[4] a date of 1886 has been proposed by Alain Beausire and Nicole Barbier[5] through its association with a marble described as a woman "screaming in terror" shown at the Galerie Georges Petit in 1886. This may have been one example of *The Tempest*.[6] The earlier date may also be supported by the resemblance of *The Cry* to the style of Camille Claudel. The tininess of this bronze and the delicate proportions of its features call to mind the small scale in which Claudel habitually worked. The similarity between *The Cry* and a small clay *Head of a Slave* (Paris, private collection) which bears her signature (on a strip of clay at the base of the neck)[7] might suggest an attribution to Claudel, whose liaison with Rodin resulted for a time in a commingling of their styles.[8] Was it a coincidence that their relationship was documented in 1886 in a curious contract,[9] Rodin promising not to take on any other students and eventually to marry Claudel, which he never did? Their definitive rupture occurred in 1898.[10]

FIGURE 6

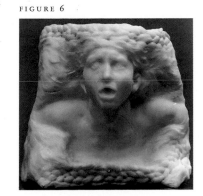

Auguste Rodin

FRANCE, 1840–1917

Jules Bastien-Lepage

CATALOGUE NO. 37

c. 1887
Musée Rodin cast 2/8, 1987
Bronze
71 x 36½ x 33½ in.
(180.3 x 92.7 x 85.1 cm)
Inscribed on base, top, right:
A. Rodin/Nº 2/8; back: © By
musée Rodin 1987
Stamped on base, beside ©:
Coubertin foundry mark: FC with
rising sun (in relief)
Gift of Iris and B. Gerald Cantor
Foundation in honor of the
museum's twenty-fifth anniversary
M.90.89

The painter Jules Bastien-Lepage died at age thirty-six in 1884. His career had begun slowly with little success at the salons, but he soon found his way with a straightforward treatment of portraits that showed Manet's influence. Turning to his home in the Meuse region of northeastern France for inspiration, he developed a style of landscape painting in which nostalgic sentiment softened a fastidious realism. He advocated a direct approach to landscape, painting out of doors. "I come from a village in Lorraine: so I will paint the farmers and landscapes of my home, as they are," he said.[1] Although Bastien-Lepage's name has fallen into obscurity, his monumental *Joan of Arc* (FIGURE 7), meticulously rendered, seen close in but suffused with the luminosity of open air, is today one of the most popular nineteenth-century paintings in this country.[2] When he died, a group of his friends decided to commission a monument to him. It was to be erected at the town of Damvillers, whose native son he was. In 1886 the commission was awarded to Rodin, who had met the young artist in Paris in 1880.[3] The monument was unveiled in 1889.[4]

FIGURE 7

Jules Bastien-Lepage
France, 1848–84
Joan of Arc, 1879
Oil on canvas
100 x 109⅞ in. (254 x 279 cm)
The Metropolitan Museum of Art,
gift of Erwin Davis, 1889
89.21.1

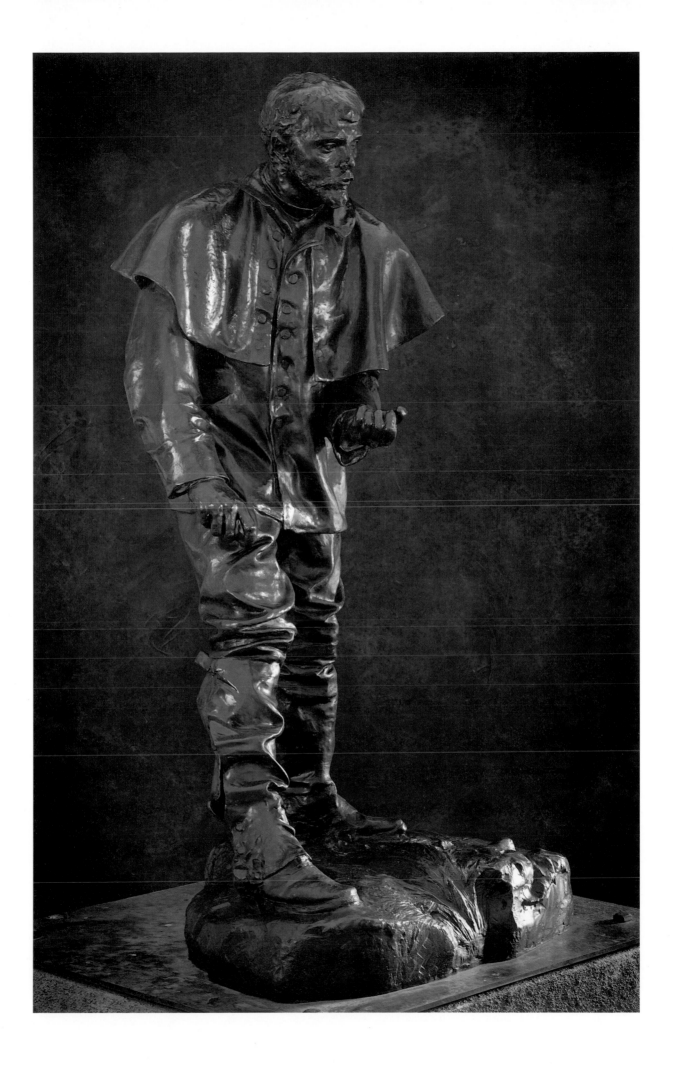

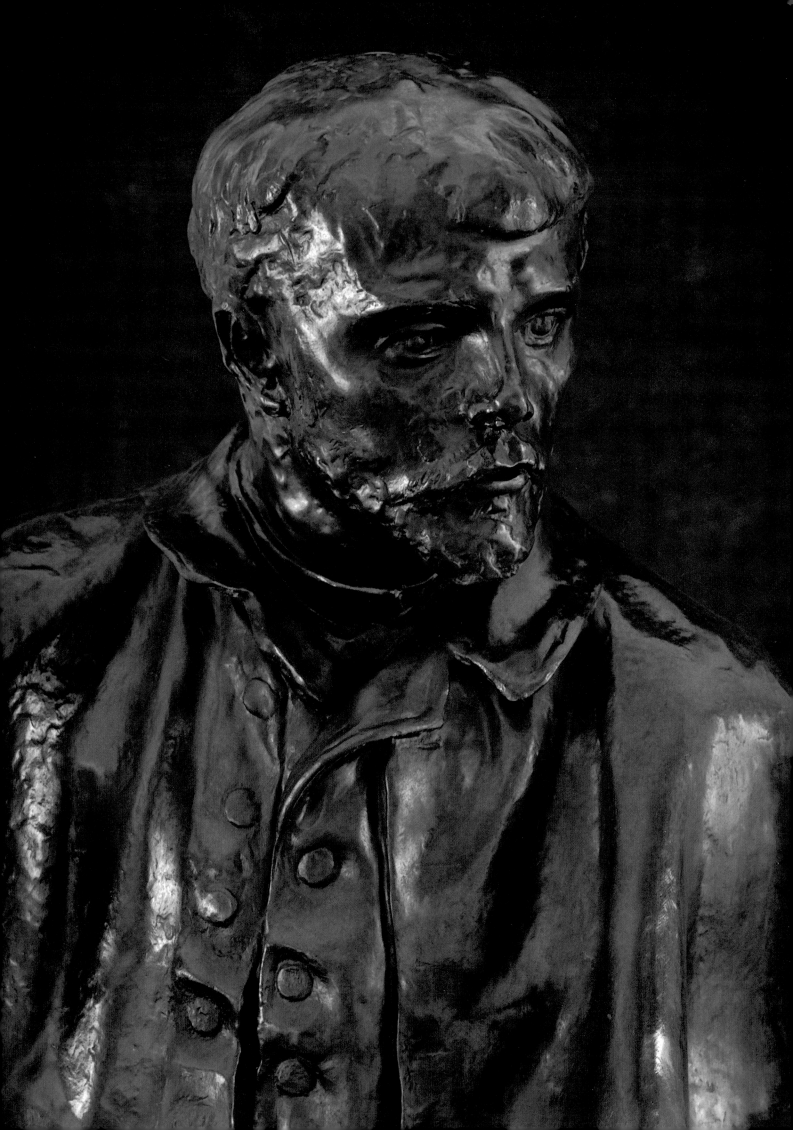

Up to the time of the *Bastien-Lepage* Rodin was primarily concerned with sculpture of the naked human form, so this statue might seem anomalous in his oeuvre. It is nevertheless very similar to Rodin's monument to Claude Lorrain (Nancy, Pépinière Gardens),[5] in which the painter is also shown in everyday costume. In both, the figure's clothing is appropriate for painting outdoors, whereas such specificity would be superfluous for the archetypal subjects that preoccupied Rodin. This, and perhaps the limitations imposed by the prosaic rendering of contemporary styles of clothing, also persuaded Rodin to avoid a too carefully described costume in the *Balzac* (CATALOGUE NOS. 31–34). Certainly the evolution of the *Bastien-Lepage* had nothing of the complexity of the *Balzac*.

Rodin recorded at least three stages of his conception of the Bastien-Lepage monument. Probably the earliest of these still extant is a bronze statuette from 1886–87 in the Baltimore Museum of Art.[6] The painter, with his right arm outstretched and a palette in his left hand, pauses on a grassy mound as if interrupted in his effort to capture what he sees. Hunched over, he turns vigorously to his right. In a plaster study (probably 1887) preserved at the Rodin Museum in Meudon,[7] the figure has been made more erect, giving it a more heroic stance, and the grass now extends up the left leg. This may be a device added simply to provide more support to the plaster, but it can also be seen as a more emphatic, elliptical reference to the open landscapes where Bastien-Lepage demonstrated his commitment to plein-air painting; a plaster study for the monument, shown at the Monet-Rodin exhibition in 1889, bore the alternate title *Plein Air*.[8]

The present bronze was cast from the full-size plaster model now in Meudon. In this final version the vegetation was confined to the base, a few details of the costume were more sharply rendered, yet the turn of the body and the dynamic spread of the legs were maintained. The figure was thus given a sense of uncompromised resolve. Its aggressive character was very different from the statue of Claude Lorrain. Nothing, however, prepared the way for the base of the monument to *Claude Lorrain*, which would burst like a revelation on a world not yet ready for it.[9]

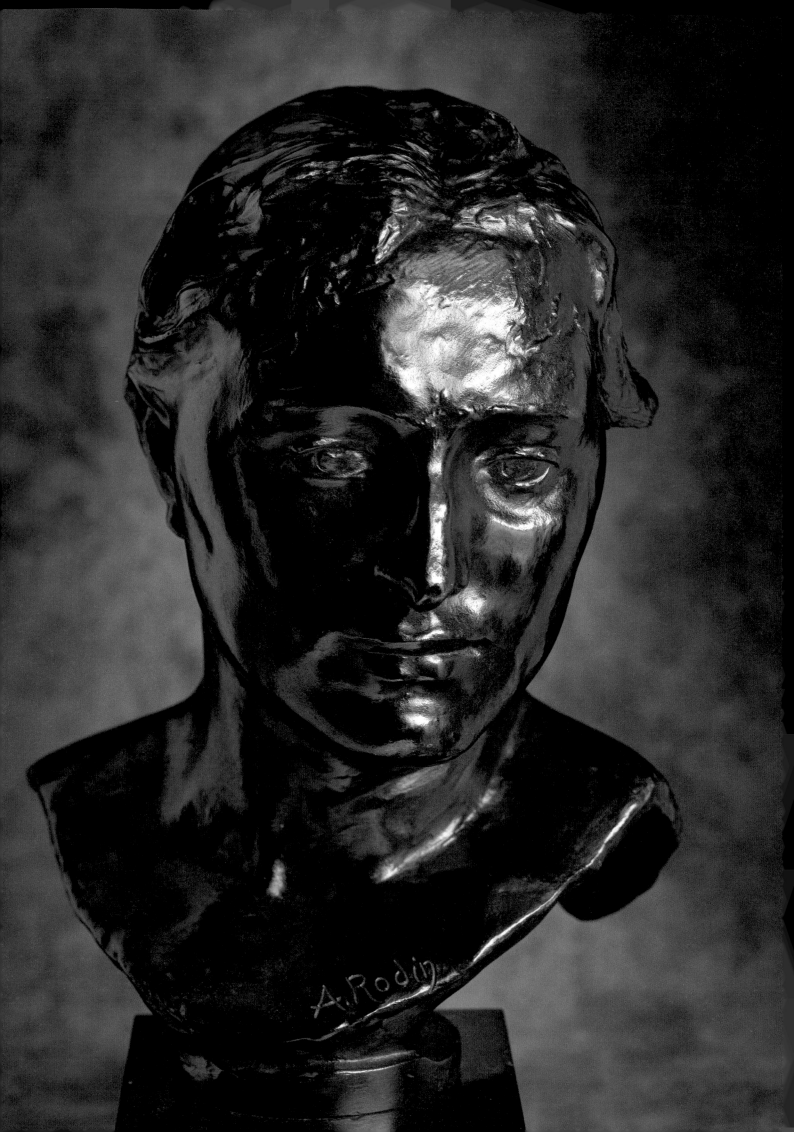

The Italian Marianna Mattiocco della Torre (1865–1908) married the Australian painter John Russell (1858–1931). According to one account, Rodin is said to have met her around 1886–88, when the couple came to Paris for Russell's studies. They may have been introduced to Rodin by Claude Monet or the critic Gustave Geffroy.[1] It has also been suggested that Marianna della Torre was a model for Rodin before she met Russell, who is said to have commissioned her portrait from Rodin when they married in 1888.[2] A silver mask of her was shown in the Monet-Rodin exhibition in 1889.[3]

While not offering absolute conformity with the stylized classical ideals of earlier periods, the nearly pre-Raphaelite fullness of Mrs. Russell's open, even features gave her face a calm timelessness; the irregular bridge of her nose and asymmetry of her face were enough to show in portraits that this was a real woman, not a formula invented by the sculptor's artifice. Rodin handled her features with comparative restraint, vaguely differentiating the focus of her eyes, showing the hair wound casually at the back, and turning the head slightly above the rolling margin of the truncation. A point of bronze was left at the center of the right eye, illusionistically catching the light, and a few flecks of excess metal were left in the strands of hair that slipped across the forehead, as though they were the signature of the impressionist sculptor.

From these harmonious features Rodin developed allegorical busts, mostly with references to the antique. He made various marble and plaster busts of the Greek goddess Athena, helmeted or crowned by the Parthenon, and a bust of Ceres[4]—all based on the portrait of Mrs. Russell. There is also a veiled plaster of her transformed into Saint George.[5] These offer a marked contrast with the sculptures he derived from the image of Camille Claudel, whose troubling personality is reflected in their titles: *The Convalescent (La Convalescente), The Farewell (L'Adieu), The Thought (La Pensée).* Deceptively simple, the bronze portrait of Mrs. Russell is one of the most understated and subtle of Rodin's works.

Auguste Rodin

FRANCE, 1840–1917

Portrait of Marianna Mattiocco della Torre (Mrs. Russell)

CATALOGUE NO. 38

c. 1887–89
Musée Rodin cast 5/12, 1972
Bronze
13¾ x 9½ x 10 in.
(34.9 x 24.1 x 25.4 cm)
Inscribed on front: A. Rodin; inside throat, upside down: A. Rodin (in relief); on proper left shoulder truncation: © by musée Rodin 1972
Foundry mark on proper right shoulder, back: .Georges Rudier./.Fondeur.Paris.
Gift of B. Gerald Cantor Art Foundation
M.73.108.17

Auguste Rodin

FRANCE, 1840–1917

Eternal Idol

CATALOGUE NO. 39

Probably 1889
Musée Rodin cast 4/12, 1967
Bronze
29 x 21 x 15 in.
(73.7 x 53.3 x 38.1 cm)
Inscribed on base, front, top:
A. Rodin; at lower edge:
© by musée Rodin 1967
Foundry mark on base, right,
at lower edge: .Georges
Rudier./.Fondeur.Paris.
Gift of B. Gerald Cantor Art
Foundation
M.73.108.20

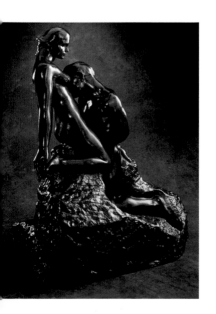

Reviewing, as would an apologist, Rodin's reputation as a womanizer, Judith Cladel cited an account given by Jules Desbois, which put Rodin's prodigious output in the context of his enormous appetite for life.

One day, from up on the scaffold where I was working on the Burghers of Calais, *I noticed Rodin, who between some screens, was doing a nude sculpture, for which the model was a young woman, stretched out on the table. As the session was drawing to a close, he bent over toward the woman and kissed her tenderly on her belly—a gesture of adoration of nature, which gave him so much joy.*[1]

Rodin alluded to this caress in several compositions: *Man and His Thought* (*L'Homme et sa pensée*),[2] *Pygmalion and Galatea* (*Pygmalion et Galatée*),[3] *Christ and the Magdalene* (*Le Christ et la Madeleine*),[4] as well as *Eternal Idol* (*L'Eternelle Idole*), which was alternatively called *The Host* (*La Hostie*).[5] The first two treat the creative inspiration of the artist; the last one venerates the human body either literally or symbolically. The idol was traditionally a physical representation intended to be worshipped; by abstraction's leap Rodin distorted it to correspond with the host, the object of veneration in Christian thought. It is not surprising that Rodin should conflate what would otherwise seem to be contradictory titles.[6] This was appropriate enough for a sculptor whose primary subject was the human body.

The present sculpture is derived from a plaster model with a rocklike base; it also exists in marble.[7] A variant in bronze has had the rocky material in front of the male figure's legs cut out so that the composition is more open.[8]

A secure date for the final composition has not yet been determined. It was said to have been seen in Rodin's studio in 1891[9] and was illustrated in Léon Maillard's *Auguste Rodin statuaire* in 1899.[10] The obvious resemblance of *Eternal Idol* to Camille Claudel's *Sakountala* (a composition also known as *Surrender* [*L'Abandon*] or *Vertumnus and Pomona* [*Vertumne et Pomone*]), which is datable to 1887 or 1888,[11] supports a comparable date for Rodin's sculpture.

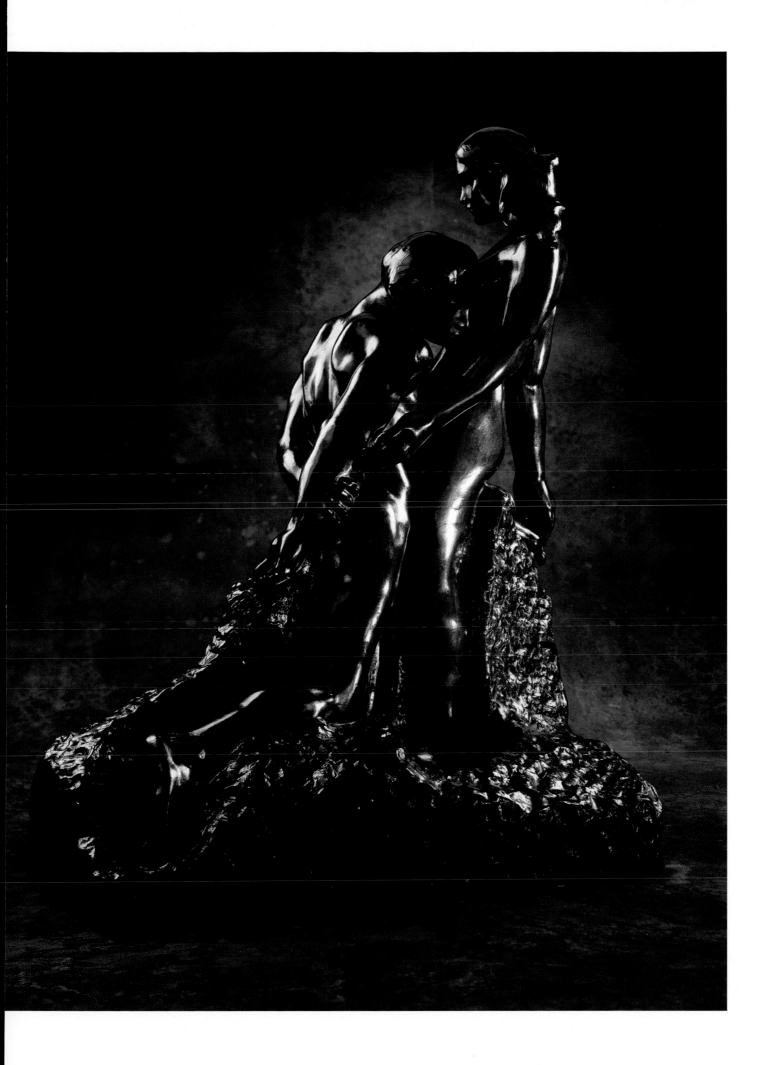

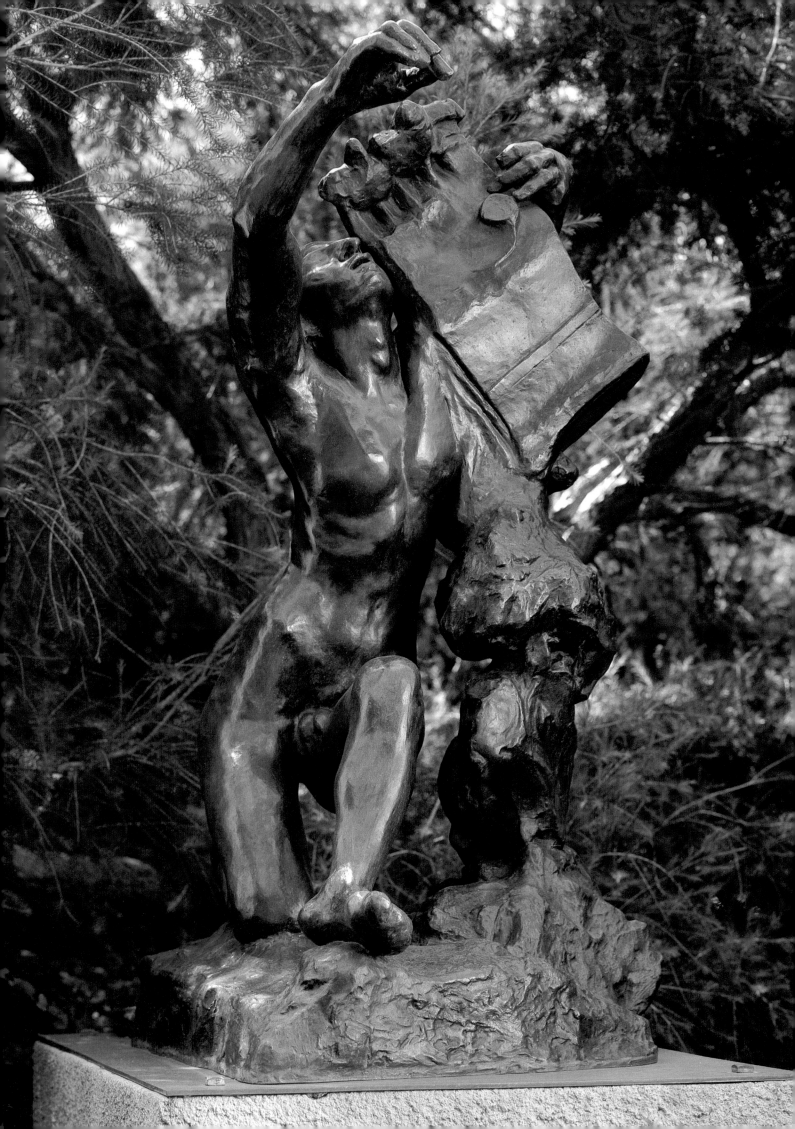

In Greek mythology the greatest singer after Apollo was Orpheus, upon whom the god had bestowed his gift of music. Orpheus's singing was so beautiful that it charmed nymphs and rendered the dangerously seductive song of the Sirens powerless, thus saving the Argonauts in their quest for the Golden Fleece. His music tamed wild animals into harmonious coexistence, and he was seen as an agent of the civilization of mankind as well.[1] The greatest demonstration of his enchanting power was given in the underworld during his attempt to win his wife, Eurydice, back from the dead:

The blend of lyre and word
Made bloodless ghosts fall weeping as they heard.
. . . .
Then [for the] first [time] the Furies wept: their cheeks that hour
Were wet, they say, with tears through music's power.[2]

It was this moment, Rodin said, that he represented in bronze: "'Having tuned his lyre for the infernal chorus and having been awarded the coveted prize of Eurydice, he sinks back overcome by the fatigue of his wanderings and the memory of his past anguish.'"[3] Moved by Orpheus's song, the lord of the underworld restored Eurydice to life on condition that Orpheus not look at her as she followed him up to the light of day. Unable to control himself, however, Orpheus turned to see if Eurydice was indeed behind him, and she was immediately sucked back into Hades. Orpheus wandered, mourning his lost Eurydice until his death at the hands of the Thracian women he spurned.[4]

Although Rodin explicitly identified the subject of the sculpture *Orpheus* (*Orphée*) as a specific episode in the myth of Orpheus, enriching his description with layers of emotion, there have been further interpretations of it. The action has been described as Orpheus's lament either upon his first or second loss of Eurydice, his plea to the gods to restore her, or because of the figure's closed eyes, his ignorance of her presence when he sang in Hades.[5] There is every reason to believe that Rodin indeed saw his sculpture primarily as he described it, because in addition to it he created two other distinct compositions based on identifiable episodes of the myth of Orpheus as well as a variant of the present one (now destroyed) that combined this figure of Orpheus with that of a woman floating at his right shoulder like the shade of

Auguste Rodin

FRANCE, 1840–1917

Orpheus

CATALOGUE NO. 40

Probably 1890–1900
Musée Rodin cast 4/12, 1969
Bronze
59 x 50 x 32 ½ in.
(149.9 x 127.0 x 82.6 cm)
Inscribed on base, right:
RODIN/COPYRIGHT BY MUSÉE
RODIN 1969
Foundry mark on base, left: SUSSE
FONDEUR.PARIS
Gift of B. Gerald Cantor Art
Foundation
M.73.108.3

Eurydice or his own muse.[6] The hand left on the back of Orpheus's kithara[7] is evidence of the figure that was added to the sculpture, and then, like Eurydice, taken away.[8]

The two other compositions representing episodes from the myth are *Orpheus and Eurydice* (*Orphée et Eurydice*, 1893), which shows the couple emerging from the underworld,[9] and the one commonly referred to as *Orpheus and the Maenads* (*Orphée et les ménades*, c. 1903–5), which transforms the figure of the *The Kneeling Female Faun* (CATALOGUE NO. 21) into Orpheus and shows him attacked by the Thracian women.[10]

Rodin's multiple treatments of the story of Orpheus are very much of his time, given the interest in the myth in the final quarter of the nineteenth and early twentieth centuries. As a symbol of the divinely inspired, tragic artist as well as of artistic creation and replete with parallels to the resurrected Christ, Orpheus was ripe for interpretation in the bittersweet, introspective world of the symbolists.[11]

Despite Rodin's various sculptures of Orpheus, the poet is oddly unidentified in *The Gates of Hell*. Not only did Orpheus descend into Hades to bring Eurydice back to life, but he also appears early, if briefly, in Dante's narrative (*Inferno*, book 4). Condemned to the underworld because he was not baptized, Orpheus was in Limbo with the other great poets of antiquity when Virgil and Dante encountered him; yet he is not explicitly portrayed in the *Gates*. It is possible only to speculate on why Rodin omitted such an obvious subject from his monument. There are direct correspondences between several figures from the *Gates* and the present figure of Orpheus: his head is derived from *Head of Sorrow* (*Tête de la douleur*, 1892); his slim torso is not very different from a study for the torso of one of Ugolino's sons;[12] and the figure of *The Martyr* (*La Martyre*, 1887), which recurs several times in the *Gates*, was paired with him in the plaster and marble versions of *Orpheus and Eurydice*. Indeed, a composition like *Fugit Amor* (CATALOGUE NO. 19) could easily represent these lovers, and yet they were given their own existence by Rodin, independent of the underworld that he created.

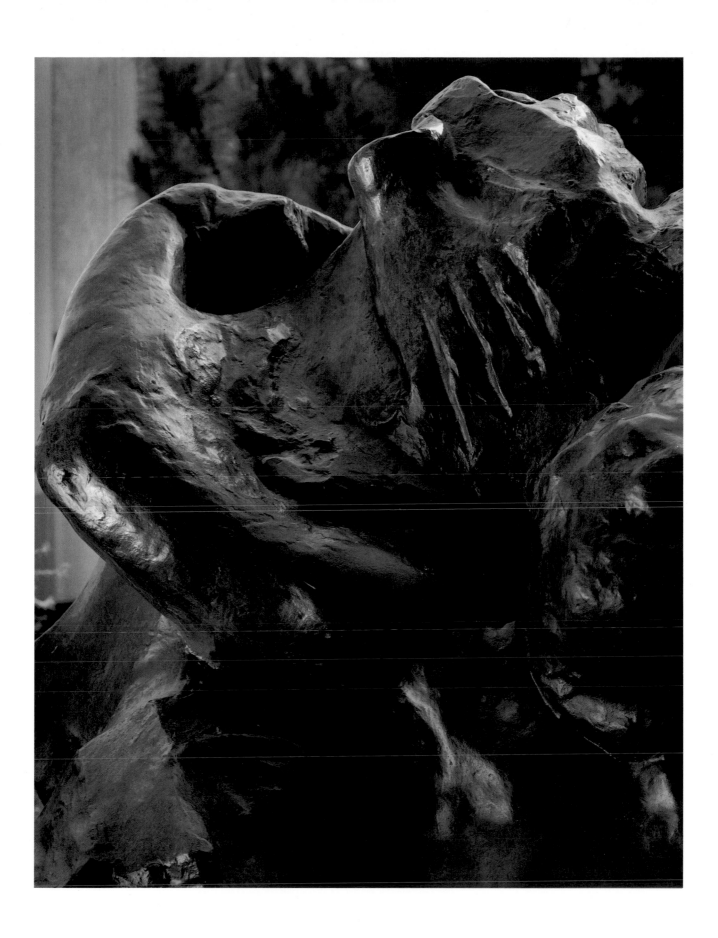

Auguste Rodin

FRANCE, 1840–1917

Invocation

CATALOGUE NO. 41

c. 1900
Musée Rodin cast 4/8, 1986
Bronze
22 x 10¼ x 9½ in.
(55.9 x 26.0 x 24.1 cm)
Inscribed on base, right:
A. Rodin/4/8; back, at lower edge:
© BY MUSEE RODIN 1985
Foundry mark on base, left, at
lower edge: Susse Fondeur Paris
Gift of Iris and B. Gerald Cantor
Foundation
AC1992.III.1

Although Georges Grappe suggested a date of about 1886 for the present figure,[1] the earliest documented date for it is 1900, when it was shown in Rodin's exhibition at the Pavillon de l'Alma in Paris. There it was called *Dawn Awakening* (*L'Aurore s'éveillant*).[2] Nicole Barbier suggests that *Invocation* is an adaptation of a sculpture made for the 1900 exhibition.[3]

Grappe also related the figure to another called *Old Man in Supplication* (*Vieillard suppliant*, c. 1886?),[4] most likely because of the similarity of the gestures of their upraised arms. Although it cannot yet be determined with complete certainty whether these compositions really were related, there is a slight visual correspondence between them. Perhaps they also share a correspondence with Rodin's sculptures of dancers, whose limbs in extension produce movement in the silhouettes. Their gracefulness is achieved through unnaturalistic distortion in different parts of the body. The rising line of the form of *Invocation* emerges from the tenuous position of the figure on its base and opens and returns into the lyrical double arc of the arms. Although it is recognizably representational, *Invocation* shows how far Rodin moved away from modeling realistic anatomies. Even in bronze this sculpture retains all the characteristics of an incidental sketch, in which the human body is nothing more than a pretext for developing a nearly abstract composition.

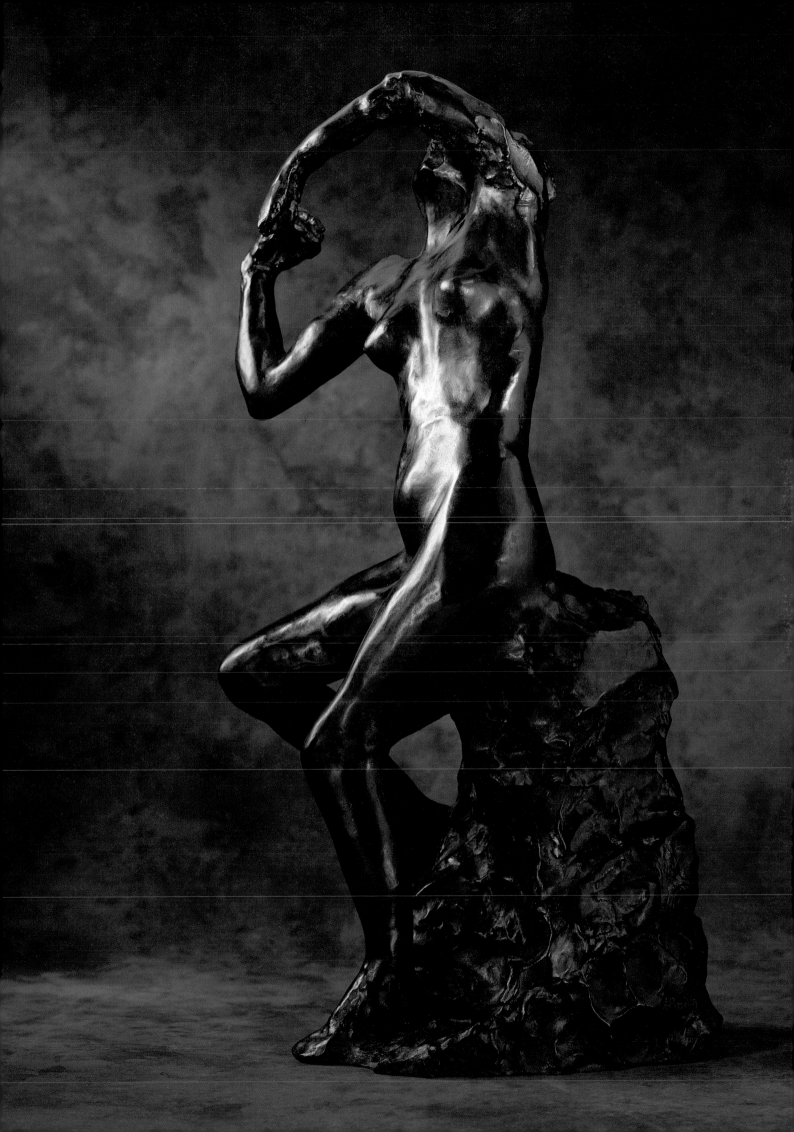

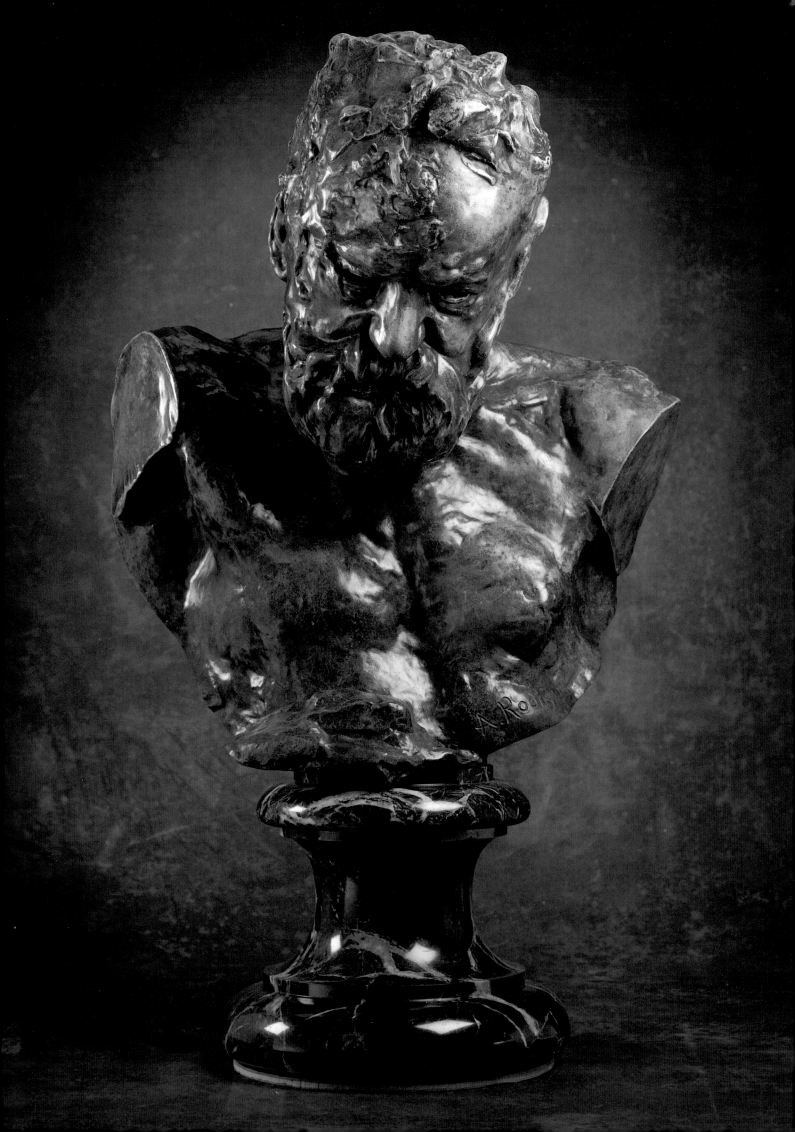

Author of such quintessentially romantic dramas and novels as *Hernani* (1830), *Notre-Dame de Paris* (1831), and *Les Misérables* (1862), as well as satires and a multitude of poems, including *Les Châtiments* (1853), Victor-Marie Hugo (1802–85) was not only one of France's greatest writers but also a hero to all who advocated the reestablishment of democracy in France. In 1850 Napoleon's nephew Louis-Napoleon seized power; on January 1, 1851, he was given the right in a national plebescite to draw up a new constitution; that year he was installed as president and quickly reinstituted an autocratic government; and in November 1852 he took the name Napoleon III as emperor. Hugo, who had spoken out sharply against him, fled to Brussels, and eventually settled on the island of Guernsey in the English Channel. In spite of the emperor's offer of amnesty in 1859, Hugo remained in exile until the collapse of the Second Empire in 1870. Hugo's determination and probity, his unflinching commitment to political and spiritual freedom, and the vast well of imagination from which he drew his inspiration made him a figure of tremendous stature.

In 1881 a national celebration was declared to honor Hugo's eightieth year. One of its organizers, Edmond Bazire, introduced the author to Rodin in 1883.[1] Rodin set his heart on doing a portrait of Victor Hugo, but the writer was satisfied by the bust Pierre-Jean David d'Angers had done of him many years before, and he had, moreover, just finished lengthy sittings for another sculptor. Finally he acquiesced and permitted Rodin to observe him informally. Rodin filled a notebook with drawings of Hugo and modeled clay sketches rapidly while stationed on a balcony, out of Hugo's way.[2] Rodin thus knew Hugo's face intimately, in contrast to that of Balzac. Rodin's efforts resulted in several life-size portrait busts of Hugo, one of which was exhibited at the Salon in 1884.[3] In 1889, four years after the writer's death, Rodin received the government commission to create a monument to him as part of a broad program for the interior of the Pantheon in Paris.[4]

Rodin produced plaster models in two distinct formats for this commission. The first (1886–90) showed Victor Hugo seated, almost reclining, surrounded by a number of smaller figures of muses; this was rejected in 1890 because of its "lack of clarity and confusing shape"[5] and probably also because a horizontal format was less appropriate for such a monument commissioned for the Pantheon. Nevertheless, in 1891 it was deemed worthy of execution in marble and was intended for the Luxembourg Gardens. Rodin exhibited a simplified maquette for it in 1897, and the marble, representing Hugo alone, was ready in 1901. It came to be known as the Palais Royal version, because in 1907–8 it was erected there instead.[6]

Auguste Rodin

FRANCE, 1840–1917

Heroic Bust of Victor Hugo

CATALOGUE NO. 42

1890–97 or 1901–2
Musée Rodin cast 5/12, 1967
Bronze
27¾ x 18¾ x 18¾ in.
(70.5 x 47.6 x 47.6 cm)
Inscribed on torso, proper left:
A. Rodin; below this, on support:
© by musée Rodin.1967.
Foundry mark on back of proper right shoulder: .Georges Rudier./ .Fondeur.Paris.
Gift of B. Gerald Cantor Art Foundation
M.73.108.18

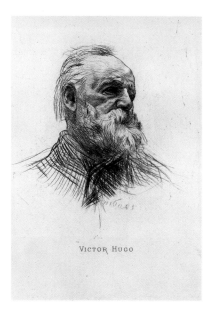

Auguste Rodin
France, 1840–1917
Victor Hugo, 1884
Drypoint
8¾ x 15¹⁵⁄₁₆ in. (22.2 x 40.5 cm)
Los Angeles County Museum of Art,
gift of B. Gerald Cantor Foundation
M.87.76.3

Rodin's second design was in a vertical format better suited to the function of filling the vast reaches of space in the Pantheon. Called the *Apotheosis of Victor Hugo* (*Apothéose de Victor Hugo*), it came to nothing because of a long period of government neglect.[7] Both ideas, which underwent successive modifications, alluded to Hugo's exile on Guernsey by representing him seated or standing on its rocky outcrops and surrounded by muses, nymphs, or figures symbolizing his sources of inspiration.

Georges Grappe asserted that the heroically scaled bust of Victor Hugo was derived directly from the standing nude study of Hugo modeled for the *Apotheosis*,[8] but its relationship with the Palais Royal version deserves fresh consideration. The turn of the head to the proper left, rather than to the right as in the *Apotheosis*, in addition to the upraised set of the shoulders as in the Palais Royal maquette, are signals for reexamination. Whether or not the scumbled surface of the proper right side of the face is due to separation from the supporting right hand, and whether or not the irregular waves of bronze at the lower edge of the truncation are traces of the right hand from the *Apotheosis* or drapery from the Palais Royal format are questions that cannot be answered without a direct comparison.[9]

The date of the *Heroic Bust of Victor Hugo* is not certain; various sources claim that it was either exhibited as a finished sculpture in 1897 or 1900 or in the course of execution in 1898 or in 1901–2.[10] A bronze example in the Musée d'Orsay dates at the latest from 1906.[11]

The present bust is on an over-life-size scale. Rodin's practitioner Aristide Rousaud, who carved a large marble bust of Hugo now in the Musée Rodin, wrote, "[Rodin] saw his work built from great volumes for [installation] outdoors, with powerfully modeled passages in pronounced relief, but veiled in stone in order to obtain a contrast that was simultaneously broad and strong."[12] Except for the reference to that distinctive style of "veiling" practiced for Rodin's marbles, this statement explains much, but not all, about the form of the present bust too; its size can also be interpreted literally as meaning the *heroic*, the appropriate scale for a portrait of this revered writer. The turn of the head suggests the exiled hero's strength of contemplation, and the weight of his moral responsibility is enhanced by the powerful cast of the shoulders.

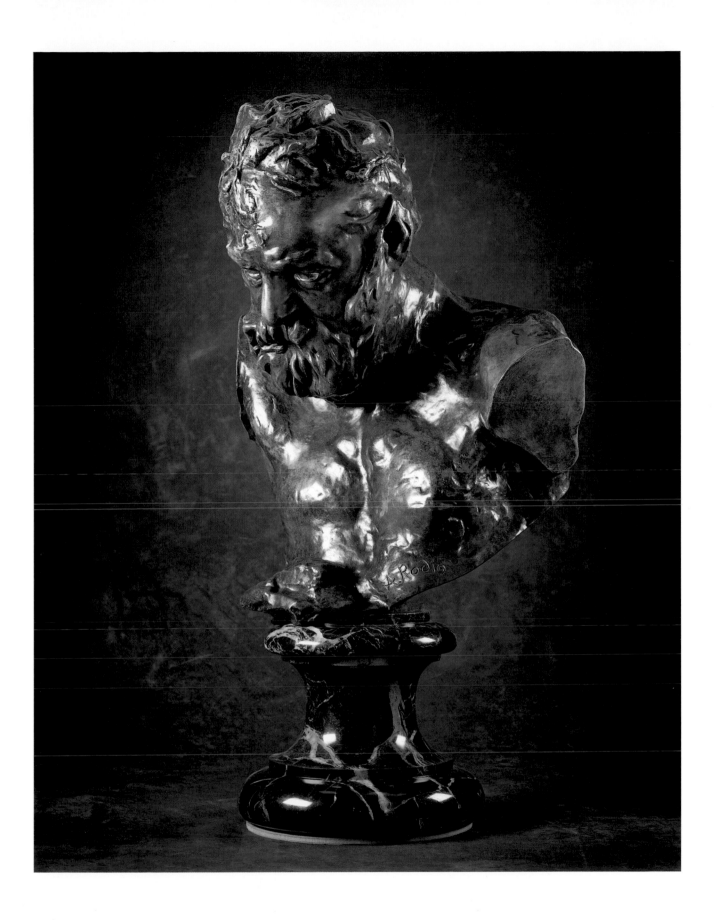

Auguste Rodin

FRANCE, 1840–1917

Iris,
Messenger of the Gods

CATALOGUE NO. 43

1890–1900
Musée Rodin cast 9/12, 1966
Bronze
31 x 35 x 14 in. (78.7 x 88.9 x 35.6 cm)
(without base)
Inscribed on sole of proper right
foot: A. Rodin; on base, left: © by
musée Rodin.1966
Foundry mark on base, back:
.Georges Rudier./.Fondeur.Paris.
Gift of B. Gerald Cantor Art
Foundation
M.73.108.11

Like the *Flying Figure* (CATALOGUE NO. 45), the present bronze probably originated as a study in one of the maquettes for Rodin's second idea for the monument to Victor Hugo destined for the Pantheon[1] (see CATALOGUE NO. 42); it was derived from one of the figures that hover about the writer's shoulders in the maquette known as the *Apotheosis of Victor Hugo*, which shows the writer standing.[2] *Iris, Messenger of the Gods* (*Iris, messagère des dieux*) is tightly grouped with other figures above that of Victor Hugo, so its startling pose is difficult to discern at first. Its unabashed frankness may constitute Rodin's stunning retort to the government committee that rejected his first model for the Hugo monument.[3]

A unique disposition was not intended for *Iris* as an independent figure, so it could be set directly on the ground as though representing a stretching exercise for ballet.[4] When balanced on a toe, the bronze has even more spontaneity and kinetic tension, because it has virtually no static referent.

The title may have been arbitrarily applied, unless the arc of this sculpture makes a vague allusion to the rainbow, Iris's symbol, while the dynamism of this composition implies a superhuman velocity. Realized in bronze, this form has energy absent from Rodin's drawings and watercolors of stretching women that date from after about 1897.[5] While the two-dimensional images have a vestige of material restraint due to their very flatness, the sculpture, with its physical third dimension, has an immediate impact that goes beyond eros, art, or any traditionally defined notions of historical styles.

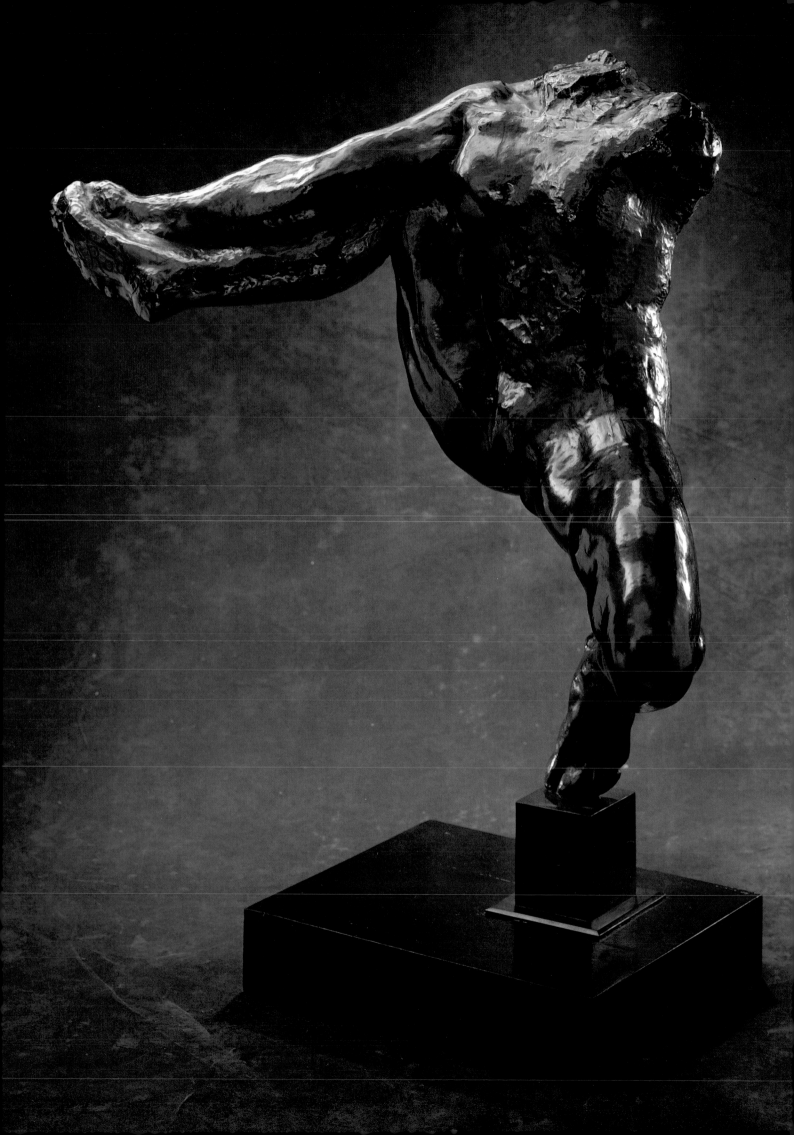

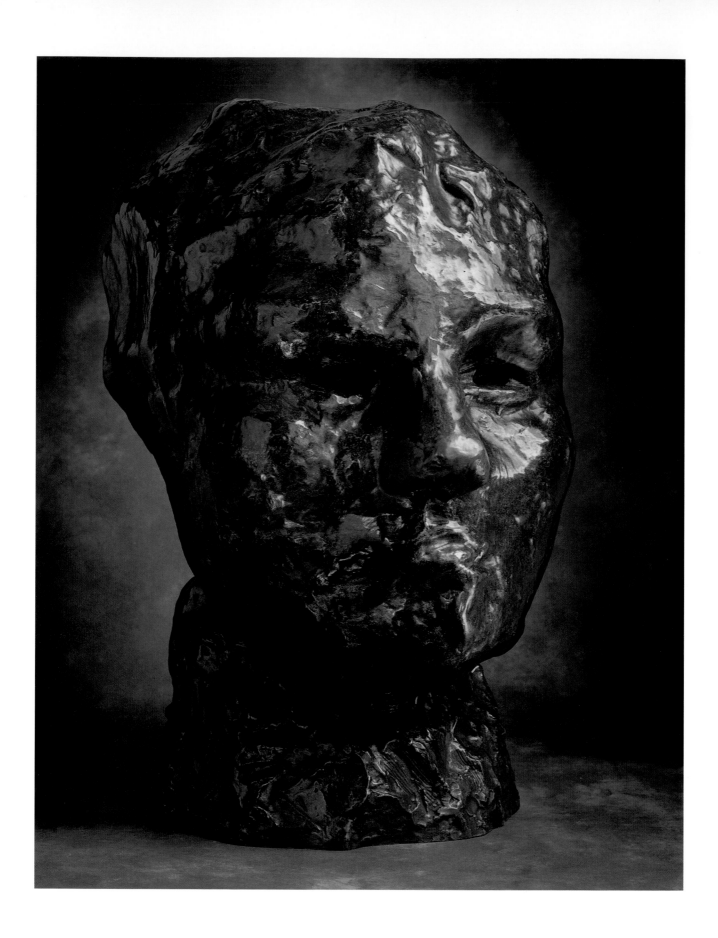

The title of this bronze is derived from Rodin's *Iris, Messenger of the Gods* (CATALOGUE NO. 43),[1] but whether Rodin intended it from the outset to be associated with that figure is by no means clear. A vintage photograph of a plaster in progress[2] shows that the attachment of this head to the torso was accomplished without concern for anatomical accuracy or formal coherence. It can therefore be assumed that this head was developed separately, which leaves open the question of its date of origin.

The *Large Head of Iris* (*Grosse Tête d'Iris*) was first shown in 1909,[3] at a time during which Rodin's experiments with enlargements of his models reached a climax. Georges Grappe commented that the monumental head was a fragment of a colossal sculpture that was never realized.[4] His assertion that this was "an enlargement of a head made for *The Gates of Hell*"[5] is equally plausible. There is more than a passing similarity between this over-life-size sculpture and a tiny (3½ in.) sketch called *Little Head of a Damned Woman* (*Petite Tête de damnée*), which Grappe tentatively associated with *The Gates of Hell* too. The sunken eyes and the curling lips are features shared by both. In the present bronze the broad, flattened face catches the light like a mirror, and the eyes seem to peer into eternity, so that the title *Large Head of Iris*,[6] although probably applied after the fact, suggests an appropriate reference to the gods' messenger who traveled across the firmament and who, bearing the rainbow, held light in her hands.

Auguste Rodin

FRANCE, 1840–1917

Large Head of Iris

CATALOGUE NO. 44

Possibly 1890–1900,
enlarged by 1909
Musée Rodin cast 4/12, 1967
Bronze
24 x 12 x 14¾ in.
(61.0 x 30.5 x 37.5 cm)
Inscribed on base, right: A. Rodin;
at lower edge: © by musèe [sic]
Rodin 1967
Foundry mark on base, left,
at lower edge: .Georges
Rudier./.Fondeur.Paris.
Gift of B. Gerald Cantor Art
Foundation
M.69.52

Auguste Rodin

FRANCE, 1840–1917

Flying Figure

CATALOGUE NO. 45

c. 1890–91
Musée Rodin cast 5/12, 1970
Bronze
20⅞ x 28½ x 12 in. (53.0 x 72.4 x
30.5 cm) (cast integrally with base)
Inscribed on base, top, right:
A. Rodin / Nº 5; at lower edge:
© by musée Rodin 1970
Foundry mark on base, back:
.Georges Rudier./.Fondeur.Paris.
Gift of B. Gerald Cantor Art
Foundation
M.73.108.8

Like *Iris, Messenger of the Gods* (CATALOGUE NO. 43) this sculpture is customarily associated with Rodin's commission for a memorial to Victor Hugo, but it can also be interpreted as an adaptation of the couple called *Avarice and Lust* (*L'Avarice et la luxure*, c. 1887), developed for *The Gates of Hell*.[1] The *Flying Figure* (*Figure volante*) is one of the best-known demonstrations of Rodin's arguments for an inherent completeness of compositions based only on their formal achievements in balance, proportion, mass, and movement.[2] Completeness is subjectively determined by what the mind chooses to accept as complete and by what satisfies the eye. Much of this is in turn determined by convention and custom: rare are the descriptions of portrait busts as "partial figures," although that is technically what they are.

The modern eye has become accustomed to the editing of the human figure in sculpture, but in Rodin's time viewers were still shocked by what was interpreted as a kind of artistic deceit or insolence on Rodin's part; traditional perception demanded that a newly modeled figure be complete with head and limbs and hands and feet.[3] Despite such criticism Rodin continued to cut, break, and edit his figures, testing the integrity of each part of his compositions, to see if it could live on its own.[4] There are perhaps further meanings to be found in this treatment of the human figure, in which selective destruction suggests resemblance to damaged antiques, lending the impression of venerability to a modern work.[5]

The dynamism of the *Flying Figure* is communicated not only by the brilliant extension of the right leg into space and the verve of the taut body but also by the startling treatment of the back, still raw from a bold stroke of the modeler's knife. Left "unfinished," this is the mark of speed and instantaneity.

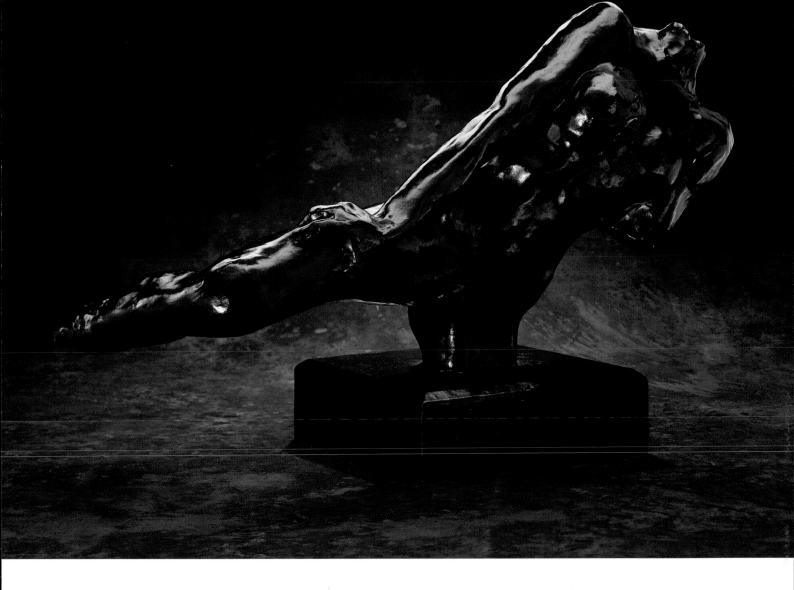

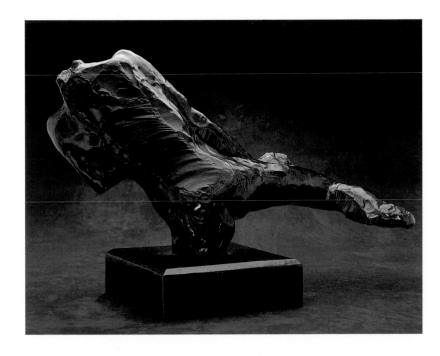

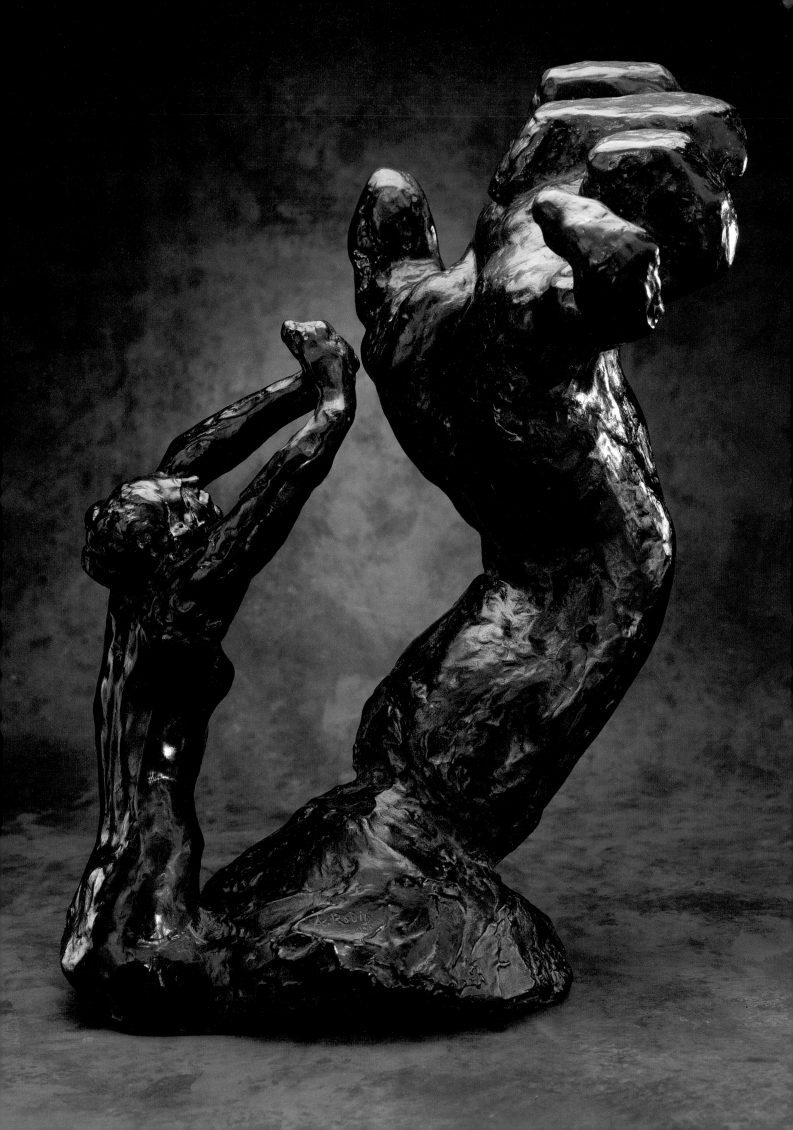

The *Large Clenched Hand with Figure* is a prime example of Rodin's combination of unrelated fragments to produce new, independent, compound compositions. This practice has been associated more with Rodin than with any of his contemporaries. Indeed, in the art of sculpture this practice is truly identified with Rodin.

Rodin's interpretation of a "partial" image as complete in itself can be traced back to the beginning of his career, to his attempt to exhibit *Mask of the Man with a Broken Nose* (*Masque de l'homme au nez cassé*, 1863), in the Salon of 1864 as a finished, and therefore complete, work of art.[1] Doubtlessly his experiments on *The Gates of Hell* were the real catalysts for the development of his process of agglutination, as the *Gates* were themselves aggregate works of art. So was *The Burghers of Calais*.

The torso in the present composition was made up from the one that was used in the *Female Centaur*, whose outsized arms are perhaps derived from a different sculpture, *The Despairing Adolescent* (*L'Adolescent désespéré*).[2] The great, swollen hand seems to be a fresh creation.[3] Although a relationship between it and Rodin's models for the *Burghers* has been suggested,[4] the hand seems too grossly distorted to have come from Rodin's essays on that monument. Its highly expressionistic charge, very coarse surfaces, and audaciously out-of-scale combination with the imploring torso probably indicate a date later than the *Burghers*. Furthermore Nicole Barbier has demonstrated that a photograph of Rodin with a plaster variant of this composition, taken in December 1906, likely provides a *terminus post quem* for the model cast in bronze, which therefore would be later, about 1907.[5]

This sculpture is open to many interpretations as it treats the tension of a vulnerable, small, graceful figure in supplicating confrontation with a monstrous, anonymous, overwhelming power. By comprehending the fullness of the emotive strength of his fragmentary images, Rodin also revealed their pathos as inanimate objects (in this case, little plaster sculptures, partial or broken) as though he understood their inner lives and sympathized with them.

Auguste Rodin

FRANCE, 1840–1917

Large Clenched Hand with Figure

CATALOGUE NO. 46

c. 1907?
Musée Rodin cast 8/12, 1972
Bronze
17½ x 11½ x 10⅜ in.
(44.5 x 29.2 x 26.4 cm)
Inscribed on base: A. Rodin/Nº 8;
opposite: © BY MUSÉE RODIN 1972
Foundry mark on base, to the right
of ©: E. GODARD/Fondᴿ
Gift of B. Gerald Cantor Art
Foundation
M.73.108.21

Auguste Rodin

FRANCE, 1840–1917

*Monumental Mask
of Hanako*

CATALOGUE NO. 47

Probably 1907–8,
enlarged c. 1908–12
Musée Rodin cast 2/12, 1972
Bronze
21 x 13½ x 11¼ in.
(53.3 x 34.3 x 28.6 cm)
Inscribed on base, left:
A. Rodin/Nº 2; at lower edge:
© BY MUSEE RODIN 1972
Foundry mark on base, left, at
lower edge: Susse Fondeur Paris
Gift of B. Gerald Cantor Art
Foundation
M.73.108.10

The Japanese actress Ohta Hisa (also called Hisako Hohta, 1868–1945) was introduced to Rodin by the dancer Loïe Fuller, who gave her the stage name Hanako ("little flower" in Japanese).[1] Rodin was fascinated by her expressive face and athletic body.[2] She modeled for an extraordinary number of drawings and portraits by him. The sculptured portraits, for which there are numerous preparatory sketches, have been classified conventionally in seven or eight basic types. The present sculpture, a slight variant on a plaster in the Musée Rodin (inv. no. s546), belongs to classification D. This category is itself a refinement and extension of the type C (best known through Edward Steichen's atmospheric photographs, dating from 1908).[3]

Rodin seems to have begun his study of Hanako's face as early as 1906,[4] but the precise date of the enlargement of the portrait is not entirely clear. Around 1908–10 Rodin seems to have shown great interest in developing enlargements of pre-existing models, but letters dated November 1912 from his collaborator Henri Lebossé mention new work on masks of Hanako.[5]

The interest shown by American and European artists and designers in Asian art grew dramatically in the final quarter of the nineteenth century. This obviously must have nourished Rodin's fascination with Hanako, and it was but one aspect of a taste revealed in his private collection, which included netsuke, Japanese prints, Chinese ceramics, and Indian sculptures.[6] Besides this, however, Hanako presented something quite particular to an artist who was obsessed with the expressive capacity of the human body and face. Although the Kabuki theater, with its stylized repertoire of facial expressions, was closed to women, Hanako surely was familiar with its intense, codified language. Furthermore her arrival in Europe had been immediately preceded by that of the Japanese actress Sadda Yakko, active in the Shimpa theater, which allowed women to play female roles.[7]

Whether Hanako was trained as a player in Shimpa theater is not known. She was a member of a lowly itinerant troupe in Japan and became a geisha at age sixteen. In 1901 she left Japan for Denmark with a circuslike show and went on tour in England and Germany. Fuller probably met her in 1904–5 and signed her group for a series of plays. Except for a brief trip to Japan in 1916, she continued to perform in Europe until about 1922, when she returned to her homeland. She died in 1945, shortly before her house was destroyed in a bombing raid.[8]

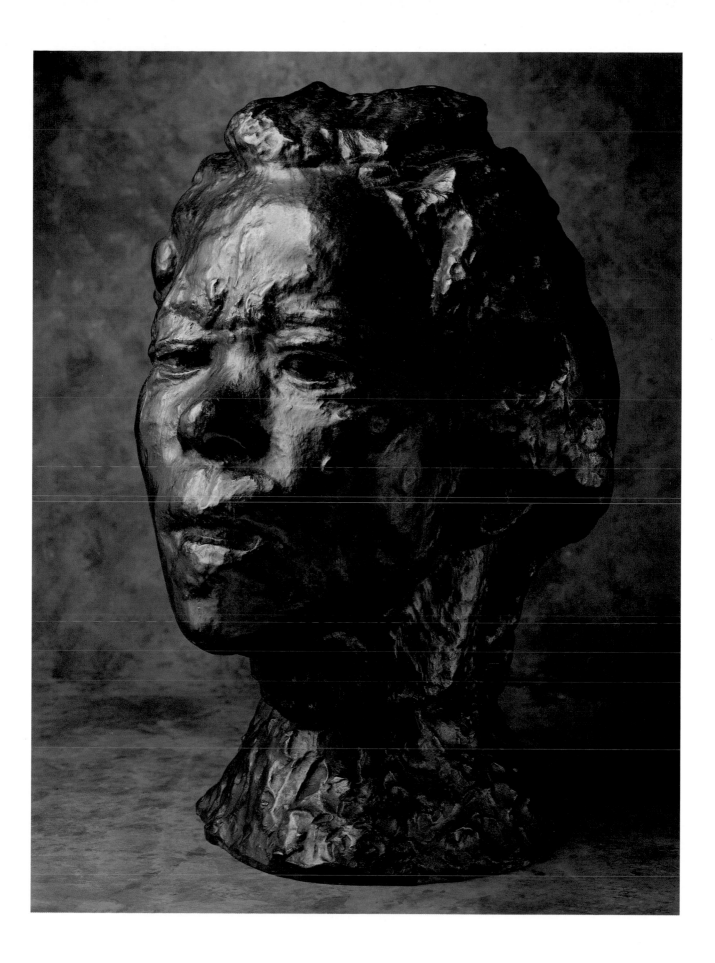

Auguste Rodin

FRANCE, 1840–1917

*Study for
"The Hand from
the Tomb"*

CATALOGUE NO. 48

c. 1910
Date of cast unknown
Bronze
5 x 3½ x 1⅜ in. (12.7 x 8.9 x 3.4 cm)
Inscribed on back of wrist:
A. Rodin
No foundry mark
Gift of B. Gerald Cantor Art
Foundation
M.85.268.1

After the face the hand is the most expressive part of the human body. While Rodin's fragmentary torsos reveal his gift for communicating sentiment through the body's attitude alone, without recourse to the traditional focus of facial expression, he was also keenly aware of the affective abstraction of disembodied hands. There are myriads of little plaster sketches of hands that are still being identified and classified at Meudon.

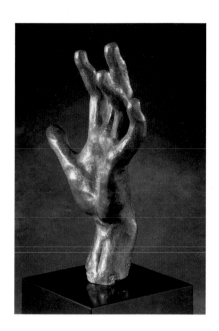

It has been suggested that Rodin's absorption with the emotive possibilities offered by these fragments can be traced to his training in design, when he was taught to treat the human body in sculptured fragments.[1] Such was his working method on an ambitious project like *The Burghers of Calais*, in which the heads were developed independently in due course. His numerous experiments in representing the hands resulted in evocative morsels that could remain independent or generate new compositions when recombined with other fragments (see, for instance, CATALOGUE NO. 46).

The present hand may be related to the right hand of *Pierre de Wissant*,[2] albeit with straighter fingers. The title of the present sculpture, *Study for "The Hand from the Tomb,"* refers to Rodin's *Hand [Emerging] from the Tomb ("Main sortant de la tombe")*, which was cast in bronze in 1910 for Jules Mastbaum (now in his Rodin Museum in Philadelphia)[3] and carved in marble in 1914.[4] In the latter composition the hand is attached by its wrist perpendicular to a block of marble; the palm is oriented toward the side of the block articulated by a panel surrounded by shallow molding. A cloth, presumably a shroud, is draped across the upper left corner and about the top of the slab, forming a transition to the base of the wrist. The primary function of the *Hand [Emerging] from the Tomb* is not known.[5] Additional titles impart a threatening tension to the composition (*Punishment [Châtiment]* and *"Mene, Tekel, Peres,"* the words of divine warning written on the wall of Belshazzar's palace by a disembodied hand in the Book of Daniel),[6] although the hand independently may be interpreted with more positive emotion. The present study is noteworthy for the extreme delicacy of the modeling and the subtle modulation of the curves in the articulation of the fingers.

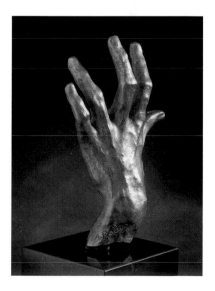

Auguste Rodin

FRANCE, 1840–1917

Pas de Deux G

CATALOGUE NO. 49

c. 1910–13
Musée Rodin cast 3/12, 1966
Bronze
13 1/2 x 6 1/2 x 6 1/2 in.
(34.3 x 16.5 x 16.5 cm)
Inscribed on lower figure, sole of
proper left foot: A. Rodin; on
proper right shin: © by Musée
Rodin 1966
Foundry mark on lower figure, sole
of proper right foot: .Georges
Rudier./.Fondeur. Paris.
Gift of Iris and B. Gerald Cantor
M.87.167

This sculpture is representative of a group of summary sketches of dancing figures that Rodin modeled late in life which bear some similarity to other compositions, like the *Flying Figure* (CATALOGUE NO. 45) and *Iris, Messenger of the Gods* (CATALOGUE NO. 43). They are customarily dated to about 1910.[1] This is about two decades after the *Little Dancer* (*Petite Danseuse de quatorze ans*) by Edgar Degas but contemporary with Degas's later wax ballerinas (FIGURE 8).[2] Rodin's sculptures, unlike Degas's, which have explicit references to classical ballet, are stripped to essential form, with barely a suggestion of their sex.

Rodin knew Loïe Fuller and Isadora Duncan,[3] two of the pioneers of modern dance, and it is likely that the same impulses guided them all to the elemental sources of dancing, the pure heart of movement and increased abstraction. In addition to this Rodin also investigated popular and traditional dance in various forms: Cambodian and Javanese[4] as well as the burlesque cancan that scandalized and entertained Paris. A composition like the present sketch can be interpreted as a reference to either the exercises of classical ballerinas or the performances at the Moulin Rouge.[5]

In these small sketches Rodin seized a vignette of movement that existed and vanished in the blink of an eye. There is little concern for anatomical naturalism or proportion. Such summary execution enhances their sense of kinetic speed. In the case of the present sculpture the repetition of the same figure calls to mind the concept of simultaneity of the futurists' experiments as well as showing how Rodin repeated identical figures to make new compositions.

FIGURE 8

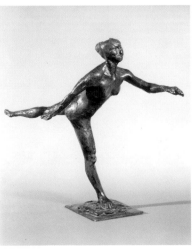

Edgar Degas
France, 1834–1917
Arabesque, c. 1890–95
Bronze
11 5/8 x 14 1/2 x 4 3/4 in.
(29.5 x 36.8 x 12.1 cm)
Mr. and Mrs. George Gard De Sylva
Collection
M.46.8.6

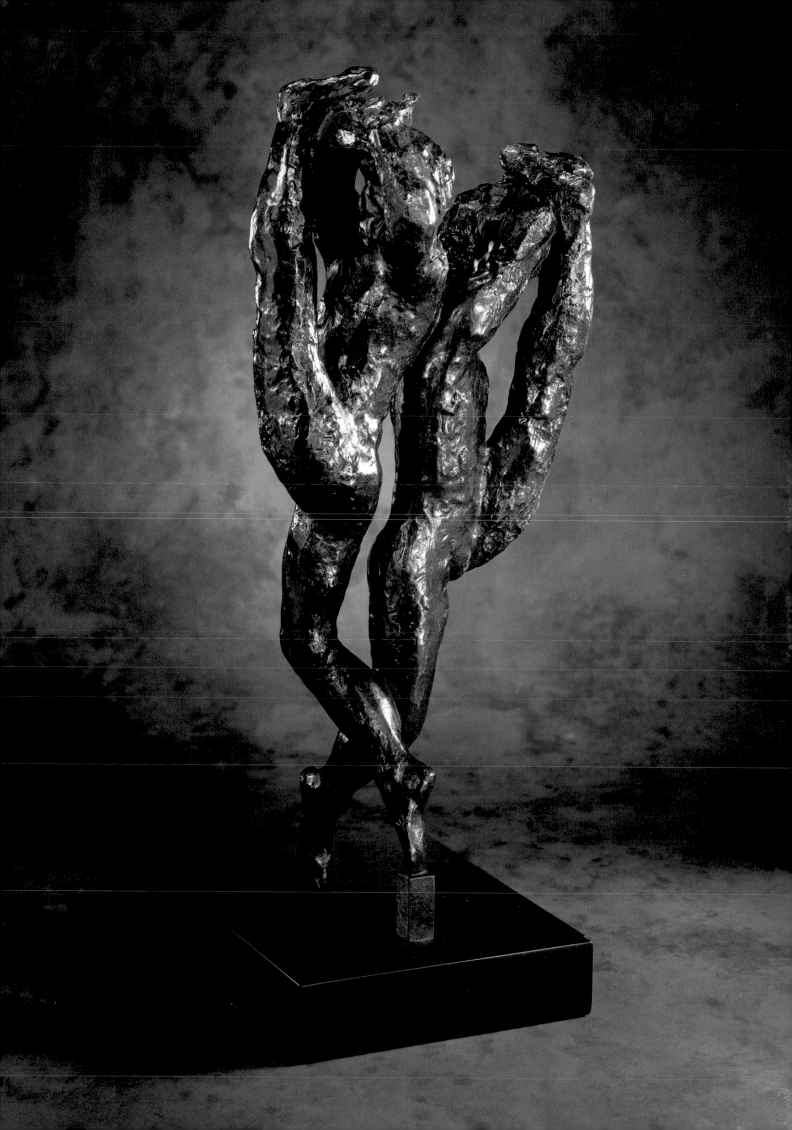

Auguste Rodin

FRANCE, 1840–1917

Portrait of Pope Benedict XV

CATALOGUE NO. 50

1915
Musée Rodin cast 7/12, 1971
Bronze
9¹/₂ x 6³/₄ x 9³/₄ in.
(24.1 x 17.1 x 24.8 cm)
Inscribed on collar, proper left side:
A. Rodin; at lower edge: © by
musée Rodin 1971
Foundry mark on back, proper
right side: .Georges
Rudier./.Fondeur.Paris.
Gift of B. Gerald Cantor Art
Foundation
M.73.108.16

FIGURE 9

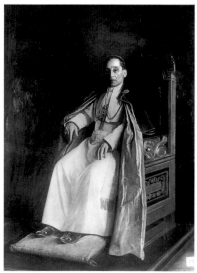

The winter of 1914 saw the introduction in the French Chamber of Deputies of a bill to establish a Rodin museum. The artist was in ill health and poor spirits. He left Paris for the warmer climate of southern France.[1] In the spring he was able to travel to London for an exhibition of his work. Shortly after his return that summer to Paris, even on the brink of World War I, the establishment of his museum was approved.[2] As the German army invaded France, Rodin and his companion, Rose Beuret, fled to England with the family of Judith Cladel, his devoted biographer.[3] In the autumn he turned from there toward Rome.

Benedict XV had just been elected pope. Born Giacomo della Chiesa (1854–1922), he was the son of an aristocratic family. His career took him into the diplomatic service of the Holy See, and this led to his appointment as undersecretary of state for the Vatican. Nominated to the college of cardinals in May 1914, he was elected pope only four months later, probably because of his diplomatic experience, while armies mobilized across Europe.[4]

Rodin, who went to Rome apparently to seek its warmth and tranquility at a distance from the conflict, responded to the request of certain individuals in the Vatican who were positively disposed toward France[5] to model the pope's bust. Albert Besnard (1849–1934), the director of the Académie de France in Rome, was to paint a formal portrait of the pope. Benedict allowed Besnard only four sittings; Rodin's appointment was put off to the following year. He too would be granted only a few sittings.[6]

Rodin went back to France and returned again to Rome, eagerly anticipating his encounter with the pope. Cladel, who left a fascinating account of Rodin's experience on this portrait, relates that he wanted very much "'to discuss the war.' Like half of Christendom, [Rodin] was astounded that Benedict XV had not protested against the invasion of Belgium."[7] Rodin was told that no one in Rome really knew the pope's true feelings about the war. The pontiff's stance was one of strict neutrality, and it provoked the hostility of the French, who interpreted it as a favorable attitude toward the Austro-Hungarian Empire. Indeed, doctrinaire members of the Church supported Austria as the true defender of Catholicism.[8] Besides this, since 1905, when the Church was disestablished in France, the French republic had had no diplomatic relations with the Vatican. Monasteries and convents were closed. Anticlerical sentiment was high.[9] Cladel believed that in these tense political circumstances, even the pope's agreement to have his portrait done by two French artists had considerable significance.[10]

According to Cladel, Rodin began the sittings and "'told [the pope] the truth.'" It was partly to Rodin's candor that Cladel suggested attributing Benedict's discomfiture before the sculptor and his refusal to continue the

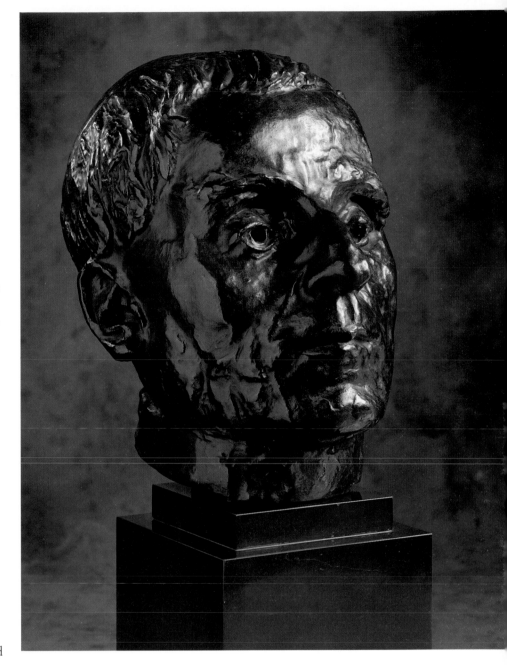

sessions.[11] The pope denigrated Rodin's portrait and abruptly silenced him as he tried to explain his method of working. The abrasive suggestion to Rodin made by the pope (who was, after all, trained as a diplomat) that the sculpture would be finished more quickly if Rodin simply copied the "bust"[12] done by Count Berthold Lippay (1864–1920), court painter to the Vatican, might have had a political edge: Lippay was an Austrian artist. His primary works were portraits of Emperor Franz-Josef, the czar of Bulgaria, and various Austrian archdukes. He could not have been more closely identified with the Austro-Hungarian Empire. (Cladel's account was likely incorrect in identifying Lippay's portrait as a bust: the only portrait of Benedict xv by Lippay preserved in the Vatican collections is an oil painting of the seated pope [FIGURE 9]).[13] Rodin left Rome with the model of the unfinished portrait carried on a tray by Boni de Castellane, who referred to it in his memoirs as being like a relic.[14]

Certainly its surprisingly abbreviated shape, sliced at the neck as a result of Rodin's customary procedure,[15] made the portrait resemble a decapitated head. Its form, left without any kind of extension into a bust or even a softening around the truncation, is unlike most of the other portraits in Rodin's oeuvre. Because of this it can be considered a portrait that was deliberately left unfinished by Rodin. The skin of the face is treated with an irregularity that suggests wrinkles and lines with a shocking aggressiveness, and the right eye seems punched out in a single blow.[16] Such brutal rendering may reflect Rodin's disillusionment before this man from whom he had hoped so much at such a dark time.

OPPOSITE [FIGURE 9]
Count Berthold Lippay
Austria, 1864–1920
Portrait of Benedict XV, probably 1914
Oil on canvas
87 3/8 x 63 3/4 in. (222 x 162 cm)
Musei Vaticani, inv. no. 2509
Photo: Archivio fotografico dei Musei Vaticani

Rodin's Contemporaries and Successors

ROMANTIC SCULPTORS REVITALIZED SUBJECT MATTER, extending it quickly to include the acclamation of the worth of the common man. This new hero was treated with realistic directness. The successors of the early romantics, including Auguste Rodin, also developed fresh, impressionistic techniques in modeling. This was a natural evolution from the revival of the rococo, with its plays of light and shadow orchestrated by Albert-Ernest Carrier-Belleuse and Jean-Baptiste Carpeaux, to Rodin's use of irregular, vibrating surfaces that suggest the movement of the entire composition, thus drawing the viewer's eye across and into the form. Such treatment also reveals the sculptor's activity in modeling and preserves his vital presence in the finished work.

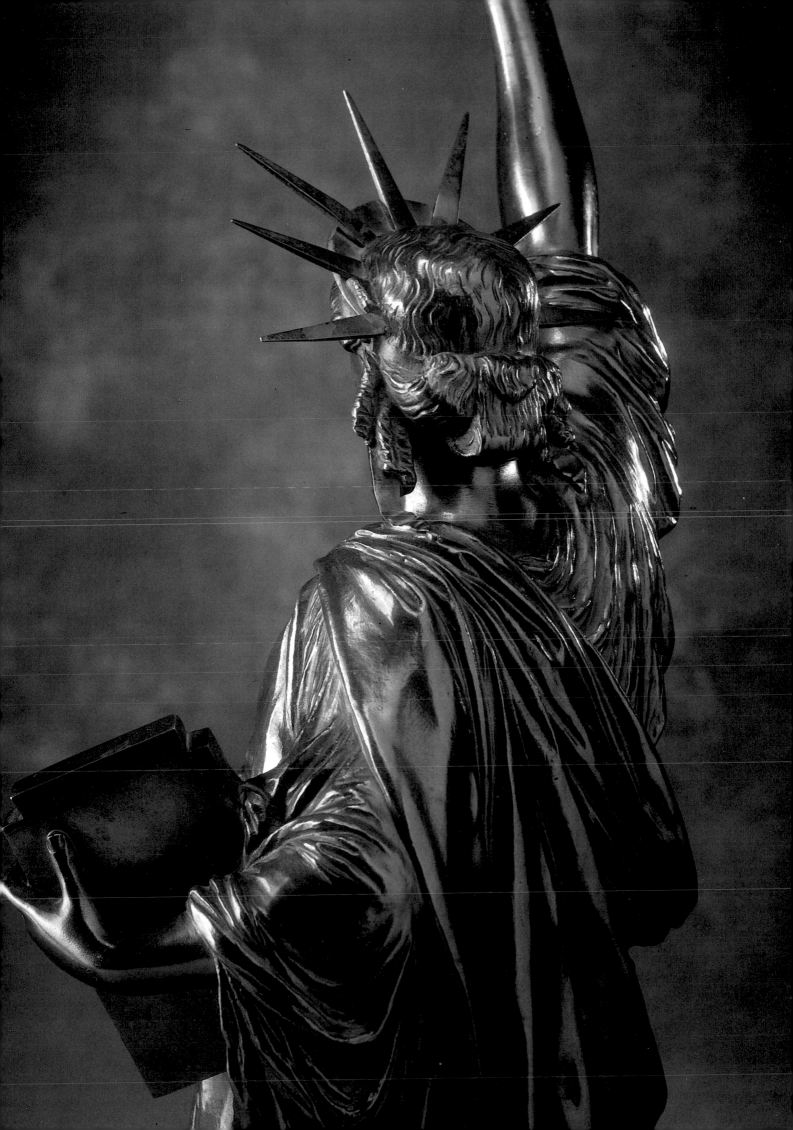

Jean-Alexandre-Joseph Falguière

FRANCE, 1831–1900

Resistance

CATALOGUE NO. 51

First modeled 1870;
this example probably 1894
Bronze
23 x 15¾ x 11¾ in.
(58.4 x 40.0 x 29.8 cm)
Inscribed on cannon: A Falguiere
[sic]; on front: LA RESISTANCE
Foundry stamp on back, right:
THIEBAUT FRERES/FONDEURS/PARIS
Gift of Cantor Fitzgerald Art
Foundation
M.76.30

In the winter of 1870 Paris braced for the German onslaught in the Franco-Prussian War. Among the French soldiers positioned at the barricades was the artist Alexandre Falguière. According to an account left by the writer Théophile Gautier,[1] a heavy snowfall blanketed the ramparts. From this in an idle moment Falguière, aided by the sculptor Henri Chapu, modeled a statue on a core of rubble and finished it in just two or three hours. This was the first version of the composition shown by the present bronze. Falguière painted the title *La Résistance* on a plank and set it below the snow sculpture. Hippolyte Moulin (1832–84) modeled a complement to it in the form of a heroic bust personifying the republic.

The ephemeral sculpture would disappear "in the first breath of warm air," wrote Gautier, but Falguière promised to preserve it in a more durable medium. Its appearance was recorded in two etchings.[2] Apparently not until the end of 1894 did Falguière, relying on a drawing made in 1870 by one of his comrades, model his *Resistance* anew;[3] the present sculpture along with related studies and variants are the results of the sculptor's efforts to reincarnate his allegory.[4] They differ from the original snow sculpture in the orientation of the cannon, which now points toward the viewer's left (rather than to the right, as in the etchings)[5] and in the position of the arms. In the etchings the arms are crossed higher on the body as though shielding the snow statue from the cold, while in the bronze they are crossed lower, accentuating the defiant attitude of the figure. The rough skin of the bronze may either recall the texture of the snow sculpture, built from rudimentary materials, or it may simply be one of Falguière's two customary but widely divergent techniques (the other being highly finished).[6] The faceted dimpling of the bronze may show the influence of Rodin's impressionistic technique on Falguière's.

The subject and format of the present sculpture, Peter Fusco suggests, may owe a debt to Jean-Baptiste Carpeaux's *Valenciennes Defending the Fatherland* (CATALOGUE NO. 9), the model of which was probably ready in the fall of 1869.[7] Falguière may have known about its design from Carpeaux himself: in June 1864 Carpeaux acted as Falguière's representative in the state's acquisition of the latter's *The Winner of the Cockfight* (*Le Vainqueur au combat de coqs*, 1864), and by December Carpeaux had at least been consulted about the plans for the new city hall of Valenciennes. The two artists were surely in communication, and Carpeaux referred to himself as Falguière's friend.[8] Their sculptures provide an instructive study in contrast. Even though the iconographic accessories of Carpeaux's were originally ordered by the architect of the town hall of Valenciennes, and even though Carpeaux reduced their number to lighten the weight of the sculpture, its

character remained true to his taste for ornament and was almost as much in the spirit of the neo-rococo as his *Flora*. Falguière's sculpture, conceived originally in unusual circumstances and built from snow, which did not allow for superfluous attributes, presents itself with more forthright clarity, highly appropriate to its subject. Only its odd, irregular silhouette reveals the painterly side of Falguière's artistic personality, which would emerge in a more surprising vision in such complex compositions as *The Triumph of the Revolution* (*Triomphe de la Révolution*, 1881; destroyed; wax model on loan to Musée d'Orsay).

Even though Falguière was only nine years older than Rodin, he achieved official success much earlier. In his lifetime he was constantly in the public eye. Born in Toulouse to a humble mason, he took his first art classes in his native city before going on to work in Paris with Albert-Ernest Carrier-Belleuse.[9] He gained admittance to the École des Beaux-Arts. Winning the Prix de Rome in 1859 gave him five years in the Eternal City, where he may have met Carpeaux. Two sculptures—one sent from Rome, *The Winner of the Cockfight*, and the other possibly begun there, *Tarcisius, the Christian Martyr* (*Tarcisius, martyr chrétien*, 1867)—brought him critical acclaim in France. In 1870 he was named to the Legion of Honor, rising to the rank of commander in 1889. His many sculptures of female nudes brought him considerable popularity. He was appointed professor at the École des Beaux-Arts and nominated to the Académie des Beaux-Arts. Such credentials made his defense of Rodin in the controversy over *The Age of Bronze* all the more remarkable. The critic Roger Marx wrote that when Rodin was accused of casting *The Age of Bronze* from nature, "Falguière was among the first to dissent and to declare himself in favor of the great injured [party]. This was not at all surprising: in the most diverse situations, Falguière proved himself to be profoundly an *artist*; a spontaneous inventor, painter and etcher . . . he continued the completely French tradition of a vital, expressive, dramatic sculpture."[10] Falguière was enormously productive, exhibited constantly in the salons, and enjoyed tremendous popularity in his lifetime. Today he is all but forgotten.

Jean-Alexandre-Joseph Falguière

FRANCE, 1831–1900

Revolution Holding the Head of Error and Striding over the Cadaver of Monarchy

CATALOGUE NO. 52

c. 1893
Bronze
37 x 24 x 13¾ in.
(94.0 x 61.0 x 34.9 cm)
Inscribed on base, front, right:
A. Falguiére [sic]
Foundry stamp on base, back, right:
GALERIA ARTISTICA/S C
REGUAN/PERÚ 134 (in circular cachet)
Gift of B. Gerald Cantor Art
Collections
M.82.126.4

In 1890 Falguière received a commission for a bronze monument commemorating the Revolution, destined for the Pantheon. He worked on it until he died, producing several multifigured and colossal maquettes, but not one of his ambitious ideas was carried out. Although the sequence of these projects is uncertain,[1] the present sculpture most likely corresponds to an intermediate stage of development.

The first sketch Falguière produced for the monument was a multifigured arrangement around a modified conical pedestal. It was populated with allegories of the defense of France, the purpose of the Revolution, and personifications of liberty, equality, fraternity, law, and fame.[2] The final model, greatly simplified, was a tremendous monolith of a woman, clothed in a long, belted gown that resembled the costume of contemporary sculptures of Joan of Arc.[3] With her arms lifted in invocation, this giant seemed to rise into the vast reaches of the Pantheon's dome. At her feet was rendered a blindfolded hag, which a contemporary critic called a symbol of ignorance.[4] It had been retained, without doubt, from the model of the present sculpture.[5]

The arrangement of *Revolution Holding the Head of Error* recalls earlier representations of Virtue overcoming Vice.[6] A debt to Cellini's *Perseus* (1545–54, Florence, Loggia dei Lanzi), may account for *Revolution*'s averted eyes as well as the composition as a whole.[7] In Falguière's sculpture, however, the pose of the vanquished figure has been opened up so that almost all of the Cadaver of Monarchy can be seen in a glance. The prone body has an unusual physical presence and importance, almost rivaling that of Revolution. This gives the sculpture a surprisingly scenographic character, which can be discerned also in Falguière's other monumental groups, like *The Seine and Its Tributaries* (*La Seine et ses affluents*, 1878, formerly at the Trocadero, Paris) and *The Triumph of the Revolution*.[8] These groups defy traditional concepts of monumental sculpture, which, according to convention, required more unified silhouettes.

There is in this bronze group, moreover, evidence of a curious dichotomy, which occurs throughout Falguière's sculptured oeuvre, between the naturalistically styled bodies that seem calculated to appeal to the most conventional taste and those like the present figure of Revolution, whose crude surfaces and matted hair are modeled without any acknowledgment of standard norms of corporeal beauty or even everyday reality. In his paintings too this duality is apparent. Some are in full-blown pompier taste, while a picture like *The Wrestlers* (*Les Lutteurs*, 1875)[9] is worthy of competition with Courbet's work, a comparison that was not lost on their contemporaries. Because of this a true characterization of Falguière's style is still, oddly enough, elusive.

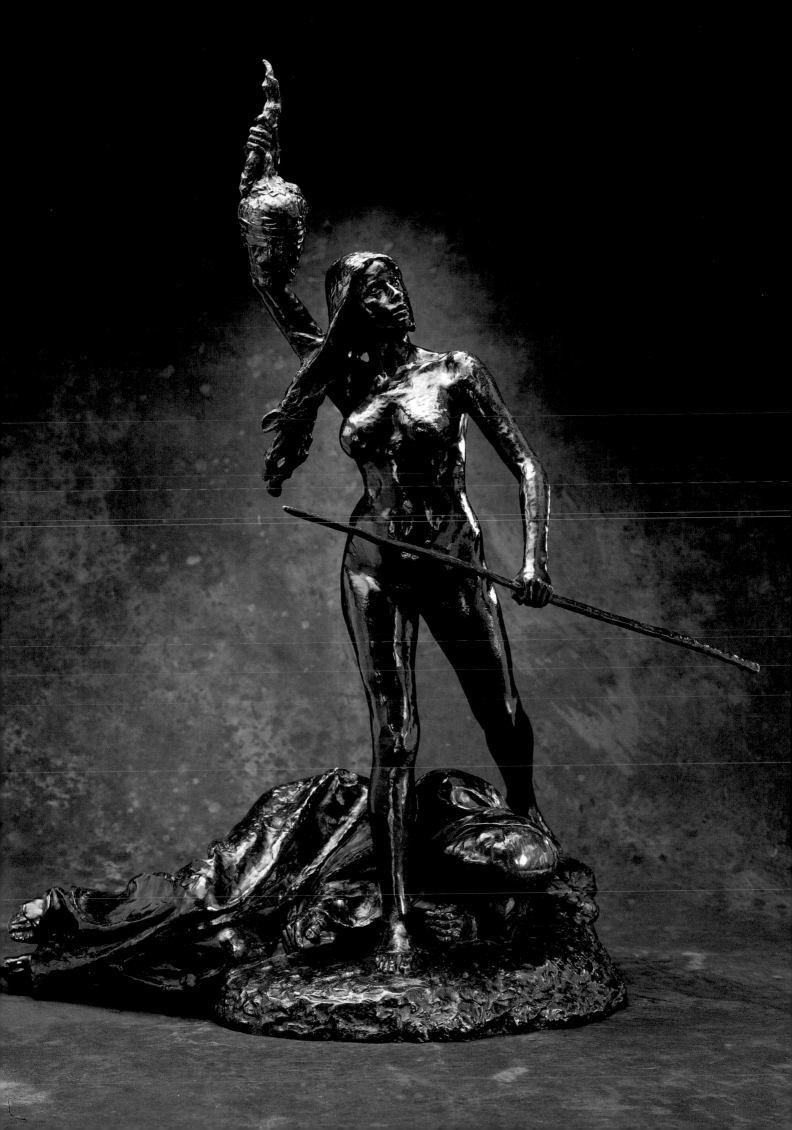

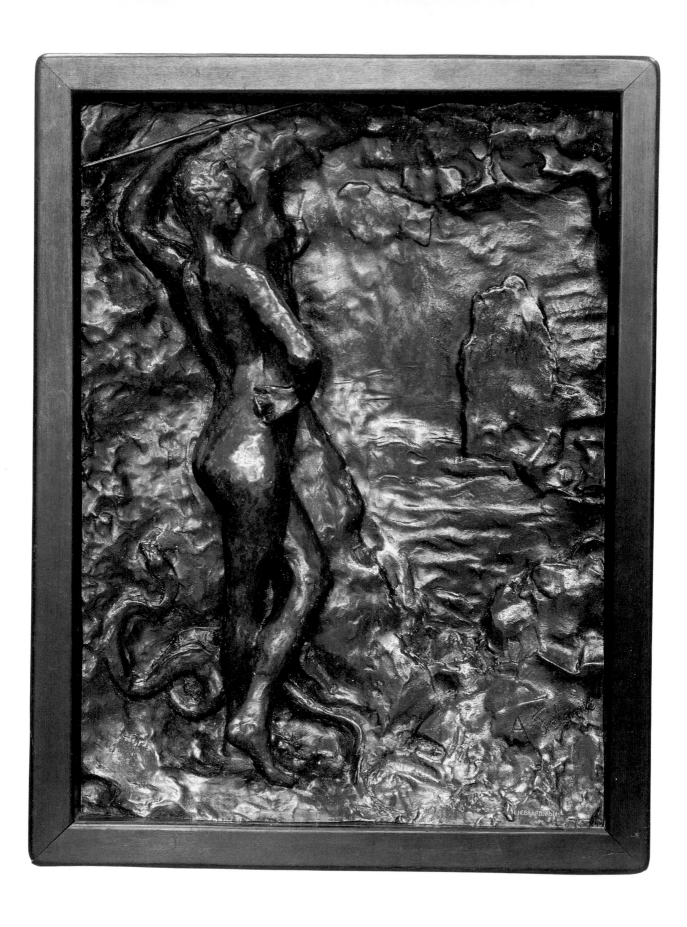

The highly pictorial character of Falguière's sculpture is most obvious in a relief, the type of sculpture most closely related to painting. In the present bronze the legendary sorceress Circe, a serpent coiled at her feet, stands before a seaside grotto, looking out toward an island.[1] A variety of surface textures and modeling techniques creates an illusion of depth and remoteness intended to rival painted seascapes. Circe's body is modeled in highest relief, almost fully in the round, which puts it closest to the viewer and thus in sharpest focus. This effect is enhanced by the dimpled surface of the grotto, set behind her as a repoussoir. The rippling waves of the sea are scored with a slower rhythm and punctuated just before the horizon by a cliff shaped without the surface details that under the laws of optics are lost to the eye in the far distance. The sky beyond is smooth. This twinkling bronze relief is a picture painted only with light and blackness.

The composition of *Circe* (*Circé*) can easily be related to paintings by Falguière, like his *Offering to Diana* (*L'Offrande à Diane*, 1884).[2] In both the painting and the relief the figure is placed like an independent, three-dimensional sculpture before a background. These show how Falguière interchanged his three-dimensional models for use in painting as well as sculpture: except for the raised position of her left arm, the figure of Circe corresponds to a free-standing sculpture seen from the front, illustrated in the June 1, 1898, issue of *La Plume*,[3] which was devoted to him.

That illustration accompanied an article praising Falguière for having developed solutions to formal problems different from those advocated by the instructors at the École des Beaux-Arts. The École was criticized for its policy of teaching students to enliven the composition of a sculpture by building it up through a series of planes and using set formulas of contrapposto. Falguière, by contrast, gave "movement to the arms of some of his statues to form a long, continuous, upright line, full of simplicity and grandeur, that permits the viewer to take in and understand the whole composition at once, without fatigue."[4] Although the serpentine line of Circe's pose conforms perfectly with this formula, the composition of the relief, in contrast, is itself set up in distinct planes.

An example of *Circe* in terra-cotta was listed in the collections of the city of Paris.[5] A wax version is in the Musée Carnavalet.[6] A statuette in marble titled *Circe* was catalogued in Mme Falguière's sale of May 14, 1907.[7]

Jean-Alexandre-Joseph Falguière

FRANCE, 1831–1900

Circe

CATALOGUE NO. 53

c. 1884–98?
Bronze
16 x 11½ x approx. 4 in.
(40.6 x 29.2 x approx 10.2 cm)
Inscribed at lower right:
A. Falguière
Foundry mark below inscription:
HEBRARD.édit/15 (stamped)
Gift of B. Gerald Cantor
M.78.60

Jean-Alexandre-Joseph Falguière

FRANCE, 1831–1900

Portrait of Honoré de Balzac

CATALOGUE NO. 54

1899
Marble
19¼ x 13½ x 11 in.
(48.9 x 34.3 x 27.9 cm)
Inscribed on base, right: A Falguiere
[sic]/1899; front: BALZAC
Gift of B. Gerald Cantor Art
Foundation
M.81.262.1

The story of the Balzac monument, sponsored by the Parisian literary union, the Société des Gens de Lettres, was dominated by Rodin (see CATALOGUE NOS. 31–34), but other artists were also involved in its protracted saga. The commission was awarded in 1888 to Henri Chapu, who died in 1891 before completing a finished monument. Falguière, Antonin Mercié, and Paul Dubois advised the society to proceed in having Chapu's design realized, but Émile Zola, the society's new president, exercised his influence so that the commission would be transferred to the sculptor he advocated, Auguste Rodin.

Rodin's quasi-abstract plaster model (CATALOGUE NO. 34), exhibited in 1898, caused such an outburst of contention that the commission was taken away from him and given to the officially popular and successful Falguière, who was very much in the public eye at that time.[1] Rodin later wrote that Falguière had supported him during the controversy and that this had moved him to do a portrait of Falguière.[2]

When Falguière applied himself to the commission, he apparently returned to Chapu's idea of a seated figure[3] and produced a study for the monument in 1898 that portrayed Balzac in a rather informal pose, with his legs crossed and his hands clasped around his knees. A bronze now in the Maison de Balzac in Paris probably preserves this sketch[4] or is a reduction of the full-scale model, which was ready the following year. In 1900 Falguière, like Chapu before him, died without fulfilling the commission. The definitive marble monument was brought to completion by another sculptor and erected in 1902 close to the house where Balzac died.[5]

A bronze bust of Balzac now in the Musée d'Orsay is said to have been exhibited in all likelihood when Falguière's full-scale model was shown at the Salon des Artistes Français in 1899,[6] and it can be related, in turn, to the present sculpture. This marble bust is considerably more abbreviated than the bronze, the silhouette of its head is broader, and the expression of the face has greater decisiveness. In contrast to the bronze, with its conventional truncation, the present sculpture takes an impressionistic transition to its base, carved in-one with the portrait. The cloudy forms and light hatching of the marble suggest the influence of Rodin's technique of *non finito*, with its illusion of veiling achieved by a feigned lack of finish in the bases and backgrounds of his marble sculptures. The present sculpture thus makes a fitting and ironic tribute to the impact of Rodin's style.

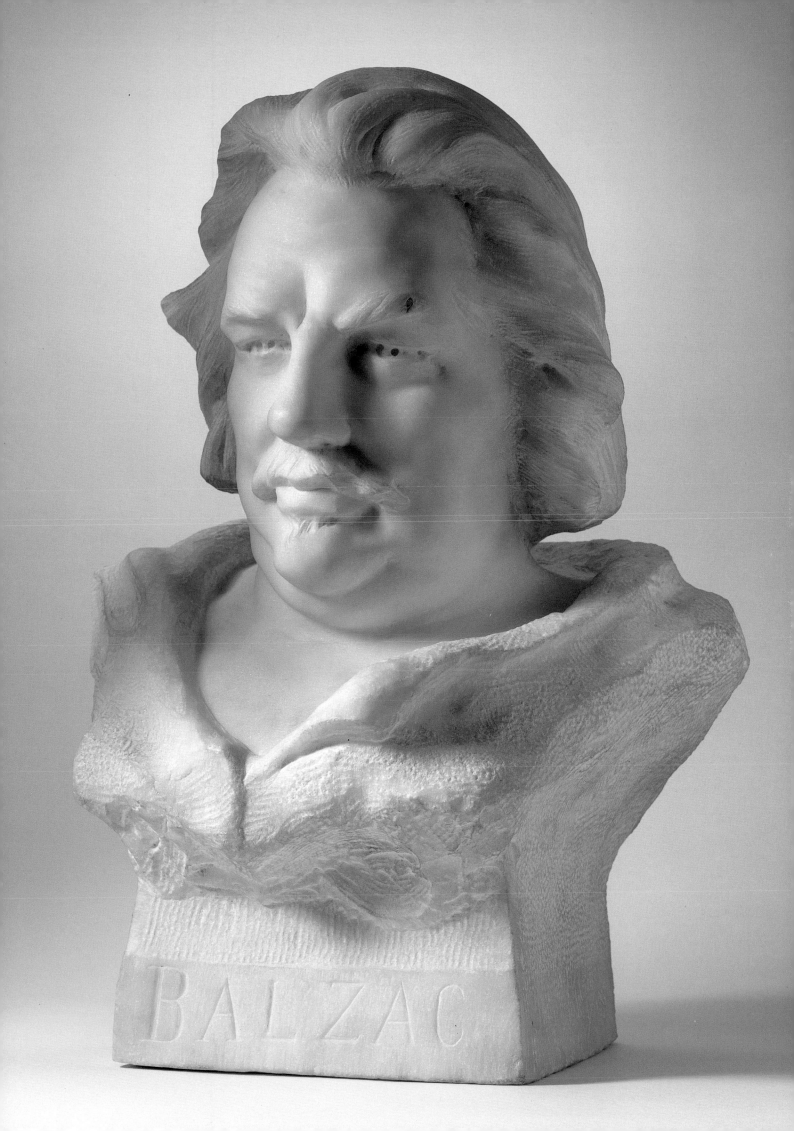

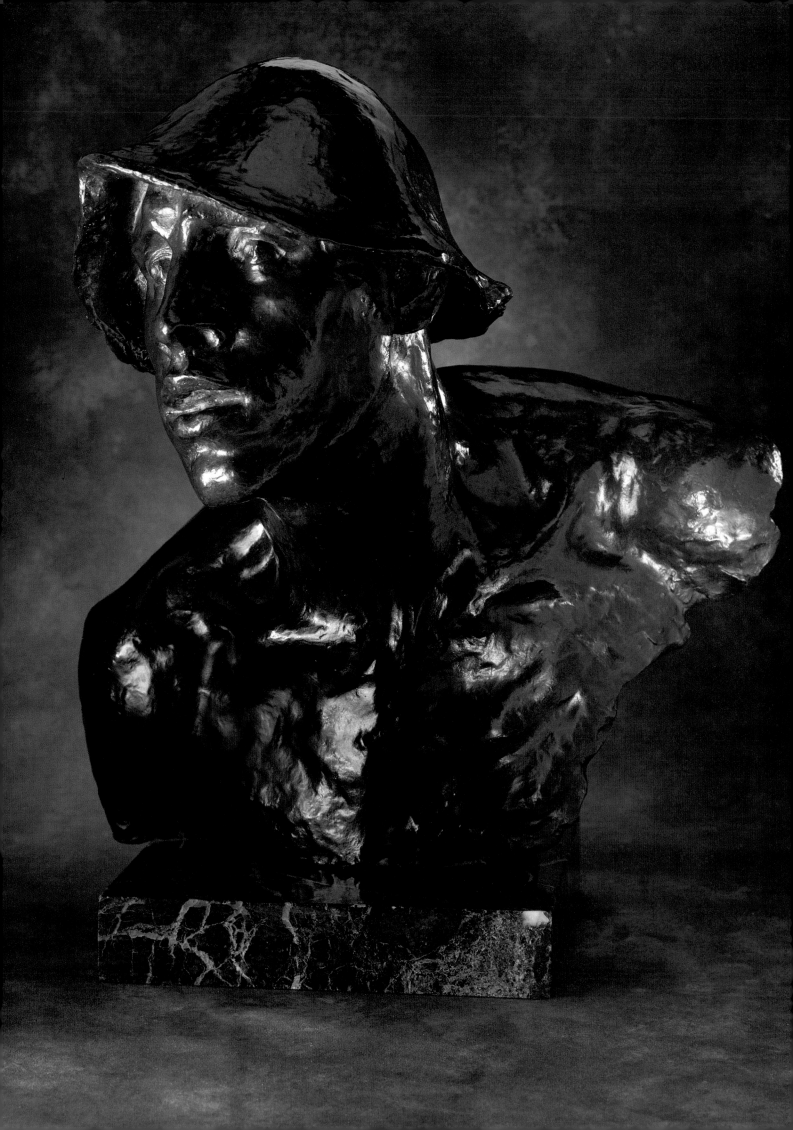

More than any other sculptor the Belgian Constantin Meunier is associated with subjects drawn from the world of heavy industry and its attendant manual laborers, but he did not begin to produce the oeuvre that brought him international recognition until he was well into his maturity. Meunier was already about fifty years old and a relatively well-established painter and recipient of state commissions when his travels to the "Black Land," Belgium's industrial zone, changed his life. "I was struck by that tragic and wild beauty," he wrote. "I felt within me something like the revelation of a life's work.... An immense pity seized me. I was not yet thinking of sculpture.... [Six years after this encounter] without having reflected very much, I made a statue of *The Hammersmith* [*Le Marteleur*, c. 1885]...which was noticed in Paris at the Salon des Champs-Elysées; this was followed by *The Puddler at Rest* [*Le Puddleur au repos*, c. 1885–86]."[1]

Although Meunier seems to have been introduced to the life of the Black Land almost by chance,[2] his methodical study of it was undertaken when he accompanied the writer Camille Lemonnier (1844–1913) on a trip through the region. The socially conscious Lemonnier, who occupied in Belgium the place that Zola held in France, intended to write a series of articles about his country and to have them illustrated by Meunier and the painter Xavier Mellery (1845–1921).[3]

Thanks to Belgium's vast reserves of coal, its industrialization followed soon after that of England and preceded the industrial development of France and Germany by about forty years. The condition of a large number of its workers, however, remained below that of its neighbors. No doubt because of this a workers' political organization, the Parti Ouvrier Belge, was formed in 1885; by 1894 it had become Belgium's second-largest political party. Although it recognized Meunier's work and published his drawings in its newspaper, he never participated in its exhibitions. Meunier never joined the party,[4] but his art could not have taken the direction it did if he had been oblivious to the fact that the drama of the social condition of industrial laborers was imposing itself in the collective awareness. Meunier's simplified style, with its gracefully balanced masses, was favored too by a widespread rejection of academic art, already nearly moribund in Belgium.

The full expression of Meunier's revelation in the Black Land was deferred for a few years, while he filled a government commission that required a sojourn in Spain, although as early as 1880 he exhibited a small painting, *Copperworks* (*La Chaudronnerie*), in Paris.[5] His waxes of *The Puddler* (*Le Puddleur*) and *The Dockworker* (*Le Débardeur*) were shown in

Constantin-Émile Meunier

BELGIUM, 1831–1905

Bust of a Puddler

CATALOGUE NO. 55

Probably 1895
Bronze
18¾ x 17⅛ x 12⅛ in.
(47.6 x 43.5 x 30.8 cm)
Inscribed on back of proper left
shoulder: C. Meunier
Foundry mark on back of proper
right shoulder:
J.PETERMANN.FONDEUR./BRUXELLES.
Gift of B. Gerald Cantor Art
Collections
M.82.126.1

1885 in Antwerp and Brussels.[6] *The Hammersmith* was shown in Paris in 1886, where Octave Mirbeau advocated awarding it the medal of honor. It was apparently then that Meunier came to know Rodin,[7] who remained one of his great admirers.[8] Thereafter followed the "life's work" produced in twenty years: the sculptures, drawings, and paintings of the men, women, and horses that labored in industry and agriculture.

Meunier died while working on his project for the monument to Zola (c. 1904, formerly Paris; destroyed in World War II), commissioned by the Ligue des Droits de l'Homme et du Citoyen (League of the rights of man and the citizen). His close friend Alexandre Charpentier (1856–1909) was his collaborator on this monument, but Charpentier soon followed Meunier to the grave, leaving the project to be completed by others. Meunier's idea for a monument to labor (modeled 1894–1900, Brussels) was carried out with government support after his death.

In Meunier's obituary in the Italian journal *Il Marzocco*, the sculptor Domenico Trentacoste wrote that Meunier "felt all the dark grandeur of those un-self-conscious heroes of modern labor.... In a grand synthesis Meunier grouped together all fundamental aspects of human creation.... [In his painting] *In the Black Land* [1889], a vision of smoking chimneys above a vast, solitary, blackening plain . . . he found the models he would use forever.... The titles of his sculptures alone reveal the essence of his oeuvre."[9]

Bust of a Puddler (Puddleur) bears a similarity to a figure from the left wing of Meunier's triptych *The Mine* (*La Mine*, Brussels, Musée Constantin Meunier),[10] and it is quite independent of *The Puddler at Rest* (Brussels, Musées Royaux), a complete figure that shows a man at rest, just as the title states, not overcome; but in that sculpture the right arm is full of the same energy that is understood in the present bust, which is pitched forward as the puddler turns his rods of iron in the furnace.[11] His eyes and mouth are open in exertion before the heat of molten metal; the sleek planes of glossy bronze stand for his sweating skin. Small wonder that Meunier, who excelled in the fire-art of bronze sculpture, so often chose as his heroes the workers of iron, glass, and coal! Challenged to produce finished materials from raw elements, they push forward industry's cycle of destruction and creation.

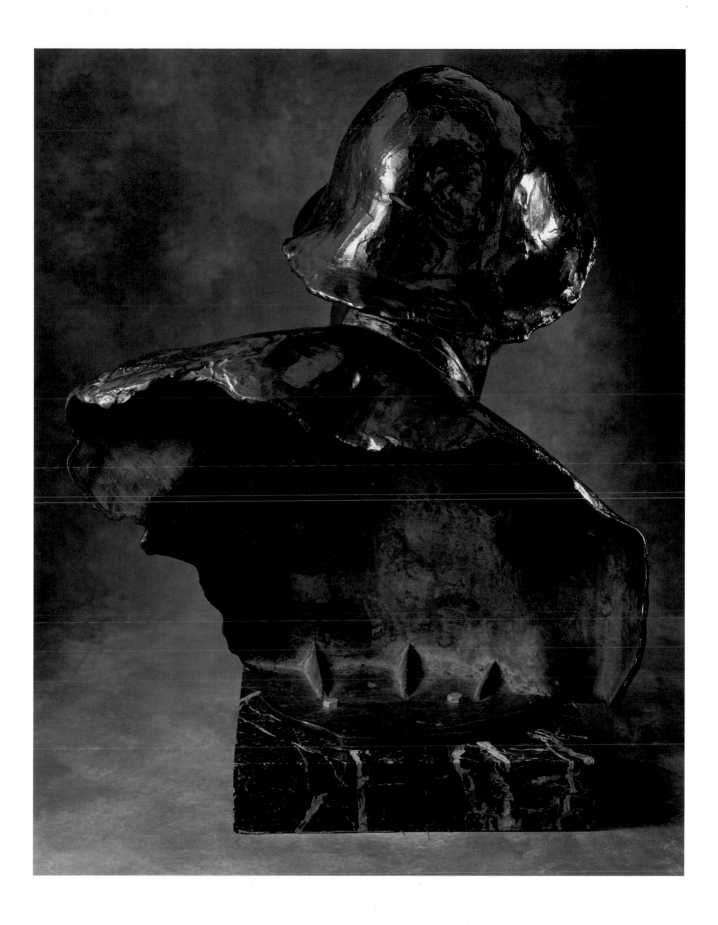

Frédéric-Auguste Bartholdi

FRANCE, 1834–1904

Liberty Enlightening the World

CATALOGUE NO. 56

c. 1884
Bronze
20⁷/8 x 8¹/2 x 6¹/2 in. (53.0 x 21.6 x
16.5 cm) (including base)
Inscribed on base, left:
A. BARTHOLDI; on tablet:
JULY/IV/MDCCLXXVI
Foundry stamp on base, top, back:
THIEBAUT FRERES/FONDEURS/PARIS
(in circular cachet)
Gift of B. Gerald Cantor
M.82.209.3

This bronze is one of a very limited number of reductions cast by the Parisian foundry Thiébaut Frères, apparently in the course of production (1884–89) of a thirty-six-foot replica[1] of the colossus *Liberty Enlightening the World* (*La Liberté éclairant le monde*), which was inaugurated in New York Harbor at Bedloe's Island (now Liberty Island) on October 26, 1886. This monument, known throughout the world as the Statue of Liberty, was designed by Auguste Bartholdi. It was conceived by him with the eminent French historian Édouard-René de Laboulaye not only as a gesture of France's long-standing solidarity with the United States but also as an emblem of the commitment of French republicans to keeping alive the ideal of democracy under the imperial government reinstituted by Napoleon III.[2]

Bartholdi, a native of Alsace, was first trained in architecture. In Paris he continued to study architecture and painting with Ary Scheffer (1795–1858), who advised him to study sculpture too, which he did under the direction of Jean-Antoine Soitoux (1816–91) and Antoine Etex.[3] The determining factor in his creative development, however, was without doubt his journey to Egypt in 1856, taken with the orientalist painter Léon Gérôme (1824–1904). With his own eyes Bartholdi saw the colossi of Memnon at Thebes and the Sphinx at Ghiza. Their stupendous scale fed his imagination, which was already attuned to the gigantic, beginning with his statue of General Jean Rapp (1854–55, Colmar) and culminating in *The Lion of Belfort* (*Le Lion de Belfort*, 1875–80, Belfort)[4] and the Statue of Liberty.

The romance of ancient Egypt seems to have stirred Bartholdi in 1867 to propose a colossal sculpture, *Egypt Carrying the Light to Asia* (*L'Égypte apportant la lumière à l'Asie*), as the lighthouse for the Suez Canal, then being built under the direction of Ferdinand de Lesseps.[5] As a colossal sculpture positioned at the entrance to a harbor, it would have had a direct reference to the Colossus of Rhodes, and as a lighthouse, to the Pharos of Alexandria—two of the seven wonders of the ancient world. Although this project came to nothing, it would seem to have been resurrected in the Statue of Liberty, despite Bartholdi's own denials.[6] The affinity between Bartholdi's terra-cotta models for the Suez lighthouse, which are preserved in the Musée Bartholdi in Colmar,[7] and the illuminated Statue of Liberty is too clear to ignore. Furthermore, the responsibility for obtaining the financing for the statue in France and the pedestal in the United States passed at the death of Laboulaye to Lesseps.[8]

Bartholdi's first known explicit reference to the project of *Liberty* was made in 1869 (the year that the Suez Canal was opened), in December,[9] and the earliest known dated clay sketch for it was modeled the following year.[10]

Bartholdi sailed for New York in 1871 to select a site for the monument.[11] In Europe the Franco-Prussian War triggered the collapse of Napoleon III's empire; the sculptor's native Alsace was relinquished as part of the indemnity paid by France to Prussia. It is likely that this loss strengthened the resolve of the patriotic Bartholdi in the realization of the project.[12] The definitive model for the sculpture was prepared in 1875. This was too late for the statue to be erected for the 1876 celebrations of the centennial of the Declaration of Independence, as Bartholdi had originally hoped, but the full-size torch-bearing right hand (21 feet) was ready for exhibition at the Philadelphia Centennial Exposition that year.[13]

The French firm Gaget, Gauthier et Cie was engaged to produce the successive enlargements of Bartholdi's model to a colossal scale. Photographs taken in their workshops (Colmar, Musée Bartholdi) are a testament to the limitless potential of human ingenuity, and they document Bartholdi's devotion to the project.[14] The final model, built up of planks of wood, was further adjusted by the artist for coherence at the colossal scale.

For the interior structure of the colossus Bartholdi had initially turned to Eugène-Emmanuel Viollet-le-Duc for advice. Although better known for his knowledge and restoration of medieval architecture, he was interested in structural innovations. He died, however, in 1879, so Bartholdi chose Gustave Eiffel, the wizard of large-scale engineering in metal, to invent the internal structure of the colossus. Eiffel designed a wrought-iron spire, from which a cantilevered branch supported the uplifted torch-bearing arm.[15] The Statue of Liberty was made of fine (approx. 1/10 in.) hammered copper sheets attached by trusses to this towering armature.[16]

The imagery of the sculpture comes from several sources, magisterially integrated by Bartholdi: the figure of the woman bearing a torch had numerous antecedents as a symbol of faith and truth before being used to personify revolution or freedom, and her crown with its rays of light, derived from the iconography of Helios (the sun as a deity in ancient mythology), reinforces the "enlightenment" embodied by the monument. The slab held by Liberty has a distant reference to the tablets of the law held by Moses,[17] while the date July 4, 1776, identifies a specific historic event. So too might the chain upon which Liberty treads: only five years before Bartholdi modeled the first version of the sculpture, the United States emerged intact from the bloody Civil War, which ended the scourge of slavery in America.

The facial type and the drapery of the figure are based on Roman sources. Although it has been called a "stock image"[18] by "a man of meager talent,"[19] it was, in fact, an inspired choice for a sculpture of its scale and meaning. Even with similarities to eighteenth-century classicizing images, the

Statue of Liberty draws on a type that had been proven over centuries. It neutralized references to contemporary styles or ephemeral fashions;[20] indeed, the triteness of other French colossal sculptures of the time shows how important Bartholdi's choice would be.[21] The form of the figure can be even better appreciated in comparison with Bartholdi's earlier sketches for the Suez sculpture, which were modeled with a pronounced contrapposto. By straightening the pose, he obliterated all traces of the coquettishness of these previous sketches. The composition, thus strengthened, was given great resolution, while the graceful majesty of the figure's stride and the diagonals of the himation and sleeve of the right arm, which is swept back as the torch is lifted, invest the sculpture with living power. Through his innate feeling for proportion, scale, and economy of design, Bartholdi achieved the harmony required for a sculpture of this tremendous size.

All these qualities can be understood in the present bronze, but ultimately the design was determined by its purpose, which was application to the colossal scale. Eiffel's comments in defense of his own, now eponymous, tower in Paris (1889) could have been spoken for the Statue of Liberty as well:

There is in the colossal an attraction . . . to which the theories of ordinary art are hardly applicable. . . . [Is] it by their aesthetic value that the pyramids have struck man's imagination so strongly? . . . Who is the visitor who remains cold in their presence? . . . Who has not returned from seeing them filled with an irresistible admiration? [22]

It must not be judged by the ordinary standards commonly applied to normal sculptures.

This monument is one of the few to which the word *successful* can be applied with full validity. Rising up from the bastions of Fort Wood in the harbor, its distinctive silhouette is directly understandable from afar.[23] It is a point of stability above the swelling waves, and the crescendo of emotion that is felt in a traveler's stages of approach to it is difficult to duplicate in words. Enhanced by Emma Lazarus's poem, "The New Colossus" (1883), the universality of its appeal is directly united with our country's message to the world.

Bartholdi's achievement is all the more remarkable in that, from the dwindling possibilities offered by a classicizing vocabulary, he created what has become the one, the abiding, emblem of mankind's modern dream.

Aimé-Jules Dalou

FRANCE, 1838–1902

Torso of "Peace"

CATALOGUE NO. 57

Modeled 1879–89
Probably cast later
Bronze
19¼ x 8½ x 7⅛ in.
(48.9 x 21.6 x 18.1 cm)
Inscribed on base, back: J. DALOU
Foundry stamp on base, back, lower
right: SUSSE FRÈRES EDITEURS PARIS
(in circular cachet)/w
Gift of Iris and B. Gerald Cantor
Foundation in honor of the
museum's twenty-fifth anniversary
M.90.143

This composition is the torso of the figure *Peace* (*La Paix*),[1] which with other allegorical figures of liberty, labor, and justice accompanies the chariot of the personification of the republic in Dalou's monument *The Triumph of the Republic* (*Le Triomphe de la République* (FIGURE 10). This is a gigantic ensemble, about thirty-three feet high, weighing about forty tons, erected at the Place de la Nation in Paris in 1899.[2] The generous physical scale of its figures, lush decorative details, and heroic composition make it one of the most grandiose freestanding monuments in France. It was the greatest achievement of Dalou's career.

Although Dalou came from humble beginnings, his natural talent in the modeling of clay brought him to the attention of Jean-Baptiste Carpeaux, who recommended him for instruction at the Petite École, where he enrolled in 1852.[3] There he became acquainted with Rodin, who would remain, almost to the end of their lives, his admirer, friend, and competitor.[4] Two years later Dalou was admitted to the École des Beaux-Arts in the studio of Francisque Duret, but he became disaffected with academic instruction and quit the school, earning his livelihood partly in taxidermy and goldsmith's work and partly by making ornamental sculpture. Dalou's most important commission of the latter type was in the collaborative effort on the lavish neo-Renaissance decor of the *hôtel* of the marquise de la Païva. In this Parisian mansion, a prime example of Second Empire flamboyance, Dalou's marble, bronze, stucco, and tinted plaster figures intermingled with those of Albert-Ernest Carrier-Belleuse and Louis-Ernest Barrias (1841–1905).

The downfall of the government of Napoleon III in 1870 was the turning-point in Dalou's life. The artist was an avowed social democrat; he was involved in the short-lived commune that sprang up in place of the imperial government. In July 1871, when in its turn the commune also collapsed, Dalou fled to London. He achieved considerable success there. His naturalistic sculptures of robust women engaged in everyday activities[5] won the attention of a wide public, including that of Queen Victoria. Dalou was chosen to create a memorial to the queen's grandchildren who had died at a young age; the terra-cotta was installed in the royal chapel at Windsor Castle.

In 1879 a general amnesty was declared in France for the opponents of the imperial government. Before Dalou returned to his native country that year, he entered the competition sponsored by the city of Paris for a monument to the French republic. His project did not conform with the requirements of the designated site, so it could not win the competition. The merit of the design was such that the city decided to have Dalou's monument carried

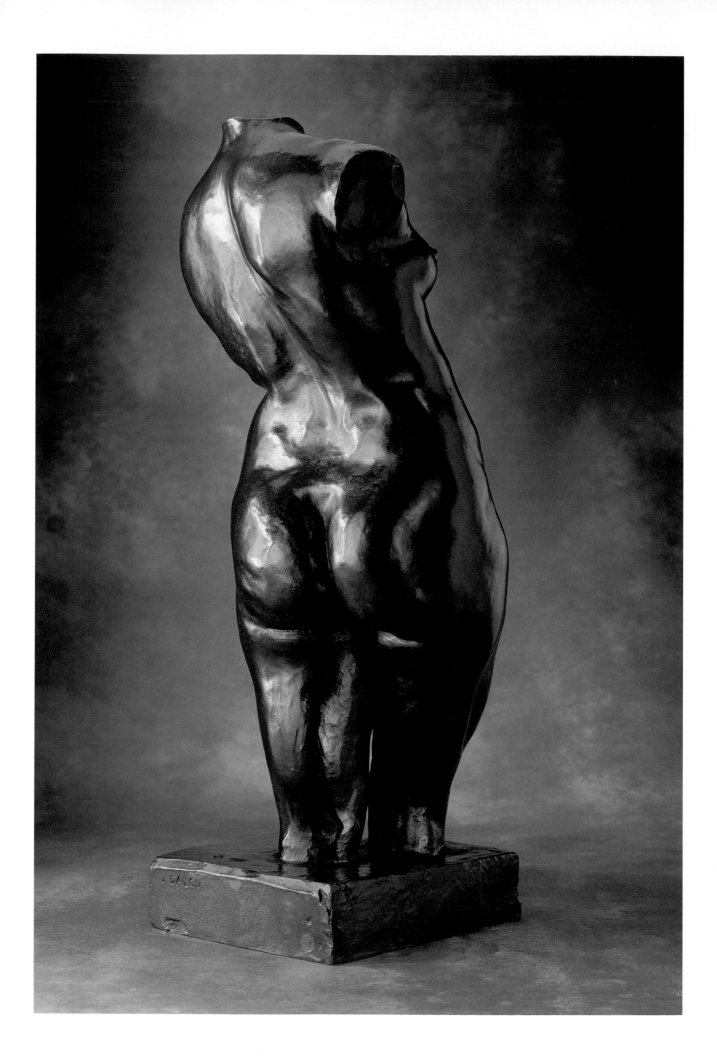

FIGURE 10

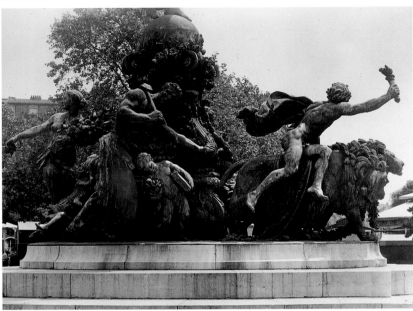

out anyway, but in a different location, the Place de la Nation. His full-scale patinated plaster model was unveiled to the public in 1889 with great ceremony. The finished *Triumph*, the most ambitious bronze-casting project of the nineteenth century in Europe, was erected ten years later.[6] The format of this bronze cortège and the amplitude of its individual members show its debt to the baroque Triumphs painted by Rubens[7] and the sculptured ensembles designed by Bernini.

The idea of making fragmentary figures that were to be understood as complete, independent works of art is most often associated with Rodin, but the *Torso of "Peace"* predates many of Rodin's fragments. Dalou's sculpture thus takes on an added historical significance. That Dalou intended the *Torso of "Peace"* to exist as a finished work of art can be adduced from the fact that he signed a patinated plaster example of it (Paris, Musée du Petit Palais),[8] although the decision to cast it in bronze was apparently made after his death.[9]

While the corpulence of this torso might show the influence of the fleshy ideal body of baroque art, its well-nourished form is itself the appropriate symbol of the abundance assured by peace. Its upward spiral can be interpreted as embodying the optimism of the French republic as the country emerged from one hundred years of political turmoil.

Aimé-Jules Dalou
France, 1838–1902
The Triumph of the Republic
(*Le Triomphe de la République*, detail),
1879–99
Bronze
Height: approx. 33 ft. (10 m)
Paris, Place de la Nation
Photo: Marburg/Art Resource

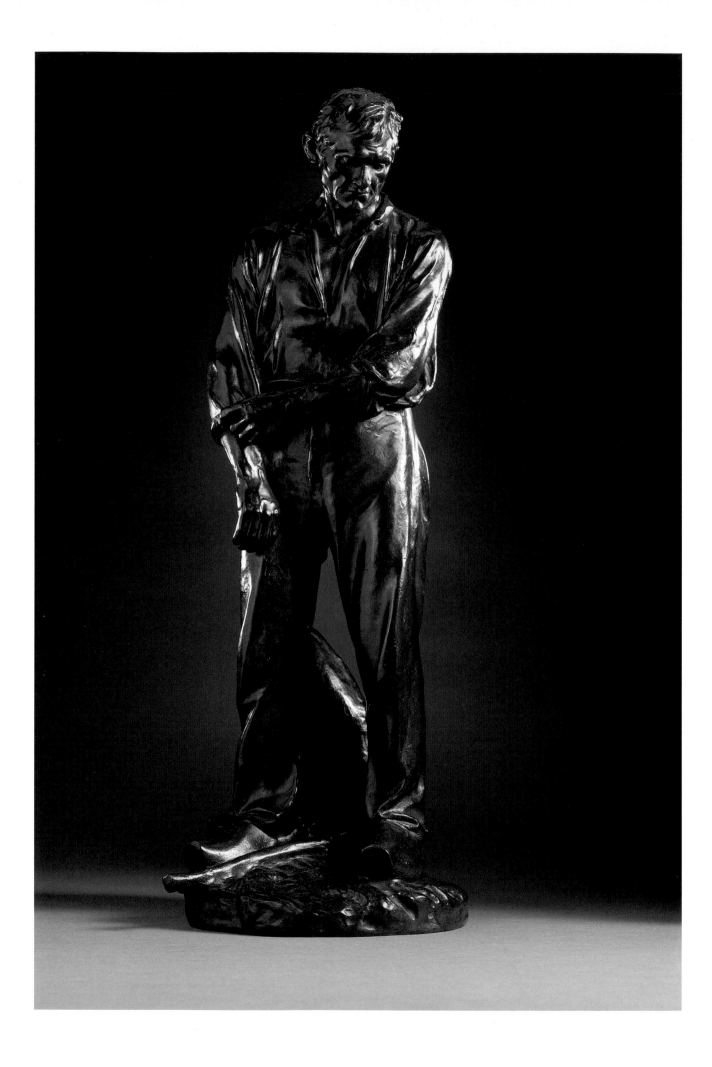

Dalou's *Peasant* (*Le Paysan*) evolved from sketches prepared for an ambitious monument to labor, which was never completed.[1] The idea for the monument came to Dalou in 1889 at the ceremonies for the unveiling of the plaster model of his *Monument to the Republic* (see CATALOGUE NO. 57).[2] Dalou was chagrined by the military character, customary though it was, of the parades at the ceremony. Deploring the comparatively limited number of manual laborers involved in this celebration of democracy, he decided to create a monument from which those workers would never be excluded, because it would be a monument dedicated to them alone.[3]

Dalou, known for his integrity and eloquence, was committed to the egalitarian ideals of the new French republic. In what was still a stratified society he saw the honor, valor, and dignity of the plebeian. As early as 1873 his terra-cotta *French Peasant Nursing Her Child* (*Paysanne française allaitant son enfant*) acknowledged the value of the peasant's life by treating it in life-size sculpture. He modeled two more full-size terra-cottas of related subjects in the 1870s.[4]

As the 1890s unfolded, Dalou worked on dozens of terra-cotta sketches of peasants and workers in various trades, developing the idea of his *Monument to Labor*. Before the decade ended, he had achieved the model for the definitive scheme of the monument. Set on a squared socle, it rose like a great blunted column, the phallic symbolism of which, according to Dalou's own account, alluded to Priapus, antiquity's god of gardens and abundance.[5] Around the base of the column sixteen niches were to house statues of laborers about six and a half feet tall.[6]

Dalou's was one of three ambitious projects designed at the turn of the century to honor the efforts of workers. The other two were by the Belgian Constantin Meunier (see CATALOGUE NO. 55) and Rodin,[7] but only Meunier's was realized in any way. It has been said that Dalou did not know of Meunier's plans for a workers' monument in Brussels.[8] Nevertheless he could not have been completely unaware of the different activities generated in Belgium for the amelioration of the social condition of its workers. From a confluence of political and cultural developments emerged new directions in literature, music, and the visual arts,[9] sponsored especially by the group Les XX and its successor, the Libre Esthétique. Their salons in Brussels provided a forum for Meunier, his collaborator, Alexandre Charpentier, Rodin, the impressionists and fauves, and the designers of art nouveau. There were ample reasons for Dalou to say that the idea for a monument to labor was "in the air."[10]

Aimé-Jules Dalou

FRANCE, 1838–1902

The Peasant

CATALOGUE NO. 58

c. 1897–99
Bronze
16 7/8 x 6 1/4 x 6 1/4 in.
(42.9 x 15.9 x 15.9 cm)
Inscribed on support, back:
DALOU/Susse Freres Ed ts/Paris;
on base, below proper left foot:
cire perdue
Foundry stamp on support, back:
SUSSE FRÈRES EDITEURS PARIS
(in circular cachet)
Gift of Iris and B. Gerald Cantor
M.86.219.1

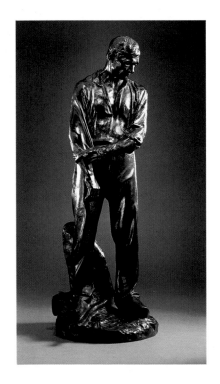

Meunier's life-size plaster *Hammersmith*, exhibited in Paris in 1886, was by virtue of its scale like a monument in itself. Charpentier, devoted to egalitarianism and social justice and possibly influenced by Dalou,[11] modeled a heroic, plaster relief *The Bakers* (*Les Boulangers*, 1889), which was produced in glazed, polychromed terra-cotta in 1902 (Paris, Square Scipion),[12] as well as several medals and plaquettes honoring stonecutters, masons, master craftsmen, and the writer Émile Zola, who championed social reform. Rodin's monument to labor, destined to remain a visionary's maquette (1898–1908, Meudon, Musée Rodin), was an arcaded tower honoring mankind's work and progress, represented by sculptures within its arches.[13]

By 1895 Dalou had produced a monument to the agronomist Jean-Baptiste Boussingault (Paris, Conservatoire des Arts et Métiers).[14] Its format was conservatively pyramidal, with a bust elevated on a column and flanked by two figures, one of them a peasant, rendered with a realism more direct than any of the stylized sculptures modeled by Meunier and Charpentier. Dalou's powers of observation were acute, and his feeling for naturalism was innate. When he applied himself to the model of the present bronze, he achieved an independent figure of uncanny presence. The facial features are more particularized, the shape of the clothes is less streamlined than those in Meunier's sculptures, and the stance is one of absolute simplicity. The subtle artistry of this bronze can be found precisely in its directness and reticence: a slight pull on the sleeve draws a horizontal around the body; the pensive glance directed to the earth carries with it a reflection on the nature of life. It was through the model of *The Peasant* that Dalou, by his own testament, chose to be remembered.[15]

Dalou's biographer and executor, Maurice Dreyfous, wrote that as the sculptor's coffin was carried toward the cemetery at Montparnasse, whole phalanxes of workers emerged spontaneously from their factories and workshops to accompany the artist's body out of the city.[16]

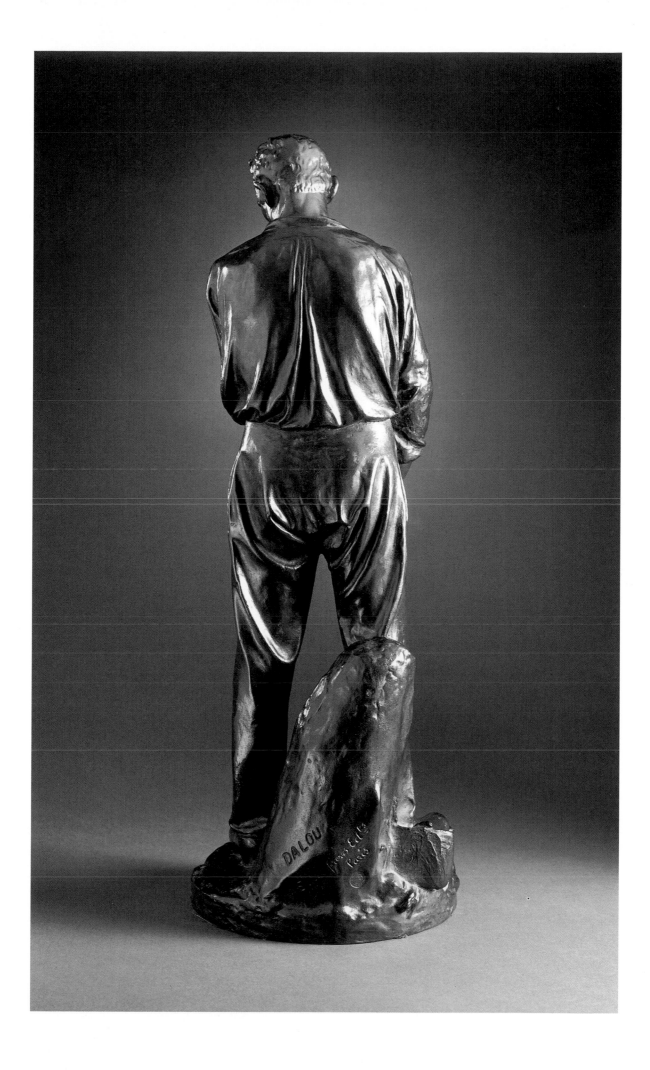

Domenico Trentacoste

ITALY, 1859–1933

Portrait of the Actress Emma Gramatica

CATALOGUE NO. 59

1900
Terra-cotta
10³/₁₆ x 8 x 1³/₈ in.
(25.9 x 20.3 x 3.4 cm)
Inscribed at upper right:
EMMA/GRA/MATI/CA; at left:
AN/NO/MCM; at lower left:
D. TRENTACOSTE
Gift of B. Gerald Cantor Art
Foundation
M.80.82

The daughter of a stage prompter and a costume seamstress, Emma Gramatica (1875–1965) ignored the dissuasive remarks of those who told her she would never succeed in the theater. Persisting in her efforts, she became as famous as her older sister, Irma, and second only to Italy's greatest actress, Eleonora Duse. Described as headstrong, cultivated, and intelligent, she seems to have made a specialty of plays by such Northern writers as George Bernard Shaw and Henrik Ibsen, often portraying characters with temperaments completely unlike her own. In her later years she played roles both on stage and in the cinema (FIGURE 11).[1]

In 1900, when she was twenty-five years old, Gramatica affirmed herself professionally in the lead role of Gabriele d'Annunzio's *La Gioconda*.[2] That year Domenico Trentacoste modeled this portrait of her in the brilliant clarity of a pure profile, which is tempered by the softly impressionistic treatment of her hair, the fuller relief of the bust, the lightly scumbled surface of the field, and the neutral simplicity of her tunic. In addition to the carefully delineated profile, the flatness of the sculpture and the importance given to the legend immediately express the very medallic character of this composition. Not surprisingly its author, Trentacoste, was one of the outstanding Italian medalists of the early twentieth century.[3]

As a youth in Sicily Trentacoste overcame the abject poverty into which he was born by using a small amount of money, earned for the decorative accessories of Vittorio Emmanuele's funeral catafalque, to make his way to Florence to study art, presumably in 1878, the year the king died. Eventually he went on to Paris. His stubborn and wry character, wittily described by his friend the critic Ugo Ojetti,[4] saw him through the difficulties of this early period of the 1880s. He finally penetrated the circle of important Parisian artists of the day, succeeded at the salons, and triumphed in 1891 at the Royal Academy in London when the princess of Wales bought one of his sculptures. With continuing success in international exhibitions, including first prize in sculpture at the first Biennale in Venice, he returned to Italy in 1895 to make his home in Florence. There he was appointed a professor at the Institute of Fine Arts, a position he held until his death in 1933. (Marino Marini [1901–80] was one of his students.)

Parisian sculpture clearly influenced his style. His *Portrait of Mme Herbillon*[5] has an obvious reference to Jean-Baptiste Carpeaux's work and possibly to Rodin's as well (*Portrait of Mme Vicuña*, 1888). Rodin's influence can also be felt in a study Trentacoste did for a fountain,[6] where the melancholy of the figure that is seen from the back is expressed by the

EMMA
GRA-
MATI
CA

AN
NO
MCM

U·TRENTACOSTE

attitude of the body alone (thus recalling *La Douleur*, CATALOGUE NO. 23); Trentacoste's *Niobid* (*La Figlia di Niobe*, Venice, Galleria Moderna)[7] is like a descendant of Stefano Maderno's *Saint Cecilia* (1599, Rome, Santa Cecilia) and Rodin's *Danaïd* (CATALOGUE NO. 35). Rodin's influence is most obvious in Trentacoste's *Cain* (*Caino*, 1903, Rome, Galleria Nazionale d'Arte

FIGURE 11

Emma Gramatica
with Vittorio De Sica in
Napoli d'altri tempi, 1938
Astra Film Productions
Directed by A. Palermi

Moderna),[8] which has a great resemblance to *The Thinker*.

The *Portrait of Emma Gramatica* owes a debt to French medallic art of its time. Toward the end of the nineteenth century a renewed interest in the medal was fostered in Paris. A looser, more fluid style of modeling brought new life to an art form that had become rigidified and mechanical as a consequence of designers' temptation to exploit only the technical advances in machine-made medals. Louis-Oscar Roty (1846–1911) revived the rectangular format of the plaquette, little used since the sixteenth century. Jules-Clément Chaplain's (1839–1909) flair in the handling of graphics and his superb treatment of the structure of faces (FIGURE 12) brought new vibrancy to the portrait medal and undoubtedly influenced the treatment of Gramatica's profile, with its strong jaw and noble carriage.[9]

Trentacoste's style is also rich in subtle historical references to the Italian Renaissance.[10] His *Emma Gramatica* surely acknowledges the profile portraits of Quattrocento reliefs,[11] and the present example of the actress's portrait, modeled in rosy terra-cotta,[12] is part of the long tradition of the use of this material in Italy, so expressive of the warmth and expansiveness of the Southern temperament.

FIGURE 12

 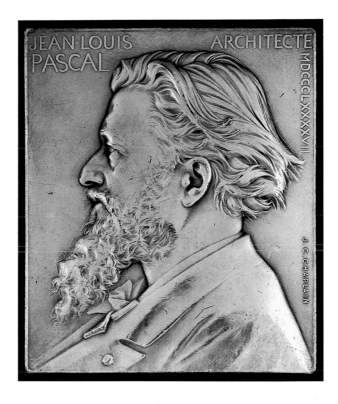

Jules-Clément Chaplain

France, 1839–1909

Jean-Louis Pascal, 1897

Silvered bronze

2³/₄ x 2³/₈ x ³/₄ in. (71 x 60 x 2 mm)

Purchased with funds provided by the

Marion Davies Collection and funds

donated in memory of Mrs. Mary

M. Edmunds

79.4.113

Émile-Antoine Bourdelle

FRANCE, 1861–1929

Bust of Rodin

CATALOGUE NO. 60

1909–10
Bronze
35 x 27 x 24 in.
(88.9 x 68.6 x 61.0 cm)
Inscribed on front: AU MAITRE
RODIN/CES PROFILS; on back:
Bourdelle (in relief)/sculpt; at lower
edge: © BY BOURDELLE
Foundry mark at proper left: SUSSE
FONDEUR Paris Nº 2
Gift of B. Gerald Cantor Art
Foundation
M.73.108.23

The many practitioners who worked for Rodin were employed in various capacities. Some worked on the pointing of models, others carried out enlargements, some were responsible for patination of bronzes, and still others collaborated on the carving of marble. Of these practitioners several went on to achieve fame in their own right, such as Jules Desbois (1851–1935), Joseph Maratka (1874–1937), and Jacques-Lucien Schnegg (1854–1909). Today the best known are Antoine Bourdelle, Charles Despiau (1874–1946), and François Pompon (1855–1933).[1]

Bourdelle was born to a poor family in Montauban in southwestern France.[2] His grandfather was a goatherd and his father a cabinetmaker. The double heritage of earthiness and handiwork was manifest early in his life, as he tended goats and modeled figurines as a child. Assisting his father by carving ornament for furniture, he attracted the attention of two philanthropists, who sponsored his first formal studies in Toulouse in 1876. In 1884 a scholarship provided by the city of Montauban allowed him to study in Paris, where he won entrance to the École des Beaux-Arts and acceptance into Alexandre Falguière's studio. Unable to bear the school's rigid academic program of competitions and prizes for more than two years,[3] he went to work on his own, producing several portrait busts. In 1893 he began his first major monument, commonly called *The Montauban Monument* (*Le Monument aux combattants et défenseurs du Tarn-et-Garonne, 1870–1871*), completed by 1902 and dedicated to the heroes of the Franco-Prussian War who had defended the district of the Tarn-et-Garonne, where Montauban is located.[4] Falguière's influence can be seen in its busy silhouette, but the forms modeled by Bourdelle were bolder, heavier, and more expressionistic than his teacher's.

It was also in 1893 that Bourdelle entered Rodin's studio as a practitioner to earn a dependable salary.[5] He continued in this capacity until 1908.[6] Bourdelle was a protégé of Judith Cladel's father, and he adored Rodin, Cladel noted, before he entered Rodin's employ. He "was carried away by his enthusiasm" for Rodin.[7] Although he carved for Rodin, Bourdelle did not imitate his style, yet his respect for Rodin never diminished. In 1907 Bourdelle conceived a book of their correspondence about medieval cathedrals, but the letters were never written, and in 1922 Claude Aveline suggested publishing some of Bourdelle's notes and the lecture he gave in Prague in 1909 in homage to Rodin. This book includes sketches of Rodin at work as preparatory studies for Bourdelle's sculptures of Rodin in bronze.[8] His standing portrait of Rodin (1910, Musée Rodin) represents the master like Moses, holding a relief sculpture instead of the tablets of the law. It was surely no coincidence that one of the sculptures most admired by Bourdelle was Michelangelo's *Moses*, with its "nearly divine expression."[9]

The present *Bust of Rodin* (*Buste de Rodin*) is a truncation of that full-length portrait, but its form has been further consolidated by the suppression of the arms. To judge from one of the drawings in Bourdelle's book, *La Sculpture et Rodin*,[10] which shows Rodin tightly grasping a slab, Bourdelle may, in fact, have contemplated such a compact silhouette for a bust that was from the outset completely independent of the full-length bronze. The obdurate character of this portrait is enhanced by the angular, denaturalized stylization of the beard. The inscription *"ces profils"* (these profiles) refers to Rodin's method of developing a composition by recording a sequence of silhouettes:

When I begin a figure, first I look at the front, the back, and the two profiles [i.e., contours] within the four corners; then, using clay, I set up the basic form as I see it, as exactly as possible. Then I do the intermediary [views], [that is] the profiles seen [when the form is viewed] at three-quarters; then, successively turning the clay and my model, I make comparisons between them, and refine them.[11]

Bourdelle quoted Rodin's evocation of the profound formal meaning of his "profiles": "[Finally] there is calm, the tranquility of the profiles penetrates you." Bourdelle added his own recognition of "the need for the completeness [fullness] balanced and contained by the firmness of the profiles."[12] This appreciation for determinate form gives Bourdelle's work its disciplined vigor.

Bourdelle's over-life-size statue *Carpeaux at Work* (*Carpeaux au travail*, FIGURE 13) was first exhibited in 1909.[1] It was commissioned by the Musée des Beaux-Arts of Lyons.[2] Bourdelle made separate studies of the hands in plaster, which were cast in bronze by the Musée Bourdelle in order to preserve them better.[3] The present bronze is the left hand from the portrait of Carpeaux; the right was also cast separately.[4]

A reference to Rodin's marble *The Hand of God* (*La Main de Dieu*, 1902),[5] with its highly autobiographical charge, is unavoidable in the context of Bourdelle's conception of a portrait of an artist and his relationship with the artist he called his master. *The Hand of God* is a superb manifesto of the sculptor's power: unlike painting, which is an illusionistic art, sculpture claims the modeling of plastic reality. Such symbolism is implicit in a comparison of *The Hand of God* with the life-cast of Rodin's right hand holding a model of a woman's torso, which was made shortly before his death in 1917 by Paul Cruet.[6] In addition to this, it is clear that Bourdelle considered the motif of a hand holding a small sculpture an important aspect of Rodin's iconography, because it appears in five of Bourdelle's drawings in his reflections on art.[7] Furthermore, Clare Vincent has shown that the torso in the *Hand of Carpeaux* is not a sculpture by Carpeaux but is instead Rodin's *Galatea* (*Galatée*, 1889).[8]

Rodin's influence on Bourdelle can also be discerned in various "fragments" that Bourdelle treated as independent works of art, like the *Despairing Hand* (*Main désespérée*, c. 1900) and the *Hands of Séléné* (*Mains de Séléné*, 1917).[9] Bourdelle's style, however, was less fluid than Rodin's. The difference between *The Hand of Carpeaux* and Rodin's *Large Clenched Hand with Figure* (CATALOGUE NO. 46) is obvious; Bourdelle's dictum to his students of "Contain, maintain, and master; this is the order of the builder"[10] can be understood immediately through this comparison.

FIGURE 13

Émile-Antoine Bourdelle

FRANCE, 1861–1929

Left Hand of Carpeaux

CATALOGUE NO. 61

1909
Possibly cast later
Bronze
12 1/4 x 13 3/4 x 5 1/4 in.
(31.1 x 34.9 x 13.3 cm)
Inscribed at truncation, back:
© By BOURDELLE; above this: his
star-shaped monogram; on top
of sleeve near cuff: 1908 Musée
Bourdelle cast no. 1/10
Foundry mark on back, at lower
edge: Susse Fondeur Paris Nº 1
Gift of B. Gerald Cantor
M.70.7

Émile-Antoine Bourdelle
France, 1861–1929
Jean-Baptiste Carpeaux at Work,
c. 1908–9
Bronze
98 1/2 x 42 in. (250.2 x 106.7 cm)
The Metropolitan Museum of Art, gift of
Mr. and Mrs. B. Gerald Cantor, 1983
1983.562

Émile-Antoine Bourdelle

FRANCE, 1861–1929

Head of the Figure of Eloquence

CATALOGUE NO. 62

1916–18
Bronze
19 x 14¼ x 18³/₁₆ in.
(48.3 x 36.2 x 46.2 cm)
Inscribed on neck, proper left side:
AB (in star-shaped monogram);
on back: © BY BOURDELLE
Foundry mark on back: № 4 /
Susse Fondeur/Paris
Gift of B. Gerald Cantor Art
Foundation
M.83.65

Émile-Antoine Bourdelle
France, 1861–1929
Monument to General Alvear, 1912–25
Bronze, granite, and masonry
Height: about 50 feet (15.25 m)
Buenos Aires, Plaza de la Recoleta

This bronze is the head of the personification of eloquence, which stands with those of strength, liberty, and victory at the base of Bourdelle's monument to General Carlos María de Alvear, erected in 1925 at the Plaza de la Recoleta in Buenos Aires (FIGURE 14). Bourdelle did the preliminary model for the ensemble in 1912 and won the commission the following year.[1] This commission from the Argentine government is said to have been initiated by a connoisseur of Argentine descent, Rodolfo Alcorta, who knew Bourdelle in Paris, but the coincidence of Alvear's grandson's having been appointed Argentina's ambassador to France (from 1916 until 1922, when he was elected president of Argentina)[2] in the later years of Bourdelle's work on the monument might have given some impetus toward its completion.

General Alvear was a founder of the quasi-Masonic Lautaro Lodge, which installed a new government in the form of a general constituent assembly in 1812–13. Although the assembly did not overtly declare independence from Spain, its symbolic gestures toward reformation reflected democratic concerns. Titles of nobility were abolished, slavery was to be slowly eliminated, and certain limits imposed on traditional practices of Catholicism had parallels with the secularization advocated during the French Revolution.[3] Alvear was named supreme director of this government, but by 1815 he was caught in a complex web of political forces, many of which depended on changing fortunes in Europe: Napoleon was defeated and Ferdinand VII was restored as king of Spain. Alvear began to seek better relations with Spain and England, and he was increasingly viewed by the revolutionaries in rural areas as representing the centralized power of the urban capital. He was overthrown in 1815.[4]

FIGURE 14

Bourdelle's monument, set on a wide, square base, consists of an equestrian bronze of Alvear supported on a tall quadrangular shaft, which is articulated on each side by a flattened arch. The system is executed with the restraint that enhances the heavy solidity of masonry walls. Near the base of the shaft a broad band supports the four over-life-size bronze allegories of strength, victory, liberty, and eloquence. The poses of these figures are nearly as compact and

186

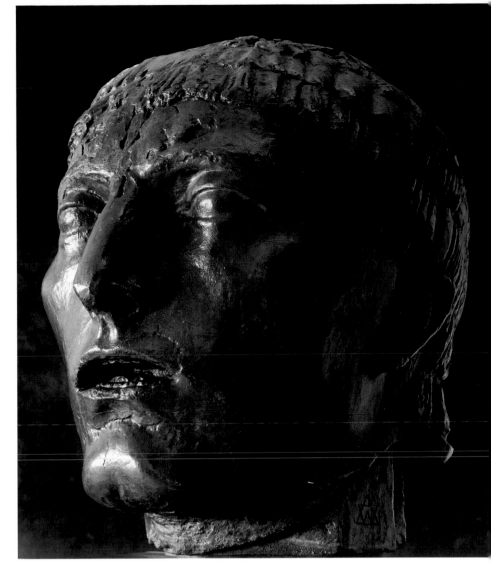

dense as those of statue-columns. Even *Eloquence* (*Éloquence*), which should traditionally open into a gesture communicating its symbolism, stands immobile, its arms straight down. The only movement in the figure is in its stiff turn to the proper left; the only symbolic action is conveyed by the mouth, open to speak. The firmness and cohesiveness of this one personification is echoed throughout the disciplined structure of the entire monument: even the equestrian gives an impression of rigidity. The horse is posed in near-immobility.[5] The monument shows the salient characteristics of Bourdelle's style.

Engaged to carve marble for Rodin, Bourdelle was equally adept as a sculptor in bronze, and his mature work is a synthesis of the two activities. This was, in fact, demonstrated as early as 1900 in his bronze *Head of Apollo* (*Tête d'Apollon*), which provoked Rodin to exclaim, "Bourdelle, you are leaving me!"[6] In contrast to Rodin's supple figures, Bourdelle's were obdurate. He explored the planarity of modeled surfaces, and often his treatment of bronze had a lapidary quality. Although bronze is a tractable material, Bourdelle's hands invested it with flinty density.

Bourdelle admired Romanesque sculpture for its solidity, its plastic coherence, its architectonic character, and its monumentality. These properties deeply informed his own sculptures. He worked primarily on the monumental scale,[7] which was consistent with his interpretation of the venerable grandeur and expressive force of sculpture. His style also shows his esteem for antique types,[8] which are, however, treated with only limited references to classical antiquity. The *Head of Eloquence*, for example, detailed with an angular rendering of the hair, offers only a tenuously identifiable similarity to Archaic vocabulary.

Such geometric stylization is especially appreciable in his monumental reliefs for the Théâtre des Champs-Élysées (1910–13),[9] the *Monument to the Dead of the War of 1914–1918* (*Monument au morts de la guerre 1914–1918*, 1919–30),[10] and the Mickiewicz Monument (1910–24),[11] which combine impulses of expressionism with art deco and the discipline of cubism. In his interpretation of figurative sculpture Bourdelle stood at the watershed of representational art and the pure abstraction practiced by future generations.

Prince Paul Troubetzkoy

ITALY, 1866–1938

Portrait of Rodin

CATALOGUE NO. 63

1905–6
Bronze
20¼ x 13 x 13 in.
(51.4 x 33 x 33 cm)
Inscribed on front of base:
Paul Troubetzkoy
Foundry stamp on left: Valsuani
Purchased with funds provided
by Iris and B. Gerald Cantor
Foundation
M.90.54

Prince Paul Troubetzkoy was born in Intra in northern Italy, close to the city of Verbania on Lake Maggiore, where today the Museo del Paesaggio houses an extensive collection of his plaster models. Troubetzkoy inherited his title from his father, Peter, a Russian aristocrat who had moved to Florence as an attaché in the Russian embassy. His mother, Ada Winans, was an American singer who came to Italy to study music. Their Villa Ada on Lake Maggiore became the setting for a lively salon that attracted writers, musicians, and artists. Among these was the sculptor Giuseppe Grandi (1843–94), the leading figure of the artists called the Scapigliati (disheveled).[1] Rejecting orthodox academic precepts of order, finish, and symmetry, the Scapigliati advocated a fresh, sketchy technique in painting and sculpture, which they saw as fully interrelated art forms.[2] Grandi's style would have a direct influence on Troubetzkoy's decades later.

Even in his childhood lessons Paul Troubetzkoy displayed exceptional talent in drawing and modeling. His mother showed one of his sculptures to Grandi, who immediately noticed the boy's ability. Troubetzkoy was enrolled in art school in Milan, but he resisted academic training. Nevertheless he won a number of commissions and prizes, and with them came recognition and success.

He moved to Moscow in either 1897 or 1898. Ironically this artist who treated academic doctrines with such insouciance was invited by 1898 to teach at the Imperial Academy of Fine Arts. He instructed his students to study directly from life instead of plaster casts. Troubetzkoy had a singular feeling toward nature. An avowed vegetarian, he had an almost utopian attitude toward the animal world. He kept pet wolves among his huskies and had two tame bears; the sculptures he made of these companions are among the most sensitive animal sculptures in Western art.[3] His friendship with the humanitarian Count Leo Tolstoy (1828–1910), whom he portrayed several times in bust-length portraits and equestrian statuettes, confirmed his convictions.[4]

Troubetzkoy moved as easily among aristocrats as he did among his beasts. Both were the subjects of sculptures exhibited in Milan, Venice, and at the International Exposition of 1900 in Paris, where Troubetzkoy won the grand prize. An equestrian portrait of Tolstoy was acquired by the French government for the Musée du Luxembourg[5] (now in the Musée d'Orsay). He was noticed by Rodin; their acquaintance may date from this time.[6] In Moscow he won the commission for a monument to Alexander III (1900–1909, now in St. Petersburg, State Russian Museum).

The political disturbances of 1905, foreshadowing the Bolshevik revolution of 1917, prompted Troubetzkoy to quit Moscow for Paris.

He became a member of the Société Nouvelle des Peintres et Sculpteurs (New society of painters and sculptors). Its chairman was Rodin. Troubetzkoy's portrait of Rodin was completed by April 1906, when Jean Mériem noted it in his article on Troubetzkoy for the magazine *L'Art et les artistes.*[7]

In this portrait, which bears the characteristic marks of Troubetzkoy's confident, quick touch, Rodin is shown in an attitude full of self-assurance and candid elegance. With his hands thrust into his pockets and his elbows out, his silhouette is widened and made more powerful and assertive, despite the otherwise casual nature of his pose. The present bronze, tawny as cured tobacco shot with bright green, was most likely cast from a model in wax, not from the plaster in the Museo del Paesaggio.[8]

Rodin's was only one of the many portraits that brought Troubetzkoy international fame. In New York the noted collector Archer Huntington arranged for the most extensive exhibition of Troubetzkoy's work held until that time (1911), and by 1919 Troubetzkoy had set up a studio in Hollywood. Paris, however, was essentially his residence, until near the end of his life he returned to Italy and died from acute anemia, still refusing to eat animal flesh.[9]

Today Troubetzkoy is known primarily as a society portraitist. The society portrayed by him, however, is not just the worldly Vanderbilts, Huntingtons, or Montesquiou; it was also an aristocracy of the creative spirit that knew no borders. Besides Tolstoy and Rodin, the society of his acquaintances and subjects of his portraits included the artists Giovanni Boldini, Rembrandt Bugatti, Paul Helleu, Ilya Repin, Giovanni Segantini, and Joaquín Sorolla y Bastida; the writers Gabriele d'Annunzio, Anatole France, and George Bernard Shaw; and the singer Enrico Caruso.

In a sense Troubetzkoy's portrait statuettes are the descendants of a type of sculpture, developed around 1830, which has been classified under the newly coined name *sculpture-mémoire* (memory sculpture).[10] These veristic figurines were highly detailed portraits of the celebrities of the day. As souvenirs they offered records of the appearance of their subjects much as photographs were to do a few years later. In contrast to these statuettes intended for the popular market, however, Troubetzkoy's bronzes on the whole were not produced in vast numbers (the major exception being, perhaps, the Dancers he made in the 1910s), and their subjects, known to him personally, would not be considered "popular" either, apart from Tolstoy and Rodin. Troubetzkoy's style had none of the meticulousness of the earlier statuettes. To the contrary, his intention was only to suggest a fashion through contour and a limited number of details, modeled in rapid, broad strokes. Although costume was employed to enhance the vivid presence of the sitter (as, for example, in the seated portrait of Adelaide Aurnheimer, 1898),[11] it was never rendered in a way that would preserve every last detail of the subject's appearance.

Troubetzkoy said that great art was simply the faithful interpretation of the material furnished by life;[12] he wanted only to give an impression of his living heroes. Few sculptors have succeeded as he did in evoking the dynamism of the creative process of the artist, the vitality of his sitters, and the vanished world they shared.

Prince Paul Troubetzkoy

ITALY, 1866–1938

Mother and Child

CATALOGUE NO. 64

Probably 1907
Bronze
15 x 12½ x 13⅞ in.
(38.1 x 31.8 x 35.2 cm)
Inscribed at left front:
Paul Troubetzkoy
No foundry mark
Gift of Iris and B. Gerald Cantor
Art Foundation
M.85.268.2

Troubetzkoy met the Swedish Elin Sundstrom (1883–1927) in Stockholm in 1898. They were married in 1902. Their only son, Pierre, was born in 1905 and died at the end of 1907, while they were in Paris.[1] The tragedy provides an approximate date for this double portrait of the artist's wife and child, which was probably shown in Paris in 1908 in a marble entitled *Mother and Child* (*Mère et enfant*).[2]

Elin Troubetzkoy's hieratic pose is softened by her instinctively gentle embrace of her son, who is seated more casually, off-center on his mother's lap. The faces are smoothly finished, but their small features are only summarily rendered, with much of their definition depending on the play of shadows in the contours rather than upon actual detailing. The neckline of Elin's kimono is the only identifiable accessory in this portrait; otherwise the sculpture consists essentially of virtually unformed material handled with the distinctive, impressionistic technique of the Scapigliati (see CATALOGUE NO. 63). Elin's tapering fingers and Pierre's delicate limbs are conjured from this mass of bronze. Their natural grace and casual elegance are the charm of Troubetzkoy's portrait style. A sense of luxury is communicated by the artful interplay of colors and textures in the surface, with shadowy whites and hints of malachite green in a patina suggestive of antiquity.

The composition succeeds because the boldly modeled forms, which seem almost uncontrolled, are disciplined by a strict inner structure, set out in the direct frontality of the pair. A pure vertical drawn through the center and marked by the edge of her sleeve, straight as a plumb line, is the axis upon which Elin's otherwise relaxed posture is balanced. This dominant vertical is cut by the neat horizontal of her arm; together they form a perpendicular grid of control. The broad base provides a stable context and larger environment for the group, as it does in the portrait of Rodin (CATALOGUE NO. 63) and the more highly elaborated seated portraits by Troubetzkoy, like those of Count Robert de Montesquiou (1907) and Mme Aurnheimer (both Musée d'Orsay).

It is this pyramidal form, favored above all others by Troubetzkoy, which attracted the attention of Gabriele d'Annunzio in 1892. Praising Troubetzkoy's competition model for the monument to Garibaldi in Naples as the best of any of the candidates, d'Annunzio wrote that Troubetzkoy

alone has shown that he has an exact idea of what a work of art should be. He has understood that in a work of art all the various effects must converge in unity. In fact, he renounced haphazard decorative tricks, wishing [instead] to guide the eye of the viewer up the path of a simple formula right to the head of the hero, knowing full well that all the parts of the work must

contribute to showing heroic character most powerfully in the head, [along with] energy and the sublime nature of [the heroic] will. He chooses the pyramid for his basic form; it is, in the abstract geometric sense, the symbol of greatness; having broken it off at the top, he uses the head of the hero to mark off the ideal apex. Nothing distracts the viewer's eye, trained on that apex.[3]

Troubetzkoy, who cared nothing about the opinions of others, responded to this glowing praise and trenchant analysis, "D'Annunzio? Who's d'Annunzio?"[4] He made two portraits of the great Italian writer, one in the year of the review and another in Paris in 1911.

Elin Troubetzkoy died in 1927.

FREQUENTLY CITED SOURCES

AMBROSINI AND FACOS
Ambrosini, Lynne, and Michelle Facos. *Rodin: The Cantor Gift to the Brooklyn Museum*. Brooklyn: Brooklyn Museum, 1987.

BARBIER
Barbier, Nicole. *Marbres de Rodin: Collection du musée*. Paris: Musée Rodin, 1987.

BEAUSIRE
Beausire, Alain. "Oeuvres de Rodin." In Vilain, Jacques, ed. *Claude Monet — Auguste Rodin: Centenaire de l'exposition de 1889*. Exh. cat. Paris: Musée Rodin, 1989.

CLADEL
Cladel, Judith. *Rodin, sa vie glorieuse, sa vie inconnue*. Paris: Bernard Grasset, 1936.

DE CASO AND SANDERS
De Caso, Jacques, and Patricia Sanders. *Rodin's Sculpture: A Critical Study of the Spreckels Collection, California Palace of the Legion of Honor*. San Francisco: Fine Arts Museums of San Francisco; Rutland, Vt., and Tokyo: Charles E. Tuttle, 1977.

DESCHARNES AND CHABRUN
Descharnes, Robert, and Jean-François Chabrun. *Auguste Rodin*. Lausanne: EDITA, 1967.

ELSEN 1963
Elsen, Albert. *Rodin*. New York: Museum of Modern Art, 1963.

ELSEN 1981
Elsen, Albert, ed. *Rodin Rediscovered*. Exh. cat. Washington, D.C.: National Gallery of Art, 1981.

ELSEN 1985
Elsen, Albert. *"The Gates of Hell" by Auguste Rodin*. Stanford: Stanford University Press, 1985.

FONSMARK
Fonsmark, Anne-Birgitte. *Rodin: La Collection du Brasseur Carl Jacobsen à la Glyptothèque*. Copenhagen: Ny Carlsberg Glyptotek, 1988.

FUSCO AND JANSON
Fusco, Peter, and H. W. Janson, eds. *The Romantics to Rodin: French Nineteenth-Century Sculpture from North American Collections*. Exh. cat. Los Angeles: Los Angeles County Museum of Art; New York: George Braziller, 1980.

GOLDSCHEIDER
Cécile Goldscheider. *Auguste Rodin: Catalogue raisonné de l'oeuvre sculpté*. Vol. 1, *1840–1886*. Lausanne: Wildenstein Institute; Paris: Bibliothèque des Arts, 1989.

GRAPPE
Grappe, Georges. *Catalogue du musée Rodin*. Vol. 1, *Hôtel Biron. Essai de classement chronologique des oeuvres d'Auguste Rodin*. Paris: Musée Rodin, 1927.

GRAPPE 1944
Grappe, Georges. *Catalogue du musée Rodin*. Vol. 1, *Hôtel Biron. Essai de classement chronologique des oeuvres d'Auguste Rodin*. 5th ed. Paris: Musée Rodin, 1944.

KEISCH
Keisch, Claude, ed. *Auguste Rodin: Plastik, Zeichnungen, Graphik*. Exh. cat. Berlin: Staatlichen Museen, 1979.

MAISON ET AL.
Maison, Françoise, Anne Pingeot, and Dominique Viéville, eds. *De Carpeaux à Matisse*. Exh. cat. Lille: Association des Conservateurs de la Région Nord-Pas-de-Calais, 1982.

PINGEOT 1986
Pingeot, Anne, ed. *La Sculpture française au XIXe siècle*. Exh. cat. Paris: Grand Palais, Réunion des Musées Nationaux, 1986.

PINGEOT 1990
Pingeot, Anne, ed. *Le Corps en morceaux*. Exh. cat. Paris: Grand Palais, Réunion des Musées Nationaux, 1990.

PINGEOT ET AL.
Pingeot, Anne, Antoinette Le Normand-Romain, and Laure de Margerie. *Musée d'Orsay: Catalogue sommaire illustré des sculptures*. Paris: Réunion des Musées Nationaux, 1986.

SCHMOLL
Schmoll gen. Eisenwerth, J[osef] A[dolf]. *Rodin-Studien*. Munich: Prestel, 1983. This volume includes a bibliography of works about Rodin up to 1983 (pp. 415–574).

SPEAR
Spear, Athena Tacha. *Rodin Sculpture in the Cleveland Museum of Art*. Cleveland: Cleveland Museum of Art, 1967.

TANCOCK
Tancock, John. *The Sculpture of Auguste Rodin: The Collection of the Rodin Museum, Philadelphia*. Boston: Godine, 1976.

VINCENT
Vincent, Clare. "Rodin at the Metropolitan Museum of Art," *Metropolitan Museum of Art Bulletin* 38, no.4 (spring 1981): 1–48.

NOTES

● *Catalogue no. 1*

1. Antonia Nava Cellini, *La scultura del settecento* (Turin: UTET, 1982), pp. 164–67. Corradini (1668–1752) came from the Veneto, but he carved *Tucia* in Rome.

2. Ibid., pp. 98–100. See most recently Oderisio de Sangro, *Raimondo de Sangro e la Cappella Sansevero* (Rome: Bulzoni, 1991).

3. In Milan at the Palazzo Reale. They were heavily damaged during World War II (Cellini, *La scultura*, p. 124).

4. In the church of Sta. Maria Maddalena dei Pazzi. Ibid., p. 144; and John Pope-Hennessy, *Catalogue of Italian Sculpture in the Victoria and Albert Museum* (London: HM Stationery Office, 1964) 2: cat. no. 683 (the terracotta model, but catalogued as *Penitence*).

5. Giuseppe Campori, *Memorie biografiche degli scultori, architetti, pittori, ecc., nativi di Carrara* (Modena: Tipografia di Carlo Vincenzi, 1873; reprinted, Bologna: Forni, 1969), pp. 158–59.

6. Elena di Majo and Stefano Susinno, "Pietro Tenerani, da allievo di Thorvaldsen a protagonista del purismo religioso romano: Una traccia biografica," in *Bertel Thorvaldsen, 1770–1844: Scultore danese a Roma*, exh. cat. (Rome: De Luca, 1989), p. 313.

7. Ibid., pp. 314–15; and Campori, *Memorie biografiche*, p. 242. Tenerani was the son of Marchetti's sister, who had married a master quarryman.

8. Renato Carozzi, "La Scuola di Carrara tra Canova e Bartolini," in Mario di Micheli, ed., *Scultura, marmo, lavoro: Triennale internazionale 1981 Carrara*, exh. cat. (Milan: Vangelista, 1981), pp. 228–30.

9. Gérard Hubert, *Les Sculpteurs italiens en France . . . 1790–1830* (Paris: E. de Boccard, 1964), pp. 89–90, 160.

10. Klaus Lankheit, "Zwischen Idealismus und Realismus: Die italienische Skulptur auf den Weltausstellungen des 19. Jahrhunderts," in *Von der napoleonischen Epoche zum Risorgimento*, vol. 15 of *Studien zur italienischen Kunst des 19. Jahrhunderts; Italienische Forschungen*, 3d ser. (Munich: Bruckmann, 1988), pp. 205–10.

11. Cellini calls attention to the intriguing suggestion made by M. P. Paresca and V. Vaccaro ("Massoneria ed ermetismo nella Napoli del '700: La Cappella Sansevero," *Psicon* 4 [1974]: 101–11) that the veiled *Chastity* has an additional, Masonic significance referring to "initiation and resurrection, in the form of Isis or Persephone" (*La scultura*, p. 166).

● *Catalogue no. 2*

1. H. W. Janson asserts that it is not a relief ("Historical and Literary Themes," in Fusco and Janson, p. 71); Alan Darr, that it is ("François Rude," in ibid., p. 352). Rude's sketches for the sculpture (e.g., Musée Carnavalet, inv. no. s836; and Louvre, inv. no. RF2433, illustrated in Pingeot 1986, p. 170) are high reliefs, but the figure of the young boy in the forward plane was carved virtually in the round. Measurements given by Stanislas Lami (*Dictionnaire des sculpteurs de l'école française au dix-neuvième siècle*, s.v. "François Rude") for the sculpture on the Arc de Triomphe are 12.7 x 6 m with figures of 5.85 m.

2. Darr studies the example in the Los Angeles County Museum of Art (Fusco and Janson, pp. 352–53).

3. Several variants are listed in Darr (ibid., p. 356 n. 14). The present bronze is not the example shown in that exhibition. See also Meribell Parsons, *Sculpture from the David Daniels Collection*, exh. cat. (Minneapolis: Minneapolis Institute of Arts, 1979), cat. no. 58.

4. Although Louis de Fourcaud wrote that he could find no documentation for the existence of this brigade (*François Rude, sculpteur: Ses Oeuvres et son temps* [Paris: Librairie de l'Art Ancien et Moderne, 1904], p. 26), such evidence seems to have been discovered subsequently by Joseph Calmette

(*François Rude* [Paris: H. Floury, 1920], p. 3). Fourcaud's comment that "Rude spoke about the brigade to his friends so often, and with such precision" might support an argument for the importance of this experience in Rude's life.

5. Fourcaud, *Rude*, pp. 41–51. He notes that Cartellier encouraged Rude to explore the use of costumes other than classical ones ("even the ancient French costume") and the affective potential of gesture and attitude (p. 50).

6. Amaury Lefébure in *Bronzes "De la Renaissance à Rodin": Chefs-d'oeuvre du musée du Louvre*, exh. cat. (Tokyo: Tokyo Metropolitan Art Museum, 1988), cat. no. 65.

7. Paul Gsell, *Art by Auguste Rodin*, trans. Mrs. Romilly Fedden (Boston: Small, Maynard, 1912) pp. 69–70.

8. The history of the choice of subjects is summarized by Ruth Butler, "'Long Live the Revolution, the Republic, and Especially the Emperor!': The Political Sculpture of Rude," in Henry Millon and Linda Nochlin, eds. *Art and Architecture in the Service of Politics* (Cambridge: MIT Press, 1978), pp. 93–98. The arch was no longer intended to honor Napoleon's army but everyone who had defended France. See also Daniel Rabreau, "L'Arc de Triomphe: De la gloire au sacrifice," in Pingeot 1986, pp. 163–67.

9. Rude provided sketches for several subjects. Butler proposes that this did not mean that Rude was to have been the sole author of the arch's sculptures but rather that he was responding to Thiers's request for iconographic suggestions ("'Long Live the Revolution,'" pp. 96–98).

- *Catalogue no. 3*
1. Ruth Butler, "'Long Live the Revolution, the Republic, and Especially the Emperor!': The Political Sculpture of Rude," in Henry Millon and Linda Nochlin, eds. *Art and Architecture in the Service of Politics* (Cambridge: MIT Press, 1978), p. 93.

2. Louis de Fourcaud, without citing a primary documentary source (*François Rude, sculpteur: Ses Oeuvres et son temps* [Paris: Librairie de l'Art Ancien et Moderne, 1904], p. 407). Fourcaud's appended chronology provides essentially the same information as his earlier study in the *Gazette des beaux-arts*, 3d ser., vol. 5 (March 1891): 222–26, 232–33.

3. Ibid., p. 496.

4. Ibid., pp. 403, 497. Rude wrote that he had been working on the model for more than a year. The title is given by Rude. Jupiter could take the form of an eagle, but he also used the eagle as his messenger.

5. Ibid., pp. 404–5.

6. Ibid., p. 499.

7. Ibid., p. 407.

8. Ibid., p. 503.

9. Joseph Calmette, *François Rude* (Paris: H. Floury, 1920), p. 154. The wax model is in the Musée des Beaux-Arts of Dijon (illustrated in Pierre Quarré, "Musée des Beaux-Arts de Dijon: Nouvelles Acquisitions," *Revue du Louvre* 14, nos. 4–5 [1964]: 253–54).

10. Isabelle Leroy-Jay Lemaistre, "*Hébé et l'aigle de Jupiter*," in *Bronzes "De la Renaissance à Rodin": Chefs-d'oeuvre du musée du Louvre*, exh. cat. (Tokyo: Tokyo Metropolitan Art Museum, 1988), p. 254.

11. Ian Wardropper of the Art Institute of Chicago kindly provided details about the example (in warm brown bronze) in that museum. The bronze (light golden patina) in the Minneapolis Institute of Arts was published by Meribell Parsons, "Nineteenth-Century French Sculpture: Jean-Pierre Dantan and François Rude," *The Minneapolis Institute of Arts Bulletin* 58 (1969), pp. 61–63. Another example is in the Art Museum, Princeton University. Recently an example cast by Thiébaut, Fumière et Gavignot passed at auction in London (Christie's, 29 October 1992, lot no. 32); the cup and diadem correspond to those of the Los Angeles bronze, as does the striated drapery.

12. Most notable are the silvered bronzes (probably c. 1855–59) by Albert-Ernest Carrier-Belleuse. A large bronze by Charles Buhot (1815–65) may have been inspired directly by Rude's sculpture (an example passed at auction, Christie's, Wrotham Park, Herts., 2 October 1990, lot no. 207). For other sculptures of Hebe, see Peter Fusco, in Fusco and Janson, cat. no. 139 (bronze by Jules Franceschi).

13. Letter quoted in *François Rude 1784–1855: Commémoration du centenaire*, exh. cat. (Dijon: Musée des Beaux-Arts, 1955), cat. no. 93.

- *Catalogue no. 4*
1. He added "d'Angers" to his name to distinguish it from that of the painter Jacques-Louis David (1748–1825).

2. A summary biography and fundamental essay on *Philopoemen* are given in a superb essay by James Holderbaum, "Pierre-Jean David d'Angers," in Fusco and Janson, pp. 211–12, 222–23.

3. In Paris David studied with Philippe-Laurent Roland (1746–1816). David was in Rome 1812–15.

4. Which sculptors could seem further apart than Canova and David? It is true that David denigrated many of Canova's sculptures because they were decorative and had no pedagogic raison d'être; he also criticized Canova's writings on art. ("I desperately hoped to find in his writings some great thought on the moral purpose of art. How surprised I was to find they that were nothing more than little jottings, [like] grammatical [aphorisms]!" Quoted in Henry Jouin, *David d'Angers: Sa Vie, son oeuvre…* (Paris: E. Plon, 1878), 2:27. Jouin notes, however, that David was said to have gone every night to Canova's studio (ibid., 1:82). David himself indicates that he "owed much to Canova" (ibid., 1:79), and his account of the following incident suggests that Canova's work incited him to devote himself to sculpture with a more elevated heroic purpose. David wrote,

*One night...I was...at Canova's studio
...he was talking about his art....*

*I contemplated his [Three Graces and
other mythological figures].... There was
a moment at which I thought I saw them
move in the dusk like fabulous appari-
tions...[as though] these poetic figures
were going to leave their pedestals and
begin to dance. In that moment every-
thing that was seductive in those lovely
forms spoke to my imagination; sculpture
seemed to me like a pure expression of
exquisite beauty, like the art that made
form divine.... But when I left the studio
and went out into the quiet streets of
Rome and breathed the night air and
calmed down somewhat, I felt a powerful
reaction; the austere recollection of
Poussin...ordered me to remember
myself; I was then at the mercy of another
kind of exaltation; I felt my soul rise up to
the regions of thought, I recalled the pre-
cepts of Plato. The statues that I encoun-
tered here and there on my path and
[which] form, so to speak, another popula-
tion in Rome, redoubled in me the vener-
ation of heroes. They revealed to me all
the grandeur of sculpture, destined to per-
petuate heroic virtues ["mâles vertus"],
[examples of] noble loyalty, and made the
features of a man of genius live 4,000
years after he died. I say make them live,
because I dreamed, in my enthusiasm, of
animating marble and bronze, I wanted
to show movement and life [ibid., pp.
247–48].*

Could David have come to such a pro-
found understanding of his own calling
without a fundamental knowledge of
Canova's art?

In this context it is important to note
that David never portrayed mythological
figures.

Canova's thoughts on art, recorded as
long epigrams, are hardly superficial.
They were collected and edited by
Melchior Missirini and published in 1824
as *Pensieri di Antonio Canova su le belle
arti* (and newly reprinted as Antonio
Canova, *Pensieri sulle arti* [Montebelluna:
Amadeus, 1989]).

5. His *Alphonse de Lamartine* is dis-
cussed by Isabelle Lemaistre in Jean-René
Gaborit et al., *Skulptur aus dem Louvre,
89 Werke des französischen Klassizismus
1770–1830*, exh. cat. (Karlsruhe: Prinz-
Max-Palais, 1989), cat. no. 89.

6. Holderbaum, "David d'Angers,"
p. 211.

7. Henry Jouin, *David d'Angers*,
2:49.

8. Ibid., 1:318.

9. Ibid. The version given in André
Bruel, ed., *Les Carnets de David
d'Angers* (Paris: Librairie Plon, 1958),
2:41, is slightly different.

10. Henry Jouin, *David d'Angers*,
1:319.

11. Cf. Bruel, *Les Carnets*, 2:177. The
face of David's *Philopoemen* is much like
Rude's *Head of the Old Warrior* (CATA-
LOGUE NO. 2), completed in 1836.

12. Holderbaum, "David d'Angers,"
p. 222.

13. Ibid. The model is in the Musée
d'Angers.

14. Ibid., p. 223; and Bruel, *Les
Carnets*, 2:117, 269.

15. Holderbaum, "David d'Angers,"
p. 223.

16. Meribell Parsons, *Sculpture from
the David Daniels Collection*, exh. cat.
(Minneapolis: Minneapolis Institute of
Arts, 1979), cat. no. 53.

17. Holderbaum, "David d'Angers,"
pp. 222–23.

● *Catalogue no. 5*

1. A thorough discussion of this
bronze is offered by James Holderbaum
in Fusco and Janson, cat. no. 102. The
spelling of Gutenberg's name on the base
is a kind of elision to ease pronunciation
in French. On the base of a terra-cotta
version of the Gutenberg statuette the
name is spelled "Guttenberg," and on a
bronze in the Louvre it is spelled
"Guttemberg." The inscription *Et la
lumière fut* (Genesis 1:3) identifies the
page as the beginning of the Bible printed
by Gutenberg, the first book produced
by movable type.

2. Henry Jouin, *David d'Angers: Sa
Vie, son oeuvre...* (Paris: E. Plon, 1878)
2:512; cited by Holderbaum ("Pierre-Jean
David d'Angers," in Fusco and Janson,
p. 225 n. 57). David saw the reductions of
his sculptures produced by Collas as a
way of providing examples of them to a
broad public (p. 225 n. 58). A recent
study of Collas's technical contribution is
Meredith Shedd, "A Man for Statuettes:
Achille Collas and Other Pioneers in the
Mechanical Reproduction of Sculpture,"
Gazette des beaux-arts, 6th ser., vol. 120
(July–August 1992): 36–48.

3. Jacques de Caso, "Le Romantisme
de David d'Angers," in H. W. Janson,
ed., *La scultura nel XIX secolo*, vol. 6 of
*Acts of the International Congress of the
History of Art, 1979* (Bologna: Editrice
CLUEB, 1984), p. 98 n. 17 (citing André
Bruel, ed., *Les Carnets de David
d'Angers* [Paris: Librairie Plon, 1958],
2:41).

4. Ibid., p. 97 n. 12, quoting a manu-
script in the Bibliothèque Municipale
d'Angers, *fonds* Robert David.

5. Ibid., p. 98 n. 17. Also, Jacques de
Caso, *L'Avenir de la mémoire* (Paris:
Flammarion, 1988), p. 158.

6. De Caso, *L'Avenir*, fig. 150; David
calls this drawing "the résumé of His
[Christ's] public moral [philosophy]"
(quoted in ibid., p. 210).

7. The drawing in the Musée
d'Angers is illustrated in ibid. (fig. 151).

8. Jouin, *David d'Angers*, 2:491.

9. Ibid.

10. The terra-cotta is illustrated in
Bruel, *Les Carnets*, 2: opp. p. 321. The
Louvre bronze is illustrated in Pierre
Pradel and Pierre Dehaye, *David
d'Angers 1788–1856*, exh. cat. (Paris:
Musée de la Monnaie, 1966), cat. no. 54,
with a brief description of the reliefs on
the base of the statue. The statue without
the base is illustrated in Maurice Rheims,
19th Century Sculpture (New York:
Abrams, 1977), p. 82, fig. 2.

11. Cf. Millia Davenport, *The Book
of Costume*, reprint (New York: Crown,
1976), ills. 832 and 868.

12. A fine stylistic analysis is offered by Holderbaum in Fusco and Janson, pp. 223–24. June Hargrove points out that the technique may have influenced Carrier-Belleuse (*The Life and Work of Albert Ernest Carrier-Belleuse* [New York: Garland, 1977], pp. 96–97). The proportions of the figure are noticeably different from the shorter type David used on the pediment of the Pantheon in Paris but are similar to those of David's *Jefferson* (1832–33, Washington, D.C., Capitol rotunda).

● *Catalogue no. 6*
1. Elizabeth Briggs Lynch, "Barye's Mythological Subjects," in Lilien F. Robinson and Edward J. Nygren, eds. *Antoine-Louis Barye: The Corcoran Collection*, exh. cat. (Washington, D.C.: Corcoran Gallery of Art, 1988), p. 45. The duc de Montpensier was born in 1824, so he was only twenty-two when he commissioned the bronze.

2. This statistic is calculated from the editions of *Orlando Furioso* catalogued in the New York Public Library.

3. Martin Sonnabend suggests that Barye did not conceive of sculptures like *Theseus and Minotaur* (*Thésée combattant le minotaure*), shown in the Salon of 1843, as unique, that he was already considering the primacy of serial repetition for his work, and that he left open the option of producing *Roger and Angelica* as an edition (*Antoine-Louis Barye [1795–1875]: Studien zum plastischen Werk*, vol. 23 of *Beiträge zur Kunstwissenschaft* [Munich: Scaneg, 1988], p. 220). The four most famous examples of *Roger and Angelica* are in the Corcoran Gallery of Art, Washington, D.C.; the Louvre; the Metropolitan Museum of Art, New York; and the Walters Art Gallery, Baltimore. The Metropolitan and Walters examples are of a fairly uniform golden brown; the Louvre example is considerably darker, with patches of brilliant green, a coloration similar to that of the present

example, where, however, a loss of detailing in a small passage like the left foreclaw of the hippogriff suggests a later date of casting. A variant (presumably on the London art market) is illustrated by Jane Horswell, *Bronze Sculpture of "Les Animaliers"* (Woodbridge, Suffolk: Antique Collectors' Club, 1971), p. 43. Unlike many of Barye's bronzes, the models of which were purchased by the foundry Barbédienne after his death, that of *Roger and Angelica* was bought by the Hector Brahme foundry, and the casts produced by this foundry have not been enumerated. (See Stuart Pivar, *The Barye Bronzes* [Woodbridge, Suffolk: Antique Collectors' Club, 1974], p. 25; and *The Nineteenth Century: European Ceramics, Furniture, and Works of Art* [London: Christie's sales catalogue, 28 January 1988], pp. 70–71.)

4. In addition to Pivar, *The Barye Bronzes*, see Glenn Benge, "Antoine-Louis Barye," in Fusco and Janson, pp. 124–40; idem, *Antoine-Louis Barye: Sculptor of Romantic Realism* (University Park: Pennsylvania State University Press, 1984); and Robinson and Nygren, eds., *Barye*.

5. Paul Mantz noted that in 1823 Fauconnier was recognized for having "a collection of good models for the imitation of animals, but according to people who knew him, he was hardly a sculptor, and it was about this time that a young artist, [then] almost unknown, entered his studios; [this was] our glorious master Barye" ("Recherches sur l'histoire de l'orfévrerie française," *Gazette des beaux-arts*, 1st ser., vol. 14 [May 1863]: 413–14).

6. For an account of Barye's commercial ventures in manufacturing and selling his bronzes, see the chapter "Art for the Middle Class: Barye as Entrepreneur," in Benge, *Barye*, pp. 155–65, especially pp. 163–64 on the catalogues issued 1847–55 and 1865.

7. Théophile Gautier, "Exposition de tableaux modernes au profit de la Caisse de Secours," *Gazette des beaux-arts*, 1st

ser., vol. 5 (15 March 1860): 326: "In treating the tiger, only Delacroix and Méry have the strength of Barye."

8. The models of his magnificent *surtouts de table* (centerpieces) were rejected by the jury of the Salon of 1837 (Benge, "Barye," p. 124). Sonnabend has suggested that this may have been caused in part by the press's condemnation of the royal patronage that took Barye away from public commissions (*Barye*, pp. 16–17).

9. Robinson and Nygren, eds., *Barye*, p. 7.

10. Maxime du Camp, *Les Beaux-Arts en 1855 à l'Exposition Universelle de 1855* (Paris: Librairie Nouvelle, 1855), p. 23.

11. Tancock notes that until 1885 Rodin signed himself "pupil of Barye and Carrier-Belleuse" in the first salons in which he exhibited (p. 498 n. 7).

12. Antoine Bourdelle, *La Sculpture et Rodin*, ed. Claude Aveline (Paris: Émile-Paul Frères, 1937), p. 27. It is interesting to note the similarity of a small sculpture called *Man Carrying off a Woman (Enlèvement)* modeled by Rodin the year after Barye's death; its silhouette is similar to that of *Roger and Angelica*. (For Rodin's *Enlèvement*, see Goldscheider, cat. no. 85.)

13. Elisabeth L. Cary, "Antoine-Louis Barye: His Methods of Work, part 2," *The Scrip* 2, no. 4 (January 1907): 110. Barye's working method is further described:

By his perfect familiarity with the facts . . . he was fitted to use them intelligently, omit them . . . exaggerate . . . minimize them where he chose. . . . Having modeled the different parts of his composition, he is said to have brought them together and supported them from the outside by means of crutches and tringles after the fashion of the boat builders. . . . The definitive braces were put in place only at the moment of molding in plaster (p. 111).

● *Catalogue no. 7*

1. Carrier-Belleuse's technique in terra-cotta varied widely from the freshest, roughest sketch to the highly finished. X radiographs of the present bust show that the head and torso were modeled as a unit; the hair, breasts, and flowers were modeled separately and then blended into the bust. The rounded back of the bust was filled in separately from the front. The sculpture was then almost completely covered with a thin slip; the smoothness of the surface was perfected by a film of matte milk-paint. A long, hand-wrought spike inside the bust attaches it to the socle. Two smaller nails next to the spike prevent the clay from rotating around the spike.

2. See June Hargrove's fine monograph, *The Life and Work of Albert Ernest Carrier-Belleuse* (New York: Garland, 1977), pp. 3–4.

3. Ibid., pp. 5–6.

4. Ibid., p. 13.

5. The title of the earlier edition (1886) was *Études de figures appliquées à la décoration* (Studies [sketches] of figures applied to decoration).

6. On Chéret see Bruce Davis, "The Art of Persuasion: Sources of Style and Content in Belle Epoque Posters," in *Toulouse-Lautrec and His Contemporaries: Posters of the Belle Epoque*, exh. cat. (Los Angeles: Los Angeles County Museum of Art, 1985), pp. 38–43; and Lucy Broido, *The Posters of Jules Chéret* (New York: Dover, 1980).

● *Catalogue no. 8*

1. Jacques Berthon, "Aimée Olympe Desclée," in *Enciclopedia dello spettacolo*.

2. June Hargrove, *The Life and Work of Albert Ernest Carrier-Belleuse* (New York: Garland, 1977), p. 83 n. 142; Stanislas Lami gives the height of the bronze as 70 cm (*Dictionnaire des sculpteurs de l'école française au dix-neuvième siècle*, s.v. "Albert-Ernest Carrier-Belleuse."

3. Berthon, "Desclée."

4. The Carnavalet example is terra-cotta; Hargrove lists it in both materials (*Life and Work*, fig. 31).

5. Ibid., p. 83 n. 142.

6. The Carnavalet example is a light tan color.

7. John Tancock points out that Carrier-Belleuse's studio organization provided an example for Rodin, whose own productivity would have been impossible without it (p. 498).

● *Catalogue no. 9*

1. For concise biographies of Carpeaux, see Victor Beyer and Annie Braunwald, eds., *Sur les traces de Jean-Baptiste Carpeaux*, exh. cat. (Paris: Grand Palais, 1975); and Anne M. Wagner, "Jean-Baptiste Carpeaux," in Fusco and Janson, pp. 144–45. See also Wagner's fundamental study of Carpeaux, *Jean-Baptiste Carpeaux: Sculptor of the Second Empire* (New Haven and London: Yale University Press, 1986).

2. See especially André Mabille de Poncheville, *Carpeaux inconnu* (Brussels: G. van Oest, 1921), p. 185.

3. An extensive study of the Valenciennes commission is offered by Anne Pingeot, "La Ville de Valenciennes défendant la patrie," in Maison et al., pp. 129–38, where most of the intermediary sketches are illustrated.

4. Ibid., p. 130.

5. For Janet's painting, see Marie-Claude Chaudonneret, "Ange-Louis Janet: Die Republik," in Dario Gambino and Georg Germann, eds., *Zeichen der Freiheit: Das Bild der Republik in der Kunst des 16. bis 20. Jahrhunderts*, exh. cat. (Bern: Bernisches Historisches Museum and Kunstmuseum Bern, 1991), cat. no. 405 with further bibliography on Janet's painting.

6. Pingeot, "Valenciennes," p. 137. On the rights to reproduce Carpeaux's models, see Jacques de Caso, "Serial Sculpture in Nineteenth-Century France," in Jeanne L. Wasserman, ed., *Metamorphoses in Nineteenth-Century Sculpture* (Cambridge: Harvard

University Press, 1975), p. 11; and Annie Braunwald and Anne Wagner, "Jean-Baptiste Carpeaux," in ibid., pp. 112–13.

7. The Tanenbaum example measures 51.5 cm (*Un Autre XIXe Siècle: Peintures et sculptures de la collection de M. et Mme Joseph M. Tanenbaum*, exh. cat. [Ottawa: Galerie Nationale du Canada, 1978], cat. no. 74).

● *Catalogue no. 10*

1. The controversial episode is summarized in de Caso and Sanders, cat. no. 1.

2. Cladel, p. 132; Ruth Butler Mirolli, "The Early Work of Rodin and Its Background," Ph.D. diss., Institute of Fine Arts, New York University, 1966, p. 184.

3. Auguste Rodin, interview with T. H. Bartlett, in *American Architect and Building News*, 2 March 1889, p. 99, quoted in Ruth Butler, "Rodin and the Paris Salon," in Elsen 1981, p. 38. See also Butler, "Early Work," pp. 184–87. The statue was subsequently cast in three sizes: besides the 80 cm, there are casts in 50 cm and 20 cm (de Caso and Sanders, p. 78).

4. Henri-Charles Dujardin-Beaumetz, *Entretiens avec Rodin* (Paris: Dupont, 1913, p. 65); quoted in Butler, "Rodin and the Paris Salon," p. 188. De Caso and Sanders suggest that this anecdote may refer to the sculpture called *The Walking Man* instead (p. 78) (see n. 10. below).

5. Matthew 3:3–4; Mark 1:6.

6. Butler, "Early Work," p. 185, citing Léonce Bénédite, *Rodin* (Paris: Rieder, 1926), p. 26. A drawing sketched after the sculpture was finished (Fogg Art Museum, Harvard University; illustrated in de Caso and Sanders, p. 75), shows a wispy indication of such a cross tied with a banner, but it cannot be taken as evidence of Rodin's initial intention for the sculpture.

7. For the *Bust of Saint John the Baptist* (1878; bronze, 1891–92) see Goldscheider, cat. no. 102a.

8. Paul Gsell, *Art by Auguste Rodin*, trans. Mrs. Romilly Fedden (Boston: Small, Maynard, 1912), pp. 67–75.

9. The same distortion occurs in Rodin's *The Walking Man* (*L'Homme qui marche*, Goldscheider, cat. no. 103a), which is thought to be either a study for the *Baptist* or a work created just after it. Arguments about the chronology of *The Walking Man* and the *Baptist* are analyzed extensively by Werner Schnell in *Der Torso als Problem der modernen Kunst* (Berlin: Gebrüder Mann, 1980), pp. 25–29, 43–44.

10. Antoine Bourdelle, *La Sculpture et Rodin*, ed. Claude Aveline (Paris: Émile-Paul Frères, 1937), p. 140.

● *Catalogue no. 11*

1. In canto 4 Dante and Virgil encounter Adam, consigned to Limbo because he was not baptized. On interpretations given in 1886 and 1889, see Tancock, p. 129.

2. Beausire quotes the relevant documentation from Rodin's practitioner Henri Lebossé (pp. 176, 178), but this is primarily in relation to the enlargement of *The Three Shades*, the individual figures of which present slight variations from the single *Shade*.

3. The drawings in the Musée Rodin (inv. nos. MR6937 and 6940) are illustrated in Elsen 1985, figs. 39 and 41.

4. Ruth Butler, "Auguste Rodin," in Fusco and Janson, p. 335.

5. A discussion of the sculpture done in Belgium is furnished by Tancock (p. 122). Cladel recounts that Rodin's assistants referred to *Adam* as *The Slave* (p. 143).

6. Referred to by Cladel (p. 112).

7. Also noted by Albert Alhadeff ("Michelangelo and the Early Rodin," *Art Bulletin* 45, no. 4 [December 1963]: 365). Of course, two of Michelangelo's Slaves were in the Louvre, and in the École des Beaux-Arts there were plaster casts of some of the marbles from the Medici Chapel, but Rodin said that seeing the sculptures in person was an experience of vital importance for him.

Michelangelo's sculptures were set before students as examples to be copied, but his lessons seem to have been lost on many of them. Thus Carpeaux's and Rodin's penetrating analysis of Michelangelo's art is distinct from merely facile imitation, although it must be said that Rodin did not go further in understanding Michelangelo's influence on his immediate successors. (Cladel quotes a letter of Rodin: "'However, none of his students, nor his masters, worked the way he did'" [p. 112].) This opinion about Michelangelo's lack of followers was, however, widely shared in Rodin's day.

It is interesting to remark in this context that the only known carved variant of *Adam* or *The Shade* is a small (19½ in.) marble, *Niobid* (c. 1900, Toledo Museum of Art; Tancock, fig. 4-3), in contrast to the several marble examples of *Eve*.

8. Beausire, pp. 176–78; Nicole Barbier notes that it was exhibited also as *Three Despairing Figures* (in Pingeot 1986, pp. 107–9). See also Tancock for relevant illustrations of the variants (pp. 132–33); and de Caso and Sanders, cat. no. 20.

● *Catalogue no. 12*

1. Reproduced in Elsen 1985 as figs. 39 and 41 (Musée Rodin inv. nos. MR6937 and 6940); and in Yann le Pichon and Carol-Marc Lavrillier, *Rodin: La Porte de l'Enfer* (Paris: Pont Royal, 1988), p. 46 (MR5478).

2. Camille Mauclair comments that figures of Adam and Eve were to surmount the *Gates* (quoted in Elsen 1985, p. 45). Ruth Butler Mirolli writes that "the idea for . . . *Adam* and *Eve* existed before he had received the commission," but that "there is no reason to assume that the two statues were conceived as a pair" ("The Early Work of Rodin and Its Background," Ph.D. diss., Institute of Fine Arts, New York University, 1966, pp. 207, 210). Tancock suggests that *Adam* was developed first as Rodin's

response to Michelangelo's work and that *Eve* was a natural choice to complete the pair (p. 148).

3. Illustrated in such basic texts as Arthur Gardner, *Medieval Sculpture in France* (Cambridge: University Press, 1931).

4. From correspondence to Rose Beuret written during his trip to Italy in 1875–76, quoted by Cladel (p. 110). Rodin mentions the beauty of the cathedral of Rheims (the implication being, however, that he admired the building in its entirety): "'Here are three lasting impressions that I had: Rheims, the walls [*murailles*] of the Alps and the Sacristy [of San Lorenzo]'" (p. 111).

5. Rodin mentions "'those two figures that are near [*autour de*] my Gates and which have not been officially commissioned'" (Cladel, p. 140). Cladel says that without further support Rodin would not have been able to produce them; she identifies the two sculptures as *Adam* and *Eve*. Ruth Butler dates the letter to late 1880 ("Auguste Rodin," in Fusco and Janson, p. 335).

6. The drawing in the Musée Rodin (MR1963) is reproduced in Elsen 1985, fig. 33, and related discussion, p. 44. The trumeau in this drawing may have evolved ultimately into *The Thinker* (1880–81) instead. The fireplace is illustrated in Tancock, fig. 8-9.

7. Butler, "Rodin," p. 335.

8. Fonsmark, p. 86 (the example in Denmark was carved by Antoine Bourdelle); Barbier, p. 198; de Caso and Sanders say that it was exhibited in London in 1883 (p. 144). Alain Beausire notes that the exhibition was sponsored by the Cercle des Arts Libéraux (Circle of liberal arts) (*Quand Rodin exposait* [Paris: Musée Rodin, 1988], p. 82). A marble was begun the same year. Tancock lists the many examples of *Eve*, which was much in demand (pp. 155–57); in addition to these, another marble (30 in., ex-coll. Charles Laurent, the concierge at Rodin's blvd. d'Italie studio;

then Wildenstein) passed at auction in London, 1 December 1992 (Sotheby's, sale no. 3361, pt. 1, lot no. 3); de Caso and Sanders compare the half-size and full-scale models (p. 144): the proportions of the body in the small version are shorter, and the surfaces tend to have a higher finish; the positions of the left hand (more open in the large version) and foot (on a lower support in the small version) and the arrangement of the hair are the primary differences. See note 12 below.

9. Ambrosini and Facos, p. 150.

10. Tancock, p. 150. Butler comments that the figure's monumentality and rough surface are closer to Rodin's style of the 1890s than the 1880s ("Rodin," p. 336). Beausire writes that the first known bronze of the large *Eve* was cast by François Rudier in 1887 (*Quand Rodin exposait*, p. 88).

11. Beausire, p. 198.

12. Tancock, pp. 148–51; "the two types remain in distinct sizes" (de Caso and Sanders, p. 144).

13. Although Rodin recalled that his *Eve* was "incomplete" because the pregnant Mme Abruzzezzi, unable to stand the cold of his studio, quit modeling for him, Carmen Visconti left his employ because she married one of his Russian pupils (Ambrosini and Facos, pp. 150–51). Ambrosini and Facos summarize the biography of Abbruzzezzi, especially the circumstances of her 1895 pregnancy (p. 154 n. 21). De Caso and Sanders mention anecdotes concerning two models: the woman Rodin remembered as Mme Abruzzezzi and an English model (p. 144). The distinctly different types of bodies of the small and large versions of *Eve* may have resulted from Rodin's having posed two different models.

14. Well illustrated in le Pichon and Lavrillier, *La Porte de l'Enfer*, p. 42; well summarized by de Caso and Sanders, pp. 143, 147 n. 3 (one of the rare references to a possible inspiration by Houdon's bronze *La Frileuse* [1783], an example of which entered the Louvre in 1881).

● *Catalogue no. 13*
1. The traditional date of 1882 (Grappe, cat. no. 52) is accepted by Tancock for the related work *I Am Beautiful*.

● *Catalogue no. 14*
1. Tancock quotes Rodin's letter to Roux (pp. 163–64). Grappe remarks that Rodin ceded the reproduction rights to *The Man with a Serpent* to his patron (p. 38); consequently the Musée Rodin does not own an example of this model.

2. *The Falling Man* is attached to the frame of the *Gates* at the base of his ribcage, so the cusp cannot be attributed to the separation of *The Falling Man* from the *Gates*. This can be determined from a photograph taken at a high viewing point (illustrated in Elsen 1985, p. 187).

3. This first stanza of Baudelaire's poem is in Grappe: "*Je suis belle, ô mortels! comme un rêve de pierre, / Et mon sein, où chacun s'est meurtri tour à tour, / Est fait pour inspirer au poète un amour / Éternel et muet ainsi que la matière*" (p. 39). The entire poem, illustrated by Rodin, is in Charles Baudelaire, *Les Fleurs du mal*, ed. Camille Mauclair (Paris: Limited Editions Club, 1940), pp. 25–26.

4. The drawing (coll. Mrs. Noah L. Butkin) is reproduced in Ruth Butler, "Auguste Rodin," in Fusco and Janson, p. 337, as *The Genius of the Sculptor* (although it is inscribed in French *la genie de la Sculpture*), and in Rosalyn Frankel Jamison, "Rodin's Humanization of the Muse," in Elsen 1981, p. 106, where it is called *The Genius of Sculpture*. It is directly related to a more elaborate rendering of the same subject, reproduced without credits or location in J. K. T. Varnedoe, "Rodin's Drawings," in ibid., p. 169. It is tempting to relate these to *The Falling Man* because of the position of one of the legs, propped up at the knee on a support, much like the bend of the leg in the bronze, and to *Je suis belle* because of the way the male figure is

combined with a smaller figure attached above him. This might lead to a different interpretation of the drawings and of *Je suis belle* as the artist's struggling, not with a benevolent source of inspiration, but instead with a succubus or incubus representing the force that demands artistic expression. These are images of the artist's mortal struggle, paralleling the choice between sacred and profane love.

5. Grappe: "Everything indicates that this is the torso named *Marsyas* by some critics" (p. 38).

6. Beausire proposes that *Marsyas* is the torso (called simply *Torse*) shown at the 1889 exhibition and gives it the alternate titles *Marysas* and *Torso of a Man in Extension* (*Torse d'homme en extension*, cat. no. 28). For other compositions related to *The Falling Man*, see Nicole Barbier, "Homme qui tombe," in Pingeot 1990, pp. 128–32. Tancock notes that it was exhibited in Düsseldorf in 1904 as the *Torso of Louis XIV* (p. 164).

7. On the production of the enlargements, see Albert Elsen, "Rodin's 'Perfect Collaborator,' Henri Lebossé," in Elsen 1981, p. 253.

● *Catalogue no. 15*
1. Tancock dates the composition 1880–82 (p. 136); Elsen dates the Musée Rodin terra-cotta 1881 (1985, fig. 76). The example in the *Gates* is illustrated in Elsen 1985, fig. 162.

2. Illustrated in Elsen 1985, fig. 75.

3. Tancock, fig. 6-3a, as *The Head of Lust*. Grappe calls it simply *Lust* (*La Luxure*, cat. no. 55).

4. Tancock, p. 140.

5. Ibid., with a survey of examples (e.g., Musée Rodin, Hirschhorn).

6. On the plasters as gifts, see Elsen 1981, pp. 127, 150 n. 4. Elsen writes that records in the Musée Rodin show that "he must have given away to friends nearly as many plasters as bronzes that he sold."

7. Jay Cantor kindly shared his observations on the high quality of the present plaster.

8. On the patination of the large-scale bronze in the Musée Rodin, see Elsen 1963, p. 59.

9. Georges Bergner, "Auguste-Jean Richepin," in *Enciclopedia dello spettacolo*.

10. Monique Laurent, "Preface," in Yann le Pichon and Carol-Marc Lavrillier, *Rodin: La Porte de l'Enfer* (Paris: Pont Royal, 1988), p. 9. The precise date of this meeting in unknown, but a letter from Rodin to M. Liouville, dated 3 December 1883, is the earliest of their correspondence to be preserved in the Musée Rodin. (See Alain Beausire and Hélène Pinet, eds. *Correspondance de Rodin: 1860–1899* [Paris: Musée Rodin, 1985] 1:62–63.) Mme Liouville's husband was the representative of the Meuse region from 1876 to 1887, so he may have been instrumental in securing for Rodin the commission for the Bastien-Lepage monument (cat. no. 37).

11. Alain Beausire of the Musée Rodin kindly reviewed the archival material at the museum for documentation on the relationship of Richepin and Rodin. Beausire suggested that Richepin's letter of 13 March 1897, mentioning *"votre délicieuse 'Faunesse,'"* might refer to *The Crouching Woman* if Richepin confused the title of this sculpture with another by Rodin.

● *Catalogue no. 16*
1. Jacques de Caso ("Rodin and the Cult of Balzac," *Burlington Magazine* 106, no. 735 [June 1964]: 284 n. 69) draws attention to the importance of this passage in Stanislas Lami, *Dictionnaire des sculpteurs de l'école française au dix-neuvième siècle*, s.v. "Auguste Rodin": "In 1890…he changed his technique. Until then, he had modeled his statues in the size in which they would be carried out; after that he was happy to work on figures and groups in small sizes, which he decided to enlarge using a mechanical process, that of reduction, but inverting the role of the [measuring] needles"

(4:162). In *The Gates of Hell* Rodin deliberately used small figures to prove that he did not make life-casts.

2. Ruth Butler, "Auguste Rodin," in Fusco and Janson, p. 334.

3. Claudie Judrin, Monique Laurent, and Dominique Viéville, *Auguste Rodin: Le Monument des Bourgeois de Calais (1884–1895) dans les collections du musée Rodin et du musée des Beaux-Arts de Calais*, exh. cat. (Paris: Musée Rodin; Calais: Musée des Beaux-Arts, 1977), p. 234.

4. Ibid.

5. The drawing by E. Matthes appeared in *Jugend*, no. 47 (1907): 1059 (reproduced in Keisch, p. 34).

6. Albert Elsen, "Rodin's 'Perfect Collaborator,' Henri Lebossé," in Elsen 1981, pp. 258–59.

7. Tancock, p. 138.

8. Léonce Bénédite mentioned a small marble in the collection of Octave Mirbeau, but its present location is unknown (Tancock, pp. 136, 138 n. 7).

9. Lami says that Lebossé "developed an extraordinary facility in practically duplicating the modeled [surface] of the clay by altering the machine-made plaster enlargement, so that he could reproduce as exactly as possible—in spite of the difference in size—the look of the maquette that had been entrusted to him" (quoted in de Caso, "Rodin and the Cult of Balzac," p. 284). Lebossé's relationship with Rodin and the process they used are analyzed by Elsen ("Rodin's 'Perfect Collaborator,'" pp. 250–53).

● *Catalogue no. 17*
1. The legend recounted by Vitruvius (*Architecture* 1:5) that they were architectural representations of the women of Karyai, taken prisoner by the Greeks, is probably a fiction.

2. Grappe, cat. nos. 36–38. Grappe notes the additional title *Destiny* (*Destinée*) (Grappe 1944, cat. no. 64).

3. De Caso and Sanders mention other variants: one with a globe and another possibly without a burden, unlocated but said to have been in Argentina

(p. 157 n. 7). For further information, see Fonsmark, cat. no. 8. The urn may have funerary symbolism.

4. Clare Vincent suggests that the version with the urn is a variant of the caryatid with a stone (p. 23).

5. Dante Alighieri, *The Divine Comedy*, trans. Rev. H. F. Cary (Danbury: Grolier [1978]), p. 226. Noted also in de Caso and Sanders, p. 156 n. 4.

6. Rainer Maria Rilke, *Rodin*, trans. Robert Firmage (Salt Lake City: Peregrine Smith, 1979), p. 46.

7. Ruth Butler, "Auguste Rodin," in Fusco and Janson, pp. 340–42. Its hybrid forms, however, suffer from a meaninglessness owed to its contrived pose, so this marble has little of the coherence of its sources. It is worth noting in this context that a marble figure of a crouching boy in the State Hermitage Museum in St. Petersburg, often cited as a possible inspiration for Rodin, was, during Rodin's lifetime, not only attributed to Michelangelo but also known by the title *Caryatid* (see Sergei Androsov, *Western European Sculpture from Soviet Museums. 15th and 16th Centuries* [Leningrad: Aurora, 1988], p. 53). Androsov implies that around 1900 fresh interest in this sculpture developed because of new publications on Michelangelo. This marble can no longer be attributed to Michelangelo. There is some interest in comparing the history of the attribution of the Hermitage marble with the story of another crouching figure also formerly attributed to Michelangelo (see John Pope-Hennessy, "Michelangelo's *Cupid*: The End of a Chapter," in *Essays on Italian Sculpture* [London: Phaidon, 1968], pp. 111–20).

8. Grappe, cat. no. 36 and p. 35.

9. Grappe 1944, cat. nos. 63, 91.

10. Daniel Rosenfeld, "Rodin's Carved Sculpture," in Elsen 1981, p. 88.

11. Coll. Mrs. Noah Butkin, Chicago; reproduced in Rosalyn Frankel Jamison, "Rodin's Humanization of the Muse," in ibid., p. 106.

● *Catalogue no. 18*

1. Paul Gsell, *Art by Auguste Rodin*, trans. Mrs. Romilly Fedden (Boston: Small, Maynard, 1912), p. 37.

2. Ibid., p. 42. John Tancock notes that in 1892, when Gustave Geffroy discussed literary sources in Rodin's work, he mentioned Baudelaire and Ronsard, but not Villon (p. 146). Tancock also points out that there is no reason to assume that Rodin modeled this figure with Villon's poem in mind; rather, in keeping with his customary practice, he applied an appropriate title to the sculpture (p. 145).

3. Gsell, *Art*, pp. 37–39

4. Tancock, p. 146.

5. The sculpture cited by Beausire (p. 204) is, however, a relief. (The plaster of *Springs Gone Dry* is in the Musée Rodin at Meudon). A related composition, in which the old woman is associated with the figure of a child, is called *Youth Triumphant* (*La Jeunesse triomphante*), which is one of several titles given to this sculpture (see de Caso and Sanders, cat. no. 3).

6. Gsell, *Art*, p. 44. Rodin later (1888) illustrated this poem for Gallimard's edition of *Les Fleurs du mal* (see Charles Baudelaire, *Les Fleurs du mal*, ed. Camille Mauclair [Paris: Limited Editions Club, 1940]), pp. 42–44.

7. Gsell, *Art*, pp. 42–43.

8. Ibid., p. 45

9. Illustrated in Descharnes and Chabrun, p. 65, and dated 1880; Goldscheider dates the Sèvres vase (referred to as the Limbo Vase) to 1882–87, based on its association with *The Gates of Hell* (cat. no. 112k). Albert Elsen retains the date of c. 1878–82 for the vase (Elsen 1985, p. 213), while Ruth Butler says that the vase was probably not finished until 1887 ("Auguste Rodin," in Fusco and Janson, p. 349 n. 50). (See following note.)

10. *Poverty* is in the Musée Rodin (illustrated in Descharnes and Chabrun, where it is said to postdate *The Helmet-Maker's Wife* [p. 95]), and *Misery* is in the Musée des Beaux-Arts in Nancy (illustrated in Tancock, where it is dated 1897 [fig. 7-1]; also in Pingeot 1986, pp. 332–33: Pingeot dates the plaster sketch c. 1887–89 and the wood version 1894, the year the plaster was exhibited at the Salon). Tancock tends to adhere to the account given by Desbois: Desbois asked Rodin to look at his *Misery*, which in turn inspired Rodin (p. 141); Tancock then dates Desbois's sculpture to c. 1896, which would also postdate Rodin's. Clare Vincent writes that the *Helmet-Maker's Wife* was derived from the relief on *The Gates of Hell* and dates the independent sculpture to c. 1883 (p. 6). Albert Elsen also suggests that Rodin modeled his sculpture after seeing Desbois's (Elsen 1963, pp. 63–64). The various opinions on the date are summarized by Butler, who dates the sculpture to the mid-1880s by recounting an anecdote told to Edmond de Goncourt by Octave Mirbeau, who probably met Rodin in 1884:

One day [Mirbeau] came upon Rodin modeling a marvelous work after a woman who was eighty-two years old, a work even superior to Sources Taries.... A few days later when he asked Rodin where the clay model was, the sculptor told him that he had ruined it. Since Rodin felt very sad that he had ruined a work admired by Mirbeau, he then made the two old women that he put in the exhibition ("Auguste Rodin," p. 349 n. 50).

11. Reine-Marie Paris and Arnaud de La Chapelle, *L'Oeuvre de Camille Claudel* (Paris: Éditions d'Art et d'Histoire, 1991), cat. nos. 4, 29–31, 39–42.

12. Goldscheider, cat. no. 105.

13. Tancock, pp. 141–42.

14. Gsell, *Art*, illustrated opp. p. 38 and pp. 40–41.

15. Leo Planiscig, *Andrea Riccio* (Vienna: Anton Schroll, 1927), figs. 79–81 (as Paduan). Also noted by Jacques de Caso, "Rodin at the Gates of Hell,"

Burlington Magazine 106, no. 731 (February 1964): 82; and Fred Licht, *Sculpture 19th & 20th Centuries* (Greenwich, Conn.: New York Graphic Society, 1967), fig. iii, pp. 19 n., 320.

● *Catalogue no. 19*

1. The various titles are listed in de Caso and Sanders, cat. no. 25.

2. Pingeot 1986, cat. no. 238; and Pingeot et al., p. 234.

3. Pingeot et al., p. 234.

4. Barbier, cat. no. 45.

5. Ibid., cat. no. 46

6. Illustrated in Descharnes, p. 90; this is probably listed as a marble by Athena Tacha Spear, "A Note on Rodin's *Prodigal Son* and on the Relationship of Rodin's Marbles and Bronzes," *Allen Memorial Art Museum Bulletin* 27, no. 1 (fall 1969): 33 (no. C2). Only two marbles are catalogued now in the Musée Rodin.

7. A bronze in the Metropolitan Museum of Art (illustrated in Joan V. Miller and Gary Maratta, *Rodin: The B. Gerald Cantor Collection* [New York: Metropolitan Museum of Art, 1986], p. 25) was probably cast from the plaster in the Musée Rodin. A bronze in the Washington County Museum of Fine Arts (Hagerstown, Maryland) has a base close to the plaster's; it was probably cast in the early 1890s, the years in which the founder of this sculpture, A. Gruet the Elder, cast bronzes for Rodin (see Monique Laurent, "Observations on Rodin and His Founders," in Elsen 1981, p. 286.) It is illustrated in Athena Tacha, "The Prodigal Son: Some New Aspects of Rodin's Sculpture," *Allen Memorial Art Museum Bulletin* 22, no. 1 (fall 1964): fig. 6.

8. It is closest to the base of the Spreckels Collection example (de Caso and Sanders, cat. no. 25). The early bronze in Musée d'Orsay has several linear sketch marks in the cloud, which are omitted from the later bronzes.

● *Catalogue no. 20*

1. De Caso and Sanders say that it seems to have been used first in the *Fugit Amor* group (p. 160). See also Athena Tacha, "The Prodigal Son: Some New Aspects of Rodin's Sculpture," in *Allen Memorial Art Museum Bulletin* 22, no. 1 (fall 1964): 23–39; she mentions that the individual figures of *Fugit Amor* were probably modeled separately, because "the position of the woman is different in each of the first versions" (p. 27).

2. *L'Enfant du siècle* may also allude to the term used to designate the group of French writers born around 1800, including Balzac, Dumas, and Hugo (see André Malraux's afterword to Victor Hugo, *The Hunchback of Notre Dame*, trans. Walter J. Cobb [New York: Penguin, 1965], p. 502). One example of a small-scale version in bronze is in the Musée des Beaux-Arts et d'Archéologie in Boulogne-sur-Mer and is discussed extensively by Dominique Viéville in Maison et al., cat. no. 160. Its base is not sheared off at the left, as in the limestone example (see note 5 below) and the bronzes cast from the limestone. Also its proper left hand is open and the right closed, in contrast to the present model and to the figure used in *Fugit Amor*. Viéville interprets this as an indication of Rodin's desire to make it truly independent of *Fugit Amor*.

3. De Caso and Sanders, p. 163 nn. 6, 9. Of course, the Prodigal Son would have had no place in *The Inferno*.

4. Rainer Maria Rilke, *Rodin*, trans. Robert Firmage (Salt Lake City: Peregrine Smith, 1979), p. 65. Antoine Bourdelle perhaps made a subtle reference to this sculpture in a sketch of an imploring woman which he dedicated to Rodin (*La Sculpture et Rodin*, ed. Claude Aveline [Paris: Émile-Paul Frères, 1937], illustrated opp. p. 230).

5. The limestone is in the Ny Carlsberg Glyptotek (see Fonsmark, cat. no. 16). Fonsmark (p. 103) cites Léon Maillard, *Auguste Rodin statuaire* (Paris: H. Floury, 1899), pp. 117, 120. Athena Tacha Spear suggests dating the limestone 1898 or earlier ("A Note on Rodin's *Prodigal Son* and on the Relationship of Rodin's Marbles and Bronzes," *Allen Memorial Art Museum Bulletin* 27, no. 1 (fall 1969): 34.

6. Fonsmark, p. 105; and de Caso and Sanders, p. 160. The base of the San Francisco example (purchased from Rodin in 1914) was cast with both a void cut out of it at the left, which corresponds to the outline of the sheared-off section in the limestone, and with another at the right side. It is unknown whether or not these cuts originally had anything to do with the process of taking the mold from the limestone or casting from it. The same is true for the traces of the struts, which must have been cut off from the model made for casting. Spear notes a plaster cast of the limestone, complete with struts, in the Musée Rodin ("*Prodigal Son*," 1969, p. 34). A cast in the Bethnal Green Museum (formerly in the Victoria and Albert Museum, a gift from Rodin in 1914) is missing almost the entire front of the base, but this lack has been attributed to a flaw in casting (Jennifer Hawkins, *Rodin Sculptures* [London: HM Stationery Office, 1975], p. 18). The third of three vintage photographs by François Vizzanova (reproduced in Yann le Pichon and Carol-Marc Lavrillier, *Rodin: La Porte de l'Enfer* [Paris: Pont Royal, 1988], p. 185) is shaded in pencil around the image of the base, which may indicate a revision contemplated by Rodin. Nicole Barbier is in the process of reviewing the casting history of models of the *Prodigal Son* at the Musée Rodin.

7. Fonsmark, p. 103; and de Caso and Sanders, p. 160.

8. Quoted by Cladel, p. 312. Also cited by Spear, p. 70.

● *Catalogue no. 21*

1. Grappe dates the plasters c. 1886 (cat. nos. 95–96).

2. Barbier, cat. no. 62, *Psyche-Spring* (*Psyché-Printemps*, with the figure of spring in the form of a satyr); and cat. no. 73, *Pan and Nymph* (*Pan et nymphe*).

3. For *The Toilet of Venus*, see Tancock, fig. 11-4 (limestone in the Philadelphia Museum of Art, John G. Johnson Collection); Maison et al., cat. no. 164 (marble in Musée des Beaux-Arts, Lille, 1905); and Beausire, cat. no. 36 (stone in the Musée Rodin). A plaster *Siren I* (Musée Rodin) is illustrated in Denys Sutton, *Triumphant Satyr: The World of Auguste Rodin* (New York: Hawthorn, 1966), fig. 57, with pertinent commentary, pp. 84–85. Rodin changed the sex of *The Kneeling Female Faun* so that the figure could represent Orpheus in the marble *Orpheus and the Maenads* (*Orphée et les ménades*, c. 1903–5; Barbier, cat. no. 70).

4. In his introduction Camille Mauclair states that Gallimard commissioned the drawings for a single copy of the book. The illustration for the poem "La Mort des artistes" (p. 243) is dated 1888 (see Charles Baudelaire, *Les Fleurs du mal*, ed. Camille Mauclair [Paris: Limited Editions Club, 1940], p. 1).

5. Tancock, figs. 11-1, 11-4. *Kneeling Female Faun* or *Toilet of Venus* may be the sculpture illustrated by Eugène Carrière in his lithograph for the poster of Rodin's exhibition in 1900 at the Pavillon de l'Alma in Paris, reproduced as the frontispiece of the present catalogue.

6. Ibid., p. 168, refers to a "particularly demonic aspect" of this sculpture. The exposed teeth no doubt contribute to this.

● *Catalogue no. 22*

1. Léonce Bénédite comments that "only two specific episodes are still barely distinguishable: *Paolo Malatesta and Francesca da Rimini* and *Ugolino*" (*Musée Rodin: Catalogue sommaire des oeuvres d'Auguste Rodin...exposés à l'Hôtel Biron...* [Paris: Imprimerie Beresniak, 1922], under cat. no. 256.

2. One of the figures (Grappe, cat. no. 99) still appears semiabsorbed in a block, which looks as though it has been cast in plaster from a marble, while another (Grappe, cat. no. 100) has profiles corresponding with the present bronze. Another plaster model in the Musée Rodin corresponds directly with the present bronze, though it is marked for pointing (for reproduction in marble) and Paolo's feet are missing (illustrated in Keisch, cat. no. 23; Musée Rodin inventory number not given). Yet another plaster in the Musée Rodin (s2887) has a small support under the leftmost edge, which is a continuation of the cloudlike base under the couple (illustrated in Fonsmark, p. 27). In a letter to the author (8 April 1993) Nicole Barbier wrote that she knew of no other title for this composition and that the Musée Rodin bronzes of *Paolo and Francesca* seem not always to have been cast from one plaster only.

3. Grappe, without giving the year (p. 49). Cécile Goldscheider asserts that Rodin gave a plaster example to Paul de Vigne in 1887 ("Paul de Vigne," in *Rodin: Ses Collaborateurs et ses amis,* exh. cat. [Paris: Musée Rodin, n.d.], unpaginated. The head of Paolo is also known as an independent sculpture, *Head of Sorrow* (*Tête de la douler*). *The Kiss* has been dated c. 1884; it was cast in bronze in 1886 (Fonsmark, cat. no. 17).

4. Grappe, p. 49. In 1885 Octave Mirbeau wrote that Paolo and Francesca figured in the *Gates* opposite, not below, Ugolino and his sons (see Ruth Butler, *Rodin in Perspective* [Englewood Cliffs, N.J.: Prentice-Hall, 1980], p. 47.) For marbles in the Musée Rodin, see Barbier,

cat. nos. 80–81. Another is in the Ny Carlsberg Glyptotek (Fonsmark, cat. no. 28). The imagery of these marbles includes a more literal representation of the turbulent air of the second level of the underworld. An alternate title for cat. no. 80 is *Paolo and Francesca in Torment*.

5. This is emphasized by Tancock, p. 29.

● *Catalogue no. 23*

1. Grappe, cat. no. 179. The figures in the *Gates* and *La Douleur* are also related to Grappe, cat. nos. 298–99, life-size, plaster Aphrodites, which Grappe dates to 1908 as enlargements of earlier sketches. The composition of a sketch by Alexandre Falguière of the Magdalene in a grotto, published in *La Plume* (no. 219 [1 June 1898]: 413) bears a striking resemblance to Rodin's *La Douleur*. Reine-Marie Paris and Arnaud de La Chapelle suggest that *La Douleur* inspired Camille Claudel's *Deep Thought* (*La Profonde Pensée*, 1898), which may provide a *terminus ante quem*, extended though it may be, for Rodin's composition (*L'Oeuvre de Camille Claudel* [Paris: Éditions d'Art et d'Histoire, 1991], p. 38).

● *Catalogue no. 24*

1. Grappe, cat. no. 79; *The Earth* is Grappe, cat. no. 164. Variants on this figure can be found in Descharnes and Chabrun, pp. 81, 207.

2. Keisch, p. 162; and Alain Beausire, *Quand Rodin exposait* (Paris: Musée Rodin, 1988), p. 186.

3. Beausire, *Quand Rodin exposait*, p. 135. See also Schmoll, p. 199. Furthermore, Werner Schnell maintains that Monique Laurent told him that there is a receipt to the founder Groult, dated 1899, for casting a bronze of *The Earth*; the enlargement may be dated to 1900, while a terra-cotta study for it may be dated to about 1884 (*Der Torso als Problem der modernen Kunst* [Berlin: Gebrüder Mann, 1980], p. 207 n. 5).

4. This interpretation is offered in a fine analysis by Albert Elsen (Elsen 1963, p. 188).

5. Schmoll suggests that although words meaning "earth" are feminine in Latin, French, German, and other European languages, a variant of this figure with a male head (Meudon, Musée Rodin) suggests the procreative act (pp. 199–200).

6. Albert Elsen recounts what is known of this episode: Rodin, having seen a bronze of *The Earth* in November 1913, denied it was his, although an example of it had been shown in his exhibition of 1900. He later retracted his denial when he was told that a bronze *Earth* was purchased from him in 1898 (Elsen 1963, p. 186).

● MONUMENT TO BALZAC

1. The fundamental study on the background of the commission is by Jacques de Caso: "Rodin and the Cult of Balzac," *Burlington Magazine* 106, no. 735 (June 1964): 279–84.

2. Ibid., p. 280.

3. Spear, p. 9.

4. Athena Tacha Spear, *A Supplement to "Rodin Sculpture in the Cleveland Museum of Art"* (Cleveland: Cleveland Museum of Art, 1974), p. 112s.

5. De Caso, "Cult of Balzac," pp. 281–82. There seems to have been a hiatus in 1894–95. De Caso calls attention to the opinions of hostile representatives of the society, who visited Rodin's studio (p. 282). Their description of a maquette as "a shapeless mass, a thing without a name, a colossal fetus," is quoted in Cladel (p. 192).

6. Quoted in a superb analysis by Albert Elsen, "Rodin's 'Naked Balzac,'" *Burlington Magazine* 109, no. 776 (November 1967): 606.

7. Ibid., p. 608 n. 8.

8. Spear, p. 18.

9. Cladel says that Rodin obtained a photograph of Balzac advanced in age— fat and dissipated—and that the idea for the drapery came from the realization

that he had to avoid a literal representation of the writer's gross physique (p. 189).

10. Spear, quoting C. Chincholle's description in 1894 (p. 20).

11. Elsen suggests that the motif of the folded arms may have been derived from Balzac's image of Napoleon: "'A man is depicted with his arms folded, but who did everything! ... because he willed everything!'" ("Rodin's 'Naked Balzac,'" p. 611). See also Jacques de Caso, "Balzac and Rodin in Rhode Island," *Bulletin of the Rhode Island School of Design: Museum Notes* 52, no. 4 (March 1966): 1–22. This article includes a valuable compendium of Rodin's thoughts about his *Balzac*; de Caso notes that Rodin worked on nude and clothed studies of Balzac simultaneously (p. 9).

12. Ibid. Compare the *Small Shade* (*Petite Ombre*, 1885, Yale University Art Gallery), which has a similar support (illustrated in Tancock [fig. 5-2]; also with the alternate title *Figure of a Standing Man*).

13. Spear, pl. 36 (Meudon, Musée Rodin, measuring 54¼ in.).

14. De Caso, "Cult of Balzac," p. 283.

15. Spear, pp. 23–24. De Caso cites a newspaper account of July 1897 which mentions the crossed arms ("Cult of Balzac," p. 283 n. 67).

16. De Caso, "Cult of Balzac," p. 279. Although the original commission was for a monument either in the Palais Royal (Galerie d'Orléans) or in front of it, the 1939 cast was erected at the intersection of the boulevards Raspail and Montparnasse. The present essay avoids repeating the extensive discussions devoted in the literature cited here to the naturalist and symbolist factions in Parisian literary circles of the day, the simultaneous polemic over Zola's stance in the Dreyfus affair, and how these controversies are related to the *Balzac*. A recent compendium of studies and commentary on the *Balzac*, relying substantially on Albert Elsen, Stephen C. McCough, and Steven Wander, *Rodin and Balzac: Creators of Tumultuous Life*, exh. cat. (Beverly Hills:

Cantor Fitzgerald, 1973), is given in Rita Salvestrini, ed., *El Balzac de Rodin: Historia de un símbolo*, exh. cat. (Caracas: Centro Cultural Consolidado, Ateneo de Caracas, 1991).

● *Catalogue no. 35*

1. The story is recounted in Edward Tripp, *Crowell's Handbook of Classical Mythology* (New York: Thomas Crowell, 1970), pp. 188–89. Yves Bonnefoy points out the relationship between the punishment and the disregard shown by the Danaids for the rite of matrimony (*Mythologies*, rev. ed., ed. Wendy Doniger et al. [Chicago: University of Chicago Press, 1991] 1:400). Both authors comment on the lack of water in Argos.

2. Barbier lists the known examples in marble (p. 140).

3. The Helsinki example was in the Monet-Rodin exhibition in 1889; it is illustrated in reverse in Beausire (p. 195).

4. "I will finish this *Danaïd* [and] have it enlarged for the marble and will keep it in this size for casting in bronze" ("*Je vais finir cette Danaïde la faire grandir* [sic] *pour le marbre, et rester dans cette dimension pour la couler en bronze*") (quoted in Beausire [p. 190]). Rodin was thus ready to cast in bronze a model carved in stone. Tancock lists the known variants, including a small marble in the Art Museum of Princeton University (pp. 254, 256).

5. The Gruet cast is illustrated in Joan Vita Miller and Gary Marotta, *Rodin: The B. Gerald Cantor Collection*, exh. cat. (New York: Metropolitan Museum of Art, 1986), p. 32. In a manuscript note in the Cantor collection archives Clare Vincent commented that the cast is either late nineteenth or early twentieth century. The activity of the Gruet foundry from 1880 to 1902 in the casting of bronzes for Rodin is discussed by Monique Laurent ("Observations on Rodin and His Founders," in Elsen 1981, p. 286).

6. Illustrated in Keisch, p. 114. A plaster (32 x 70.5 cm), apparently cast after an unlocated marble given by Rodin to Félix Bracquemond, passed at auction in Paris on 19 June 1991 (Jean Morelle, Pascale Marchaudet, commissaires-priseurs, lot no. 143). Another variant in bronze (26 x 41 cm), said to have been given by Rodin to the Princesse Cantacuzène, passed at auction in London on 4 December 1991 (Sotheby's, lot. no. 108).

7. Nicole Barbier noted in a letter to the author (15 January 1993) that the plaster (Musée Rodin, s2861) most likely used to cast this bronze was itself probably taken from a marble, which she has not been able to trace.

● *Catalogue no. 36*

1. For the marble versions, see Vincent, pp. 14–15, and Barbier, pp. 86–87.

2. The marble in the Musée Rodin (Barbier, cat. no. 33) has heavier braids at the base, and the hair is carved with more specificity, in long strokes very suggestive of art nouveau style. The treatment of the hair in the Metropolitan's example is foamier and more impressionistic. In both examples the ropelike braids suggest nautical lines and thus by extension a marine context for *The Tempest*.

3. "It is believed that the origin of the bronze lay in a preliminary study for the marble" (Vincent, p. 15). See also Tancock, p. 607.

4. Tancock, pp. 607, 610 n. 4. Alain Beausire notes that *The Cry* was exhibited in 1899 in a traveling exhibition of Rodin's work, shown in Belgium and the Netherlands (*Quand Rodin exposait* [Paris: Musée Rodin, 1988], p. 15).

5. Barbier, p. 86. Beausire suggests that *The Tempest* was exhibited in 1886 at the Galerie Georges Petit (*Quand Rodin exposait*, p. 94).

6. Barbier, p. 86; Vincent, p. 15.

7. Reine-Marie Paris and Arnaud de La Chapelle, *L'Oeuvre de Camille Claudel* (Paris: Éditions d'Art et

d'Histoire, 1991), p. 105. Rodin had the head cast in bronze by Alexis Rudier in 1898, but the strip with Claudel's signature was excised and Rodin's signature was put on what remained of the neck.

8. The hollow eyes of *The Cry* argue against an attribution to Claudel, however, according to a hypothesis propounded by Reine-Marie Paris concerning Claudel's predilection for closed eyes (*Camille Claudel* [Paris: Gallimard/NRF, 1984], p. 66).

9. The contract is quoted in ibid., pp. 20–21.

10. Ibid., p. 67.

● *Catalogue no. 37*

1. The essay on Bastien-Lepage in Ulrich Thieme and Felix Becker, eds., *Allgemeines Lexikon der bildenden Künstler von der Antike bis zur Gegenwart*, was written by his contemporary, the noted critic Gustave Geffroy.

2. Charles Sterling and Margaretta M. Salinger, *French Paintings: A Catalogue of the Collection of the Metropolitan Museum of Art* (New York: Metropolitan Museum of Art, 1966), 2:207.

3. J. A. Schmoll gen. Eisenwerth, "Rodin und Lothringen," in Schmoll, p. 41.

4. Tancock, p. 71. Rodin also did a plaster portrait medallion of the painter in 1893 (Tancock, p. 75).

5. Schmoll points out that the Claude monument was prepared earlier (c. 1879–82) but erected after the *Bastien-Lepage*, so it has usually been dated after the *Bastien-Lepage* ("Rodin und Lothringen," p. 42). The maquette is usually dated 1883–89; the monument was unveiled in 1892 (Véronique Wiesinger, "Les Collaborations," in Pingeot 1986, p. 111).

6. Ibid. The Baltimore sculpture (14 1/4 in.) is illustrated in Tancock (fig. 70-4), dated as 1887. A small bronze maquette (Baltimore?) was exhibited at the Georges Petit gallery in Paris in 1887.

7. Illustrated in Descharnes and Chabrun, p. 149.

8. Beausire reproduces the page from the original catalogue (p. 68). Cladel also calls attention to the title *Plein Air* (p. 170).

9. The full-size Meudon plaster maquette, dated 1889, was exhibited in the 1989 exhibition as *possibly* the plaster exhibited in the 1889 Petit exhibition, although Cladel recalled that the maquette of the monument in the earlier exhibition was half-size (p. 170). Measurements for the Musée Rodin plaster are just 4 cm smaller than the present bronze. The *Bastien-Lepage* has a very simple base, shown in a photograph taken by Kurt Badt in 1915 (Schmoll, p. 44), and the palette and brush are included.

● *Catalogue no. 38*

1. Marion Jean Hare, "The Portraiture of Auguste Rodin," Ph.D. diss., Stanford University, 1985, p. 346.

2. *The Collection of Sir Leon and Lady Trout*, sales cat. (Brisbane: Christie's, 6–7 June 1989), cat. no. 181.

3. Beausire, pp. 104, 190.

4. Tancock dates them mostly 1886–90, except for *Pallas Wearing a Helmet* (*Pallas au casque*, executed 1905, Lyons, Musée des Beaux-Arts) (pp. 598–600). Nicole Barbier's copiously documented volume dates them mostly 1901–7 (pp. 30–33).

5. Meudon, Musée Rodin (S2826). Tancock says that the *Saint George* (*Saint Georges*) is based on Camille Claudel's face (p. 601), but Beausire correctly identifies the model as Mrs. Russell (pp. 190).

● *Catalogue no. 39*

1. Cladel, p. 271. A similar interpretation of this gesture is given by de Caso and Sanders (p. 66 n. 3).

2. Georges Grappe suggests the date of 1899 for the plaster (cat. no. 224), but in the 1944 edition of his catalogue *L'Homme et sa pensée* (cat. no. 225) is dated 1889.

3. The marble (c. 1908–9) is in the Metropolitan Museum of Art. The figures in the first sketch of the Metropolitan's marble were, however, a faun and nymph; see Vincent, p. 8.

4. Plasters are in the Musée Rodin, the Maryhill Museum of Art, Washington, and the California Palace of the Legion of Honor, San Francisco (de Caso and Sanders, p. 94); they were cast from the marble in the Thyssen-Bornemisza collection.

5. De Caso and Sanders say *Eternal Idol/The Host* was reportedly exhibited in 1896 with *Man and His Thought* under the title *The Two Hosts* (*Les Deux Hosties*) (pp. 65, 67 n. 8).

6. De Caso and Sanders allude to sacrilege (p. 65).

7. A marble is in the Fogg Art Museum (inv. no. 1943.1034). Abigail Smith, assistant archivist of the Fogg Museum archives, kindly provided information for this sculpture, but she noted that there is no record to identify it as the one illustrated in Léon Maillard, *Auguste Rodin statuaire* (Paris: H. Floury, 1899), pp. 129, 133. She adds that Cécile Goldscheider said that Rodin gave a marble to Eugène Carrière, but it remains to be identified.

8. Grappe, cat. no. 204. The plaster sketch model for this is in San Francisco (illustrated in de Caso and Sanders, p. 64).

9. De Caso and Sanders, p. 67 n. 10.

10. Maillard, *Auguste Rodin statuaire*, pp. 129, 133.

11. Bruno Gaudichon, "Çacountala," in Bruno Gaudichon and Monique Laurent, *Camille Claudel*, exh. cat. (Paris: Musée Rodin; Poitiers: Musée Sainte-Croix, 1984), p. 40. See also Denys Sutton, *Triumphant Satyr: The World of Auguste Rodin* (New York: Hawthorn, 1966), pp. 82–83.

● *Catalogue no. 40*

1. Dorothy Kosinski, *Orpheus in Nineteenth-Century Symbolism* (Ann Arbor: UMI Research Press, 1989), ch. 1.

2. Ovid, *The Metamorphoses*, trans. A. E. Watts (Berkeley and Los Angeles: University of California Press, 1954), book 10, p. 218.

3. Lynne Ambrosini, "Orpheus," in Ambrosini and Facos, pp. 167, 169 n. 35 (quoted from "Rodin's Tears Seem Real," *Chicago American*, 3 August 1901).

4. Ovid, *The Metamorphoses*, book 11; Kosinski, *Orpheus*, pp. 12–18.

5. Ambrosini, "Orpheus," pp. 166–67, quoting many contemporary sources.

6. Kosinski, *Orpheus*, fig. 5.16; Pingeot 1986, fig. 113. Kosinski writes, "Eurydice, the sculpture, inflates Rodin's heart and eyes with life. Yet, she is an ideal of unthinkable, timeless beauty, and thus, inherently unattainable, and hence, the source of pain and anguish to the sculptor" (p. 162).

7. The musical instrument shown in this sculpture is not a lyre but a kithara, an instrument made from the shell of a tortoise. (Rodin has modified the classic shape of the kithara by shortening the upright arms at the top of the sound-chest.) The kithara was the most important stringed instrument of Greco-Roman antiquity; larger than the lyre, it was preferred for performance and virtuoso display, write James W. McKinnon and Robert Anderson ("Kithara," in *The New Grove Dictionary of Musical Instruments*, vol. 2, ed. Stanley Sadie [London: Macmillan; New York: Grove's Dictionaries of Music, 1984], p. 441). Also Max Wegner, "Die Orpheus-Sage . . . ," in *Die Musik in Geschichte und Gegenwart*, vol. 10 (Kassel: Bärenreiter, 1962), p. 410, wherein Orpheus is described specifically as a player of the kithara. See also "Leier," in ibid., vol. 8, (Kassel: Bärenreiter, 1960) p. 526, fig. 13c.

9. A vintage photograph of the plaster model is reproduced in Pingeot 1986 (fig. 112). The marble is in the Metropolitan Museum of Art; see Vincent, pp. 12–13.

10. A vintage photograph of the plaster is reproduced in Pingeot 1986 (fig. 109). For the marble, see Barbier, cat. no. 70. This sculpture entered the collection of the Musée Rodin under the simple reference of "Orpheus, a small group," but its manuscript inventory reference called it *Orphée et les ménades*.

11. Kosinski notes that it is not possible to give a precise reason for this increased interest in the story: "How Orpheus comes to figure so importantly in Symbolism defies precise definition because the way in which the durable truth of myth becomes cultural currency is itself elusive" (*Orpheus*, p. XI).

12. Ambrosini and Facos, cat. no. 18. This may have some bearing on a proposed date for the present composition; Ambrosini suggests a date in the 1890s, which seems likely (p. 165). She also reviews several possibilities for dating based on reports of sculptures seen in Rodin's studio, but it is not always possible from the titles given in these reports to determine specifically which sculpture is under discussion. She notes that the enlargement to the present size was probably done in 1900. Also, Athena Tacha suggests that there is a common model used as the source for both *The Prodigal Son* and *Orpheus* and that the torso of the *Centauresse* is derived from *Orpheus*, dating it to the late 1880s ("The Prodigal Son: Some New Aspects of Rodin's Sculpture," *Allen Memorial Art Museum Bulletin* 22, no. 1 [fall 1964]: 37).

● *Catalogue no. 41*

1. Grappe 1944, no. 164. He says that an example of *Invocation* was acquired by the Metropolitan Museum of Art, but Clare Vincent, in a letter to the author (27 October 1992), wrote that "Grappe was . . . mistaken. I have never seen any evidence that [the Metropolitan] considered having an example of Rodin's *Invocation*."

2. Nicole Barbier observes that Rodin called it *Abruzzezzi Seated* (in Catherine Lambert, ed., *Rodin: Sculpture and Drawings*, exh. cat. [London: Hayward Gallery, 1986], cat. no. 84). The sculpture exhibited in London, a plaster painted a deep, blackened green, is preserved in the Musée Rodin. For this sculpture Barbier very generously supplied the fundamental information on which the present entry is substantially based.

3. Barbier, in a letter to the author (14 May 1992), notes that the sculpture was exhibited in Prague in 1902 under the title *L'Aurore s'éveillant*; it was called *Invocation* in the sale of the Octave Mirbeau collection in 1919. See also Alain Beausire, *Quand Rodin exposait* (Paris: Musée Rodin, 1988), pp. 191, 233.

4. Grappe 1944, cat. nos. 158, 164. Reine-Marie Paris and Arnaud de La Chapelle suggest that *Invocation* inspired Claudel's sculpture *The Flute Player* (*La Joueuse de flûte*) (*L'Oeuvre de Camille Claudel* [Paris: Éditions d'Art et d'Histoire, 1991], pp. 38, 202).

● *Catalogue no. 42*

1. Tancock, pp. 504–6; Jane Roos, "Rodin's *Monument to Victor Hugo*: Art and Politics in the Third Republic," *Art Bulletin* 68, no. 4 (December 1986): 635.

2. Tancock, p. 504; Fonsmark, p. 93, quoting Rodin's recollections as told to Paul Gsell.

3. Hugo's death in 1885 increased demand for examples of Rodin's portraits of him (Barbier, cat. no. 25). Other examples are illustrated in Spear, pls. 5–8.

4. Details of the commission and its background can be found in Roos, "Rodin's *Monument to Victor Hugo*," pp. 640–44.

5. An excellent review of the two formats is given by Anne Pingeot in "Fragments tirés d'un ensemble I. Rodin: Le monument à Victor Hugo," in Pingeot

1990, pp. 203–16. The statement of rejection pronounced by the Commission Consultative des Travaux d'Art is on p. 205. Pingeot notes that some of the subsidiary figures were originally done for *The Gates of Hell*.

6. Barbier, cat. no. 94. The marble was finished in 1901. It was moved to the Musée Rodin in 1933. A plaster is in the Ny Carlsberg Glyptotek (Fonsmark, cat. no. 26).

7. See Roos, "Rodin's *Monument to Victor Hugo*," pp. 650–56, especially pp. 654–55.

8. Grappe, nos. 245–46. He dates the standing nude to 1902. This source for the bust is customarily accepted, e.g., by Spear, pp. 7, 90, and by Pingeot et al. (pp. 236–37).

9. A comparison of the illustration in Grappe (cat. no. 245) with that in Barbier (p. 225) reveals an obvious similarity, as do figs. 436–37 and 440 in Pingeot 1990. In addition to this similarity, it is worth noting that a bronze of another variant of the Palais Royal type—Victor Hugo with two muses—was cast in 1964 for the city of Paris; it is installed in Paris at the Carrefour-Victor-Hugo-Henri-Martin and illustrated in Pierre Kjellberg, *Le Guide des statues de Paris* (Paris: Bibliothèque des Arts, 1973), pp. 127–28. The configuration of hair on the proper right side of the forehead is comparable with that of the present bronze. Furthermore, a plaster study for the Palais Royal monument (now at Meudon) shows a break at the left shoulder corresponding with that in the present sculpture (see Schmoll, fig. 82). Perhaps the *Heroic Bust* represents a transitional phase between the Palais Royal maquette and the *Apotheosis*. A photograph by Edward Steichen of Rodin in front of *The Thinker* and the Palais Royal monument shows the monument in reverse. Nicole Barbier, in a letter to the author (28 January 1993), suggests any of three plasters at Meudon as the model from which the present bronze was cast: inv. nos. S2487, S2919, S3167.

There is every likelihood that Rodin transferred plasters of the same head to different torsos. See the illustrations in Cécile Goldscheider, "Rodin et le monument de Victor Hugo," *Révue des arts* 6, no. 3 (October 1956): 179–84.

10. The dates are summarized by Michelle Facos ("Monumental Bust of Victor Hugo," in Ambrosini and Facos, p. 174).

11. Pingeot et al., p. 236; Facos notes that Anthony Ludovici reported having seen an example of the bust in progress in that very year, 1906 ("Monumental Bust," p. 174 n. 8).

12. Quoted in Barbier, cat. no. 26.

● *Catalogue no. 43*

1. Schmoll, p. 138.

2. Georges Grappe commented that it represented Glory; the other figures are muses (no. 171). Well illustrated by Jane Roos, "Rodin's *Monument to Victor Hugo*: Art and Politics in the Third Republic," *Art Bulletin* 68, no. 4 (December 1986): figs. 23–24.

3. This interpretation is offered by Roos, "Rodin's *Monument to Victor Hugo*," p. 654.

4. Keisch comments that it can be related to Rodin's studies of cancan dancers (cat. no. 41). However, Elsen writes that "a series of variations and enlargements of the motif of a cancan dancer . . . was perhaps a reworking of the piece done in the early nineties . . . called *Iris, Messenger of the Gods*" ("When the Sculptures Were White: Rodin's Work in Plaster," in Elsen 1981, p. 144).

5. Compare a discussion of the chronology proposed for Rodin's erotic drawings by Claudie Judrin, "Rodin's 'Scandalous' Drawings," in Rainer Crone and Siegfried Salzmann, eds., *Rodin: Eros and Creativity* (Munich: Prestel, 1992), pp. 146–47.

● *Catalogue no. 44*

1. Tancock, p. 288.

2. Ibid., fig. 46-6. This plaster is not to be confused with two others in the Musée Rodin (S695 and S706) which have more traditionally realistic heads (illustrated in Elsen 1981, p. 144).

3. Tancock, p. 288

4. Grappe, no. 172.

5. Ibid.

6. Cf. other titles given in de Caso and Sanders, cat. no. 35, p. 195.

● *Catalogue no. 45*

1. Schmoll relates it to the Victor Hugo monument (p. 138), while Elsen (p. 181) and Tancock (p. 288) emphasize its relation to *Avarice and Lust*, well illustrated in Rainer Crone and Siegfried Salzmann, eds., *Rodin: Eros and Creativity* (Munich: Prestel, 1992), pp. 23–25. These photographs show that there were slight modifications in the right hand and in the general orientation of the body, which was straightened and made more abstract.

2. Albert Elsen offers a fine analysis of it (*The Partial Figure in Modern Sculpture from Rodin to 1969*, exh. cat. [Baltimore: Baltimore Museum of Art, 1969], p. 22).

3. Ibid., p. 25, for Judith Cladel's response to this criticism; also Elsen 1963, p. 180.

4. Elsen recounts an anecdote about Rodin's deliberately cutting the head from a figure and then admiring the success of the head alone: "'How beautiful it is without the body! . . . All these fragments . . . come from enlargements. Now in an enlargement, if certain parts keep their proportions, others are not in scale. But one must know where to cut!'" (Elsen, *Partial Figure*, p. 23).

5. Elsen suggests that such treatment is an aspect of realism: damage is part of the material existence of art (ibid., p. 24).

● *Catalogue no. 46*

1. Ruth Butler recounts that the clay model froze in winter, and the back of the head broke off; Rodin submitted the fragmentary piece in this condition to the Salon of 1864 ("Auguste Rodin," in Fusco and Janson, p. 328). Pertinent facts appear in Pingeot et al. (pp. 233–34): the sculpture submitted to the Salon was a plaster cast, and it was rejected.

2. Barbier, "Assemblages de Rodin," in Pingeot 1990, p. 242. Both Butler ("Rodin," p. 346) and Monique Laurent (in·Rodin, exh. cat. [Martigny: Fondation Pierre Gianadda, 1984], p. 116) say that the figure is entirely derived from *The Despairing Adolescent*, although with a change of sex.

3. A related plaster is in the Musée Rodin at Meudon (Descharnes and Chabrun, p. 94). Rodin did numerous studies of hands (see cat. no. 48), "independent hands which live without belonging to any body," wrote his secretary, Rainer Maria Rilke, in an oft-quoted passage (in Rilke, *Rodin*, trans. Robert Firmage [Salt Lake City: Peregrine Smith, 1979], p. 37).

4. Tancock asserts that it was derived from early studies for the *Burghers* (p. 616). Butler suggests a date of the late 1890s for the composition, based on a possible relation to the *Burghers* ("Rodin," pp. 345–46). De Caso and Sanders suggest an even earlier date in the beginning of the 1880s based on a resemblance to *The Thinker* and *The Three Shades* and a mood closer to that of *The Gates of Hell* (p. 350 n. 83).

5. Barbier shows the torso posed somewhat differently, and the hand varies slightly, with longer fingers ("Assemblages," fig. 510 with accompanying commentary on p. 243). She believes that the model cast in bronze is derived from the plaster in the photograph.

● *Catalogue no. 47*

1. De Caso and Sanders, p. 305, with specific acknowledgment to Donald Keene (*Landscapes and Portraits* [Tokyo: Kodansha, 1971], pp. 208–9, 250–58) and Mrs. Yamada of University of California, Berkeley, Eastern Asia Library. Monique Laurent and Claudie Judrin note that Hisako Hohta was the name of the heroine in the play *The Geisha's Vengeance* (*Rodin et l'Extrême Orient*, exh. cat. [Paris: Musée Rodin, 1979], p. 24). (Laurent and Judrin provide a fundamental study of Rodin's interest in Hanako and Asian art. Rodin's interest in Asian art is also discussed in de Caso and Sanders, p. 308 n. 8.)

2. His comments on her body (she modeled in the nude for him) are quoted in Laurent and Judrin, *L'Extrême Orient*, p. 41. A number of Rodin's portraits of Hanako are illustrated in this catalogue.

3. For examples of type C and the related type D, see ibid., pp. 30–33. Laurent and Judrin count fifty busts, heads, and masks of Hanako in the Musée Rodin and comment that Rodin did more portraits of her than of any other model (p. 23). Tancock notes the date of Steichen's sojourn at Meudon (p. 256).

4. De Caso and Sanders, p. 307 n. 3. Laurent and Judrin caution that Rodin first saw her in Marseilles in 1906 but did only drawings of her because he was traveling and had no materials for sculpture at hand (*L'Extrême Orient*, p. 24).

5. Laurent and Judrin, *L'Extrême Orient*, p. 32. Whether Rodin repeatedly used the portrait type of the mask because of its associations with Asian masks is not known; Rodin did, however, purchase two Japanese masks in 1910 (illustrated in ibid., cat. nos. 89–90).

6. These are surveyed and copiously illustrated in ibid.

7. Sadda Yakko's performances were a spectacular success at the International Exposition of 1900 in Paris (ibid., p. 23).

8. Ibid., p. 24.

● *Catalogue no. 48*

1. Monique Laurent, "Sculptures," in *Rodin*, exh. cat. (Martigny, Switzerland: Fondation Pierre Gianadda, 1984) p. 123; Elsen 1963, pp. 174, 176 (the illustration shows a plaster hand that is possibly the original model for the present bronze). The medievalizing flavor of some of Rodin's compositions based on fragmentary hands, including *Hand [Emerging] from the Tomb*, is discussed by Albert Elsen in *The Partial Figure in Modern Sculpture from Rodin to 1969*, exh. cat. (Baltimore: Baltimore Museum of Art, 1969, p. 24), with illustrations of several plaster fragments at Meudon.

2. Athena Tacha Spear also relates it to *The Hand of God* (c. 1896; p. 79 and pl. 102). In this context it is important to note an observation made by Mathias Morhardt: "During the years in which Camille Claudel worked in Rodin's studio ... Rodin specifically [*notamment*] assigned to her the responsibility of modeling the hands or feet of many of his figures" ("Mlle Camille Claudel," *Mercure de France*, March 1898 [n.p.]; quoted in Bruno Gaudichon, "Main," in Bruno Gaudichon and Monique Laurent, *Camille Claudel*, exh. cat. [Paris: Musée Rodin; Poitiers: Musée Sainte-Croix, 1984], p. 48).

3. Tancock, p. 632.

4. Barbier, p. 212. Both are approximately 23 in. high.

5. Tancock, p. 632. Frédéric-Auguste Bartholdi used a similar motif of an arm emerging from under a slab, but in that case the tomb was, in fact, constructed and used (Barbier, p. 178). Neither the bronze nor the marble *Hand [Emerging] from the Tomb* bears an inscription.

6. Tancock, p. 632. Nicole Barbier notes Rodin's topical use of the expression (p. 212).

● *Catalogue no. 49*

1. See, for instance, Monique Laurent, "Sculpture," in *Rodin*, exh. cat. (Martigny, Switzerland: Fondation Pierre Gianadda, 1984), pp. 136–40.

2. Charles Millard, *The Sculpture of Edgar Degas* (Princeton: Princeton University Press, 1976). See, for example, the *Little Dancer* (c. 1880; p. 14), and others (pp. 18–19).

3. Cécile Goldscheider, "Rodin et la danse," *Art de France* 3 (1963): 324–27. Loïe Fuller first performed in Paris in 1892. She not only collected Rodin's sculptures but also organized an exhibition of his work in New York in 1903. See Descharnes and Chabrun, p. 246, for Isadora Duncan's performances for Rodin in 1901 and 1903.

4. Goldscheider, "Rodin et la danse," pp. 327–28; Monique Laurent and Claudie Judrin, *Rodin et l'Extrême Orient*, exh. cat. (Paris: Musée Rodin, 1979), pp. 67–107, passim.

5. Descharnes and Chabrun, p. 248.

● *Catalogue no. 50*

1. Cladel, pp. 305, 308–9.

2. Ibid., 308.

3. Ibid., pp. 11–30.

4. Gabriele de Rosa, "Benedetto xv," in *Dizionario biografico degli italiani*, especially p. 409; Filippo Crispolti, "Benedetto xv," in *Enciclopedia italiana*, reprint ed. (1949).

5. Cladel refers to them as *"personnalités favorables à la France"* (p. 311); Tancock calls them francophiles (p. 567).

6. Tancock suggests that Rodin must have known about the sittings before he left for Rome. Cladel is inconsistent on the number of sittings granted to Rodin, citing both three (p. 43) and four (p. 313). Georges Grappe says three (p. 114); he catalogues the example of the portrait in the Musée Rodin as a marble, but illustrates a bronze. Alain Beausire, Florence Cadouot, and Frédérique Vincent say that Rodin was able to secure only three sessions (Beausire et al., eds., *Correspondance de Rodin: 1913–1917* [Paris: Musée

Rodin, 1992], 4:125), which is substantiated by a letter from Rodin from early August 1914, in which he wrote that he was "going to do the portrait of His Holiness" (p. 88).

7. Cladel, p. 312. She also comments that the pope might have been favorably inclined toward France because he had served as papal nuncio in Paris, but the biographies cited here do not mention any service in France. He was secretary to the nuncio in Madrid (1878–83).

8. De Rosa notes that the pope condemned the war on an ideological basis and deplored its violence and that he was eager to reestablish ties with France after the war. De Rosa observes that members of the Roman curia had been attracted to France throughout the nineteenth century and that much of Catholic social thought came from France ("Benedetto xv," pp. 409–11, 415–16).

9. David Thomson, ed., *The Era of Violence 1898–1945*, vol. 12 of *The New Cambridge Modern History* (Cambridge: Cambridge University Press, 1964), p. 95; for the period of the war discussed here, see 354–69.

10. Cladel, p. 313.

11. Ibid. Rodin broke protocol by attempting to place himself physically higher than the pope to observe him.

12. Ibid., pp. 313–14, relying on the account given by Albert Besnard, *Sous le ciel de Rome* (Paris: Les Éditions de France, 1925), p. 256 (quoted also in Tancock, p. 570 n. 2). Besnard's account is tinged with patriotism, referring to the sculptor as *"notre Rodin national"* (our national Rodin). Curiously Rainer Crone and David Moos describe the pope as one of Rodin's "enthusiastic acquaintance[s] . . . who took advantage of Rodin's 1915 excursion to Rome to sit for his portrait" (*Rodin: Eros and Creativity* [Munich: Prestel, 1992], p. 50).

13. Information on the painting was generously supplied by Dott. Mario Ferrazza, director of the Reparto di Arte Religiosa Moderna, Vatican City, and communicated to the author by Dott.

Guido Cornini of the Musei Vaticani in a letter of 30 November 1992. This does not obviate the possibility that the painter Lippay did do a sculpture of the pope, but such a sculpture is not in the Vatican collections, where it would otherwise logically be found. For biographical information on Lippay (spelled Lipaï by Cladel), see Ulrich Thieme and Felix Becker, eds., *Allgemeines Lexikon der bildenden Künstler von der Antike bis zur Gegenwart*, s.v. "Berthold Lippay"; and A. S. L[evetus], "Studio-Talk: Vienna," *The Studio* 54 (1912): 325–26. After Rodin's departure a marble bust of the pope was done in Rome by Ernest Durig (1894–1962), who had once worked for Rodin and served as a Swiss guard at the Vatican (Beausire et al., eds., *Correspondance*, pp. 4:158–59, 212).

14. Castellane's memoirs are quoted in Marion Jean Hare, "The Portraiture of Auguste Rodin," Ph.D., diss., Stanford University, 1985, p. 629. He said that it was made of *terre glaise* (clay). In a letter to the author (15 January 1993) Nicole Barbier states that there is no clay portrait of the pope in the Musée Rodin, only plasters. Hare, relying on a biography of the pope by Henry E. G. Rope, entitled *Benedict XV, the Pope of Peace* (London: J. Gifford, 1941), attributes his agitation to his self-consciousness and inability to sit still under Rodin's scrutiny (p. 631); Cladel makes a similar assertion.

15. Rainer Maria Rilke gave this account of Rodin's procedure for the portrait of George Bernard Shaw: "'He . . . cut off the head of the bust with a wire. . . . Shaw . . . watched his decapitation with indescribable joy'" (*Rodin*, trans. Robert Firmage [Salt Lake City: Peregrine Smith, 1979], p. 536). Hare believes that Rodin intended simply to suggest a clerical collar with this otherwise abrupt truncation ("Portraiture," p. 631).

16. Crispolti mentions his "penetrating eyes" ("Benedetto xv").

● *Catalogue no. 51*

1. Gautier's account was reprinted in the issue of *La Plume* dedicated to Falguière (no. 219 [1 June 1898]; hereinafter *La Plume*): 378–81.

2. The two etchings are reproduced in Peter Fusco's fundamental study of this sculpture, "Falguière, the Female Nude, and 'La Résistance,'" *Los Angeles County Museum of Art Bulletin* 23 (1977): 42–43. See also Fusco, "Jean-Alexandre-Joseph Falguière," in Fusco and Janson, pp. 255–57.

3. H. Galli commented enthusiastically that "just recently [i.e., before 19 January 1895] a model of rare beauty reminded him [Falguière] even more [of the snow statue]. Immediately the artist set feverishly to work" (*L'Art français*, 19 January 1895; reprinted in *La Plume*: 408.

4. In addition to Fusco's articles, see Anne Pingeot, "Le Fonds Falguière au musée du Louvre," *Bulletin de la Société de l'Histoire de l'Art Français, 1978* (1980): 267–68. For a list of studies and variants in terra-cotta, wax, plaster, bronze, and stone, see Pingeot et al., p. 149 (RF2673). Yet another related plaster of the figure without the cannon was on the Paris art market in 1991.

5. That the difference in the cannon's orientation was not caused by a reversal of the image in printing can be determined by the fact that the inscription was not reversed.

6. Regarding Falguière's technique, see CATALOGUE NOS. 52–54.

7. Fusco, "Female Nude," p. 45. Fusco also points out that *Resistance* may have been the first of a long succession of female nudes sculptured by Falguière. See Fusco, "Jean-Alexandre-Joseph Falguière," p. 263 n. 17, for bibliography on other possible compositional sources.

8. Stanislas Lami, *Dictionnaire des sculpteurs de l'école française au dix-neuvième siècle*, s.v. "Jean-Alexandre-Joseph Falguière."

9. This biography is drawn substantially from Fusco, "Jean-Alexandre-Joseph Falguière," p. 255.

10. Quoted in *La Plume*: 412.

● *Catalogue no. 52*

1. A revision of the chronology of the projects given by Yvanhoé Rambosson (*Préface de l'exposition A. Falguière* [Paris: Nouveau Cirque, 1898]) was proposed by Anne Pingeot ("Le Fonds Falguière au musée du Louvre," *Bulletin de la Société de l'Histoire de l'Art Français, 1978* (1980): 275–77). Pingeot's chronology would thus also revise the one given by Henry D. Davray in "Le Monument de la Révolution au Panthéon," *La Plume*, no. 219 (1 June 1898; hereinafter *La Plume*): 385–87. Rambosson's and Davray's chronologies were written by Falguière's contemporaries, so they should not be entirely discounted.

2. This follows his own description, quoted in Pingeot, "Le Fonds Falguière," pp. 276–77 (Archives Nationales F21.2078).

3. Falguière did two models for a sculpture of *Joan of Arc*, which closely resemble his sketches for *The Defense of Paris* (*Défense de Paris*) and *Savoy Giving Itself to France* (*La Savoie se donnant à la France*, 1892?); all are illustrated in *La Plume*: 380–83. The nationalistic symbolism of Joan of Arc would have been obvious to Falguière's countrymen. Falguière's final model for *The Revolution* was more than four times life-size; one of his critics commented that it made the marble statues (more than nine feet high) in the surrounding niches in the Pantheon look microscopic by comparison (Ernest Jetot, "La Statue de la Liberté," *La Patrie* (31 August 1897), reproduced in *La Plume*: 408.

4. *La Plume*: 408.

5. The present bronze corresponds most closely with the large plaster model in the Musée des Beaux-Arts in Lille. There is also a painted plaster model in the Musée d'Orsay (RF2672) and another plaster in the Musée du Petit Palais, Paris. An independent figure of Revolution exists in bronze also; see Robert Kashey, ed., *Viewpoints: European Sculpture 1875–1925*, exh. cat. (New York:

Shepherd Gallery, 1991), cat. no. 16; also *Skulpturen und Kunsthandwerk*, auction cat. (Munich: Neumeister, 10 December 1991), cat. no. 146. In a letter of 6 March 1979 H. W. Janson informed Anne Pingeot that he believed the foundry mark indicated that the present bronze was "surely cast in Paris, but apparently for a Peruvian dealer" (letter in Musée d'Orsay documentation).

6. For example, a bronze in the Frick Collection, New York; see John Pope-Hennessy and Anthony Radcliffe, *Italian Sculpture*, vol. 3 of *The Frick Collection: An Illustrated Catalogue* (New York: Frick Collection, 1970), pp. 234–38. A related statuette is in the Louvre. A more immediate precursor may have been Jean-Auguste Barre's *Triumph of Liberty*, shown in the Salon of 1831. (See Jacques de Caso, *L'Avenir de la mémoire* [Paris: Flammarion, 1988], fig. 138.)

7. According to Peter Fusco, the eyes are closed and represent self-involvement ("Jean-Alexandre-Joseph Falguière," in Fusco and Janson, p. 262).

8. The Trocadero fountain is illustrated in *La Plume*: 373. The wax model for the *Triumph of the Revolution* (Musée d'Orsay, DO1982–760) is discussed by Guilhem Scherf ("Triomphe de la Révolution," *Sculptures en cire de l'ancienne Egypte à l'art abstrait*, ed. Jean-René Gaborit (Paris: Réunion des Musées Nationaux, 1987), cat. no. 74.

9. Musée d'Orsay documentation.

● *Catalogue no. 53*

1. In Homer's *Odyssey* (books 10–11) Circe transformed Odysseus's crew into pigs; Odysseus himself, protected from her magic by an herb given to him by Hermes, convinced her to restore his companions to their original form. She then revealed to him the secret of a safe descent into the underworld.

2. Illustrated in Fusco and Janson, p. 261. Stanislas Lami, remarked that "in his painting[s], one finds the sculptor looking for the effects of high relief and three-dimensionality" (*Dictionnaire des*

sculpteurs de l'école française au dix-neuvième siècle, s.v. "Jean-Alexandre-Joseph Falguière." Gustave Geffroy called his paintings "colored sculpture" ("Alexandre Falguière," *Gazette des beaux-arts* 23 [1900]: 405).

3. Yvanhoé Rambosson, "L'Art de Falguière," in *La Plume*, no. 219 (1 June 1898): 359.

4. Ibid.

5. Measuring 26 x 14 cm and listed in Camille Gronkowski, *Catalogue sommaire des collections municipales: Palais des beaux-arts de la ville de Paris* (Paris: the museum, 1927), cat. no. 257.

6. Listed in Musée d'Orsay documentation, which also notes that the Hébrard foundry, according to Hébrard's fifteenth catalogue (n.d.), issued *Circe* in bronze and pewter (*étain*) in measurements of 45 x 35 cm and framed.

7. Musée d'Orsay documentation notes that this relief (no. 3 in the sale) measured 59 cm high. The relief is also mentioned by Lami ("Falguière"). It was exhibited in 1902.

● *Catalogue no. 54*

1. The present entry is based substantially on one by Peter Fusco devoted to the same sculpture, "Jean-Alexandre-Joseph Falguière," in Fusco and Janson, cat. no. 135; and one on a related bronze by Isabelle Leroy-Jay Lemaistre, "Alexandre-Jean-Joseph Falguière: Balzac," in *Bronzes "De la Renaissance à Rodin": Chefs-d'oeuvre du musée du Louvre*, exh. cat. (Tokyo: Tokyo Metropolitan Art Museum, 1988), cat. no. 72.

2. Paul Gsell, *Art by Auguste Rodin*, trans. Mrs. Romilly Fedden (Boston: Small, Maynard, 1912), p. 146. Falguière subsequently did Rodin's portrait.

3. Anne Pingeot, "Le *Flaubert* et le *Balzac* de Chapu," *Revue du Louvre* 23, no. 1 (1979): 41–42; Chapu's terra-cotta sketch (now Musée d'Orsay, RF1764) is illustrated on p. 35 and in Pingeot et al., p. 96.

4. Mme Judith Meyer-Petit, curator of the Maison de Balzac, kindly provided a photograph of this bronze and con-

firmed that a bronze bust, said in the documentation of the Musée d'Orsay to be at the Maison de Balzac, is not in that collection. Gustave Geffroy criticized Falguière's design, calling it "still-born" ("Alexandre Falguière," in *Gazette des beaux-arts* 23 [1900]: 404).

5. Lemaistre ("Falguière: Balzac," p. 256) and Musée d'Orsay documentation maintain that the monument was finished by Falguière's student Laurent-Honoré Marquestre (1848–1920), while Peter Fusco (Fusco and Janson, cat. no. 135) and Jacques de Caso ("Rodin and the Cult of Balzac," *Burlington Magazine* 106, no. 735 [June 1964]: 284) say that it was completed by Falguière's comrade from the Académie de France in Rome, Paul Dubois. (Lemaistre illustrates the monument as completed.)

6. Lemaistre comments that the bronze bust in the Musée d'Orsay was cast by Frédéric Goldscheider and implies that others bearing the date 1899 in bronze, terra-cotta, and marble were produced by his studio ("Falguière: Balzac," p. 256). Another marble, close in size to the present bust (48 x 36 x 36 cm), signed and dated 1899, is in the Musée Municipal of Evreux (Musée d'Orsay documentation); it has a slight variation in the form of the lower edge of the truncation and in the shirt. A terra-cotta sketch for the entire monument (measuring 16 x 13.5 cm) is in the Musée du Petit Palais, Paris (Musée d'Orsay documentation).

● *Catalogue no. 55*

1. A. Thiery and E. van Dievoet date *Bust of a Puddler* to 1895 (*Exposition de l'oeuvre de Constantin Meunier*, exh. cat. [Louvain: Nova et Vetera], 1909), cat. no. 34. See also Georg Treu, *Constantin Meunier* (Dresden: Kunsthandlung von Emil Richter/Hermann Holst, 1898), pp. 23–24.

2. Various motivations for the trip have been suggested. According to Treu, Meunier said that the trip was undertaken "by chance…when I was fifty years old"

(*Meunier*, pp. 23–24). Christian Brinton wrote that Meunier received "an opportune commission to furnish designs for a triumphal float depicting typical scenes in the Pays Noir" (*Constantin Meunier*, exh. cat. [New York: Avery Library, Columbia University, and Redfield Bros., 1914], p. 12). More recent standard literature generally suggests attributing the journey to a visit to the son of the realist painter Charles de Groux. See, for example, Pierre Baudson, "La Représentation du travail dans la sculpture" in vol. 1 and "Constantin Meunier" in vol. 2 of *La Sculpture belge au 19e siècle*, ed. Jacques van Lennep (Brussels: La Générale de Banque, 1990) 1:220, 2:499; and idem, *Constantin Meunier, George Minne*, exh. cat. (Brussels: Musées Royaux des Beaux-Arts and Musée Moderne, 1969), unpaginated.

3. Christine Goetz quotes a German translation of Lemonnier's memoirs for an account of this (*Studien zum Thema "Arbeit" im Werk von Constantin Meunier und Vincent van Gogh*, vol. 2 of *Beiträge zur Kunstwissenschaft* [Munich: Richard A. Klein, 1984], p. 1).

4. Peter Hielscher and Arwed Gorella give a good analysis of industrial development and workers' status in Belgium at this time and note that Meunier did not join the labor party (*Constantin Meunier*, exh. cat. [Berlin: Neue Gesellschaft für bildende Kunst, c. 1975], unpaginated).

5. Thiery and Dievoet, *Meunier*, p. 24.

6. Lucien Christophe, *Musée/ Museum Constantin Meunier* (Brussels: Minstère de l'Éducation Nationale et de la Culture, undated); information for *Copperworks* is given under cat. no. 21. Christophe gives these dates and locations of the salons of first exhibition (p. 5), which are not, however, agreed upon in the general literature.

7. Pingeot 1986, p. 363.

8. Cladel, pp. 50–51; Micheline Hanotelle, *Paris/Bruxelles: Rodin et Meunier* (Paris: Le Temps, 1982), p. 157.

9. Domenico Trentacoste, "Un glorificatore del lavoro: Costantino Meunier," *Il Marzocco* 10, no. 15 (9 April 1905): [1].

10. Pierre Baudson of the Musées Royaux des Beaux-Arts de Belgique kindly informed the author in a letter (14 October 1993) that the painting was executed after 1896 and before 1901.

11. Puddling is the process by which wrought iron is refined from pig iron. Less brittle than pig iron, wrought iron is more malleable and more resistant to shocks and thus can be used for anything that needs to be bent or withstand strain. It was used for bridges and the armature of the Statue of Liberty. See Verena Villiger, "Le Puddleur," in *Sculptures du musée cantonal des beaux-arts de Lausanne* (Lausanne: the museum, 1990), p. 34: "The first great innovation in steel-works was the method of puddling ["*marteler*," but this word really is applied to hammering], invented by the English Henry Cort, applied ... first on the Continent in Belgium. In 1820 the Cockerill brothers set up the first kiln for puddling. Thanks to this method, with which four thousand kilograms of wrought iron could be produced in twenty-four hours, iron-working became a major industry." See cat. no. 56 n. 15. Puddling squeezed impurities from semi-molten iron.

● *Catalogue no. 56*
1. The different types of replicas are discussed in detail in Edward L. Kallop et al., *Images of Liberty: Models and Reductions of the Statue of Liberty 1867–1917*, exh. cat. (New York: Christie, Manson and Woods, 1985), pp. 24–26, 47–50. This catalogue was kindly supplied to the author by one of its authors, Alice Levi Duncan. The thirty-six-foot replica, commissioned by the American community in Paris and inaugurated July 4, 1889, is now installed at the Pont de Grenelle in Paris. The five known Thiébaut bronzes are assumed to have been produced as reductions from the four-foot *modèle d'étude* while the Paris *Liberty* was being cast, and two of them have provenances related to Bartholdi, so they may have been cast at his request (p. 24). The Los Angeles

bronze has a brilliant color reminiscent of copper, with a fine, transparent varnish. See in addition Robert Baboian et al., eds., *The Statue of Liberty Restoration*, Proceedings of "The Statue of Liberty: Today for Tomorrow" Conference, New York, 20–22 October 1986 (Houston: National Association of Corrosion Engineers, 1990), p. 34. A comprehensive study of the monument is also given in Pierre Provoyeur and June Hargrove, eds., *Liberty: The French-American Statue in Art and History*, exh. cat. (New York: New York Public Library, 1986).

2. Marvin Trachtenberg, *The Statue of Liberty* (New York: Penguin, 1977), pp. 1, 26–30. The subject of the bond between the countries was discussed at a dinner at Laboulaye's house in 1865 at which Bartholdi was present.

3. A summary biography of Bartholdi is given by Marie Busco in Fusco and Janson ("Frédéric-Auguste Bartholdi," p. 121). Stanislas Lami states that Bartholdi studied architecture for two years in Colmar before he went to Paris (*Dictionnaire des sculpteurs de l'école française au dix-neuvième siècle*, s.v. "Frédéric-Auguste Bartholdi").

4. The statue of Rapp is about 138 in.; his statue of Lafayette in Union Square, New York, is over life-size; the *Lion of Belfort* is 38 x 70 feet (Trachtenberg, *Statue of Liberty*, pp. 32–33, 45–46.)

5. Kallop et al., *Images of Liberty*, p. 5.

6. Trachtenberg, *Statue of Liberty*, pp. 52–54.

7. Ibid., illustrated on pp. 52–55.

8. Baboian et al., eds., *Statue of Liberty Restoration*, pp. 32–33; Kallop et al., *Images of Liberty*, pp. 17, 28. Numbered, signed casts in terra-cotta (38 in.) were produced to be sold for financing the statue through the Union Franco-Américaine in France; in the United States, the American Committee of the Statue of Liberty, responsible for financing the pedestal, sold versions (with pedestal) in a tin alloy (6 and 12 in.).

9. Trachtenberg, *Statue of Liberty*, pp. 53–54, 57.

10. Ibid., p. 31; Kallop et al., *Images of Liberty*, p. 17.

11. Trachtenberg, *Statue of Liberty*, pp. 31, 140. Two islands in New York Harbor were available: Governor's Island and Bedloe's Island. In 1877 the federal government, represented by General William Tecumseh Sherman, granted the use of the latter, which Bartholdi indeed preferred.

12. Ibid., pp. 41–43.

13. Ibid., pp. 124–26.

14. Ibid., pp. 118–21.

15. Ibid., figs. 75–77, 83.

16. Martha Goodway points out that the repoussé copper technique, as opposed to cast bronze, permitted more delicate definition of the sculptured forms themselves ("Materials Choices for the Statue of Liberty," in Baboian et al., eds., *Statue of Liberty Restoration*, pp. 37–40). The armature was made of puddled iron, a form of wrought iron. This allowed for an elasticity in the armature, so that the monument could withstand the force of wind. See Provoyeur and Hargrove, *Liberty*, p. 109.

17. Trachtenberg, *Statue of Liberty*, pp. 63, 67, 74–77, 79, 104–5. For examples of allegories with a torch, see also those in Dario Gamboni and Georg Germann, eds., *Zeichen der Freiheit: Das Bild der Republik in der Kunst des 16. bis 20. Jahrhunderts*, exh. cat. (Bern: Bernisches Historisches Museum and Kunstmuseum Bern, 1991), cat. nos. 393d, 402–5; Bartholdi's *Liberty* is the subject of cat. no. 401 (William Hauptman, "Frédéric-Auguste Bartholdi: Die Freiheit leuchtet der Welt").

18. Trachtenberg, *Statue of Liberty*, pp. 43–44. It is worth noting that Bartholdi's contemporaries did not all believe that the painterly style in sculpture was the only valid one at that time. The critic Charles Blanc, for example, decried the colorism of Carrier-Belleuse's work and believed the only valid treatment for sculpture was the kind that sought "the type of permanence, the fundamental, unchanging, eternal idea" (quoted in June Hargrove, *The Life and*

Work of Albert Ernest Carrier-Belleuse [New York: Garland, 1977], pp. 113–14.

19. Busco, "Bartholdi," p. 121.

20. A bronze study for the head in the Musée Bartholdi (Kallop et al., *Images of Liberty*, fig. 8) has an almost impressionistic treatment of the surfaces, with a streamlining not unlike Constantin-Émile Meunier's technique (see cat. no. 56). The decorative vocabulary of the lamp is the only passage in an obvious "style," close to art nouveau; the structural members of the interior are true in style to the sources of contemporary taste of early art nouveau.

21. Cf. Anne Pingeot, "Les Vierges colossales du Second Empire," in Pingeot 1986, pp. 208–13.

22. Quoted in Trachtenberg, *Statue of Liberty*, p. 148.

23. The same effect is given in a painting by Corot, *Vision: The Burning of Paris* (Paris, Musée Carnavalet), which shows a colossus with an uncanny resemblance to Bartholdi's sculpture rising above Paris; its date of 1870 corresponds with that of the sculpture. See Gamboni and Germann, eds., *Zeichen der Freiheit*, cat. no. 370.

● *Catalogue no. 57*

1. The figure is also known as *Abundance* (*Abondance*) because of the attributes of fruit and flowers.

2. John Hunisak, *The Sculptor Jules Dalou* (New York: Garland, 1977), p. 224; and idem, "Dalou's *Triumph of the Republic*: A Study of Private and Public Meanings," in H. W. Janson, ed., *La scultura nel XIX secolo*, vol. 6 of *Acts of the International Congress of the History of Art, 1979* (Bologna: Editrice CLUEB, 1984), p. 169.

3. Maurice Dreyfous, *Dalou: Sa Vie et son oeuvre* (Paris: Henri Laurens, 1903), p. 3.

4. Ruth Butler, "Auguste Rodin," in Fusco and Janson, cat. no. 199; and Fonsmark, p. 99. Their friendship was disrupted in their competition for the monument to Victor Hugo and by what

must have been Rodin's jealousy over the assignment of Hugo's death-mask to Dalou. See Jane Roos, "Rodin's *Monument to Victor Hugo*: Art and Politics in the Third Republic," *Art Bulletin* 68, no. 4 (December 1986): 638 n. 31.

5. On the treatment of subjects of domestic life by Dalou, his predecessors, and contemporaries, see Philippe Durey, "Le Réalisme," in Pingeot 1986, pp. 357–58.

6. Pierre Kjellberg, *Le Guide des statues de Paris* (Paris: Bibliothèque des Arts, 1973), p. 108.

7. For example, Rubens's *Allegory of the Blessings of Peace* (c. 1630, London, National Gallery). On Dalou's admiration for the baroque, see H. W. Janson, *19th-Century Sculpture* (New York: Abrams, 1985), pp. 195–96.

8. The plaster (c. 1884) is illustrated in Pingeot 1990 (fig. 243). Hunisak comments, however, that Dalou disapproved of exhibiting any of his works before they reached their final state ("*Triumph of the Republic*," p. 172).

9. Dreyfous, *Dalou*, pp. 126–27. Dalou's contract with the Susse foundry was made three years before his death (Jacques de Caso, "Serial Sculpture in Nineteenth-Century France," in Jeanne L. Wasserman, ed., *Metamorphoses in Nineteenth-Century Sculpture*, exh. cat. [Cambridge: Fogg Art Museum, Harvard University Press, 1975], pp. 11–12). Another example of the *Torso*, partly gilded, is in the Cleveland Museum of Art. A plaster cast is in the Musée d'Orsay (RF3953). A silvered bronze is in the private Cantor collection.

● *Catalogue no. 58*

1. Philippe Durey says that it "was not, properly speaking, destined to figure on the monument" and that it represents "a kind of exercise for the monument, carried to its conclusion" ("Le Réalisme," in Pingeot 1986, p. 369). According to Pingeot et al., it was made "in liaison" with the monument (p. 112, RF2999).

According to Françoise Maison, it is the only one of the sketches for the monument that was fully finished ("Grand Paysan," in Maison et al., p. 180).

2. Maison, "Grand Paysan," p. 180; and John Hunisak, "Dalou's *Triumph of the Republic*: A Study of Private and Public Meanings," in H. W. Janson, ed., *La scultura nel XIX secolo*, vol. 6 of *Acts of the International Congress of the History of Art, 1979* (Bologna: Editrice CLUEB, 1984), p. 173. According to Maurice Dreyfous, Dalou began to work on the model of *The Peasant* in 1897 (*Dalou: Sa Vie et son oeuvre* [Paris: Henri Laurens, 1903], pp. 231–32); it exists in various sizes (see note 15 below).

3. Dreyfous quotes Dalou's journal: "April 28, 1897: I resolve to undertake, without waiting any longer, the monument that I have been dreaming about since 1889, to the glorification of workers. This subject is in the air; it is of its time, and one of these days it will be treated by someone else, [I must] *fix a date*. The future is here; it is the creed [*culte*] called upon to replace outmoded mythologies" (*Dalou*, pp. 248–49). (The French word *culte* is not only a generic term for religion, but in popular usage it also can allude to religions other than Catholicism, which was France's state religion under the monarchy.)

4. Pingeot 1986, pp. 358–59.

5. Ibid., pp. 369.

6. Ibid.

7. John M. Hunisak, "Images of Workers: From Genre Treatment and Heroic Nudity to the Monument to Labor," in Fusco and Janson, pp. 59–60; and Pingeot 1986, p. 371.

8. Pingeot 1986, p. 366.

9. On the activities of the Libre Esthétique, see Madeleine Octave Maus, *Trente Années de lutte pour l'art, 1884–1914* (Brussels: Librairie L'Oiseau Bleu, 1926); and recently Micheline Hanotelle, *Paris/Bruxelles: Rodin et Meunier* (Paris: Le Temps, 1982), especially pp. 52–105.

10. See note 3 above.

11. Durey, in his fine study of realism in nineteenth-century French sculpture, points out that "the association made between these maternal subjects and work is the republican symbol for the fecundity of mankind" ("Réalisme," in Pingeot 1986, p. 358). Durey also reviews precedents in Italian sculpture (p. 363).

12. Besides the references listed by Hanotelle (only French-language sources), two good studies on Charpentier, both illustrating the relief, are Gabriel Mourey, "An Interview on 'L'Art Nouveau' with Alexandre Charpentier," *The Architectural Record* 12, no. 2 (June 1902): 120–25 (Charpentier speaks of "man's free advance along the road of progress"); and Vittorio Pica, "Artisti Contemporanei: Alexandre Charpentier," *Emporium* 22, no. 130 (October 1905): 243.

13. Hunisak, "Images of Workers," pp. 59–60; Pingeot 1986, p. 371; and Maison, "Grand Paysan," pp. 180–81.

14. Hunisak, "Images of Workers," p. 56.

15. Hunisak, *The Sculptor Jules Dalou*, pp. 237–38. *The Peasant* was cast by Susse in various sizes in bronze. The Los Angeles County Museum of Art also has an example of the intermediate size, 22⅞ in. (58 cm) (M.87.119.10). A full-sized example in glazed terra-cotta is in Roubaix (École Nationale Supérieure des Arts et Industries Textiles, published in Maison, "Grand Paysan," cat. no. 84, in which porcelain examples in various sizes are also noted). Such demand for *The Peasant* testifies to its broad and profound appeal. Jacques de Caso explains that Dalou made an exclusive contract with Susse in 1899; they produced two sculptures for him (not identified by de Caso) ("Serial Sculpture in Nineteenth-Century France," in Jeanne L. Wasserman, ed. *Metamorphoses in Nineteenth-Century Sculpture*, exh. cat. [Cambridge: Fogg Art Museum, Harvard University Press, 1975], pp. 11–12). At Dalou's death in 1902 his mentally retarded daughter, cared for by the orphanage L'Orphelinat

des Arts, inherited his estate. Susse then contracted (1903) with the orphanage for the production of Dalou's sculptures for twenty years, with the proceeds going to the charitable foundation (Dreyfous, *Dalou*, pp. 264–65). The 1899 contract was for his *Lavoisier* and *The Song* (*La Chanson*), and a few months later *The Punishments* (*Les Châtiments*) was added to the agreement (Pierre Cadet, *Susse Frères: 150 Years of Sculpture 1837–1987* [Paris: Susse Frères, 1992], pp. 49, 373–82). (The author would like to thank Charles Pineles, director of the Susse foundry, for providing a copy of *Susse Frères*.) Hunisak publishes a letter dated 1904 from the Louvre archives, stating that "Dalou considered that it would be by this work that he would accept being remembered" (pp. 237–38).

16. Dreyfous, *Dalou*, pp. 278–79.

● *Catalogue no. 59*
1. Biographical information on Emma Gramatica, with further bibliography, can be found in Silvio d'Amico, "Emma Gramatica," in *Enciclopedia dello spettacolo*; and in *Enciclopedia italiana*, reprint ed. (1949), s.v. "Emma Gramatica."

2. D'Amico, "Gramatica." It is not known how Trentacoste met Gramatica, but d'Annunzio may have been involved. By no later than 1905 d'Annunzio was praising Trentacoste's work (Ugo Ojetti, *Ritratti d'artisti italiani* [Milan: Fratelli Treves, 1911], p. 175) and was involved in the movement to revitalize the Italian visual arts, especially medals (Giovanna De Lorenzi, "The Collection of Medals and Plaques by Domenico Trentacoste," in *The Medal*, no. 8 [summer 1986]: 13, 15 n. 7).

3. De Lorenzi, "Medals and Plaques," pp. 11–15; Ugo Ojetti, "Medaglie italiane," *Dedalo* 5, no. 2 (1924–25): 513–30; Leonard Forrer, *Biographical Dictionary of Medallists* (London: Spink & Son, 1916; reprinted, 1979) 6:132; and ibid., suppl. (1930) 2:238: Trentacoste designed

the dies for the Jubilee coinage of Italy in 1911. Ojetti calls him "our best and greatest medalist" (*Ritratti*, p. 176).

4. Ojetti summarizes Trentacoste's early years in *Ritratti* (pp. 164–77). See also Raffaele Monti and Fiamma Domestici, "Domenico Trentacoste," in Umberto Baldini, ed., *Scultura toscana del novecento* (Florence: Nardini Editore, 1980), pp. 329–30. Trentacoste frequented the studios of Émile-Auguste Carolus-Duran (1838–1917) and Emmanuel Frémiet (1824–1910).

5. Gustavo Uzielli, "Artisti contemporanei: Domenico Trentacoste," *Emporium* 9, no. 52 (April 1899): 245 (dated as 1888), 248 (dated as 1898–99), 254.

6. Ibid., pp. 249, 253, 255; possibly 1896, according to Ojetti, *Ritratti*, p. 175.

7. Uzielli, "Artisti contemporanei," pp. 256–57; Ojetti dates it 1899 (*Ritratti*, p. 175).

8. Illustrated in Palma Bucarelli, "Domenico Trentacoste," in *Enciclopedia italiana*. Ojetti dates it 1903 (*Ritratti*, p. 175).

9. On medallic art of this time, see Mark Jones, *The Art of the Medal* (London: British Museum, 1979), pp. 110, 119, 121–22; and Yvonne Foldenberg, *La Médaille en France de Ponscarme à la fin de la Belle Époque*, exh. cat. (Paris: Hôtel de la Monnaie, 1967), pp. 7 (Chaplain), 123–26 (Roty).

10. The renewed interest in Renaissance medals was part of this movement, according to Ojetti ("Medaglie italiane," pp. 516, 521–29). Ojetti also noted references to Italian sculpture of the fifteenth century ("Domenico Trentacoste e la statua del Vescovo Bonomelli," *Dedalo* 3, no. 7 [December 1921]: 471). See also De Lorenzi, "Medals and Plaques," p. 13.

11. De Lorenzi is perhaps too emphatic in her analysis of the relationship of Donatello's *schiacciato* (crushed) technique to Trentacoste's work, but Trentacoste was surely aware of the deli-

cate, dry treatment of extremely low relief practiced by Italian sculptors in the fifteenth century.

12. De Lorenzi illustrates additional examples of the portrait in the Galleria d'Arte Moderna in Florence ("Medals and Plaques," p. 13). Dott. Ettore Spalletti, director of the museum, kindly supplied information on Trentacoste's five relief portraits of Gramatica in gesso and bronze in the collection; except for minor details they closely resemble the present terra-cotta. Trentacoste's contemporary W. Fred noted in particular the success of the Italians in the use of terra-cotta at this time ("The International Exhibition of Decorative Art at Turin: The Italian Section," *The Studio* 27 (1903): 277.

● *Catalogue no. 60*
1. The names of these collaborators, among a total of about thirty, are drawn from the catalogue of marbles in the Musée Rodin (Barbier) and the exhibition catalogue by Cécile Goldscheider, *Rodin: Ses Collaborateurs et ses amis* (Paris: Musée Rodin, 1957).

2. Basic biographical information on Bourdelle is provided by Ionel Jianou and Michel Dufet, *Bourdelle* (Paris: ARTED, 1965).

3. Ibid., p. 21; and Peter Murray, "Emile Antoine Bourdelle, 1861–1929," in Peter Murray and Michael Le Marchant, eds., *Emile Antoine Bourdelle: Pioneer of the Future*, exh. cat. (West Yorkshire: Yorkshire Sculpture Park, 1989), p. 15.

4. Douglas Hall, however, writes that Bourdelle rebelled against Falguière ("Emile Antoine Bourdelle: Heroic Post-Modernist," in Murray and Le Marchant, eds., *Bourdelle*, p. 25). Illustrations appear in Peter Cannon-Brookes, *Emile Antoine Bourdelle*, exh. cat. (London: Trefoil Books for the National Museum of Wales, 1983), figs. 28–32.

5. Cannon-Brookes, *Bourdelle*, p. 14.

6. Most sources give the year 1908, while Hall gives 1906 ("Heroic Post-Modernist," p. 25).

7. Cladel, pp. 40–41.

8. This was eventually published as Antoine Bourdelle, *La Sculpture et Rodin*, ed. Claude Aveline (Paris: Émile-Paul Frères, 1937). Cannon-Brookes suggests that the sketches were done at the time of the Prague lecture (*Bourdelle*, p. 18). Bourdelle's daughter, Mme Rhodia Dufet Bourdelle, curator of the Musée Bourdelle, wrote in a letter to the author (26 November 1992) that at least four of the drawings in the book are preserved in the Musée Bourdelle: *Rodin at Work* (*Rodin au travail*, 1909), *Study for a Statue of Rodin* (*Recherche pour une statue de Rodin*, 1909), *For Rodin. To Rodin the Master, near the Tomb of His Shade* (*A Rodin. Au maître Rodin, près de son ombre ensevelie*, 1927), and *Symbol of Rodin* (*Symbole de Rodin*, 1928), and that the others may be found during the course of reinstalling the Musée Bourdelle.

9. Bourdelle, *Sculpture*, p. 55. The bronze is illustrated in Cannon-Brookes, *Bourdelle*, p. 19.

10. Bourdelle, *Sculpture*, opp. p. 86.

11. Quoted by Patricia Sanders, "Auguste Rodin," in Jeanne L. Wasserman, ed., *Metamorphoses in Nineteenth-Century Sculpture*, exh. cat. (Cambridge: Fogg Art Museum, Harvard University, 1975), p. 173 n. 4.

12. Bourdelle, *Sculpture*, pp. 213–14 (Aveline dates this commentary to 1908 [in Bourdelle, *Sculpture*, p. 213]).

● *Catalogue no. 61*
1. Peter Cannon-Brookes, *Emile Antoine Bourdelle* (London: Trefoil Books for the National Museum of Wales, 1983), p. 45.

2. The reason for this commission is no longer known, according to information kindly provided by Christian Briend of the Musée des Beaux-Arts of Lyons, who reviewed pertinent municipal archives (sér. 1400 WP 6 and 1400 WP 8) on the author's behalf.

3. This information was generously provided by Mme Rhodia Dufet Bourdelle in a letter to the author (26 November 1992). She notes that Bourdelle admired Carpeaux more as a painter than as a sculptor. See also Maison et al., p. 104.

4. The illustration of *Carpeaux at Work* in Peter Murray and Michael Le Marchant, eds., *Emile Antoine Bourdelle: Pioneer of the Future*, exh. cat. (West Yorkshire: Yorkshire Sculpture Park, 1989), p. 48, is reversed. An example of the *Right Hand of Carpeaux* passed at auction in London (Sotheby's) on 26 February 1986, lot no. 66.

5. For *The Hand of God*, see Spear, p. 101; and idem, *A Supplement to Rodin Sculpture in the Cleveland Museum of Art* (Cleveland: Cleveland Museum of Art, 1974), p. 133s. The plaster was exhibited at the Munich Secession in 1896; the marble, in Vienna and Berlin, 1903 (Pingeot 1990, p. 182). See also Barbier, cat. no. 86; Vincent, p. 30; and Hélène Pinet, "Mains," in Pingeot 1990, pp. 180–82.

6. Pinet, "Mains," p. 174, with comparisons with other casts of artists' hands.

7. Antoine Bourdelle, *La Sculpture et Rodin*, ed. Claude Aveline (Paris: Émile-Paul Frères, 1937), opp. pp. 198, 214. In the context of Bourdelle's oeuvre it is worth noting that he modeled at least four other figures of sculptors at work— *Sculptress at Rest* (*Femme Sculpteur au repos*, 1906), *Sculptress at Work* (*Femme Sculpteur au travail*, 1906), *Woman with a Compass* (*Femme au compas*, 1909), and *The Young Sculptor at Work* (*Jeune Sculpteur au travail*, 1906, revised and enlarged 1918)—all illustrated in Cannon-Brookes, *Bourdelle*.

8. Clare Vincent, who kindly responded to inquiries about the full-size *Carpeaux at Work* in the Metropolitan Museum, published this observation in *Notable Acquisitions 1983-1984* (New York: Metropolitan Museum of Art, 1984), p. 35. She noted that Bourdelle's

decision to put Rodin's *Galatea* in Carpeaux's hand is significant in that Galatea was a sculpture turned into a living woman by Venus in response to the sculptor Pygmalion's prayers.

9. Pinet, "Mains," p. 176; and Antoinette Le Normand-Romain, "Fragments tirés d'un ensemble II: Bourdelle," in Pingeot 1990, pp. 230, 232, 272.

10. Le Normand-Romain, "Fragments," p. 271.

● *Catalogue no. 62*

1. The basic reference used here is Peter Cannon-Brookes, *Emile Antoine Bourdelle* (London: Trefoil Books for the National Museum of Wales, 1983), which includes illustrations of Bourdelle's sculptures discussed here. He gives 1916 as the date of *Eloquence* (p. 78), while Ionel Jianou and Michel Dufet suggest 1918 (*Bourdelle* [Paris: ARTED, 1965], p. 104).

2. *Encyclopedia Britannica*, 1958 ed., s.v. "Marcelo Torcuato de Alvear." In a letter to the author (23 September 1993) Mme. Rhodia Dufet Bourdelle noted that the sculptor knew Marcelo de Alvear and did a portrait of him. Carlos María de Alvear was the first Argentine minister to the United States (appointed 1825).

3. David Bushnell, "The Independence of Spanish South America," in *The Cambridge History of Latin America*, vol. 3, ed. Leslie Bethell (Cambridge: Cambridge University Press, 1985), pp. 119–21. In the standard literature on Bourdelle, Alvear is called "the liberator of Argentina."

4. Ibid., pp. 125–26.

5. Illustrated in Cannon-Brookes, *Bourdelle*, pp. 79–80.

6. Ibid., p. 30. The *Head of Apollo* is the source for the heads of both *Eloquence* and *Strength* (*Force*). Bourdelle's treatment of the head as a fragment, emphasized by the ragged edge across the neck, may reflect Rodin's influence.

7. The monument to Alvear is about 57 feet high; the *Monument to the Dead...* is nearly 40 feet; his *Virgin of the Offering* (*Vierge à l'Offrande*, 1919–22, Niederbrück, Alsace) is about 19½ feet; and the reliefs for the Théâtre des Champs-Élysées are 69¾ in.

8. Antoine Bourdelle, *La Sculpture et Rodin*, ed. Claude Aveline (Paris: Émile-Paul Frères, 1937), pp. 61–75, 220–221. Rodin called him "a Greek from southern France" (quoted in ibid., p. 215). The concept of *taille directe* (direct carving), in which the artist was expected to carve his own sculptures without recourse to assistants, came increasingly under discussion in the first two decades of the twentieth century, partially in response to a scandal about forgeries of Rodin's sculpture. *Taille directe* was recently discussed in Peter Elliott, ed., *La Sculpture en taille directe*, exh. cat. (Saint-Rémy-lès-Chevreuse: Fondation de Coubertin, 1988), unpaginated.

9. Cannon-Brookes, *Emile Antoine Bourdelle*, pp. 66–68.

10. In Montceau-les-Mines; ibid., pp. 90–93.

11. In Paris; ibid., pp. 96–100.

● *Catalogue no. 63*

1. Gianna Piantoni and Paolo Venturoli, eds., *Paolo Troubetzkoy 1866–1938*, exh. cat. (Verbania Pallanza: Museo del Paesaggio, 1990), pp. 221–23, 234.

2. Klaus Lankheit, "Die 'Scapigliati'—Bohème in Mailand," in *Von der napoleonischen Epoche zum Risorgimento*, vol. 15 of *Italienische Forschungen* (Munich: Bruckmann, 1988), pp. 198, 201. Lankheit notes that the Scapigliati saw the sketch-model as having importance in its own right, virtually as much as did a "completed" sculpture.

3. These must have had a strong influence on his brilliant young disciple, Rembrandt Bugatti (1884–1916). See Piantoni and Venturoli, eds., *Troubetzkoy*, cat. no. 106.

4. Ibid., p. 222

5. References to other examples can be found in Pingeot et al., p. 254.

6. See Piantoni and Venturoli, eds., *Troubetzkoy*, pp. 142–43.

7. Jean Mériem, "Paul Troubetzkoy," *L'Art et les artistes* 3, no. 13 (April 1906): 12.

8. The wax is illustrated in Christian Brinton, *Catalogue of Sculpture by Prince Paul Troubetzkoy* (New York: American Numismatic Society, 1911), p. 37; the plaster is in Piantoni and Venturoli, eds., *Troubetzkoy*, cat. no. 105.

9. Piantoni and Venturoli, eds., *Troubetzkoy*, p. 223.

10. Isabelle Leroy-Jay Lemaistre, "La Statuette romantique," in Pingeot 1986, pp. 257–61; and Peter Fusco in Fusco and Janson, pp. 112–13.

11. Pingeot et al., p. 254 (with alternate spelling Anernheimer).

12. Brinton, *Catalogue*, p. 20.

● *Catalogue no. 64*

1. Gianna Piantoni and Paolo Venturoli, eds., *Paolo Troubetzkoy 1866–1938*, exh. cat. (Verbania Pallanza: Museo del Paesaggio, 1990), pp. 196, 222.

2. Ibid., p. 152. For the plaster model, with references to other examples in bronze and marble, see ibid., cat. no. 95.

3. Quoted in Gianna Piantoni, "Troubetzkoy, 'scultore della vita moderna,'" in Piantoni and Venturoli, eds., *Troubetzkoy*, p. 19. Susan Caroselli kindly reviewed the translation of d'Annunzio's text.

4. Piantoni and Venturoli, eds., *Troubetzkoy*, p. 91.

● *American Art*

Jo Davidson
UNITED STATES, 1883–1952
Female Torso, 1929
Bronze
10³⁄₄ x 3¹⁄₈ x 3¹⁄₄ in. (27.3 x 7.9 x 8.3 cm)
Inscribed on back of proper right leg:
Jo Davidson/1929 Paris
Foundry mark on back of proper right
leg (in rectangular cachet): Cire/
Valsuani/Perdue
Gift of B. Gerald Cantor Art Foundation
M.85.313

Malvina Hoffman
UNITED STATES, 1887–1966
Column of Life, modeled in small scale
1912, at this size 1917; cast 1966
Bronze
27¹⁄₂ x 7¹⁄₂ x 9 in. (69.9 x 19.1 x 22.9 cm)
Inscribed at lower edge: M. Hoffman
© BEDI-RASSY N.Y.
Gift of B. Gerald Cantor Art Foundation
M.86.261

Winslow Homer
UNITED STATES, 1836–1910
The Cotton Pickers, 1876
Oil on canvas
24 x 36¹⁄₈ in. (61 x 91.8 cm)
Acquisition made possible through
museum trustees Robert O. Anderson,
R. Stanton Avery, B. Gerald Cantor,
Edward W. Carter, Justin Dart, Charles
E. Ducommun, Mrs. F. Daniel Frost,
Julian Ganz, Jr., Dr. Armand Hammer,
Harry Lenart, Dr. Franklin D. Murphy,
Mrs. Joan Palevsky, Richard Sherwood,
Maynard J. Toll, and Hal B. Wallis
M.77.68

● *Costumes and Textiles*

James Galanos
UNITED STATES, b. 1924

Evening Dress (two-piece), fall 1972
Halter: bugle beads and silk chiffon lining
Cb: 10 in. (25.4 cm)
Skirt: printed silk satin
L: 42 in. (106.7 cm)
Gift of Mrs. B. Gerald Cantor
M.86.37.1a–b

Jumpsuit with Belt, spring 1973
Suit: striped wool with silk crepe lining
L: 57¹⁄₂ in. (146.1 cm)
Belt: leather
1¹⁄₂ x 32¹⁄₂ in. (3.8 x 82.6 cm)
Gift of Mrs. B. Gerald Cantor
M.86.37.2a–b

Evening Dress (three-piece), spring 1984
Printed silk chiffon with silk chiffon
lining
Hat: 5¹⁄₂ x 9 in. (14.0 x 22.9 cm)
Jacket: cb: 27 in. (68.6 cm)
Blouse: cb: 25¹⁄₂ in. (64.8 cm)
Skirt: l: 41¹⁄₂ in. (105.4 cm)
Belt: leather
³⁄₄ x 30¹⁄₂ in. (1.9 x 77.5 cm)
Gift of Mrs. B. Gerald Cantor
M.86.37.3a–e

Pajama (two-piece), 1975
Printed silk with silk chiffon lining
Jacket: cb: 31 in. (78.7 cm)
Pants: l: 41 in. (104.1 cm)
Gift of Mrs. B. Gerald Cantor
M.86.37.4a–b

Knicker Dress (two-piece), spring 1980
Silk jacquard with silk chiffon lining and
leather belt
Blouse: cb: 23 in. (58.4 cm)
Pants: l: 26 in. (66.0 cm)
Belt: 2 x 34 in. (5.1 x 86.4 cm)
Gift of Mrs. B. Gerald Cantor
M.86.37.5a–c

Evening Jacket (Style #266), 1977
Silk and linen lace with glass beads
and sequins
Cb: 28⁷/8 in. (73.3 cm)
Gift of Iris Cantor
AC1992.268.1

Hat, 1982
Straw with silk stitching
H. (crown): 3¹/2 in. (8.9 cm); w. (brim):
10 in. (25.4 cm)
Gift of Iris Cantor
AC1992.269.1

Jacket (Style #590), 1986
Silk twill with embroidery and appliqué,
silk velvet strips in a weave design
Cb: 31¹/2 in. (80.0 cm) (excluding collar)
Gift of Iris Cantor
AC1992.270.1

● *European Painting and Sculpture*

Frédéric-Auguste Bartholdi
FRANCE, 1834–1904
Liberty Enlightening the World, c. 1884
Bronze
20⁷/8 x 8¹/2 x 6¹/2 in.
(53.0 x 21.6 x 16.5 cm) (including base)
Gift of B. Gerald Cantor
M.82.209.3
CATALOGUE NO. 56

Antoine-Louis Barye
FRANCE, 1796–1875
*Roger and Angelica Borne by the
Hippogriff*, first modeled c. 1840–46;
probably cast later
Bronze
20 x 27 x 9⁷/8 in. (50.8 x 68.6 x 25.1 cm)
Gift of Iris and B. Gerald Cantor
Foundation
M.92.269.2
CATALOGUE NO. 6

Émile-Antoine Bourdelle
FRANCE, 1861–1929

Left Hand of Carpeaux, 1908–9; possibly
cast later
Bronze
12¹/4 x 13³/4 x 5¹/4 in.
(31.1 x 34.9 x 13.3 cm)
Gift of B. Gerald Cantor
M.70.7
CATALOGUE NO. 61

Bust of Rodin, 1909–10
Bronze
35 x 27 x 24 in. (88.9 x 68.6 x 61.0 cm)
Gift of B. Gerald Cantor Art Foundation
M.73.108.23
CATALOGUE NO. 60

Head of the Figure of Eloquence, 1916–18
Bronze
19 x 14¹/4 x 18³/16 in.
(48.3 x 36.2 x 46.2 cm)
Gift of B. Gerald Cantor Art Foundation
M.83.65
CATALOGUE NO. 62

Jean-Baptiste Carpeaux
FRANCE, 1827–75
*The City of Valenciennes Defending
the Fatherland in 1793*, 1869–73 (possibly
1871)
Terra-cotta
20¹/2 x 16 x 11 in. (52.1 x 40.6 x 27.9 cm)
Gift of Iris and B. Gerald Cantor
Foundation
M.91.138
CATALOGUE NO. 9

Albert-Ernest Carrier-Belleuse
FRANCE, 1824–87

*Portrait of the Actress Aimée-Olympe
Desclée*, c. 1874
Terra-cotta
27¹/4 x 14³/4 x 5¹/8 in.
(69.2 x 37.5 x 13.0 cm)
Gift of B. Gerald Cantor Art Foundation
M.81.262.2
CATALOGUE NO. 8

Fantasy Bust, c. 1865–70
Terra-cotta on wood socle
29⁷/8 x 11³/4 x 11 in.
(75.9 x 29.8 x 27.9 cm) (without socle)
Gift of Iris and B. Gerald Cantor
Foundation through the 1992 Collectors
Committee
AC.1992.19.1
CATALOGUE NO. 7

Aimé-Jules Dalou
FRANCE, 1838–1902

The Peasant, c. 1897–99
Bronze
16⁷/8 x 6¹/4 x 6¹/4 in.
(42.9 x 15.9 x 15.9 cm)
Gift of Iris and B. Gerald Cantor
M.86.219.1
CATALOGUE NO. 58

Torso of "Peace," modeled 1879–89;
probably cast later
Bronze
19¼ x 8½ x 7⅛ in.
(48.9 x 21.6 x 18.1 cm)
Gift of Iris and B. Gerald Cantor
Foundation in honor of the museum's
twenty-fifth anniversary
M.90.143
CATALOGUE NO. 57

Pierre-Jean David d'Angers
FRANCE, 1788–1856

Johannes Gutenberg, 1839
Bronze
16 x 6¼ x 6¼ in. (40.6 x 15.9 x 15.9 cm)
Gift of B. Gerald Cantor Art Collections
M.82.126.2
CATALOGUE NO. 5

Philopoemen, 1837
Bronze
35½ x 13½ x 14¼ in.
(90.2 x 34.3 x 36.2 cm)
Gift of B. Gerald Cantor Art Collections
M.82.126.3
CATALOGUE NO. 4

Robert Delaunay
FRANCE, 1885–1941
Summer, 1904
Oil on canvas
51 x 23¾ in. (129.5 x 60.3 cm)
Gift of Iris and B. Gerald Cantor
M.86.219.2

Jean-Alexandre-Joseph Falguière
FRANCE, 1831–1900

Resistance, first modeled 1870;
this example probably 1894
Bronze
23 x 15¾ x 11¾ in.
(58.4 x 40.0 x 29.8 cm)
Gift of Cantor Fitzgerald Art Foundation
M.76.30
CATALOGUE NO. 51

Circe, c. 1884–98?
Bronze
16 x 11½ x approx. 4 in.
(40.6 x 29.2 x approx. 10.2 cm)
Gift of B. Gerald Cantor
M.78.60
CATALOGUE NO. 53

Portrait of Honoré de Balzac, 1899
Marble
19¼ x 13½ x 11 in.
(48.9 x 34.3 x 27.9 cm)
Gift of B. Gerald Cantor Art Foundation
M.81.262.1
CATALOGUE NO. 54

*Revolution Holding the Head of Error
and Striding over the Cadaver of
Monarchy*, c. 1893
Bronze
37 x 24 x 13¾ in. (94.0 x 61.0 x 34.9 cm)
Gift of B. Gerald Cantor Art Collections
M.82.126.4
CATALOGUE NO. 52

Ferdinand Hodler
SWITZERLAND, 1853–1918
The Disillusioned One, 1892
Oil on canvas
22⅛ x 17¾ in. (56.2 x 45.1 cm)
Gift of B. Gerald Cantor in memory
of William Bernhardt Potts
M.78.63

Pierre Le Gros
FRANCE, 1666–1719
St. Thomas, about 1705
Terra-cotta
27⅜ x 21⅝ x 11¼ in.
(69.5 x 54.9 x 28.6 cm)
Purchased with funds provided by
William Randolph Hearst, The Ahman-
son Foundation, Chandis Securities,
B. Gerald Cantor, Camilla Chandler
Frost, Anna Bing Arnold, an anonymous
donor, Duveen Brothers, Inc., Mr. and
Mrs. William Preston Harrison, Mr. and
Mrs. Pierre Sicard, Colonel and Mrs.
George J. Denis, and Julia Off
84.1

Maximilien Luce
FRANCE, 1858–1941
*Montmartre: The House of Suzanne
Valadon*, 1895
Oil on canvas
21 x 25 in. (53.3 x 63.5 cm)
Gift of B. Gerald Cantor
M.86.172

Pietro Marchetti
ITALY, 1770–1846
Bust of a Veiled Child, c. 1840
Marble
15 x 11 x 9 in. (38.1 x 27.9 x 22.9 cm)
Gift of B. Gerald Cantor
M.78.117
CATALOGUE NO. 1

Constantin-Émile Meunier
BELGIUM, 1831–1905
Bust of a Puddler, probably 1895
Bronze
18¾ x 17⅛ x 12⅛ in.
(47.6 x 43.5 x 30.8 cm)
Gift of B. Gerald Cantor Art Collections
M.82.126.1
CATALOGUE NO. 55

**Attributed to
Giovanni Battista Della Porta**
ITALY, C. 1542–97
Bust of Christ, c. 1590
White, black, and red marble with
lapis lazuli
H: 30 in. (76.2 cm)
Purchased with funds provided by Mr.
and Mrs. Harrison Chandler, Mr. and
Mrs. George Gard De Sylva collection,
B. Gerald Cantor, Florence and Maurice
Chez, Mrs. William May Garland in
memory of her husband, Mr. and Mrs.
Allan C. Balch collection, Fletcher Jones
estate, Museum Associates Acquisition
Fund, Mr. Carl O. Swenson, Robert
Majer collection, and Mrs. Thyra Boldsen
M.82.70

Auguste Rodin
FRANCE, 1840–1917

Nude Study of Balzac, probably 1892;
Musée Rodin cast 4/12, 1967
Bronze
50¼ x 21½ x 23 in.
(127.6 x 54.6 x 58.4 cm)
Gift of B. Gerald Cantor Art Foundation
M.67.59
CATALOGUE NO. 33

Large Head of Iris, possibly 1890–1900,
enlarged by 1909; Musée Rodin cast 4/12,
1967
Bronze
24 x 12 x 14¾ in. (61.0 x 30.5 x 37.5 cm)
Gift of B. Gerald Cantor Art Foundation
M.69.52
CATALOGUE NO. 44

The Shade, c. 1880, enlarged c. 1901;
Musée Rodin cast 6/12, 1969
Bronze
75¾ x 20 x 44 in.
(192.4 x 50.8 x 111.8 cm)
Gift of B. Gerald Cantor Art Foundation
M.73.108.1
CATALOGUE NO. 11

Eve, c. 1881; Musée Rodin cast 9/12, 1968
Bronze
68 x 19 x 25 in. (172.7 x 48.3 x 63.5 cm)
Gift of B. Gerald Cantor Art Foundation
M.73.108.2
CATALOGUE NO. 12

Orpheus, probably 1890–1900;
Musée Rodin cast 4/12, 1969
Bronze
59 x 50 x 32½ in.
(149.9 x 127.0 x 82.6 cm)
Gift of B. Gerald Cantor Art Foundation
M.73.108.3
CATALOGUE NO. 40

The Crouching Woman, c. 1880–82,
enlarged 1906–7?; Musée Rodin cast 4/12,
1963
Bronze
37½ x 25 x 21⅛ in.
(95.3 x 63.5 x 53.7 cm)
Gift of B. Gerald Cantor Art Foundation
M.73.108.4
CATALOGUE NO. 16

Marsyas (Torso of "The Falling Man"),
c. 1882–89; Musée Rodin cast 2/12, 1970
Bronze
40¼ x 29 x 18 in. (102.2 x 73.7 x 45.7 cm)
Gift of B. Gerald Cantor Art Foundation
M.73.108.5
CATALOGUE NO. 14

The Earth, c. 1884–99?; Musée Rodin
cast 2/12, 1967?
Bronze
18⅛ x 43 x 15 in. (46.0 x 109.2 x 38.1 cm)
Gift of B. Gerald Cantor Art Foundation
M.73.108.6
CATALOGUE NO. 24

The Prodigal Son, c. 1884/1894–99;
Musée Rodin cast 8/12, 1967
Bronze
55 x 28 x 42½ in. (139.7 x 71.1 x 108 cm)
Gift of B. Gerald Cantor Art Foundation
M.73.108.7
CATALOGUE NO. 20

Flying Figure, c. 1890–91; Musée Rodin
cast 5/12, 1970
Bronze
20⅞ x 28½ x 12 in. (53.0 x 72.4 x
30.5 cm) (cast integrally with base)
Gift of B. Gerald Cantor Art Foundation
M.73.108.8
CATALOGUE NO. 45

The Kneeling Female Faun, c. 1884–86;
Musée Rodin cast 11/12, 1966
Bronze
21¼ x 8¼ x 11¼ in. (54 x 21 x 28.6 cm)
Gift of B. Gerald Cantor Art Foundation
M.73.108.9
CATALOGUE NO. 21

Monumental Mask of Hanako, probably
1907–8, enlarged c. 1908–12; Musée
Rodin cast 2/12, 1972
Bronze
21 x 13½ x 11¼ in.
(53.3 x 34.3 x 28.6 cm)
Gift of B. Gerald Cantor Art Foundation
M.73.108.10
CATALOGUE NO. 47

Iris, Messenger of the Gods, 1890–1900;
Musée Rodin cast 9/12, 1966
Bronze
31 x 35 x 14 in. (78.7 x 88.9 x 35.6 cm)
(without base)
Gift of B. Gerald Cantor Art Foundation
M.73.108.11
CATALOGUE NO. 43

Saint John the Baptist Preaching, 1878;
Musée Rodin cast 6/12, 1966
Bronze
31½ x 19 x 9½ in. (80 x 48.3 x 24.1 cm)
Gift of B. Gerald Cantor Art Foundation
M.73.108.12
CATALOGUE NO. 10

The Fallen Caryatid with Urn, c. 1883;
Musée Rodin cast 5/12, 1967
Bronze
15⅝ x 10¼ x 10¼ in.
(39.7 x 26.0 x 26.0 cm)
Gift of B. Gerald Cantor Art Foundation
M.73.108.13
CATALOGUE NO. 17

The Cry, c. 1886?; Musée Rodin cast
12/12, 1964
Bronze
10⅝ x 12⅜ x 6½ in.
(27.0 x 31.4 x 16.5 cm)
Gift of B. Gerald Cantor Art Foundation
M.73.108.14
CATALOGUE NO. 36

Danaïd, 1885–89; Musée Rodin cast
4/12, 1967
Bronze
12¾ x 28¼ x 22½ in.
(32.4 x 71.8 x 57.2 cm)
Gift of B. Gerald Cantor Art Foundation
M.73.108.15
CATALOGUE NO. 35

Portrait of Pope Benedict XV, 1915;
Musée Rodin cast 7/12, 1971
Bronze
9½ x 6¾ x 9¾ in. (24.1 x 17.1 x 24.8 cm)
Gift of B. Gerald Cantor Art Foundation
M.73.108.16
CATALOGUE NO. 50

Portrait of Marianna Mattiocco della Torre (Mrs. Russell), c. 1887–89; Musée Rodin cast 5/12, 1972
Bronze
13¾ x 9½ x 10 in. (34.9 x 24.1 x 25.4 cm)
Gift of B. Gerald Cantor Art Foundation
M.73.108.17
CATALOGUE NO. 38

Heroic Bust of Victor Hugo, 1890–97 or 1901–2; Musée Rodin cast 5/12, 1967
Bronze
27¾ x 18¾ x 18¾ in.
(70.5 x 47.6 x 47.6 cm)
Gift of B. Gerald Cantor Art Foundation
M.73.108.18
CATALOGUE NO. 42

Paolo and Francesca, c. 1887–89; Musée Rodin cast 1/12, 1972
Bronze
11¾ x 25 x 12 in. (29.8 x 63.5 x 30.5 cm)
Gift of B. Gerald Cantor Art Foundation
M.73.108.19
CATALOGUE NO. 22

Eternal Idol, probably 1889; Musée Rodin cast 4/12, 1967
Bronze
29 x 21 x 15 in. (73.7 x 53.3 x 38.1 cm)
Gift of B. Gerald Cantor Art Foundation
M.73.108.20
CATALOGUE NO. 39

Large Clenched Hand with Figure, c. 1907?; Musée Rodin cast 8/12, 1972
Bronze
17½ x 11½ x 10⅜ in.
(44.5 x 29.2 x 26.4 cm)
Gift of B. Gerald Cantor Art Foundation
M.73.108.21
CATALOGUE NO. 46

The Falling Man, 1882; Musée Rodin cast 2/12, 1972
Bronze
22⅞ x 14½ x 10 in.
(58.1 x 36.8 x 25.4 cm)
Gift of B. Gerald Cantor Art Foundation
M.73.108.22
CATALOGUE NO. 13

Monumental Head of Pierre de Wissant, first modeled c. 1884–85, enlarged 1909; Musée Rodin cast 3/12, 1971
Bronze
32 x 19 x 20½ in. (81.3 x 48.3 x 52.1 cm)
Gift of B. Gerald Cantor Art Foundation
M.73.110.1
CATALOGUE NO. 29

Monumental Head of Jean d'Aire, 1884–86, enlarged 1909–10; Musée Rodin cast 2/12, 1971
Bronze
26¾ x 19⅞ x 22½ in.
(67.9 x 50.5 x 57.2 cm)
Gift of B. Gerald Cantor Art Foundation
M.73.110.2
CATALOGUE NO. 28

Nude Study for Jean d'Aire, c. 1884–86; Musée Rodin cast 2/12, 1972
Bronze
40½ x 13¾ x 13¼ in.
(102.9 x 34.9 x 33.7 cm)
Gift of B. Gerald Cantor Art Foundation
M.73.110.3
CATALOGUE NO. 25

Jean d'Aire, first modeled c. 1886, reduced c. 1895; Musée Rodin cast, 1959
Bronze
18½ x 6½ x 5¾ in.
(47.0 x 16.5 x 14.6 cm)
Gift of B. Gerald Cantor Art Foundation
M.73.110.4
CATALOGUE NO. 27

Fugitive Love (Fugit Amor), 1881–87?; Musée Rodin cast 10/12, 1969
Bronze
17 x 14½ x 8½ in. (43.2 x 36.8 x 21.6 cm)
Gift of B. Gerald Cantor
M.73.139
CATALOGUE NO. 19

Jean d'Aire, c. 1886; Musée Rodin cast 6/12, 1972
Bronze
85 x 33½ x 28½ in.
(215.9 x 85.1 x 72.4 cm)
Gift of B. Gerald Cantor
M.82.209.2
CATALOGUE NO. 26

She Who Was the Helmet-Maker's Beautiful Wife, c. 1880–85
Bronze
19½ x 12 x 7¾ in. (49.5 x 30.5 x 19.7 cm)
Gift of Iris and B. Gerald Cantor
M.84.164
CATALOGUE NO. 18

Monument to Balzac, c. 1897; Musée Rodin cast 9/12, 1967
Bronze
117 x 47¼ x 47¼ in.
(297.2 x 120.0 x 120.0 cm)
Gift of B. Gerald Cantor Art Foundation
M.85.267
CATALOGUE NO. 34

Study for "The Hand from the Tomb," c. 1910; date of cast unknown
Bronze
5 x 3½ x 1⅜ in. (12.7 x 8.9 x 3.4 cm)
Gift of B. Gerald Cantor Art Foundation
M.85.268.1
CATALOGUE NO. 48

Balzac in a Frockcoat, c. 1891–92; Musée Rodin cast 11/12, 1980
Bronze
23½ x 8 x 10¼ in. (59.7 x 20.3 x 26.0 cm)
Gift of B. Gerald Cantor Art Foundation
M. 86.171
CATALOGUE NO. 31

Pas de Deux G, c. 1910–13; Musée Rodin cast 3/12, 1966
Bronze
13½ x 6½ x 6½ in.
(34.3 x 16.5 x 16.5 cm)
Gift of Iris and B. Gerald Cantor
M.87.167
CATALOGUE NO. 49

Jules Bastien-Lepage, c. 1887; Musée Rodin cast 2/8, 1987
Bronze
71 x 36½ x 33½ in.
(180.3 x 92.7 x 85.1 cm)
Gift of Iris and B. Gerald Cantor Foundation in honor of the museum's twenty-fifth anniversary
M.90.89
CATALOGUE NO. 37

Jean de Fiennes, Draped, 1885–86; Musée
Rodin cast III/IV, 1987
Bronze
82 x 48 x 38 in. (208.3 x 121.9 x 96.5 cm)
Gift of Iris and B. Gerald Cantor in
honor of the museum's twenty-fifth
anniversary
M.90.205
CATALOGUE NO. 30

The Crouching Woman, c. 1880–82
Painted plaster
12 1/2 x 10 x 7 in. (31.8 x 25.4 x 17.8 cm)
Gift of Iris and B. Gerald Cantor
Foundation in honor of Vera Green
M.91.153
CATALOGUE NO. 15

Invocation, c. 1900; Musée Rodin cast
4/8, 1986
Bronze
22 x 10 1/4 x 9 1/2 in. (55.9 x 26.0 x 24.1 cm)
Gift of Iris and B. Gerald Cantor
Foundation
AC1992.111.1
CATALOGUE NO. 41

Balzac in a Dominican Robe, probably
1892; Musée Rodin cast I/II, 1982
Bronze
41 3/4 x 17 3/4 x 14 5/8 in.
(106.0 x 45.1 x 37.1 cm)
Gift of Iris and B. Gerald Cantor
Foundation in honor of Earl A.
Powell III
AC.1992.248.1
CATALOGUE NO. 32

La Douleur, c. 1889–92?; Musée Rodin
cast IV/IV, 1983
Bronze
12 x 6 1/2 x 5 1/2 in. (30.5 x 16.5 x 14 cm)
Promised gift of Iris and B. Gerald
Cantor in honor of the museum's
twenty-fifth anniversary
L.90.28.1
CATALOGUE NO. 23

François Rude
FRANCE, 1784–1855

Hebe and the Eagle of Jupiter, c. 1853–55
Bronze
30 5/16 x 18 5/8 x 10 1/4 in.
(77.0 x 47.3 x 26.0 cm)
Gift of B. Gerald Cantor
M.77.79
CATALOGUE NO. 3

Head of the Old Warrior, c. 1833–36
Bronze
12 x 9 x 8 in. (30.5 x 22.9 x 20.3 cm)
Gift of B. Gerald Cantor Foundation
M.86.275
CATALOGUE NO. 2

Jean-Pierre Saint-Ours
SWITZERLAND, 1752–1809
*Caius Furius Cressinus Accused of
Sorcery*, 1792
Oil on panel
19 x 26 7/8 in. (48.3 x 68.3 cm)
Purchased with funds provided by the
Jones Foundation, B. Gerald Cantor,
Drs. Aldona and Jorge Hoyos, Miss
Carlotta Mabury, Isaacs Brothers
Company, Museum Associates
Acquisition Fund, and Mr. and Mrs.
Allan C. Balch collection
M.82.119

Alfred Sisley
FRANCE, 1839–99
The Train Station at Sèvres, 1879
Oil on canvas
18 1/4 x 22 in. (46.4 x 55.9 cm)
Gift of B. Gerald Cantor
M.87.30

Domenico Trentacoste
ITALY, 1859–1933
Portrait of the Actress Emma Gramatica,
1900
Terra-cotta
10 3/16 x 8 x 1 3/8 in. (25.9 x 20.3 x 3.4 cm)
Gift of B. Gerald Cantor Art Foundation
M.80.82
CATALOGUE NO. 59

Prince Paul Troubetzkoy
ITALY, 1866–1938

Mother and Child, probably 1907
Bronze
15 x 12 1/2 x 13 7/8 in.
(38.1 x 31.8 x 35.2 cm)
Gift of Iris and B. Gerald Cantor Art
Foundation
M.85.268.2
CATALOGUE NO. 64

Portrait of Rodin, 1905–6
Bronze
20 1/4 x 13 x 13 in. (51.4 x 33 x 33 cm)
Purchased with funds provided by Iris
and B. Gerald Cantor Foundation
M.90.54
CATALOGUE NO. 63

● *Photography*

Émile Druet
FRANCE, ACTIVE C. 1900
Rodin in the Pose of Balzac, 1914
Platinum print
10¾ x 6½ in. (27.3 x 16.5 cm)
Gift of B. Gerald Cantor Art Foundation
M.87.74.1

Edward Steichen
UNITED STATES, 1879–1973

The Silhouette, 4 A.M., Meudon, 1908;
printed later
Gelatin silver print
10¾ x 13⅝ in. (27.3 x 34.6 cm)
Gift of B. Gerald Cantor Art Foundation
M.87.74.3

Balzac, Midnight, 1908; printed later
Gelatin silver print
11 x 14 in. (27.9 x 35.6 cm)
Gift of B. Gerald Cantor Art Foundation
M.87.74.4

Balzac, Silhouette, c. 1908; printed later
Gelatin silver print
11 x 14 in. (27.9 x 35.6 cm)
Gift of B. Gerald Cantor Art Foundation
M.87.74.5

Unidentified artist
Plaster Balzac Monument, 1898
Gelatin silver print
10½ x 8½ in. (26.7 x 21.6 cm)
Gift of B. Gerald Cantor Art Foundation
M.87.74.2

● *Prints and Drawings*

Albert Besnard
FRANCE, 1849–1934
Auguste Rodin, 1900
Etching and drypoint
10¾ x 7¾ in. (27.3 x 19.7 cm)
Gift of B. Gerald Cantor Art Foundation
M.87.76.1

Eugène Carrière
FRANCE, 1849–1906
Rodin Modeling a Sculpture, 1900
Lithograph
21⅝ x 17½ in. (54.9 x 44.5 cm)
Gift of Cantor Fitzgerald & Co. Inc.
M.90.118

Pablo Picasso
SPAIN, 1881–1973
Fauns and Woman, 1946
Graphite and watercolor
20⅛ x 25¾ in. (51.1 x 65.4 cm)
Gift of B. Gerald Cantor
61.6.1

Pierre-Auguste Renoir
FRANCE, 1841–1919
Auguste Rodin, c. 1910
Lithograph
15¾ x 15³⁄₁₆ in. (40.0 x 38.6 cm)
Gift of B. Gerald Cantor Art Foundation
M.87.76.2

Auguste Rodin
FRANCE, 1840–1917

Victor Hugo, 1884
Drypoint
8¾ x 5¹⁵⁄₁₆ in. (22.2 x 15.1 cm)
Gift of B. Gerald Cantor Art Foundation
M.87.76.3

Study for the Gates of Hell, c. 1880–82
Brown ink, brown wash, and watercolor
7 x 4⁹⁄₁₆ in. (17.8 x 11.6 cm)
Gift of B. Gerald Cantor Art Foundation
M.87.76.4

*Mlle. Jean, Seated with One Knee
Raised*, n.d.
Pencil
12⅞ x 9⅞ in. (32.7 x 25.1 cm)
Gift of Iris and B. Gerald Cantor
Foundation
M.90.111.1

Mlle. Jean Simpson, Standing, n.d.
Pencil
12⅞ x 9⅞ in. (32.7 x 25.1 cm)
Gift of Iris and B. Gerald Cantor
Foundation
M.90.111.2

Mlle. Jean, Head Study, n.d.
Pencil
12⅞ x 9⅞ in. (32.7 x 25.1 cm)
Gift of Iris and B. Gerald Cantor
Foundation
M.90.111.3

Mlle. Jean, Seated, n.d.
Pencil
12⅞ x 9⅞ in. (32.7 x 25.1 cm)
Gift of Iris and B. Gerald Cantor
Foundation
M.90.111.4

● *Twentieth-Century Art*

Max Beckmann
GERMANY, 1884–1950

Springtime in Berlin, 1907
Oil on canvas
37³/₈ x 31³/₄ in. (96.2 x 80.6 cm)
Gift of B. Gerald Cantor
M.62.25.1

Bacchanal, 1909
Oil on canvas
36¹/₄ x 32 in. (92.1 x 81.3 cm)
Gift of B. Gerald Cantor
M.62.25.2

Billy Al Bengston
UNITED STATES, b. 1934
Tom, 1968
Acrylic lacquer and polyester resin on
aluminum
25 x 26 in. (63.5 x 66.0 cm)
Gift of B. Gerald Cantor
M.68.58

André Derain
FRANCE, 1880–1954
Landscape with a Mill, c. 1912
Oil on canvas
22¹/₂ x 17¹/₂ in. (57.2 x 44.5 cm)
Gift of B. Gerald Cantor
61.6.2

Otto Dix
GERMANY, 1891–1969
Leda, 1919
Oil on canvas
40³/₄ x 31³/₄ in. (103.5 x 80.6 cm)
Purchased with funds provided by
Charles K. Feldman, Mr. and Mrs. John
C. Best, and B. Gerald Cantor
85.3

Roger de La Fresnaye
FRANCE, 1885–1925
Eve, n.d.
Bronze
12³/₄ x 17¹/₄ x 7³/₄ in.
(32.4 x 43.8 x 19.7 cm)
Inscribed on base, right:
R. de la FRESNAYE
Foundry mark on base, top, back:
Valsuani Cire Perdue
Gift of B. Gerald Cantor Collections
M.84.262.1

Ernst Ludwig Kirchner
GERMANY, 1880–1938
Two Women, 1911/1922
Oil on canvas
59 x 47 in. (149.9 x 119.4 cm)
Gift of B. Gerald Cantor
60.33

Georg Kolbe
GERMANY, 1877–1947

Maria, 1943
Bronze
35¹/₂ x 10¹/₈ x 11 in.
(90.2 x 25.7 x 27.9 cm)
Gift of B. Gerald Cantor
M.73.109.3

Head of a Dancer, 1912
Bronze
11³/₈ x 8³/₄ x 10⁷/₈ in.
(28.9 x 22.2 x 27.6 cm)
Gift of B. Gerald Cantor Art Foundation
M.73.110.5

Large Seated Woman, 1929
Bronze
37¹/₂ x 25 x 23 in. (95.3 x 63.5 x 58.4 cm)
Foundry mark on base, back: BERLIN.
H.NOACK
Gift of Cantor Fitzgerald Securities
Corporation
M.82.58.1

Lucino, 1921
Bronze
82¹/₂ x 20¹/₂ x 20 in.
(209.6 x 52.1 x 50.8 cm)
Inscribed on base, front: GK
Foundry mark on base, back: H. NOACK/
BERLIN/IV
Gift of Cantor Fitzgerald Securities
Corporation
M.82.58.2

The Night, 1930
Bronze
83 x 25 x 26 in. (210.8 x 63.5 x 66 cm)
Inscribed on base, top, right: GK
Foundry mark on base, back: H. NOACK/
BERLIN-FRIEDENAU
Gift of B. Gerald Cantor
M.82.209.1

Aristide Maillol
FRANCE, 1861–1944
Kneeling Young Woman, 1900
Bronze
33¹/₂ x 19 x 13 in. (85.1 x 48.3 x 33.0 cm)
Inscribed on base, right: A. MAILLOL 4/4
Foundry mark on base, right: Alexis
Rudier/Fondeur Paris
Gift of Iris and B. Gerald Cantor
M.83.262.2

INDEX